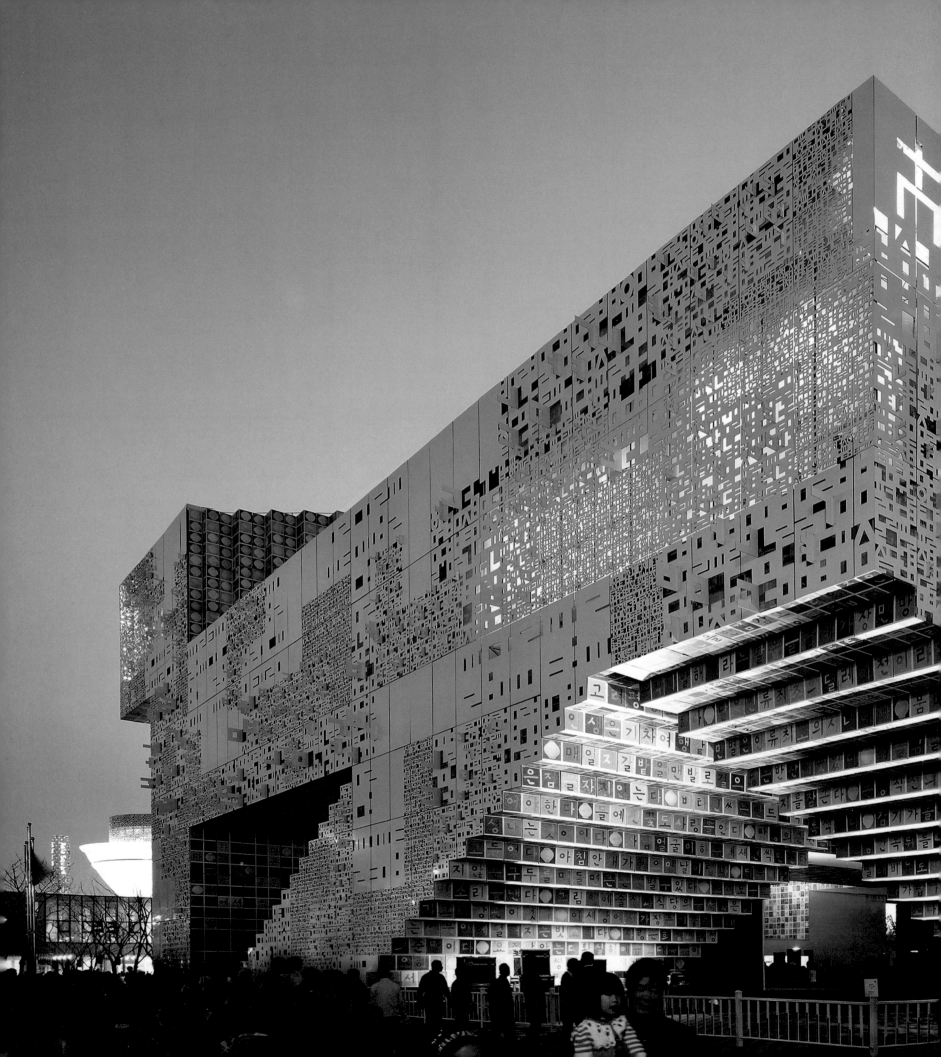

LETTERING LARGE

ART AND DESIGN OF MONUMENTAL TYPOGRAPHY

STEVEN HELLER & MIRKO ILIĆ

THE MONACELLI PRESS

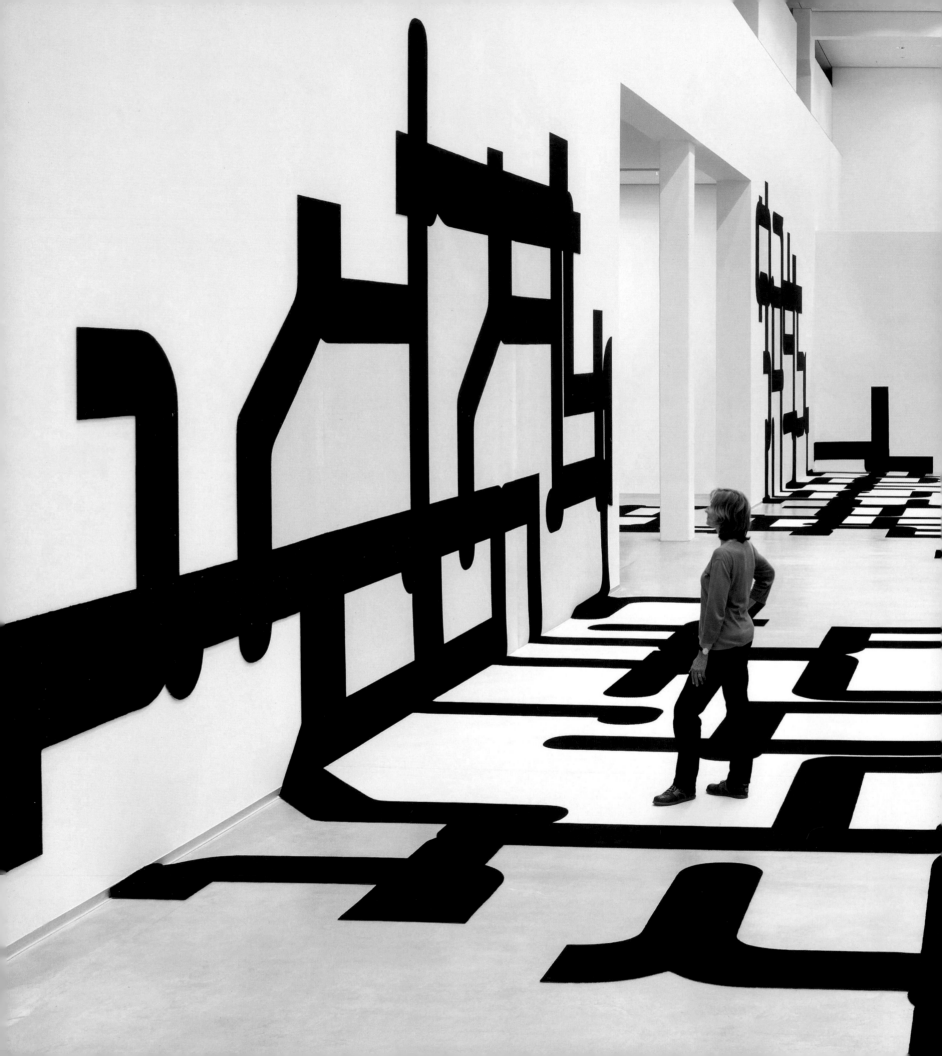

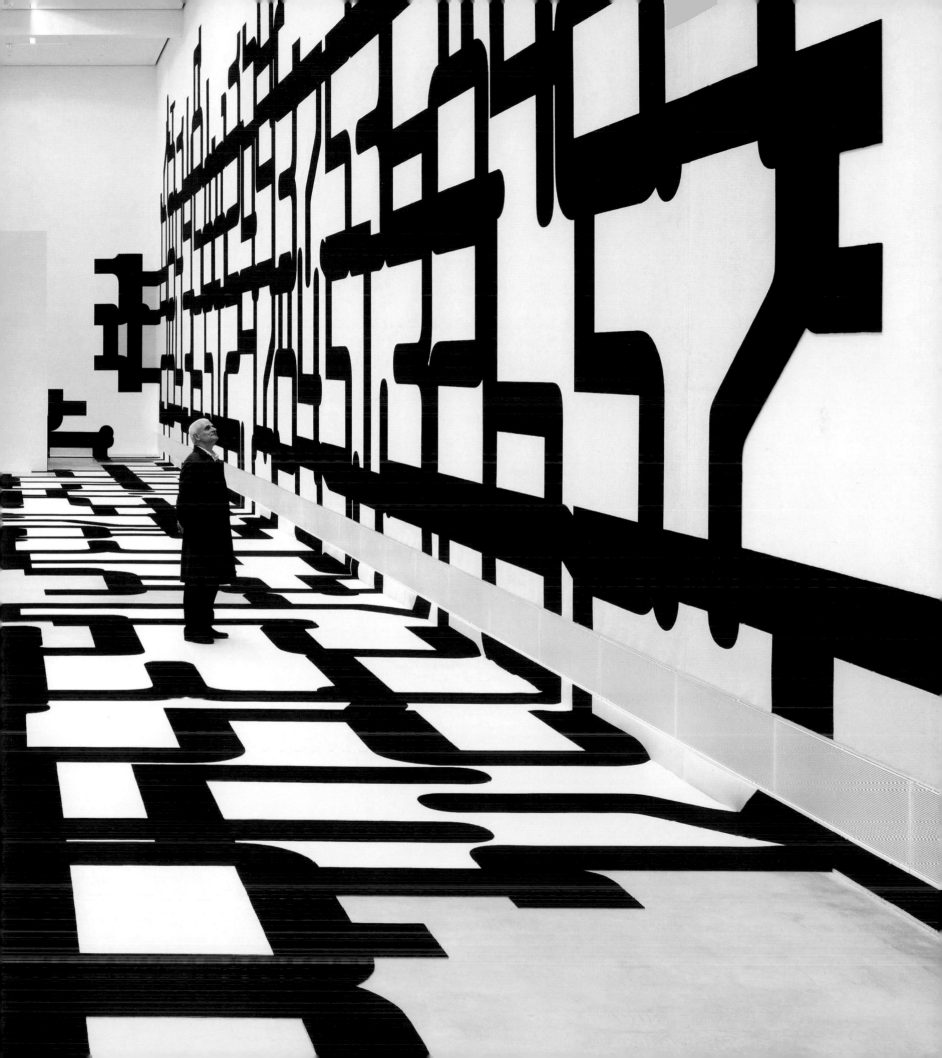

First published in the United States by The Monacelli Press

Library of Congress Control Number: 2001012345
ISBN: 9781580933599

Designed by Mirko Ilić Corp
Printed in China

www.monacellipress.com

Dedicated to Milton Glaser and Mihajlo Arsovski

Acknowledgments:
Aimee Pong
Amir Berbić
Bethany Ulrich
Gordon Young
Jee-Eun Lee
Jenny Barkdoll
Jessica Yeung
Kaila Smithem
Megan Tom
Ringo Takahashi
Sam Cox

Special thanks to Google Earth, without which some of these important images would not have been accessible

Chief Researcher: Ivana Vasić

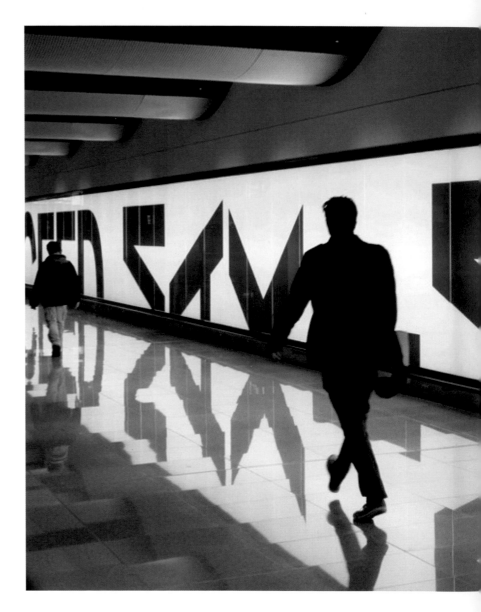

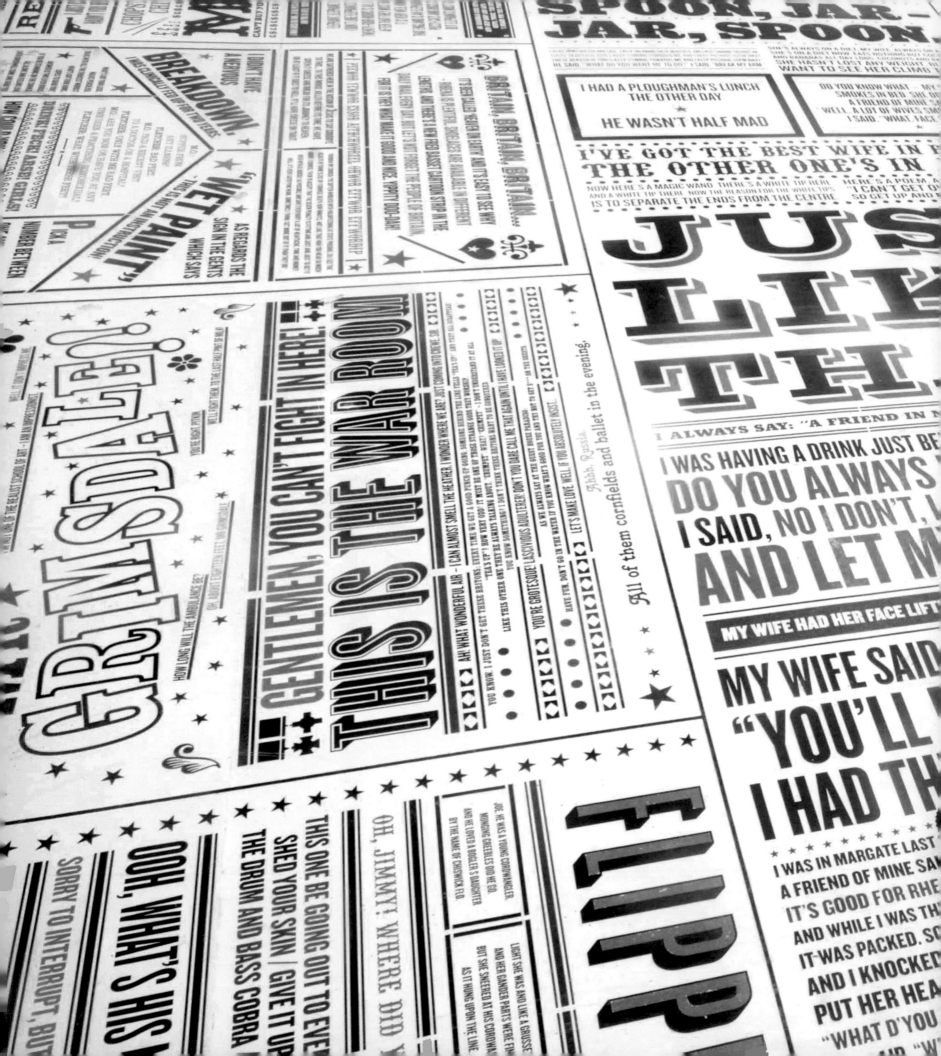

LET YOUR ARMS BE AS WARM
AS THE SUN FROM UP ABOVE
BRING ME FUN, BRING ME SUNSHINE
BRING ME LOVE

RUBBISH!

THERE WAS A MAN WHO WAS
SHIPWRECKED WITH HIS DOG
ON A DESERT ISLAND...

EVERY GAG FRESH
FROM THE QUIPPERIES!

NEVER HAS MY FLABBER BEEN SO GASTED!

...IS A PEST... GET RID OF HIM."

...THE SHOW AND A MAN SAID TO ME
...INK WHISKEY NEAT?
...METIMES DON'T WEAR A TIE
...SHIRT HANG OUT

...ST WEEK. BUT IT'S NOT HIGH ENOUGH, I CAN STILL SEE IT.

...O ME THIS MORNING, SHE SAID,
...RIVE M... MY GRAVE."
...MINUTES.

FORGET HIM.
ERNIE: WE WERE VERY POOR
ERNIE: REALLY?
ERNIE: WHAT DID THEY DO
...AND LACED UP MY TOES.

SHUT YOUR FACE!
I PAY FOR THESE JOKES
I MIGHT AS WELL USE THEM

PLEASE
YOURSELVES!

I TRIED TO SWIM THE ENGLISH
CHANNEL, BUT THREE MILES BEFORE
REACHING THE FRENCH COAST, I GOT
CRAMP AND HAD TO SWIM BACK

I HAD A FUNNY DREAM LAST NIGHT.
I DREAMT I WAS EATING A TEN-POUND MARSHMALLOW
...WOKE UP THIS MORNING
...WAS GONE.

...STAY THERE," AND SHUT THE WINDOW.
...I WANT TO STAY HERE.

The concept that type is a "crystal goblet" was introduced by the typeface expert Beatrice Warde in her 1955 essay "The Crystal Goblet, or Printing Should Be Invisible." She wrote, "Bear with me in this long-winded and fragrant metaphor; for you will find that almost all the virtues of the perfect wine-glass have a parallel in typography." Warde made the distinction between art, which draws attention to itself, and the subtleties of readable typography, which exists to convey an idea and message in the same way that a beautiful goblet is merely a transparent container for the fine wine within. Mixing metaphors, she added, "Type well used is invisible as type, just as the perfect talking voice is the vehicle for the transmission of words."

Since the time when Warde's essay was published, typefaces have evolved from metal to film to pixels. The once arcane term "font," formerly known only to typefounders, is now understandable to all who use digital devices. No longer the rarified printing craft it once was, typesetting is akin to typing, and typography is as common as handwriting (in fact, it has replaced handwriting in some quarters). Letterforms, which were never as neutral as Warde would have us believe, are

often boisterous. Crystal goblets are routinely shattered in the service of today's typographic expression in print and online media.

Another wellspring—or geyser—of extroverted typography is the physical world, where monumental letters, or "environmental type," are as imposing as Easter Island's famous heads. The number of typographic shrines, monuments, and sculptures, designed for function and folly, has grown exponentially in the past three or four decades. They can be found on, in, and around buildings, along roadways, sprinkled through parks, and affixed to anything that will hold them. As pundits decry the loss of fundamental reading skills in this frenetic digital age, large words, designed to be experienced, are appearing in the most surprising places.

Lettering Large is a chronicle of these states of the art. To some, it might seem curious to think of type as an art. It is such a pragmatic tool that to reconceive letterforms as artwork is akin to saying comic strips are literature. But in fact, some of today's comics are literature and type can be both commercial and fine art. The definition of what is art changes from generation to generation. When Cubists, Dadaists, and

Expressionists introduced cut and pasted alphabets into their collages, the basic rules changed. The Futurists went further with their *parole in libertà* (words in freedom), using typefaces in the same way as a painter would apply oils, employing various sizes and shapes of letters like pigments and textures to express feelings and thoughts. Like so many quotidian things before and after, type has been transformed by artists into art. In 1927 the Italian Futurist graphic designer and painter Fortunato Depero designed and built perhaps the first building to be made out of concrete block letters. The book pavilion in Monza, Italy, spells out the structure's function (see page 129) as a kind of "typography parlant" (typography whose physical form speaks to the semantic meaning of the words). These days type can be anything from structure to form, decoration to signifier.

Yet modern art is not where our so-called monumental-sculptural lettering originated. "The incorporation of lettering into the architectural pattern of a building is a practice with an honorable history," wrote Alan Bartram in his *Lettering on Architecture* (Whitney Library of Design, 1975). His

EXTROVERTED TY

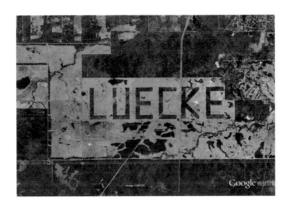

Luecke, Near Austin, Texas, 30° 5'7.55"N 97° 8'26.41"W
Image: **Google earth, Image CAPCOG**
Natural-color satellite image acquired by the Advanced Land Imager aboard EO-1 on September 12, 2011

Although this could have just been a curiosity for passing pilots and astronauts, it turns out that Johnson Space Center scientists used the letters to estimate the maximum resolution of cameras aboard the Space Shuttle. "We also made an empirical estimate of spatial resolution for lower contrast vegetation boundaries. By clearing forest so that a pattern would be visible to landing aircraft, a landowner outside Austin, Texas, created a target that is also useful for evaluating spatial resolution of astronaut photographs.

profusely illustrated book includes scores of routine government and merchant inscriptions and signs that are carved, gouged, painted, or raised fascias, but Bartram also looks back to Egyptian hieroglyphs on buildings and Assyrian cuneiform on monuments. However, the Romans "were the first people to devise monumental inscriptions as we know them," he notes, adding that "Western civilization can never repay the debt."

The statements formed by these letters, "when used in the grand manner," represented the official voice of the state speaking to the people. The letter carvers, "artists and virtuosi," worked for the empire as propagandists. With literacy on the rise by the nineteenth century, writing was more widespread, and technology for reproducing texts was accessible, so the official need for architectural lettering was lessened but not eliminated.

There are numerous examples in *Lettering on Architecture* from the sixteenth through nineteenth centuries showing how wealthy aristocrats used stone letters that formed words—sacred and devotional phrases—that were seamlessly integrated into the balustrades of their homes and gardens, in order to haunt viewers for all eternity. Of course, integrated lettering, carved or embedded, ultimately served many devious purposes, too: political, religious, and commercial. In Fascist Italy, inspirational Mussolini quotations were writ large in stone, mosaic, and neon. The Soviets also made use of gigantic sayings that dwarfed the everyday voice of the people. Gigantic quotations often underwrite cults of personality.

But this book eschews the manipulative abuse of alphabets and is more concerned with the artistic—though sometimes sensationalistic—applications by graphic and industrial designers, architects, and artists for expressive or branding reasons. *Lettering Large* is not, however, thematically organized in that way. We do not distinguish between personal expression or business branding but rather focus on the differences in form: two-dimensional flat typography attached to the interior or exterior of buildings; three-dimensional monumental typography on the surface or in the veneer of structures; outside typography that stands independent of a building but nonetheless addresses the building's function; artworks involving lettering and type as a raison d'être for conceptual art. Within these categories are structures made from type, type that supports built structures, people comprising typographical formations, and typographic optical illusions. Different alphabets—Roman, Arabic, Cyrillic, kanji, runic, and more—are represented. And let's not forget that numerals are an important part of typography. In this book there are hundreds of distinct typographic gems for which the only common denominator is the letters are large and size does matter.

PE: SIZE MATTERS

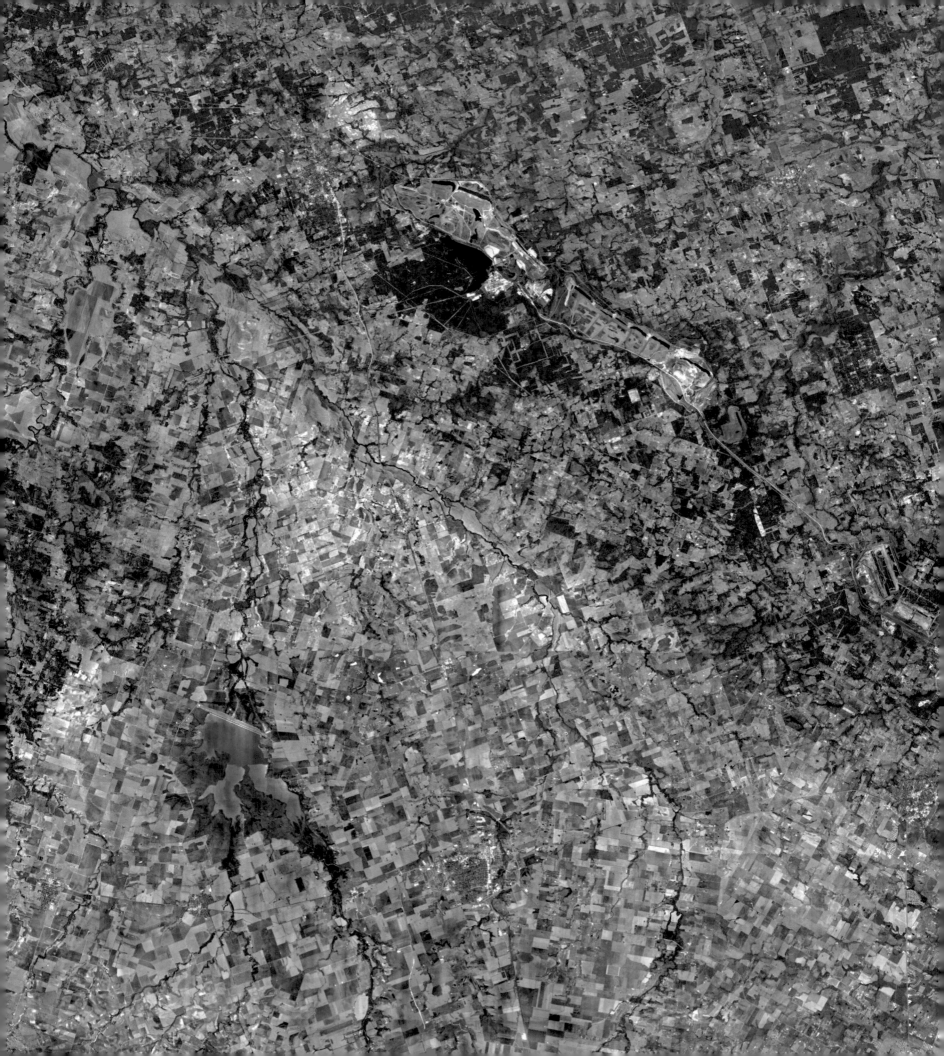

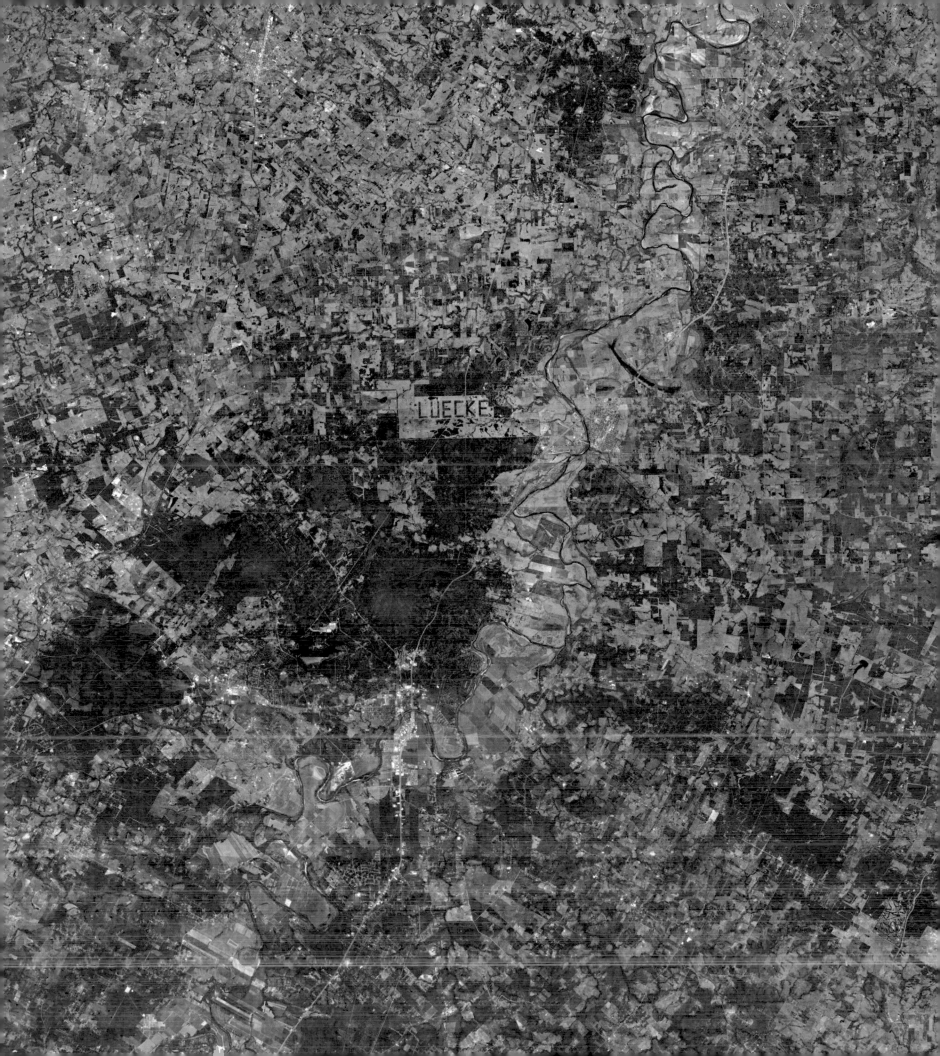

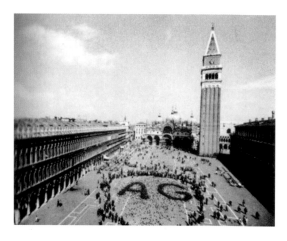

AG Insurance, St Mark's Square, Venice, Italy, 1950s
St. Mark's Square has been the site for some strange typographical promotions, here pigeons in the service of insurance.

Outdoor typography is nothing new—typographic messages, signs, proclamations, and advertisements have bombarded passersby for eons, in sometimes intrusive ways. What is new is the increasingly large number of novel conceptual ways that designers are building letters and words in natural and man-made environments.

Widespread documentation of these typographic manifestations has encouraged ever more inventive approaches to sprout and flower, if only briefly. Photography has also made it possible for creators of outdoor spectaculars to transform their one-of-a-kind works into multiples, which in turn encourages more varied typographic spectaculars that are continually developing as type fashions come and go.

One of the quirkiest, if timeworn, approaches is choreographing people en masse into formations of letters or logos. First appearing in the early twentieth century, this hugely challenging logistical exercise involved coordinating the movement of dozens of members of sports teams, marching bands, high schools, colleges, or military battalions, among other large groups. Thanks to bird's-eye and panoramic camera lenses, these idiosyncratic displays of crowd control—which were frozen for barely minutes—could be forever captured. Groups of people continue to form letters with awesome yet unnerving precision at government celebrations in North Korean sports stadiums, where thousands of people (and this is good reason for state-promoted fecundity) are employed to accomplish the spectacle.

Willing (and unwilling) masses are not the only fodder for outdoor aerial view-scapes. Satellite imaging has given rise to environmental typographic

spectaculars that are best, if only, seen from the heavens via Google Earth. The phenomenon actually started much earlier, during the Cold War in the 1970s, when earth- and plant works were constructed throughout the former Soviet Union (pages 22, 23) in the shape of words of patriotic slogans, such as "Lenin 100 years," "60 Years to USSR," and so on, as nose-thumbing "greetings" for American spy planes and satellites. The only way to see these typo- marvels was from the sky above.

In 2011 a United Arab Emirates billionaire, Sheikh Hamad bin Hamdan Al Nahyan, pulled off a similar feat. He wrote his name, "HAMAD," across two miles of sand on a spit of beach at the outskirts of Abu Dhabi. Large enough to be visible from space, it set a record for the biggest typeface ever. A project by Barbara Kruger was equally ambitious, but more in the service of art than ego. She conceived a project titled PICTURE THIS for the North Carolina Museum of Art's Outdoor Amphitheater, which was completed in 1997. Directly adjacent to the existing museum in Raleigh, the three-acre site is organized according to three big ideas: the Big Roof, the Big Screen, and the Big Letters. The Big Letters, spelling PICTURE THIS (page 32), surround the stage and are physically integrated into the architecture and the landscape, inviting visitors to engage with the message both metaphorically and literally. While discernable from the ground, the text is more dramatic when seen from the air.

Not everyone has the wherewithal to experience a firsthand aerial view of these type-scapes, so the challenge is to make outdoor typography readable from both high and low vantage points. Thonik's 2006 courtyard for Museum Boijmans Van Beuningen in

Rotterdam was designed as part of the museum's new overall graphic identity, and the mammoth graphic floor design is based on the museum's swirling logomark. The grand optical motif can be read at both walking and flying perspectives. Another dual perspective is Timm Schneider's 2010 Jump for My Love, for the water park Freibad Kleinfeldchen in Wiesbaden, Germany. Schneider explained that the work is rooted in the idea that "passivity is a way of life and surprise is the spice." By adding just a little twist into an everyday thing, in this case a swimming pool floor, Schneider transforms the perspective, and therefore the vision, of the observer. He used water refraction and font size so the viewer only can read the message when standing on top of the diving tower. The words are the chorus of the 1984 song by the Pointer Sisters, which became his mantra of "motivation and joy."

Many outdoor typographic experiences revolve around perceptual dislocation derived from planting large letters, words, or statements in unlikely environments. This is no better illustrated than through English artist Gordon Young and graphic design firm Why Not Associates' 2008–11 Comedy Carpet (page 50, 51), a 2,200-square-meter granite-and- concrete plaza made up of 180,000 individually carved granite letters cut into high- quality concrete panels. Each panel features jokes, songs, sketches, one-liners, and catchphrases from notable comedians and writers of British comedy (along with a few foreigners who performed at the resort—Mae West, W. C. Fields, Bob Hope, Laurel and Hardy, George Burns, Danny Kaye). As appropriate as the theme and design referencing old theater bills is to Blackpool, England, laying this

MONUMENTAL

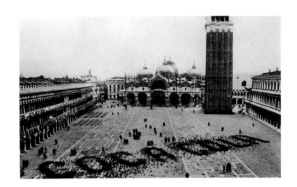

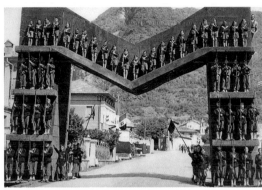

Coca-Cola, St Mark's Square, Venice, Italy, 1960s
In the early 1960s Coca-Cola marketers were inspired to spread out an excessive amount of birdseed in St. Mark's Square in the shape of its famous logo. When hundreds of hungry pigeons laded for their meal, they spelled out "Coca-Cola."

Mussolini M, c. 1928
Italian Fascist Duce Benito Mussolini used the M as his personal logo. During his reign, the M was as ubiquitous as the fascist symbol. Like any powerful person's logo, it substituted for the physical leader and was therefore a sacrosanct image. Here young Fascist Vanguardistas stand at attention on the M-ument.

massive carpet in front of the Blackpool Tower on a new promenade brought new energy to the district.

While visitors can traipse all over the Comedy Carpet in Blackpool, in Toronto, Anthony Chelvanathan's 2008 Help Hunger Disappear invites—indeed commands—visitors to interact with it by actually disassembling the sign. The word is constructed out of soup cans and cardboard dividers; each time a can is removed, part of the word "hunger" literally disappears.

Another way to express dislocation is through realignment of the familiar into an entirely new entity. To commemorate the once majestic, recently demolished Miami-Dade County Orange Bowl, Snarkitecture's 2012 A Memorial Bowing recalls the enormous Miami Orange Bowl stadium sign that appeared over the entrance from 1937 until 2008. The letters from that original sign are reconstructed at their ten-foot height and scattered throughout the east plaza of the new Florida Marlins ballpark, as if they fell off. Their positions capture an ambiguous moment between the building's ruin and rebuilding. Some letters stand vertically, others submerge themselves in the ground, and others lie horizontally as if at rest. As visitors move through the plaza, new alignments are created between the letters, spelling out different words as the new stadium is glimpsed through fragments of the old.

Words made into a pergola mark a place for contemplation in relais Landschaftsarchitekten's 2011 Der Gescgruebebe Gärten (Written Garden) in Gärten der Welt (Garden of the World) in Berlin. The type by Alexander Branczyk and typography by him and Annette Wuesthoff (both from German design firm xplicit) is used to convey multiple texts from Christian and occidental writings. The texts "form an ambulatory in the tradition of medieval cloisters": a place where visitors can quietly stroll, read, or just reflect. Xplicit designed a customized alphabet and prepared the sixteen typographic "mural segments" comprising the pergola. As they observe, "The varying number of letters per line prevents single lines from looking compressed or spaced out." The mural suggests a bramble of twigs as letters.

Outdoor typography that offers the user extremely literal information is the virtue of David LaPlante's artful 2008 Bike Rack at the Salt Lake City Public Library. In no ambiguous terms, this bike rack telegraphs exactly what the user is expected to do with the letters (park a bicycle). On a different scale Slaviša Savić's 2008 Days of Belgrade festival also featured an information-sharing scheme. Four gigantic inflated Cyrillic capitals—"DAYS"—were positioned at measured intervals on the main pedestrian street in the city, serving as markers. Each letter was a hot spot, and each initial stood for the kind of events were available during each day of the four-day festival. It is not too different from Ivan Chermayeff's bold red 9 (page 71), which also serves as a hot spot of a different kind. This New York icon, which has not moved since 1979 when it was planted on the wide, bustling sidewalk in front of 9 West 57th Street in midtown Manhattan, retains its own stand-alone, formal integrity. Yet it is also inextricably linked to the building by its singular function—to announce, in no subtle way, the address of this unique and controversial piece of New York architecture. Chermayeff's 9 was the first display of its kind in the city.

Perhaps influenced by 9, Theodore T. Gall's 1995 the Monument, an alphabetic tribute to Chicago's WBEZ public radio station, employs mammoth brightly colored letters based on Bodoni Bold and Craw Clarendon, made from welded steel. Like children's letter blocks, it has an ad hoc aesthetic that demands deciphering. If Gall added a fountain to his design scheme, it would be similar to Ante Rašić 2011 Belupo Fountain at the pharmaceutical company Belupo's factory in Koprivnica, Croatia. The colorful letters of the Belupo logo blown up hundreds of times suggest a carnival rather than a drug manufacturer. But as the centerpiece of the factory grounds, the fountain transformed a cold, indifferent space into one with what Rašić calls "humane dimensions and aesthetic content."

We are so used to seeing typographic signs in the environment they are easily ignored or taken for granted. So, to be jogged from daydreams or chronic complacency by the grand statements of extra-large letters, big words, and massive sentences in the environment— poetic and profound—is what this genre of typography was conceived to accomplish. Many do this either through wit, scale, or spectacle. When this succeeds, even the most temporary typography is forever memorable.

OUTDOOR TYPE

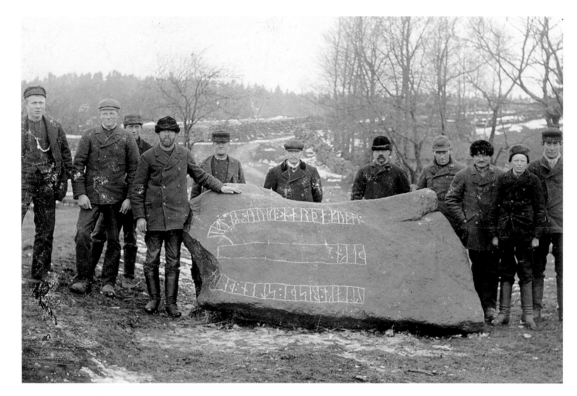

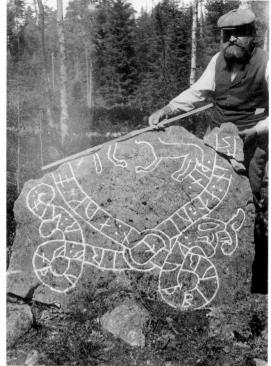

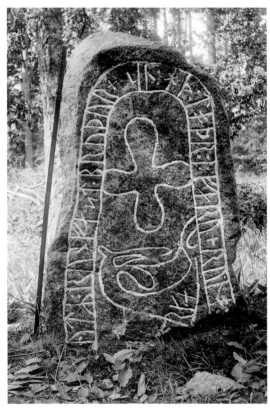

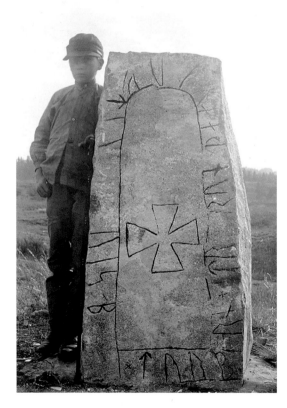

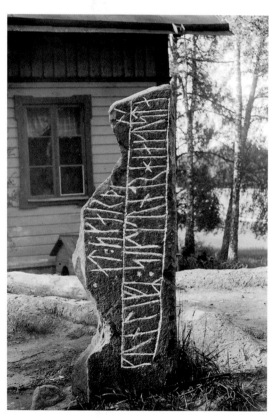

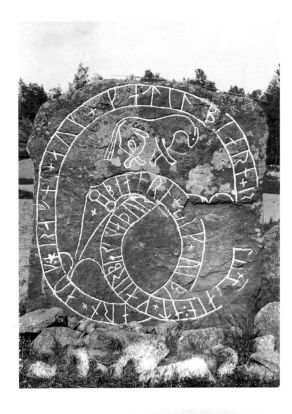

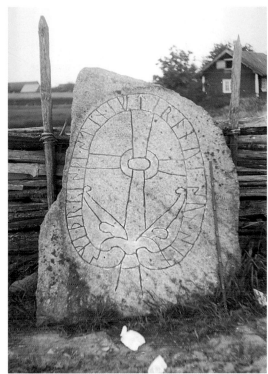

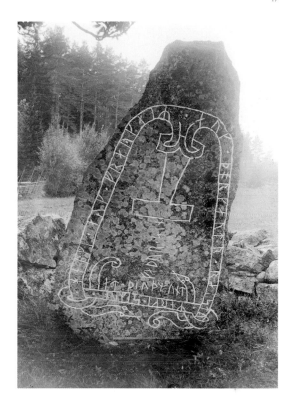

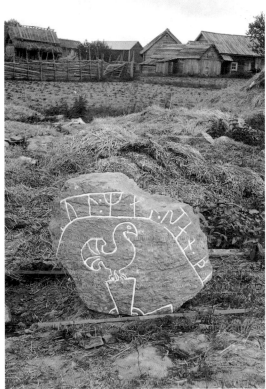

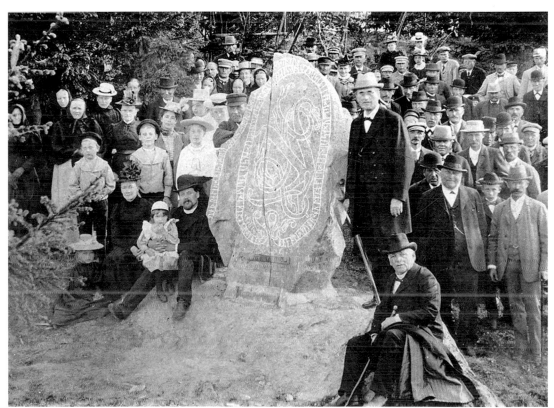

Swedish Ancient Monuments and Archaeological Sites
Precursors to environmental typography, these are runic letters on rune stones at Swedish archaeological sites, generally from the eleventh century AD and Neolithic dolmens. Some are passage graves from about 3500 BC.

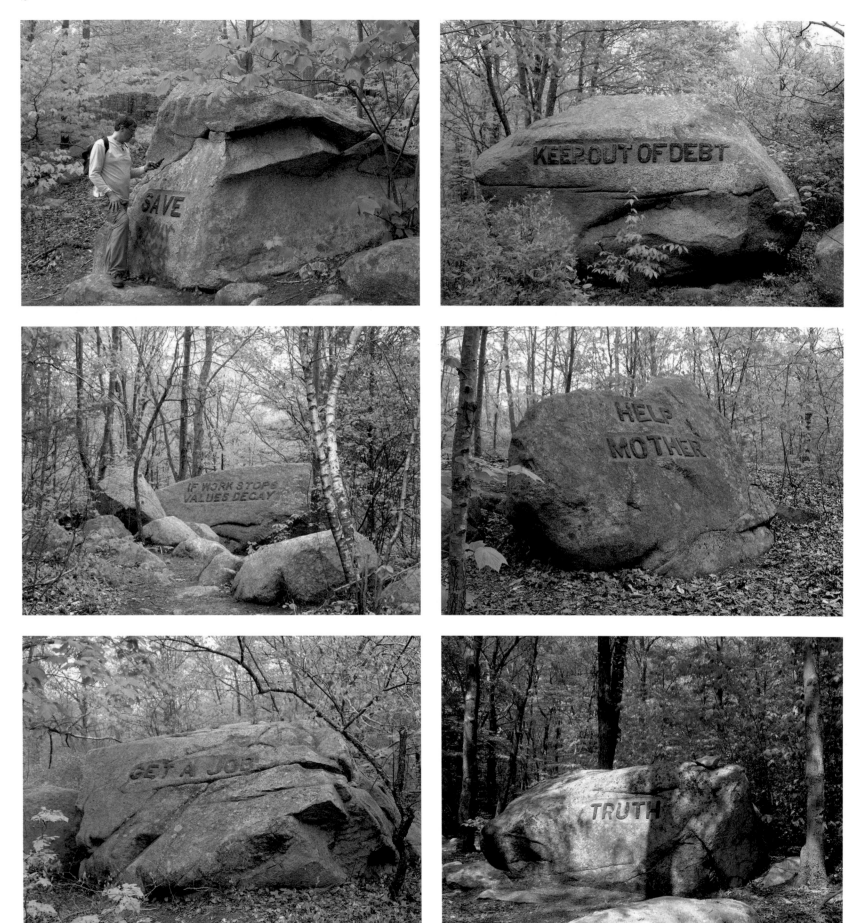

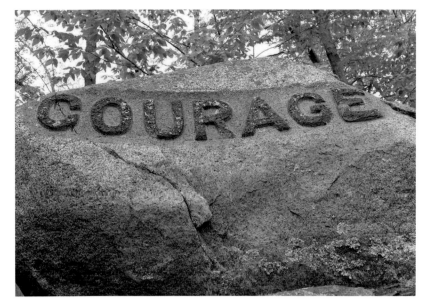

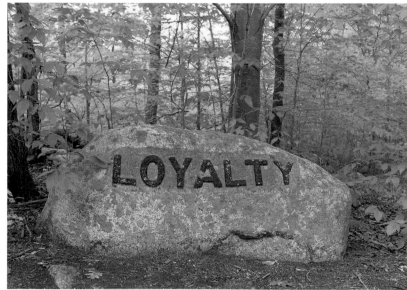

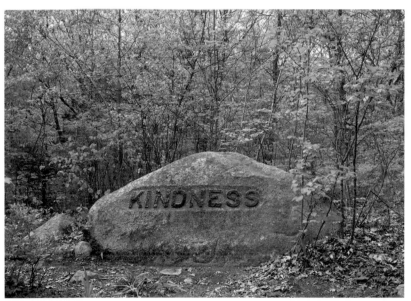

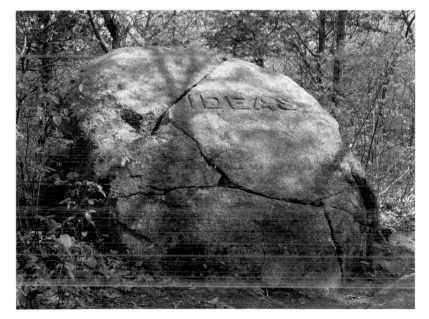

Babson Boulders, Dogtown, Massachusetts, 1930s
Photographer: Eric Brickernicks
Naturalist, historian, and philanthropist Roger Babson hired unemployed stonecutters to carve twenty-four inspirational words and phrases on large boulders along the Babson Boulder Trail, which marked the location of the area's natural "cellar holes."

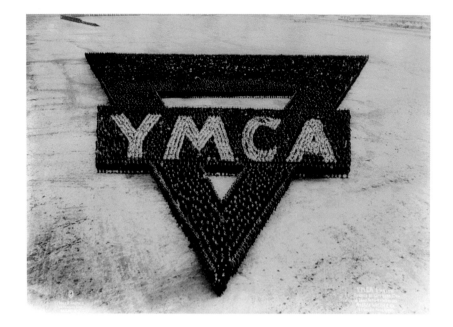

YMCA, Camp Wheeler, Georgia, about 1900
Photographers: **Arthur Mole and John Thomas**
YMCA emblem formed by officers, men, and camp activity workers with Lt. Gen. J. B. Moss commanding.

Navy, San Diego, California, 1917
Photographers: **Arthur Mole and John Thomas**
Navy personnel on parade at Balboa Park in navy flag formation.

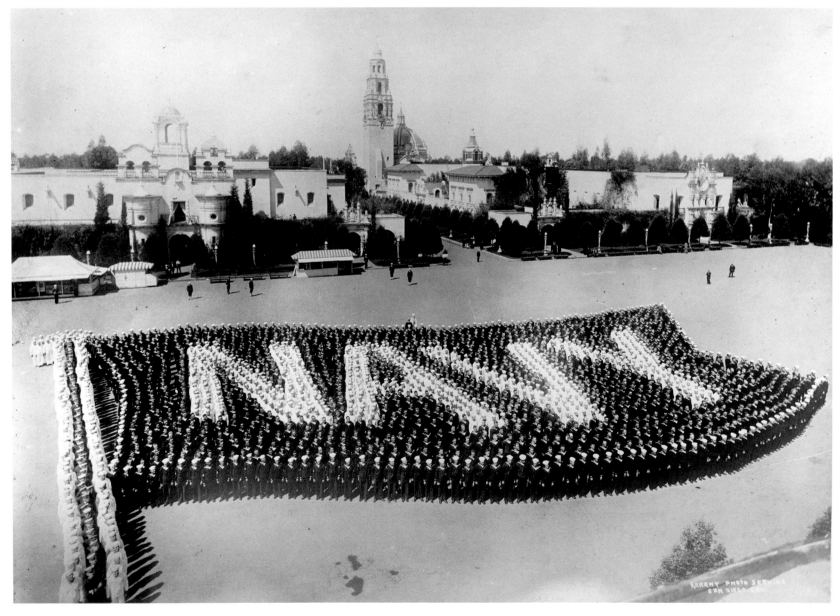

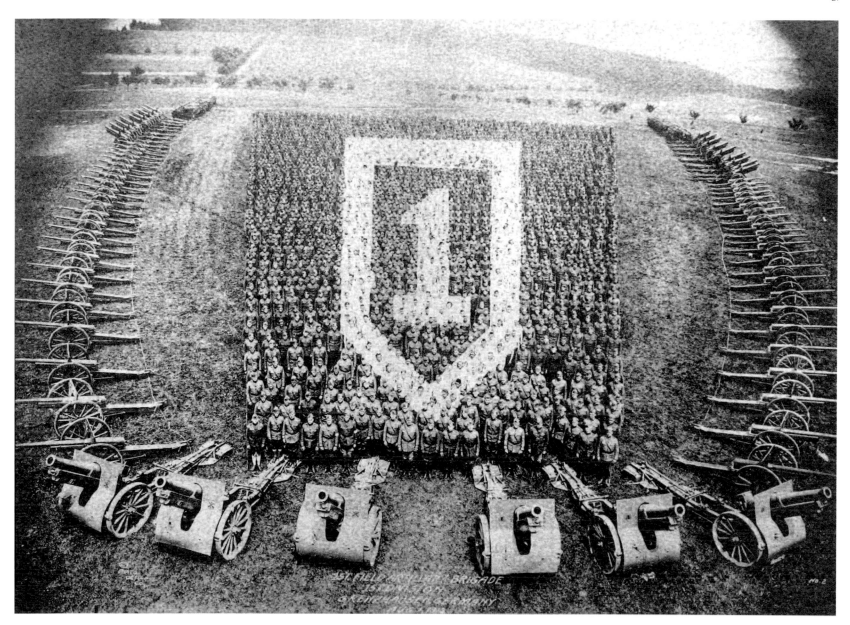

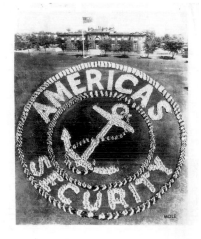

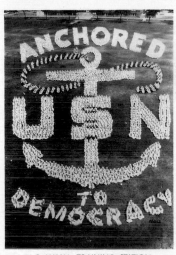

U. S. NAVAL TRAINING STATION,
GREAT LAKES, ILLINOIS
REAR ADMIRAL JOHN DOWNES U S NAVY,
COMMANDING OFFICER

U S NAVAL TRAINING STATION,
GREAT LAKES, ILLINOIS
REAR ADMIRAL JOHN DOWNES U S NAVY,
COMMANDING OFFICER

Big One, Quantico, Virginia, 1917
Photographers: Arthur Mole and John Thomas
Members of the Big One artillery battalion from World War I mass to create the army emblem.

U.S. Naval Training Station, Great Lakes, Illinois, c. 1918. (two posters)
Photographer: Arthur Mole
Aerial photographs of U.S. Navy typographic formations.

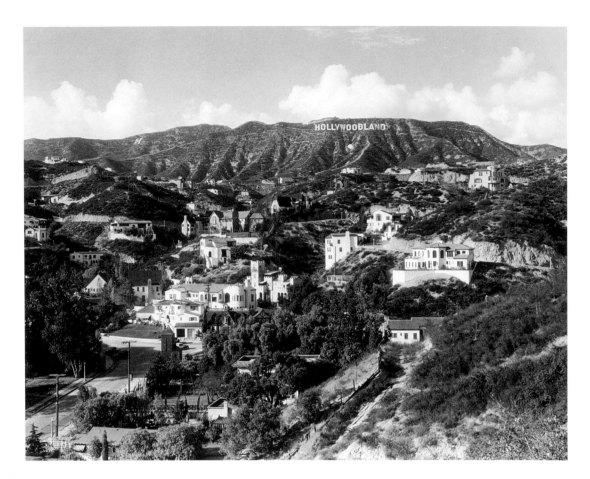

Hollywoodland, Los Angeles, 1923
Designer: **Thomas Fisk Goff**
A Los Angeles real estate group unveiled a massive billboard to promote its new Hollywoodland development. Crescent Sign Company erected thirteen letters on the hillside, facing south. Each letter was 30 by 50 feet, and the whole sign was studded with some four thousand light bulbs.

Hollywood
Photogapher: **Steve Tracy**
The word ihas been shortened and the letter spacing is awkward, but Hollywood continues to grace the hills.

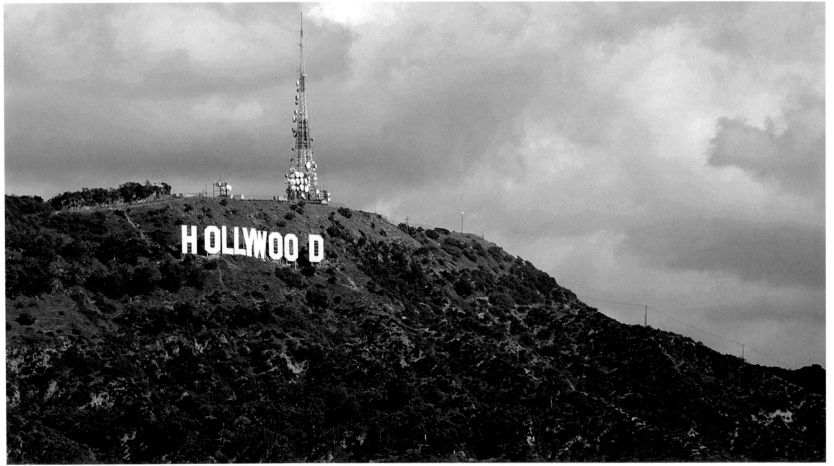

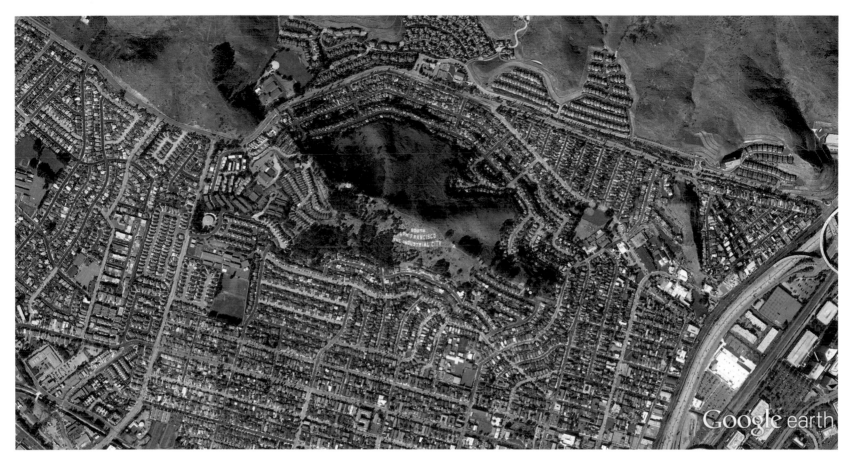

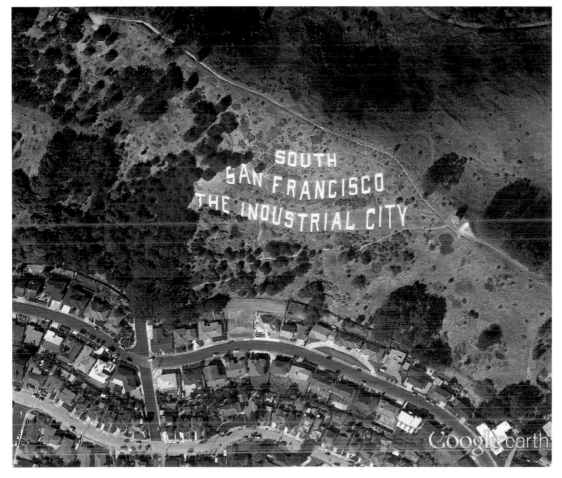

South San Francisco: The Industrial City, California, 1928
Latitude N 37° 39.805, longitude W 122° 25.101
Images: Google earth, Image © 2013 TerraMetrics
A key landmark of this industrial city is visible to anyone who travels along the San Francisco Peninsula. Sign Hill, near San Bruno Mountain, has huge letters on its side. The words were first painted on the hill in 1923 to advertise the city. In 1928 the sixty-foot high letters were cast in concrete, and sitting flush with the hillside, are essentially the same today.

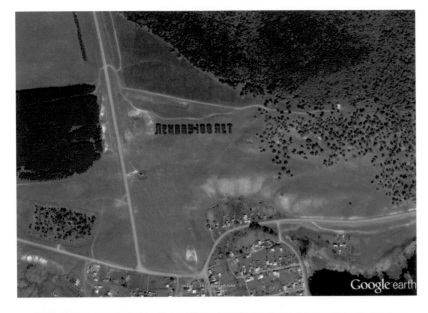

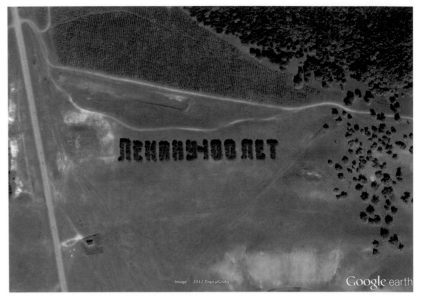

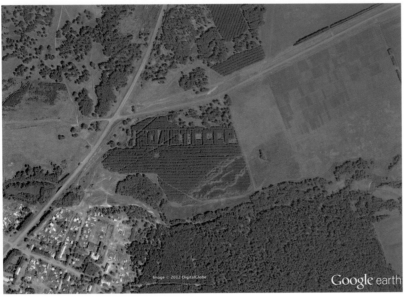

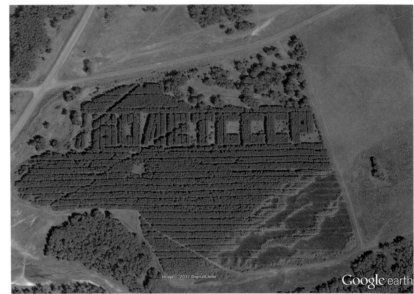

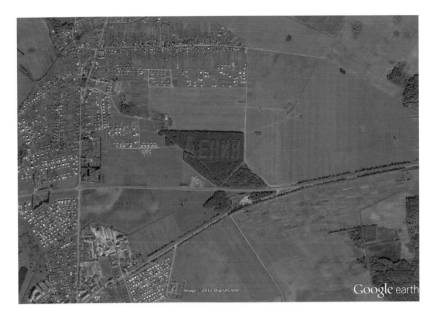

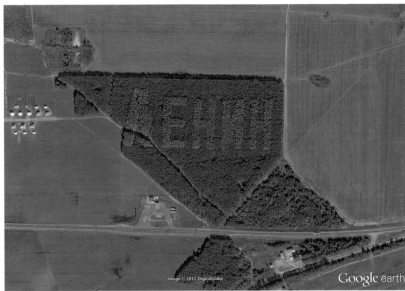

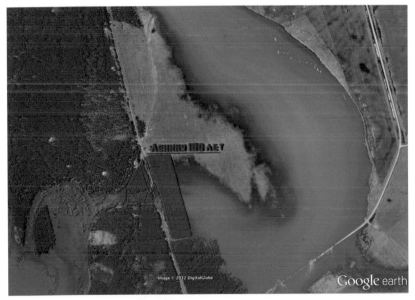

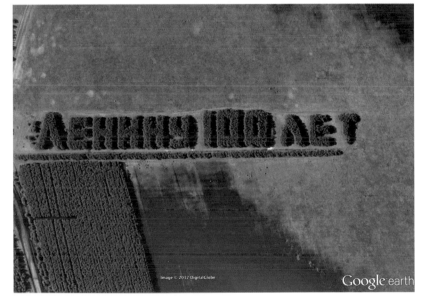

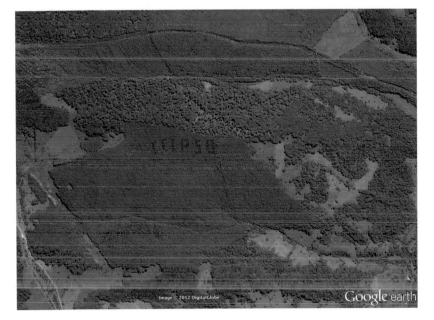

"Lenin 100 years," Soviet Union, 1970, Latitude 54.419444°, longitude 56.780278°

"60 Years to USSR," Soviet Union, 1977, Latitude 54.623889°, longitude 65.019444°

"USSR 50 Years," Soviet Union, 1967, Latitude 57.091111°, longitude 40.854444°

"Lenin," Soviet Union, no date, Latitude 52.158333°, longitude 25.562222°

"Lenin 100 Years," Soviet Union, no date, Latitude 54.468142°, longitude 64.78027°

"USSR 50 Years," Soviet Union, 1967, Latitude 48.500278°, longitude 23.342778°

Images: Google Earth, Image © DigitalGlobe
It took Google Maps to reveal that for many years the Soviets were playing games with American spy satellites and planes. These earthworks and other unnatural-natural manifestations were made to amuse the powers that were. The "anniversary images" made in the 1960s and 1970s were all discovered within a year or two of each other.

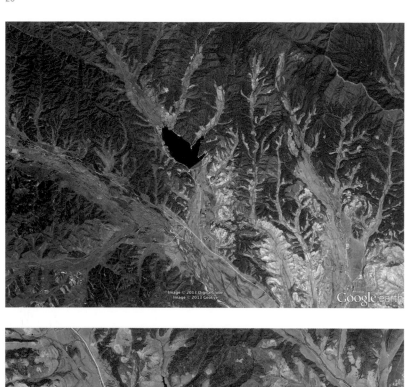

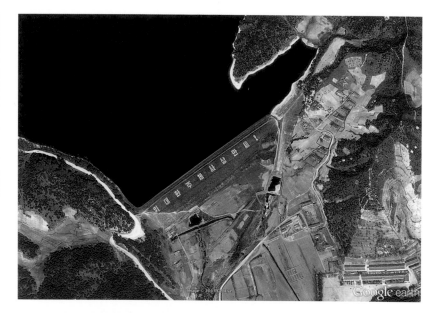

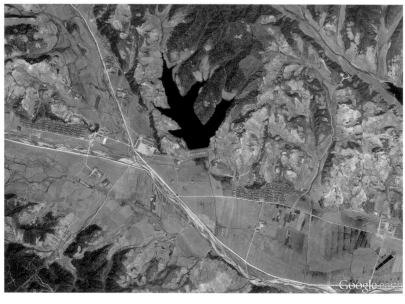

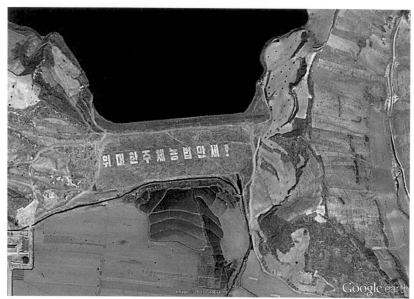

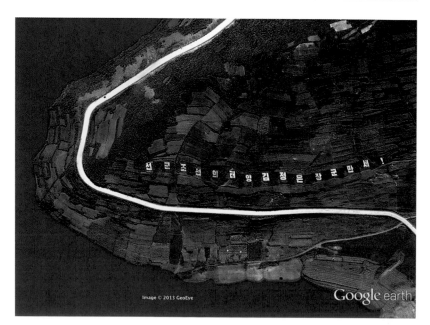

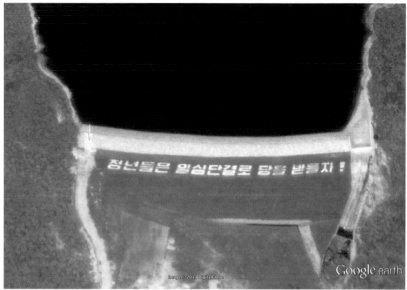

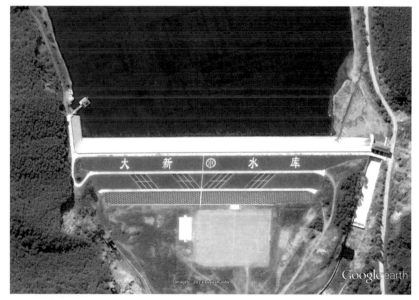

Hail to the great ideology of autonomy and self-determination!
Latitude 40°21'57.65"N, longitude128°33'0.07"E
Image: Google Earth, Image © 2013 DigitalGlobe, Image © 2013 GeoEye

Hail to the great self-sufficient agriculture!
Latitude 40°22'24.08"N, longitude 128°39'37.65"E
Image: Google Earth, Image © 2013 GeoEye

Hail to Chosun's great sunshine general Kim Jung-Eun!
Latitude 41°18'30.14"N, longitude 128° 9'28.89"E
Image: Google Earth, Image © 2013 DigitalGlobe, Image © 2013 GeoEye, © 2013 Cnes/Spot Image

Young men let's build the dam with single-minded devotion and dedication!
Latitude 42°22'5.82"N, longitude 130°15'47.87"E
Image: Google Earth, Image © 2013 DigitalGlobe, Image © 2013 GeoEye
Mammoth typographic celebrations of North Korea's "Great Leader", integrated into the countryside topology.

Da Xin Reservoir, China, Latitude 42°38'17.48"N, longitude 129°24'9.58"E
Image: Google Earth, Image © 2013 DigitalGlobe, © 2013 Cnes/Spot Image

Tie Jia Reservoir, China, Latitude 40° 2'44.55"N, longitude 124° 9'40.57"E
Image: Google Earth, Image © 2013 GeoEye, © 2013 Mapabc.com
Dams play a huge role in Chinese life and topology. These aerial views show the names of two of them.

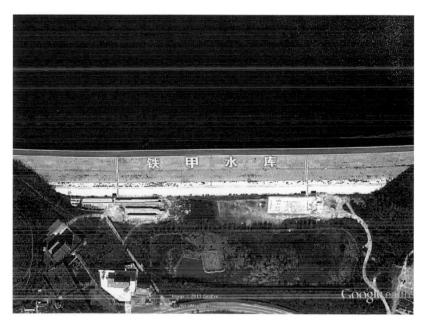

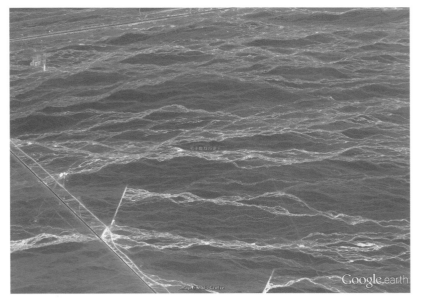

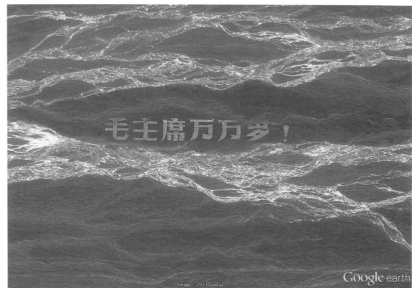

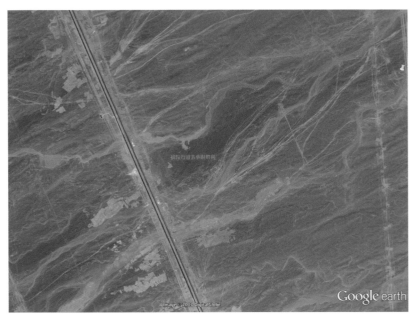

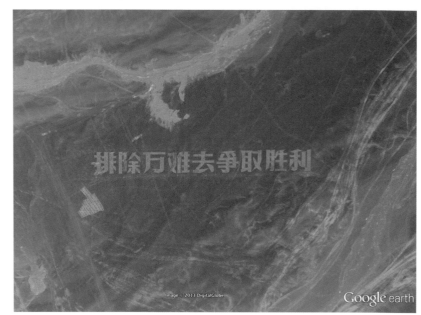

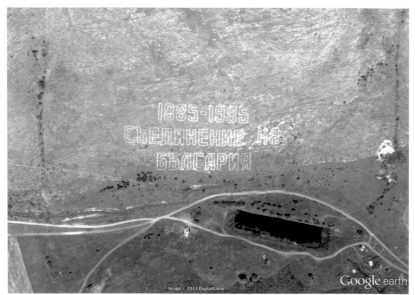

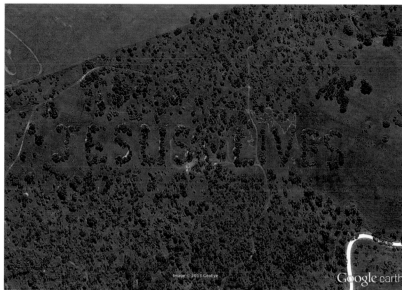

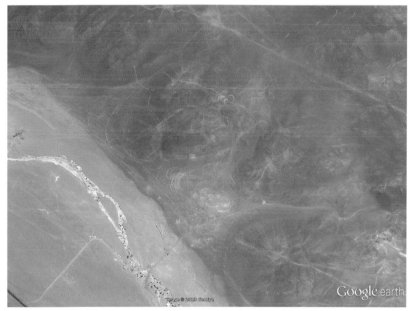

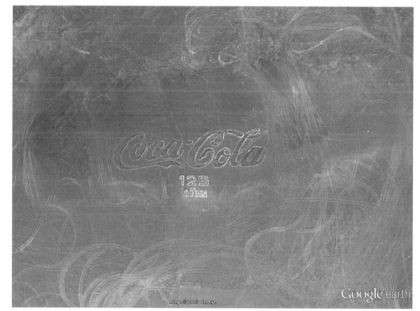

Long Live Chairman Maol, China, Latitude 42°39'14.51"N, longitude 94° 9'58.30"F
Images: Google Earth, Image © GeoEye
Near XinXiang huge geoglyphs are fairly common. This one, which is 1,300 feet from end to end, says (roughly translated) "Long Live Chairman Mao."

Overcome difficulties, challenges and strive for victory, China
Latitude 42°27'14.57"N, longitude 94° 8'48.47"F
Images: Google Earth, Image © DigitalGlobe
The Chairman's little Red Book was the source of phrases like "Overcome difficulties, challenges and strive for Victory."

Bulgarian Centennial, Bulgaria, Latitude 42°54'6.64", longitude 22°59'34.04"E
Images: Google Earth, Image © DigitalGlobe
In the southeast of Dragoman, (Sofia Province), a centennial commemoration of Bulgarian unification after the 1885 Serbo-Bulgarian war.

Jesus Lives, South Australia, Latitude 35° 0'1.90"S, longitude 139° 1'39.60"E
Images: Google Earth, Image © GeoEye, Image © DigitalGlobe
Carving words out of forests is a very difficult yet surprisingly common means of communication

125 Years of Coca Cola, Arica, Chile, Latitude 18°31'45.67"S, longitude 70°15'5.25"W
Images: Google Earth, Image © GeoEye
To commemorate the centennial of Coca Cola, this mega-advertisement was created in 1986 on the El Hacha (the Ax) hill in Arica, Chile.

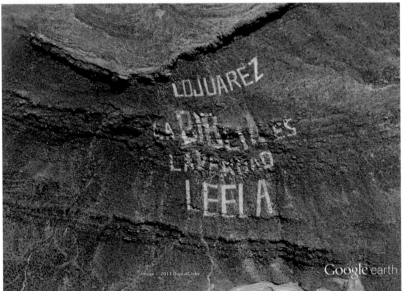

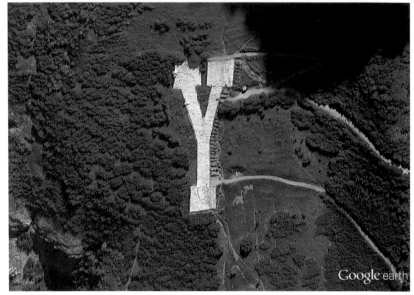

Y on the Mountainside, Provo, Utah, 1876~1968, Latitude 40°14'53.47"N, longitude 111°37'16.58"W
Image: Google earth
The famous "Y" on the mountain above Provo, Utah, symbolizes traditional rivalries between classes at Brigham Young University High School.

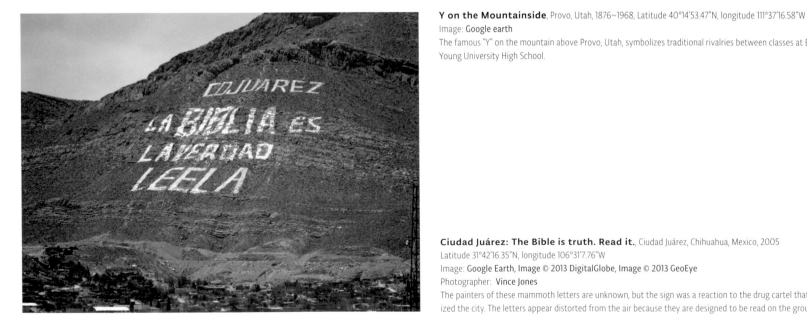

Ciudad Juárez: The Bible is truth. Read it., Ciudad Juárez, Chihuahua, Mexico, 2005
Latitude 31°42'16.35"N, longitude 106°31'7.76"W
Image: **Google Earth, Image © 2013 DigitalGlobe, Image © 2013 GeoEye**
Photographer: Vince Jones
The painters of these mammoth letters are unknown, but the sign was a reaction to the drug cartel that terror-ized the city. The letters appear distorted from the air because they are designed to be read on the ground.

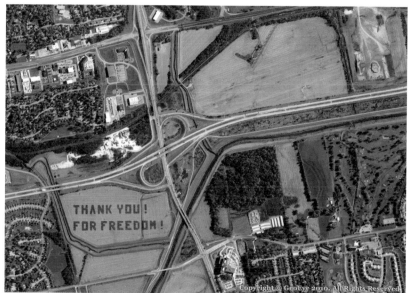

Thank You! For Freedom! / Walmart Salutes You! Our Heroes
Offutt Air Force Base, Nebrasca, 2011, Latitude 41° 7'55.22"N, longitude 95°56'1.34"W
Images: **Google Earth, Image © GeoEye**
A message routinely appears in local fields for airmen to read as they fly overhead. Messages vary, including
"You Make America Proud!" and "Thank you for Freedom!"

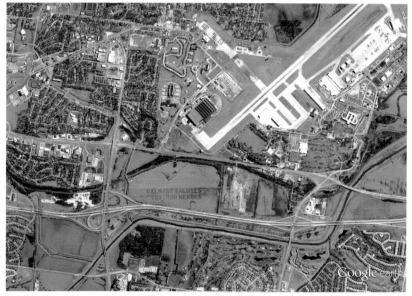

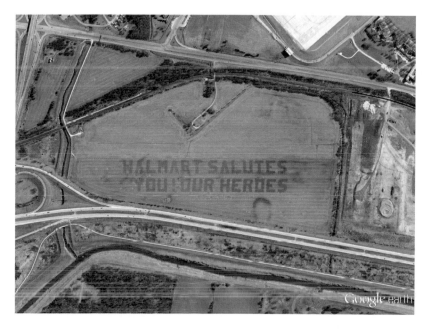

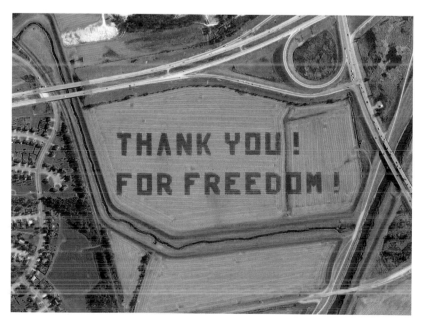

HAMAD, Abu Dhabi, UAE, 2011, Latitude 24°20'39.58"N, longitude 54°19'38.47"E
Artist: **Sheik Hamad Bin Hamdan Al Nahyan**
Image: **Google earth, Image ©2011 DigitalGlobe, Cnes/Spot Image, GeoEye, US Geological Survey**
With two miles of empty sand and a crew of diggers, Abu Dhabi billionaire Sheikh Hamad bin Hamdan Al Nahyan
sculpted his name large enough to be seen from space. The name "HAMAD" stretches across the island, forming
rivers and trenches in the sand.

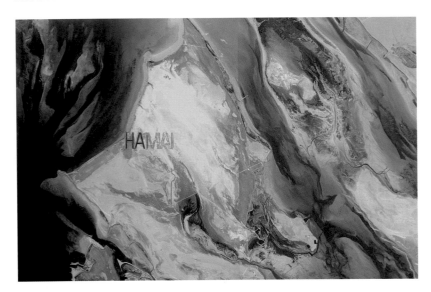

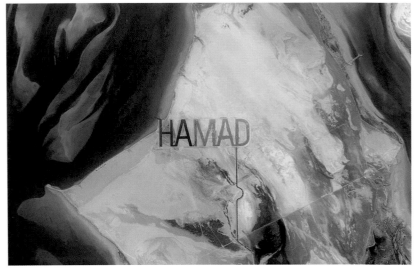

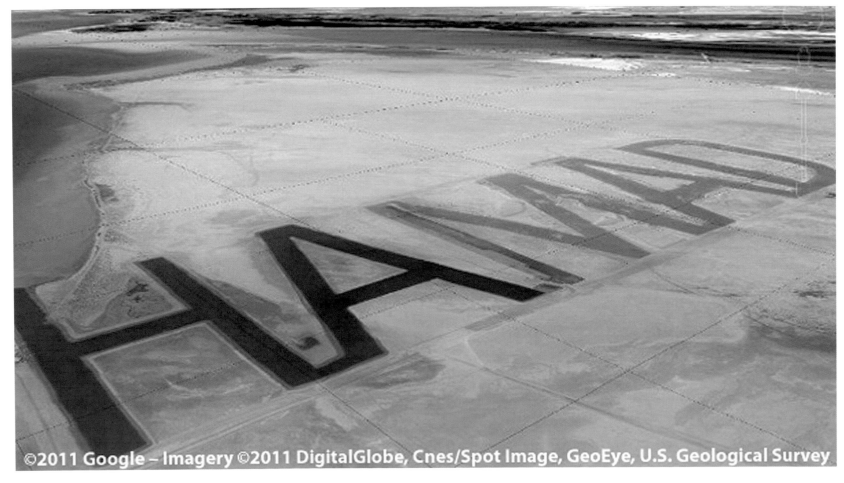

©2011 Google – Imagery ©2011 DigitalGlobe, Cnes/Spot Image, GeoEye, U.S. Geological Survey

AIGA Poster, Crescent Lake, Tofte, Minnesota, 1987
Designer: **Timothy Eaton** Photographer: **Paul Shambroom**
Materials: Snow, compass, snow plow Type: **Garamond, Caribou Style**
This poster was commissioned to celebrate the alliance of the Minnesota
Graphic Designers Association with the national organization AIGA
(American Institute of Graphic Arts). The concept played on the idea that
most think of this northern state as something akin to the frozen tundra.

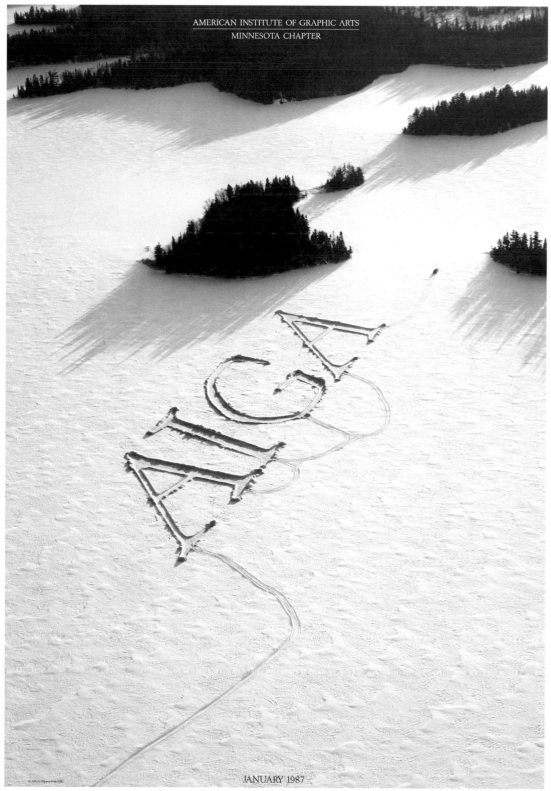

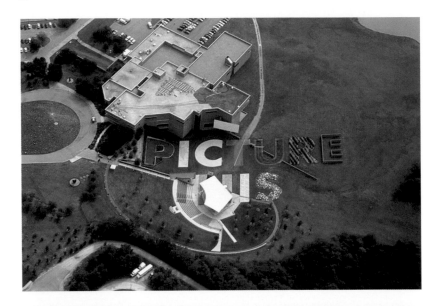

PICTURE THIS, North Carolina Museum of Art, Raleigh, North Carolina, 1997
Artist: **Barbara Kruger** Photographers: **Paul Warchol and Judith Turner**
Landscape Architect: **Nicholas Quennell, Quennel Rothschild & Partners**
Materials: **Concrete, gravel, grass, steel, chain-link, boulders, cast historical plaques**
Type: **Futura**
The built design for the outdoor amphitheater melds site, text, and the concept of spectacle. Adjoining the existing museum, the three-acre site is organized around three main ideas: big roof, big screen, big letters. Each has a function, even the big letters. In addition to branding the environment, these serve as "seat walls, retaining walls, and even buildings." Kruger's letters physically are integrated with both the architecture and the landscape, and invite imagination and engagement with the "PICTURE THIS" message.

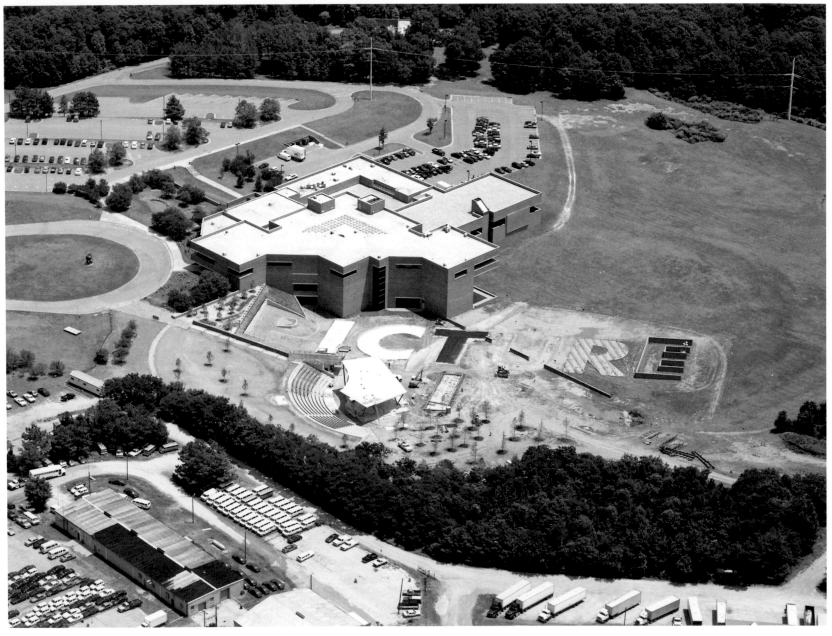

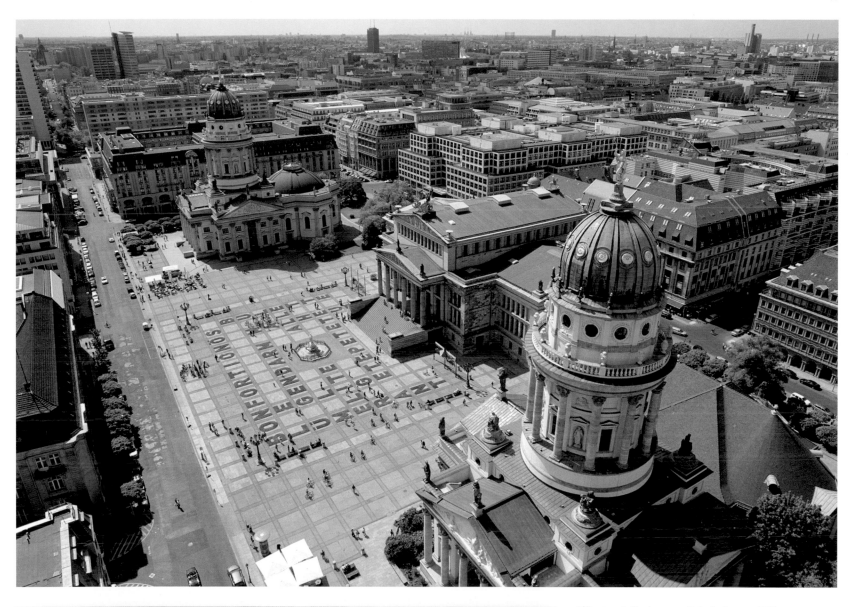

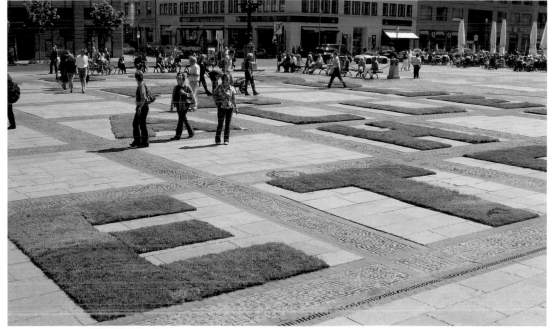

Blümerant, Gendarmenmarkt, Berlin, Germany, 2007
Designer: **msk7** Photographer: **Jurgen Hohmuth. Gertrud Kanu**
Materials: **vegetation mats, fibrous web, sand** Type: **DIN**
The artists group msk7 transformed a Berlin public square,
Gendarmenmarkt, into a walk-in crossword puzzle. Special vegetation
mats form words that show the Berliners' penchant for absorbing French
words and sounds into their everyday speech. The letters of the words
lie in columns and rows in four-by-four-meter squares, structuring
the Gendarmenmarkt. The crossword puzzle creates conceptual links
between French and German. The history of the language of the urban
populace is also part of the history of the city—Huguenots and French
émigrés fleeing the revolution. They all left traces that linger, surfacing in
common turns of phrase and in typical snappy Berlin sayings.

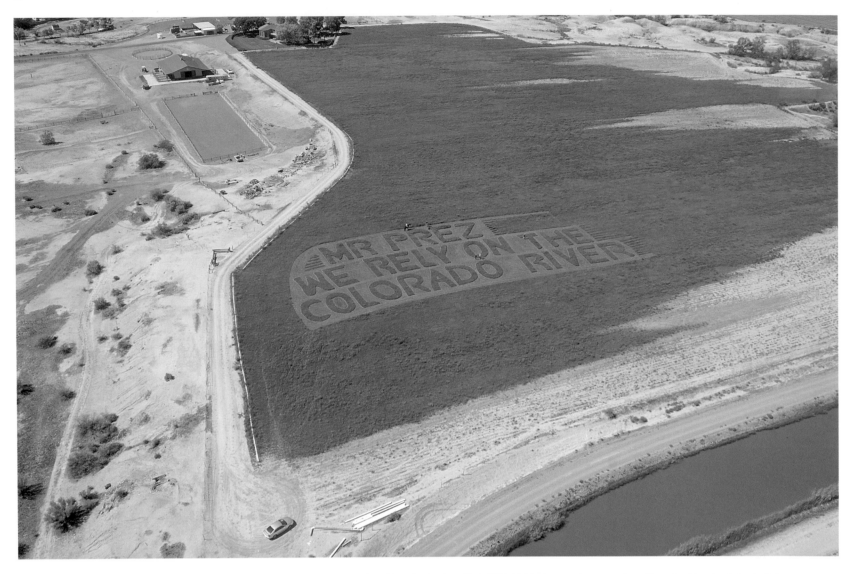

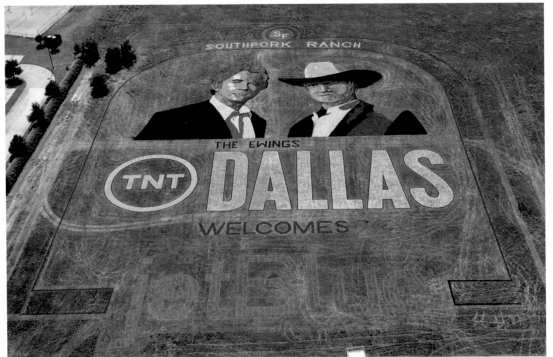

Protect River Flow, Grand Junction, Colorado, 2012
Client: **Protect River Flows**
Artist: **Stan Herd** Photographer: **Jay Canode** Material: **Alfalfa**
This message cut into the Grand Junction alfalfa field was designed to be seen by President Barack Obama in Air Force One. The type may not be pristine, but the message is clear.

TNT Dallas Welcomes Jet Blue, Dallas/Fort Worth International Airport, 2012
(Photo courtesy of **Turner Entertainment Networks**)
The approach to the Dallas/Fort Worth airport offered itself as a tabula rasa for advertising a new route for the Jet Blue fleet. The earth-scape, football field-sized billboard was painted, like a traditional sign on the grass adjacent to the landing strip.

Hur, Near Lawrence, Kansas, 1999
Artist: **Stan Herd** Photographer: **Jonathan Blumb**
The Hur is the Chinese symbol for harmony. This field-cut character was produced in response to the mistaken NATO bombing of the People's Republic of China's embassy in Belgrade, Serbia.

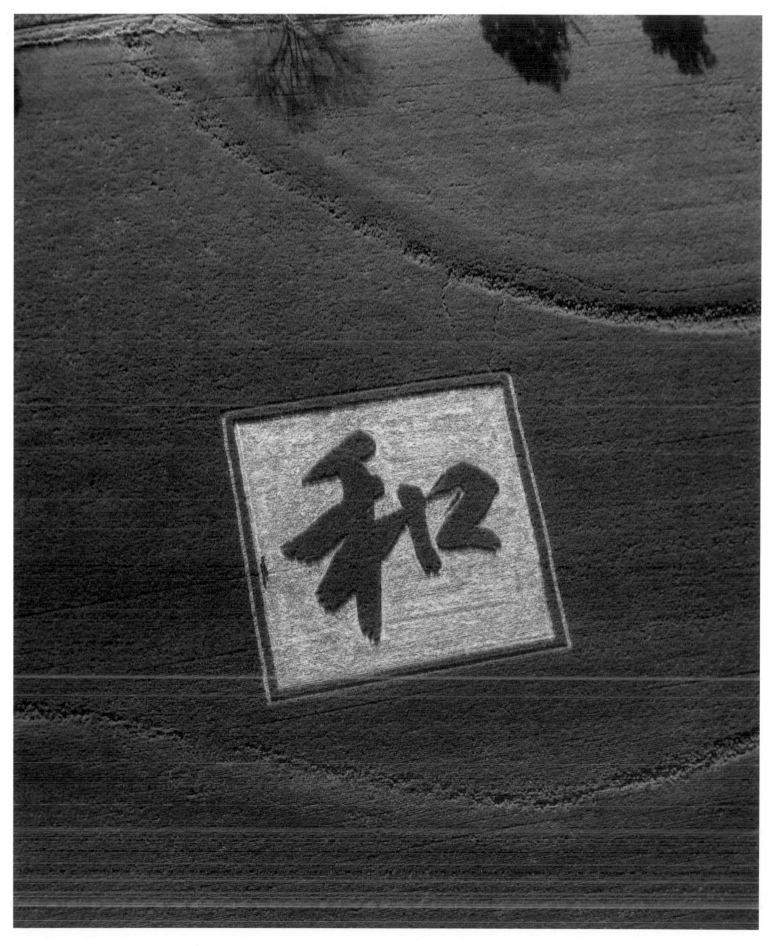

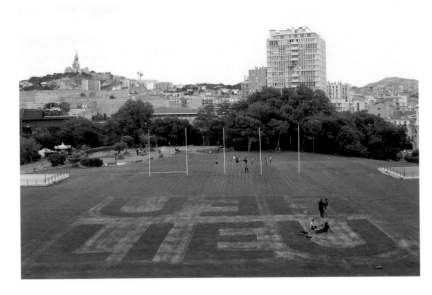

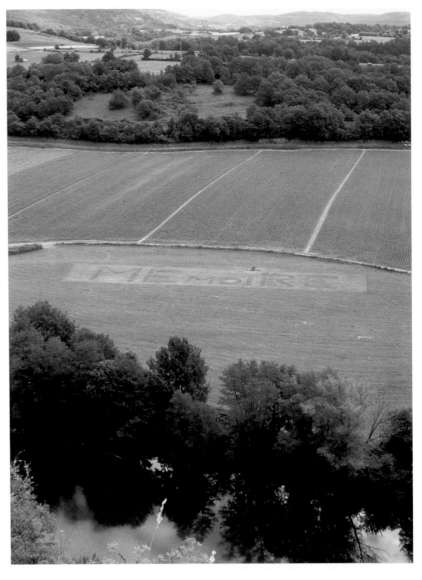

Lieu/Lien, Marseille Palaid du Pharo, 2011
Designer: **Jean Daviot** Photographer: **Jean Daviot**
Cut grass patterns and lettering has been increasing in popularity in outdoor stadiums. This wordplay was
designed as a play on the idea of a meeting place..

MEmoiRE, Calvignac, France, 2008
Designer: **Jean Daviot**
MEmoiRE (memory) is a word Daviot uses in several typescapes. Here he creates a typographic pun containing
the letters M-O-I (self) inserted between the letters of the word MERE (Mother): the mother and the self.

ImaGinE, Foundation Genshagen, Berlin, 2010
Designer: **Jean Daviot**
Daviot orchestrates "linguistic analogies." He sees words as shapes and then manipulates to find the typographi-
cal hidden meanings—even if the means are only discernable for him. ImaGinE is not just a formal artwork; it is
an area to rest and imagine.

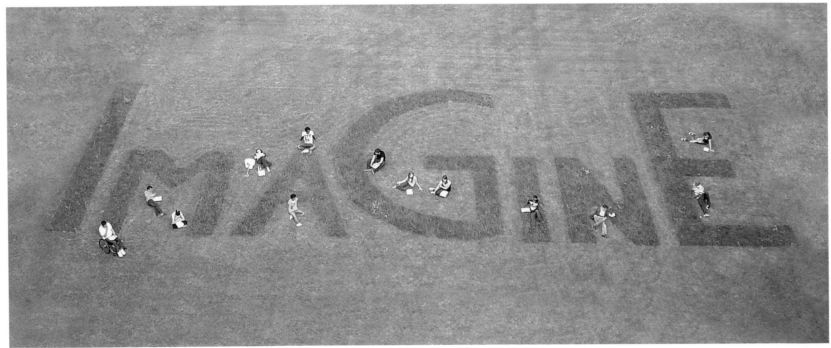

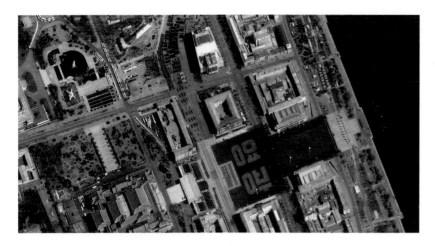

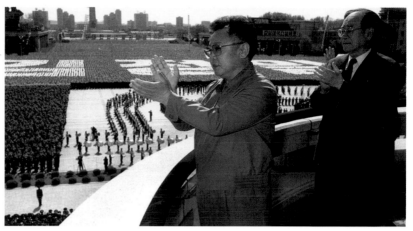

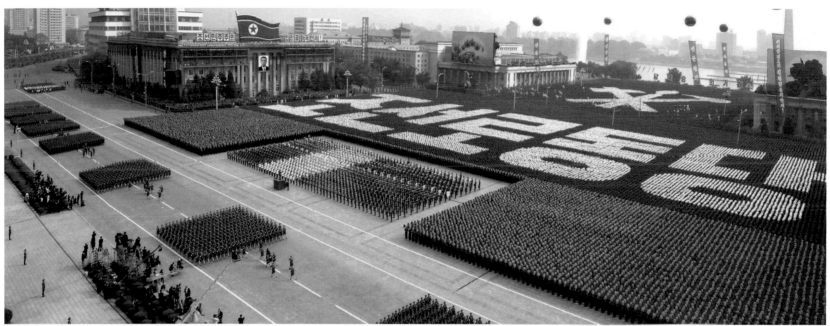

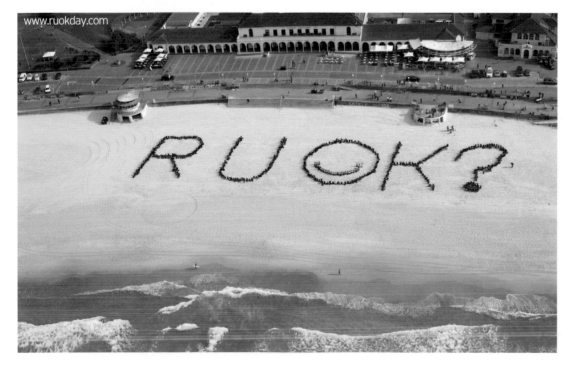

Glory, Pyongyang, North Korea, 2002
Masses of obedient North Koreans spell out their word for "Glory" to celebrate the centennial of the birth of the state's founder, Kim Il-sung (1912–1994). This was the climax of a parade in Pyongyang, overseen his successor Kim Jong-un.

RUOK?, Bondi Beach, Australia, 2012
Design: **RUOK?** Photographer: **Eugene Tan**
The Australian RUOK? Foundation dedicates the second Thursday in September to inspiring people of all creeds to ask each other "Are you ok?" The RUOK? with the happy face "O" is the group's logo, here formed by people on the coastal sands of Bondi Beach.

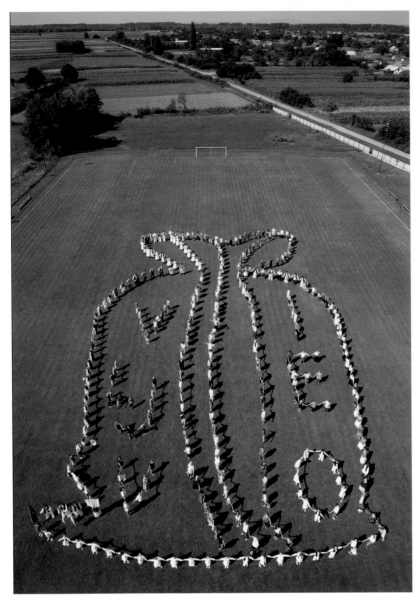

Od konoplje i lana vreća tkana (From Hemp to Flax, Sewn Bags), Viljevo, Croatia, 2011
Designer: Šime Strikoman Photographer: Šime Strikoman
Viljeno prides itself on sewing decorative bags made out of hemp and flax, so much so that for a photograph
honoring the town, five hundred residents formed the outline of the bag and spelled out the name Viljeno.

Z kao Zagorka (Z for Zagorka), Zagreb, Croatia, 2012
Designer: Šime Strikoman Photographer: Šime Strikoman
For the 139th birthday of the great Croatian writer and reporter Marija Jurić Zagorka, the Center for Female Stud-
ies in Zagreb asked Strikoman to orchestrate a massive demonstration forming a large Z for Zagorka made out of
"parasols," the trademark of the Dolac square. The event was photographed from a fire department crane.

Zlatni cvijet Europe (Golden Flower of Europe), Split, Croatia, 2008
Designer: Šime Strikoman Photographer: Šime Strikoman
Split is the host of the International tourist film and ecology festival, which is held as part of representing Croa-
tian cities and towns for The Golden Flower of Europe. This photograph includes representatives of the Golden
Flower award, two hundred people from approximately twenty different countries in Europe tied to tourism.
There were also eight hundred students. It was shot this from two cranes at a height of about one hundred feet.

Paško milenijsko kolo, Pag, Croatia, 2009
Designer: Šime Strikoman Photographer: Šime Strikoman
Pag is a little town on the island of the same name, which has an annual carnival. The main event is a Pag dance
(Paško milenijsko kolo) where the townspeople dress in traditional costumes. During the festivities in the old
town, the group formed the word Pag, which Strikoman photographed from a helicopter.

Osječka quadrilla, Osijek, Croatia, 2009
Designer: Šime Strikoman Photographer: Šime Strikoman
The Osijek quadrille is a graduation dance at the end of a school year. As a finale, Strikoman asked the 1,892
students to form the name Osijek with their bodies. The scene was recorded on the street using chalk and paint
and photographed from a helicopter.

Kali, Ugljan, Kali, Croatia, 2008
Designer: Šime Strikoman Photographer: Šime Strikoman
Kali is a beautiful seaside town on Ugljan island. Strikoman composed the name Kali out of boats and shot it
from helicopter. The scene is, he says, "precisely put together with the assistance of American GPS and Russian
Glonass systems."

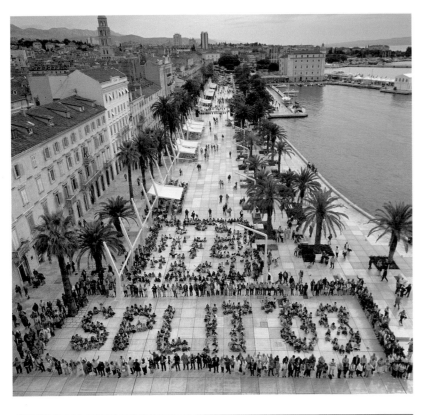

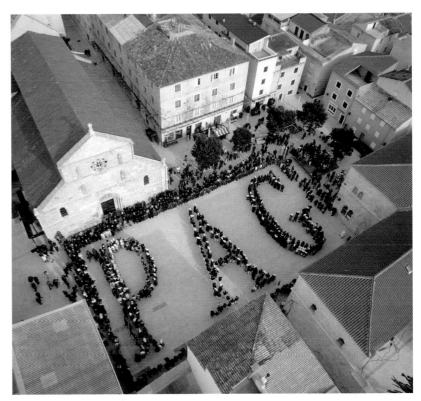

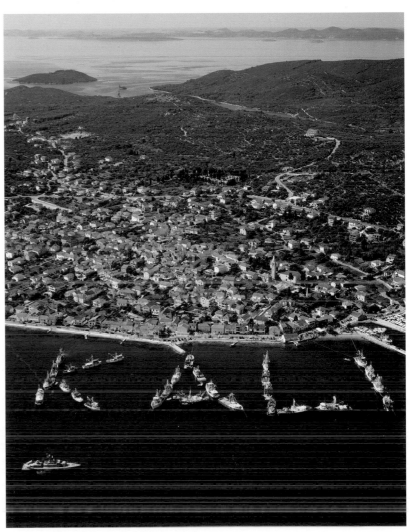

MONUMENTAL OUTDOOR TYPE

Identity and Courtyard, Museum Boijmans Van Beuningen, Rotterdam, 2008–9
Client: **Museum Boijmans van Beuningen Rotterdam**
Designer: **Thonik**
The new museum identity has a formal and an experimental side. The name of the museum is set in a dry institutional style; the content of the exhibition is represented by stark graphic image made up of a curvilinear typeface. The graphics swirl and form strings of colored lines that visually recall an art installation called Apollo by artist Olaf Nicolai, which is an interplay of lines and reflections.

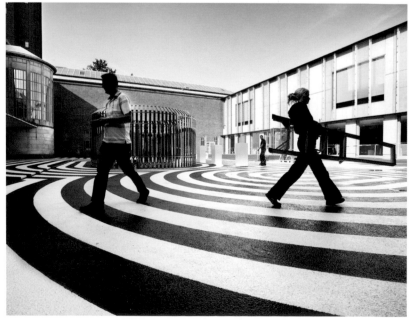

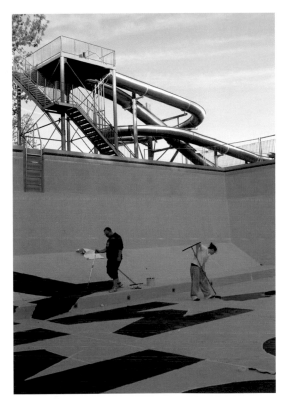
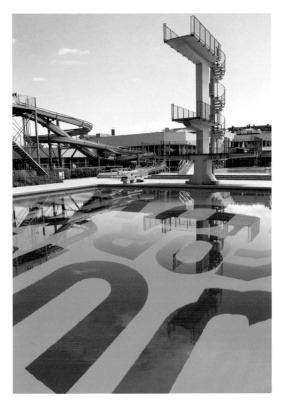

Jump for My Love, Wiesbaden, Germany, 2010
Designer: **Timm Schneider** Photographers: **Timm Schneider, Wibke Scharperberg, Matthias Zosel** Materials: **Chlorine resistant rubber paint** Type: **DIN Pro black**
"Too many things we see, we accept as static, too passive," says Timm Schneider. "I wanted to end this by surprising people. By adding just a little twist into everyday things, change an object and therefore its observer." With this goal, Schneider made a message in a swimming pool that, because of water refraction and font size, is only possible to read when the viewer is standing on top of the jump tower. The words are the chorus of the 1984 song by the Pointer Sisters. "For me the song became a mantra of motivation and joy I wanted to share," adds Schneider.

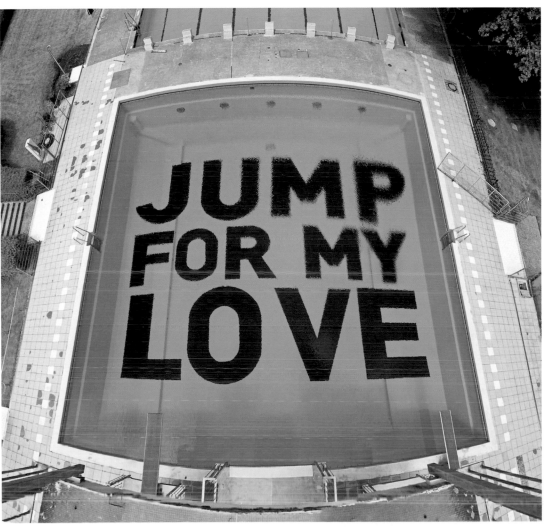

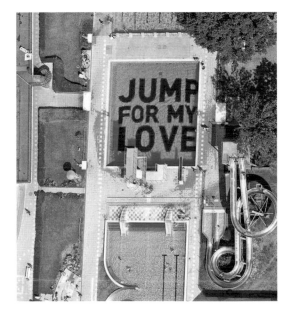

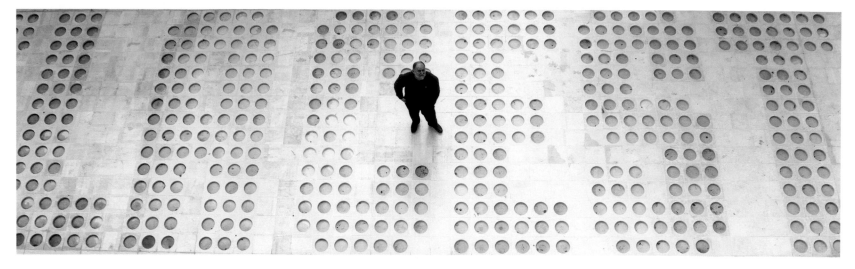

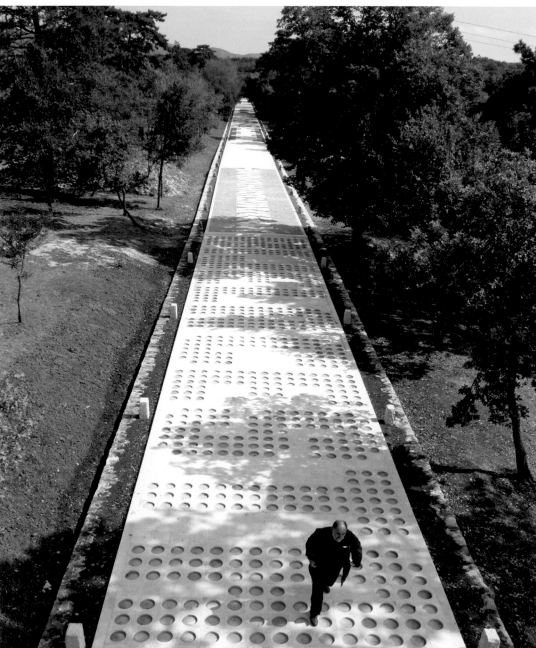

White Road—Waiting for the Rain, Dubrova Sculpture Park,
Labin, Croatia, 2008
Creative Director: **Ante Rašić.** Designers: **Ante Rašić, Vedrana Vrabec,
Marko Rašić** Fabrication: **Graditeljstvo Jakovljević**
White Road is a land-art project in a sculpture park. The road, which
is 325 meters long and five meters wide, comprises thirteen sections
made by different artists. The thirteenth section, "Waiting for the Rain,"
is composed of 1,245 square blocks made of a polished limestone found
locally in Kanfanar. About eight hundred of the blocks have cut-out
holes that make up the title of the whole project. Nature is the
determining factor here: when the shallow holes fill with rain,
the words become visible.

Marked Space—Unmarked Space, Berlinische Galerie
Berlin, Germany, 2003–4
Artist: **Fritz Balthaus** Photographer: **Paspog**
Balthus filled an entire plaza in front of the Berlinische Galerie with a
typographic carpet of equal yellow squares, each containing a capital
letter, creating effect similar to a Scrabble board or the periodic table of
the elements. The installation represents an extension of his earlier work
with exhibition graphics where names of artists and movements run
together without spaces or punctuation.

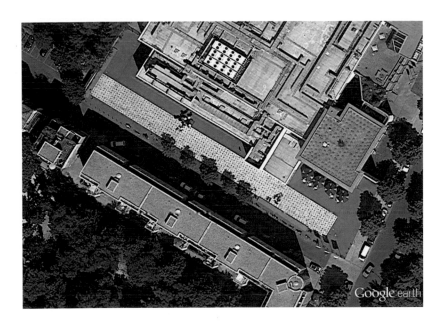

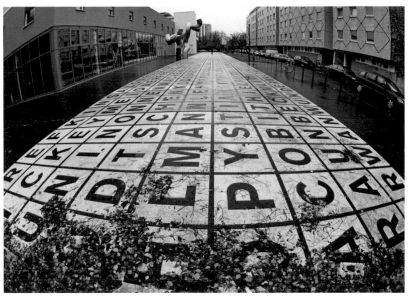

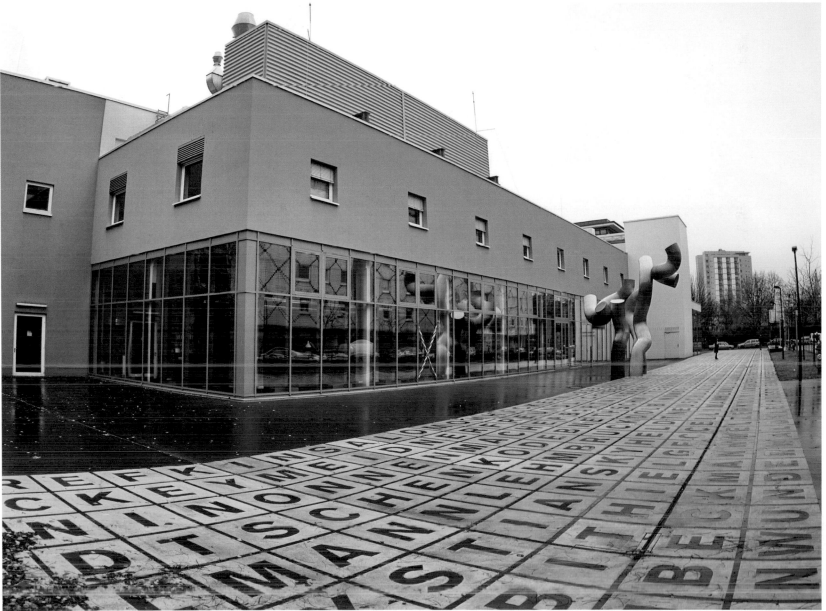

Urban Tales, Shadow Typography, Wellington, New Zealand, 2010
Designer: Katie Bevin Photographer: Thomas Le Bas Materials: Nonskid paint
Type: Custom typeface, Umbrate

Urban Tales, a time-based piece of environmental typography, combines form with shadow to create a temporal narrative. Using the ancient technology of a sundial, large-scale graphics connecting with shadows spell out the quote "From here to there and there to here" by Dr. Seuss. A custom modular typeface was designed, based on the dimensions of bollards within Waitangi Park, Wellington. Incomplete letter forms, each word a different shade of gray, sit on the concrete surface surrounding the bollards. As the sun moves across the sky, the shadows cast by the bollards move, completing each letter at an increment of 45 degrees. Words become complete when the shadows meet the shapes on the ground, constructing a phrase that appears over a ten-hour period. The lines of the phrase can be viewed from 8 AM to 6 PM, with each word appearing for approximately an hour.

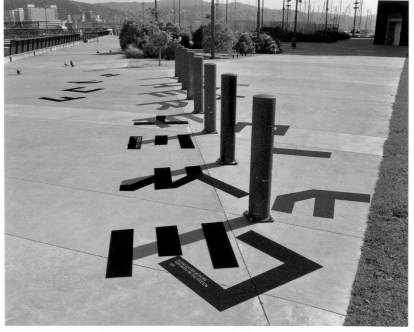

Signage for the Nagasaki Prefectural Art Museum, Nagasaki, Japan, 2005
Art Director: Kenya Hara Designers: Kenya Hara, Yoshiaki Irobe Photographer: Daichi Ano
Materials: On stainless steel square pipe steel, letters are expressed by cut-out sticker
Type: Linotype Univers Condensed Regular

Hara uses architectural louvers like the teeth of a comb. Lined up in two rows, they stand vertically on the ground. When people view them while walking past, there is a surprising dynamic movement, like a three-dimensional moiré effect. The ripple movement works with the sign to create a calm image.

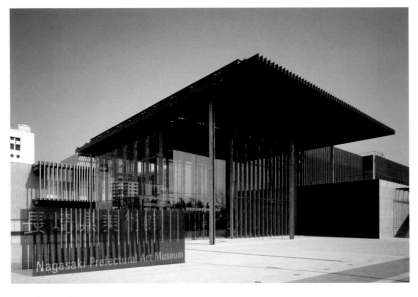

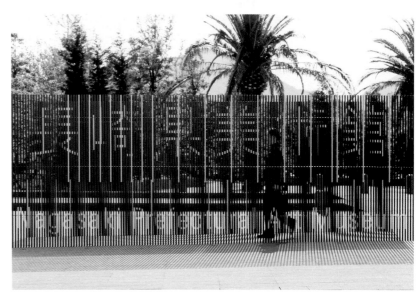

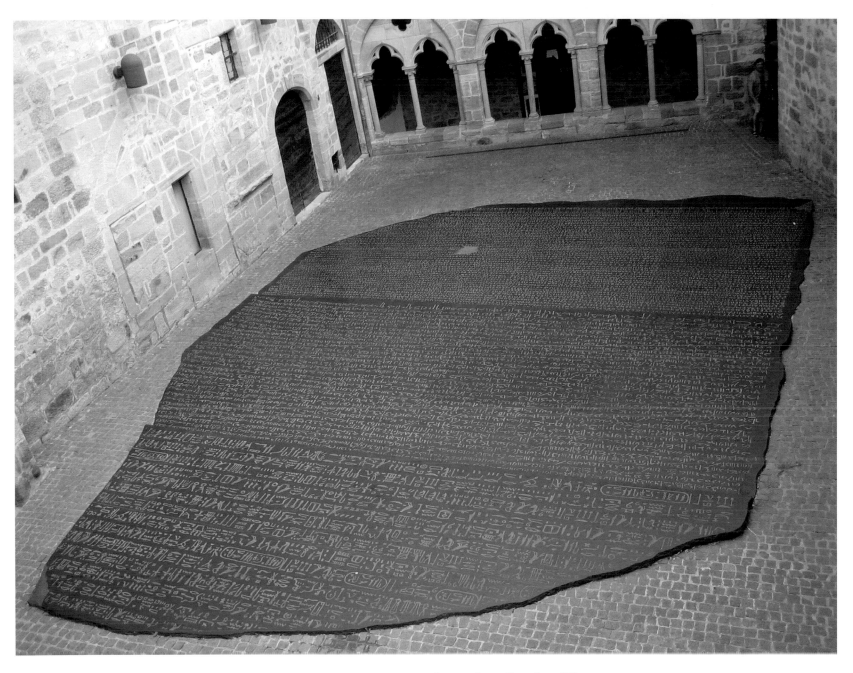

Rosetta Stone, Figeac, France, 1990s
Art Director/Designer: Joseph Kosuth Type: Ancient Egyptian hieroglyphs, Demotic script, Ancient Greek
This giant copy of the Rosetta stone was commissioned by the French government in honor of the Egyptologist
Jean-François Champollion (1790–1822), who deciphered the Rosetta Stone. The copy is in the courtyard of the
museum devoted to Champollion in his birthplace, Figeac

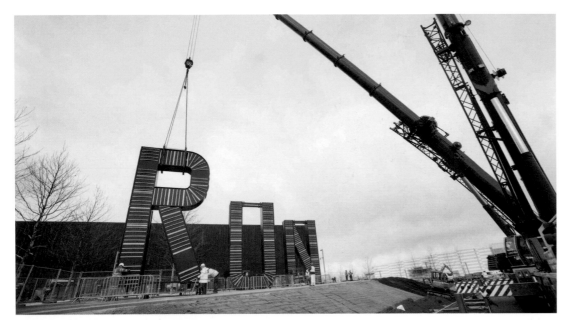

Run, Olympic Park, London, England, 2012
Artist: **Monica Bonvicini.** Photographer: **Monica Bonvicini, Jan Ralske, Getty Images.** Materials:**Twelve-millimeter ESG white glass with inside ipachrome design coating, PVB foil, ten-millimeter TVG white glass, Dibond mirror, stainless steel, stainless-steel cover with mirror-polished surface, high-performance LED**
The monumentality of a three-letter word, RUN, produced for the 2012 London Olympics, is made even more vivid by the materials used. Stainless steel reflects the environment and viewers during daylight, making the letters blend into the sky. The LED at night adds an unearthly shimmer to the same space. RUN is derived from Bonvicini's musical preferences, such as "Running Dry" by Neil Young and "Run Run Run" by the Velvet Underground.

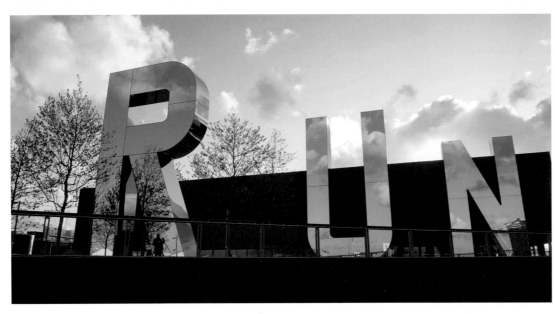

Climbing Towers, George Bancroft Park, Blackpool, 2006
Artist: **Gordon Young** Typographer: **Why Not Associates**
Photographer: **Jerry Hardman-Jones**
Materials: **Concrete, Granite** Type: **Impact**
Blackpool is famous for its eponymous tower. This alternative tower with the Blackpool name in vivid granite relief enables the viewer to see the original structure as though through a camera obscura.

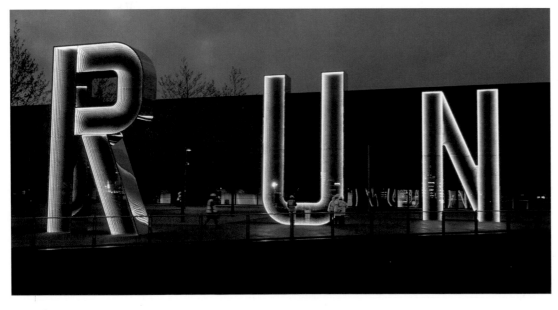

Pobl + Machines, Swansea, Wales, 2006
Artist: **Gordon Young** Typographer: **Why Not Associates**
Photographer: **Rocco Redondo** Materials: **Stainless steel, concrete, granite** Type: **Biffur, Gill Sans**
The original idea of this project for the Welsh National Waterfront Museum was to scatter a whole alphabet randomly in front of the building to contrast with the rectilinear order of the machinelike architecture by Wilkinson Eyre. However, creating all twenty-eight letters in the Welsh alphabet would have been cost-prohibitive, so the work became a simple line of letters pointing at the front entrance, spelling "Pobl + Machines" (pobl means "people" in Welsh). The sculptural letterforms double as seats. The font was inspired by the interwar posters of A. M. Cassandre on industrial themes, which are relevant for the museum.

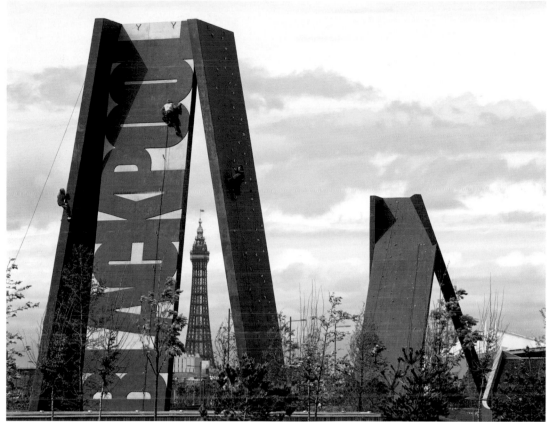

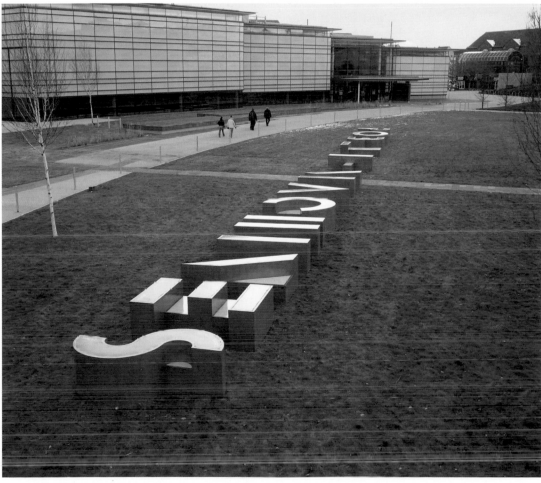

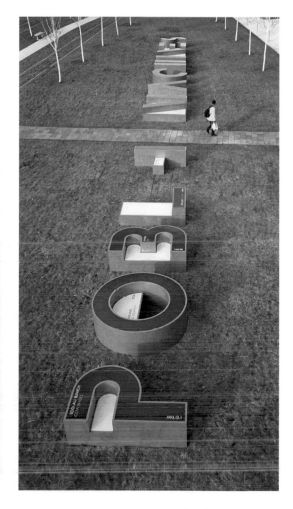

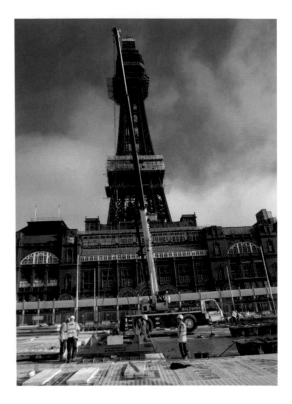

Comedy Carpet, Blackpool, England, 2008–11
Artist: **Gordon Young** Typographer: **Why Not Associates**
Photographer: **Why Not Associates** Materials: **Concrete, granite**
The Comedy Carpet is a unique celebration of Britain and Blackpool's rich tradition of comedy. The 2,200 square meters of granite and concrete is made up of jokes, songs, sketches, one-liners, and catchphrases from notable comedians and writers of British comedy (and a few foreigners who performed in the resort). The design was inspired by its location in front of the Blackpool Tower on a new headland promenade, as well as the history of theater posters. "The content was a confection of material of Andy Altmann of Why Not Associates and my choice," says Gordon Young. Over nine hundred comedians and writers gave their consent and blessings. The carpet was installed as part of the regeneration and new sea defenses in the town. Chemists and engineers as well as typographers and builders were part of the team. Due to the complexity and scale of the work, no single company was able to produce it in its entirety. As a result, over 180,000 granite letters were cut into high-quality concrete panels at a factory specially set up for the project in Hull. The font varies in size, ranging from a few centimeters to more than a meter high. The carpet engages on a very personal level, through familiar wit and humor, with a diverse audience.

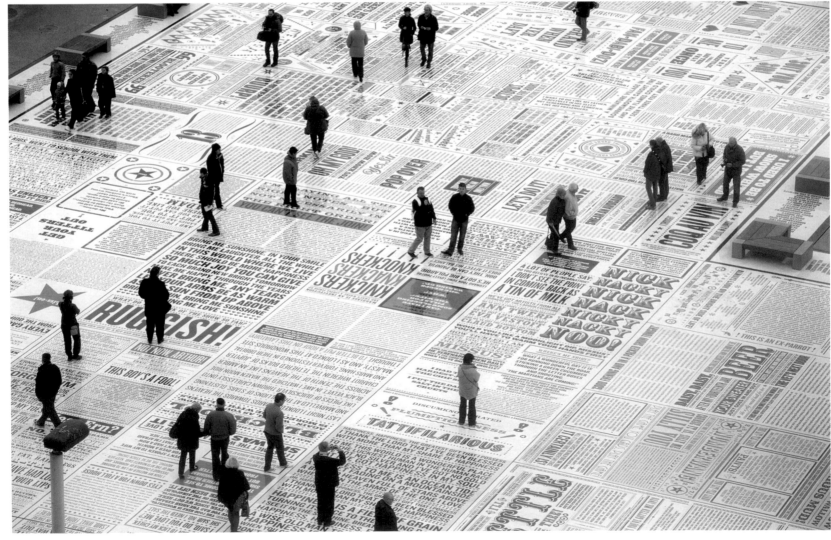

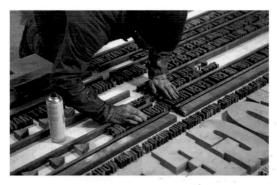

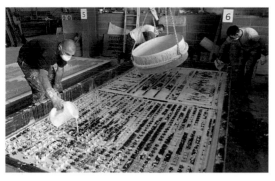

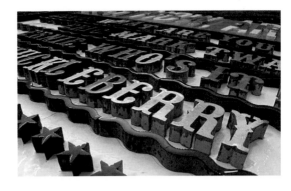

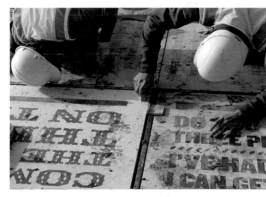

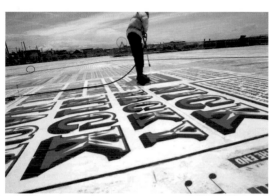

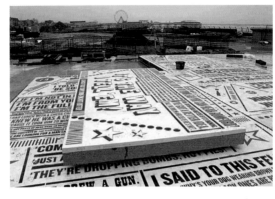

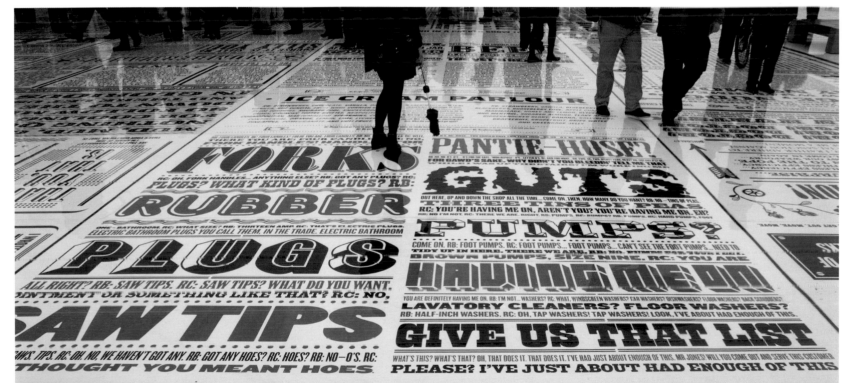

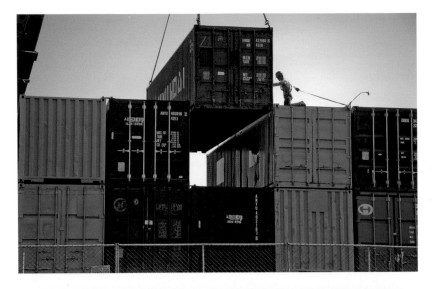

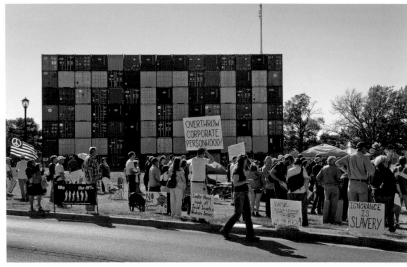

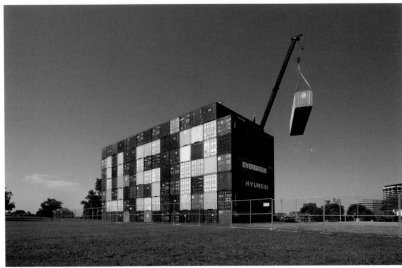

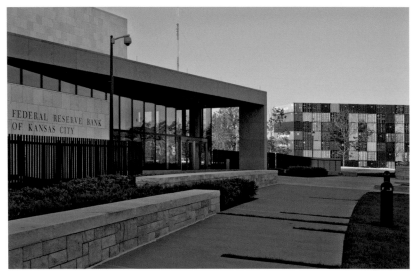

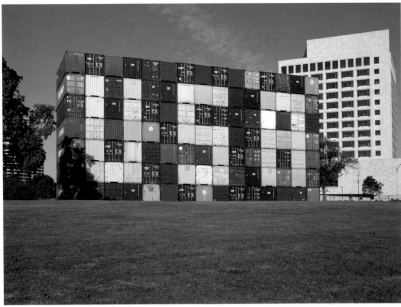

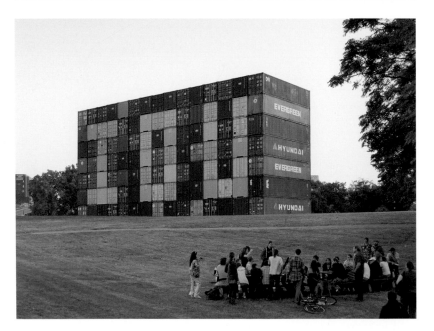

IOU/USA (The Big IOU), Kansas City, Missouri, 2011
Client: **Grand Arts**
Designer: **John Salvest** Photographer: **E.G. Schempf, Mike Sinclair.** Material: **shipping containers**

IOU/USA was a temporary public art project addressing the current U.S. economic crisis and is located in a city park adjacent to the Federal Reserve Bank of Kansas City. One hundred seventeen multicolored shipping containers created a monumental two-sided mosaic with "IOU" on one side and "USA" on the other.

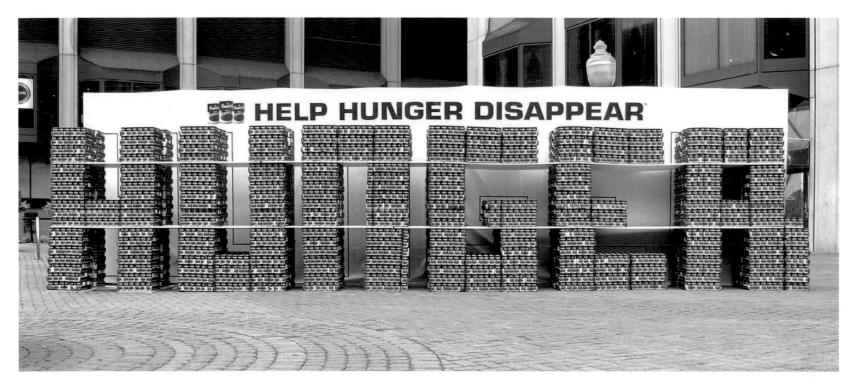

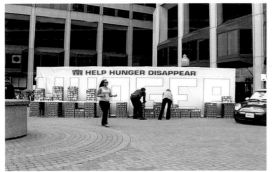

Help Hunger Disappear, Toronto, Canada, 2008
Art Director: **Anthony Chelvanathan** Writer: **Steve Persico**
Materials: **Soup cans, cardboard**
Created to raise awareness about food banks, the Help Hunger Disappear display is an interactive piece. Participants literally make the sign disappear by removing cans of soup from the display.

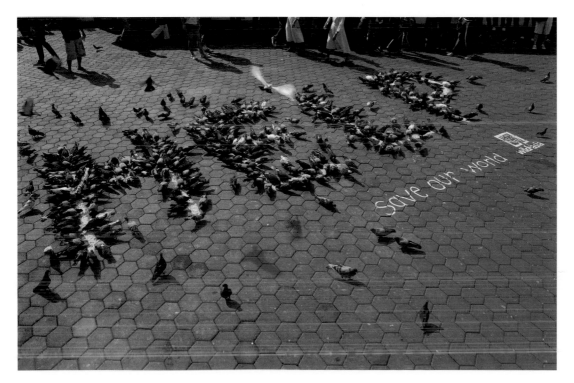

HELP, Batu Caves, Selangor, Malaysia, 2012
Designer: **Choo Chee Wee, Johan Putra, Ahmad Fariz**
Photographers: **Allen Dang, Edwin Ng, Azim Chedu**
Materials: **Rice, breadcrumbs, and birdseed**
As a timely reminder from Mother Nature of the precarious state of the natural world today, curious bystanders and tourists alike were treated to a spectacular sight when a flock of pigeons came together before their eyes and formed what is perhaps the world's first nonhuman flash mob to spell out the word "HELP." This strategy, albeit similar to the Coca Cola advertisement in Venice's St. Mark's Square without the commercial expectations, is in no way a copy.

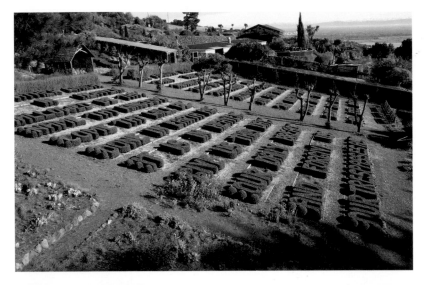
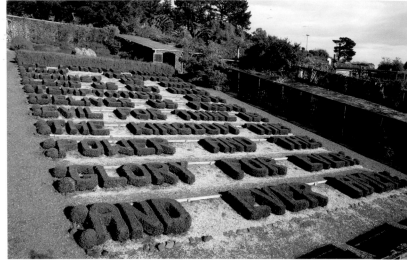

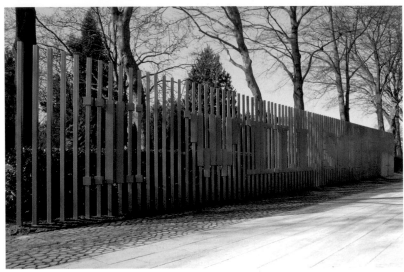
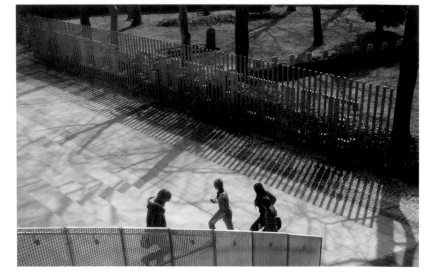

The Lord's Prayer, Clifton Hill, Christchurch, New Zealand, 1988
Designer: Beverley Loader
This is one of the gardens at the Christian-themed Gethsemane Gardens. The Lord's Prayer is spelled out in justified rows of plants made to form perfect letters and words. In winter they turn to gold (as shown above); in summer it is green.

I Will Survive, Hardenberg, The Netherlands, 2008
Designer: Martijn Sandberg Photographer: Martijn Sandberg, Axis Media
Materials: Gold metallic coated steel
I Will Survive is a freestanding site-specific artwork with an imposing row of golden-colored steel rising from the ground in front of the entrance to an education center. It looks like a fence but doesn't have that function. "It is art that addresses the public," says Sandberg, who based his proposal on locating the artwork near the old Nijenstede graveyard. He did not think that being able to look onto the adjoining cemetery was macabre. "The contrast between life and death, activity and inactivity appealed to me," he says.

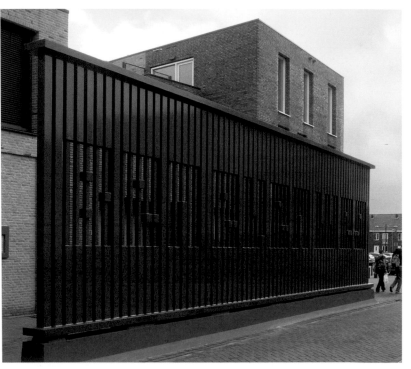

Ben Even Weg (Out for a Moment), Hankstraat, Floriande, Hoofddorp, The Netherlands, 2007
Designer: Martijn Sandberg. Photographer: Martijn Sandberg.
Materials: Brown coated steel, precast concrete.
The art begins with a semitransparent typographical screen, which Martijn Sandberg describes as "writing with railings" (schrijven met spijlen). This is based on a fence of vertical lines, comparable to the bars in a barcode. When the viewer passes the artwork, a series of letters become visible and disappear, due to the changing open and shut appearance of the fence over its full length.

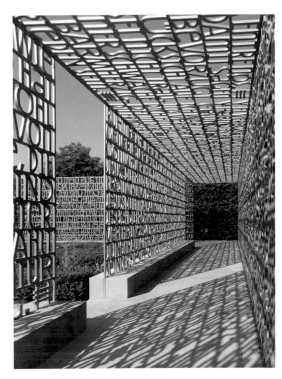

Der geschriebene Garten (The Written Garden)
Gärten der Welt, Berlin Marzahn-Hellersdorf, 2011
Art Director: **Grün Berlin GmbH, relais Landschaftsarchitekten Berlin** Landscape Architects: **relais Landschaftsarchitekten Berlin**
Typographer: **Alexander Branczyk, Annette Wuesthoff (xplicit GmbH)**
Typeface Designer: **Alexander Branczyk** Photographer: **Alexander Branczyk** Material: **Aluminium**
The Written Garden is one of Berlin's Gardens of the World recreational park areas. Located in the center of this garden is a quadrangular building made entirely of letters. The building is composed of texts from within the Christian and occidental cultures, which form an ambulatory in the tradition of medieval cloisters. The font was specially created for the sixteen mural segments that form the building. There are up to three alternate glyph variants allowing for homogenously woven textual structure, which distributes the load evenly onto the ground. The varying number of letters per line prevents single lines from looking compressed or spaced out. Up to three alternating forms of each letter (capitals, lower case letters, and special forms) result in a natural appearance with little repetition. The font can be applied to thirteen written languages, including ancient Greek and Cyrillic.

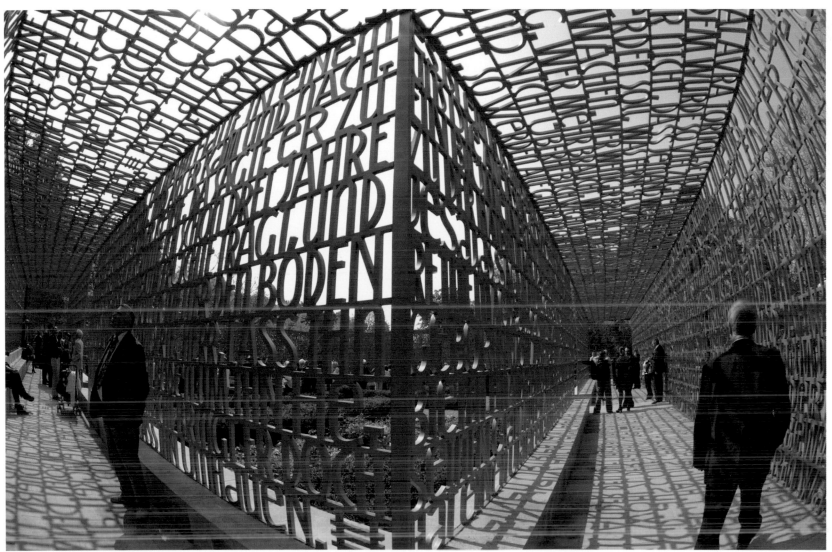

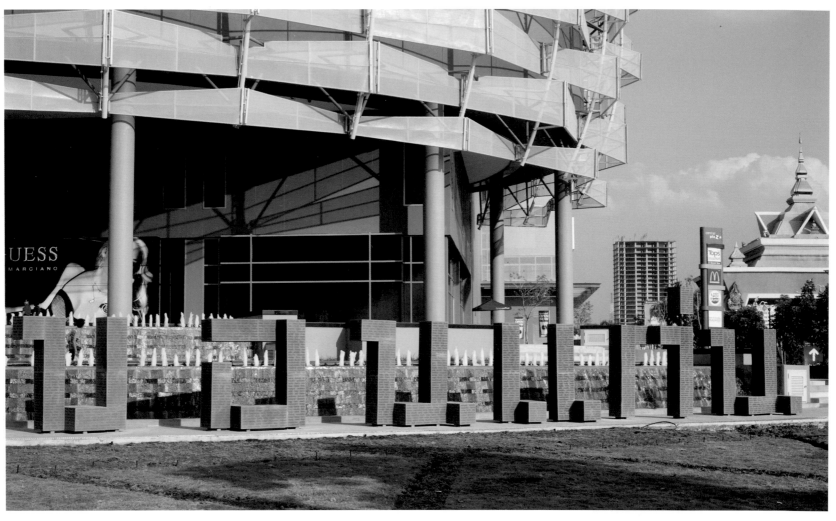

All around Khon Kaen, Khon Kaen Province, Thailand, 2010
Design: **Farmgroup Company Limited** Design Director/Art Director:
Tap Kruavanichkit Photographer: **Farmgroup**
Material: **Resin mixed with sand stone**
This typographic landmark is the first thing a visitor sees when entering
Khon Kaen Province in northeast Thailand. Three-dimensional letters
spell the name "Khon Kaen." The sculpture's surface is engraved with all
the 198 subdistrict (tambon) names within Khon Kaen and creates both
panoramic and close-up photo opportunities.

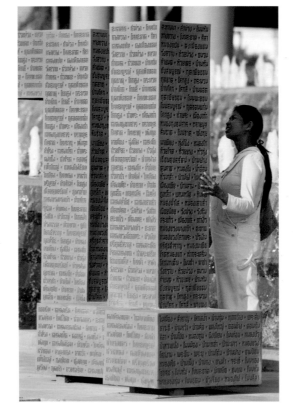

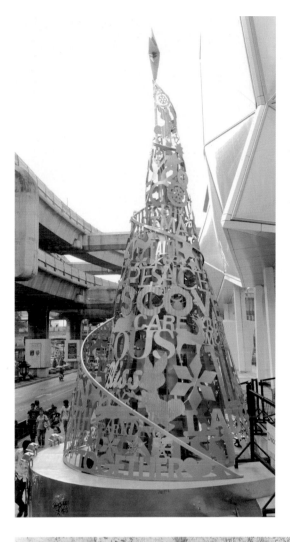
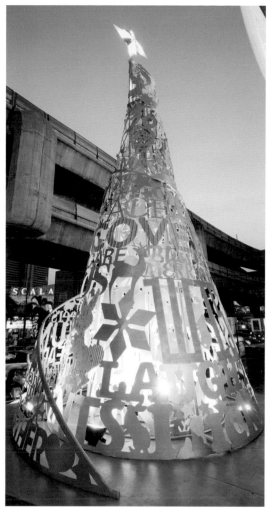
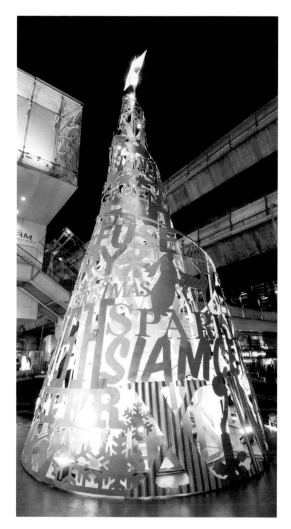

Typo Tree, Siam Center Department Store, Bangkok, Thailand, 2010. Design: **Farmgroup Company.** Design Director/Art Director: **Tap Kruavanichkit** Graphic Designers: **Tap Kruavanichkit, Kanwee Harichanwong** Photographer: **Farmgroup.** Material: **Used metal sheets and construction debris.** Type: **Bello Pro, Rockwell, Futura, Helvetica, ITC Avant Garde, Georgia, Gotham, Baskerville, Cooper Black, American Typewriter, Bell**

This is an eco-conscious typographic Christmas tree. During daytime, the metallic appearance coexists nicely with the surrounding architecture. At night when the LED light is on, the tree casts a type shadow onto the building and onto the ground. It was a great landmark and a photo opportunity for passersby. This installation tried to emphasize the idea that nearly everything can be reused..

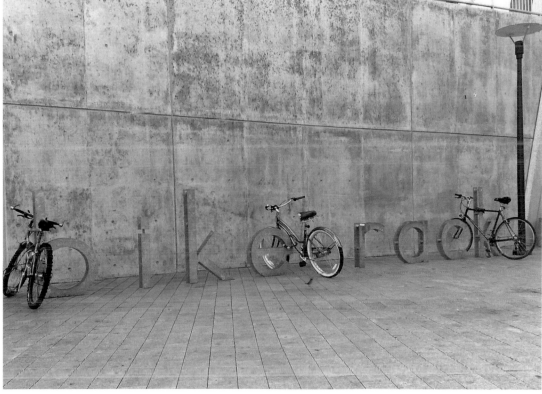

Bike Rack at the Salt Lake City Public Library
Salt Lake City, Utah, 2008
Photographer: **David LaPlante** Material: **Iron**
Bike Rack has a well-defined and stated purpose. It is "typography parlant," or lettering whose physical form conveys semantic meaning. However, some of these letters, such as the "I", are not ideal for locking up a bike.

MONUMENTAL OUTDOOR TYPE

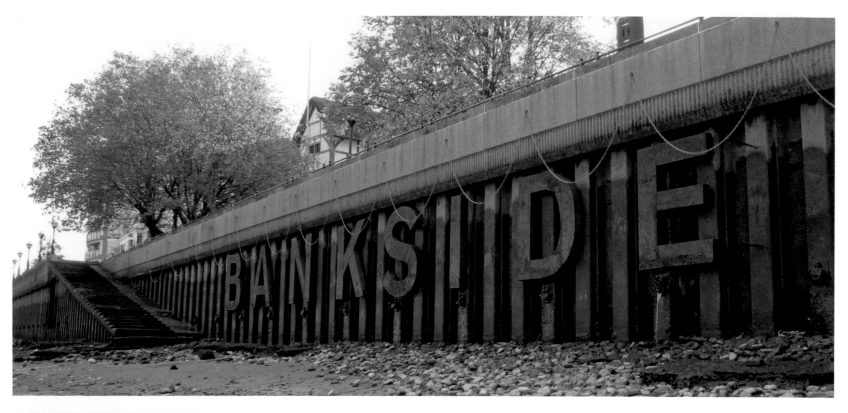

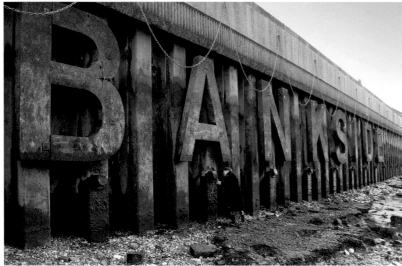

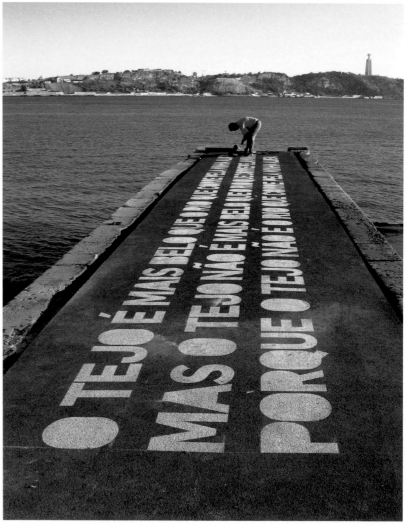

Bankside, London, England, 1996–99
Architects: **Caruse St. John Architects** Photographers: **D. Luffman, Helen Pope**
This project is part of a number of initiatives commissioned by the London Borough of Southwark to improve the quality of public spaces and enhance accessibility in an area of the city undergoing rapid renovation. The type was rendered in wood and designed to age with exposure to the tides.signs. Other signs included brass historic plaques, community notice-boards in brass and mirrored steel, large signs attached to buildings and walls that give the name of the quarter. The design draws on the history and rich potential of signs to form an integral part of the ambience of the public realm.

Lisbon Bikeway, Lisbon, Portugal, 2009
Art Director: **Nuno Gusmão, Pedro Anjos** Designers: **Giuseppe Greco, Miguel Matos, Pedro Schreck.**
Photographers: **João Silveira Ramos, P-06 Atelier** Materials: **Paintings with metallic stencils.** Type: **Flama (by Mário Feliciano)**
The goal of this project was to define a new urban environment along the river Tagus beyond the bikeway. The selection of materials was key to the success— meaning the readability—of the new system. As visitors pass by, scenic and cultural places of interest are revealed, as are signage for transports, stops, or break points. The rationale for this text is Alberto Caeiro's poem about the river Tagus and the onomatopoeic intervention illustrating the sounds of the bridge.

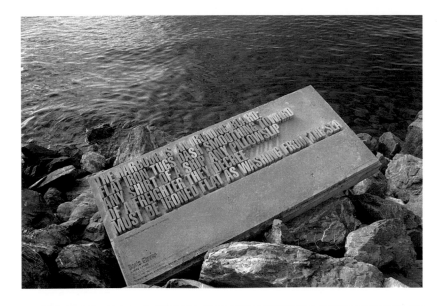

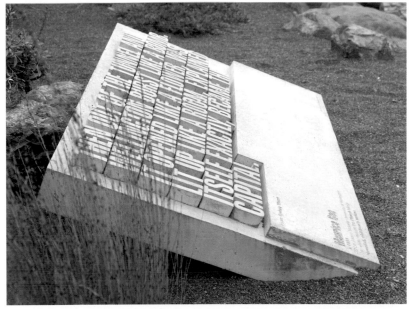

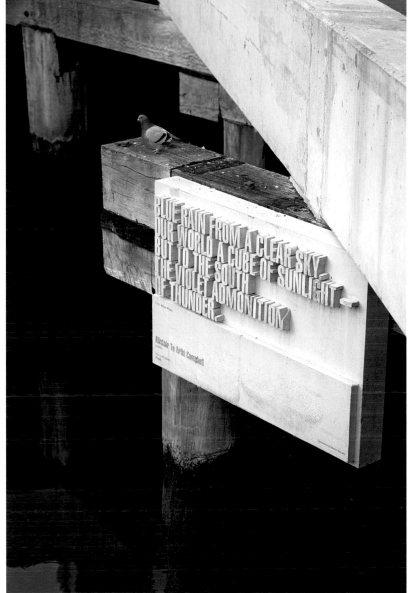

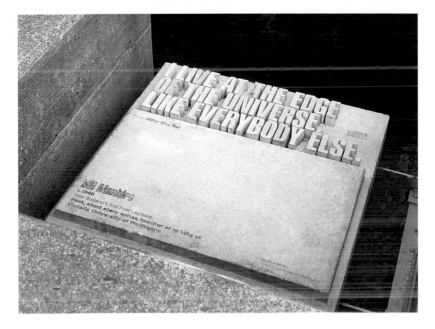

Wellington Writers Walk, Wellington, New Zealand, 2002–4
Designer: **Catherine Griffiths** Architectural consultant: **John Hardwick-Smith, Athfield Architects.** Material: **Concrete.** Type: **Helvetica Extra Compressed, Optima**
The New Zealand Society of Authors wanted a series of A4 (standard UK/ European letter size) bronze plaques, honoring local writers and poets, installed in the city's Civic Square. This was a perfect opportunity to work typographically with the poetry and prose of the writers. Fifteen large-scale concrete text sculptures are positioned in unexpected venues, like recently uncovered ruins, along the city's urban waterfront—they are floating, suspended, wedged in, lying on rocks like artifacts.

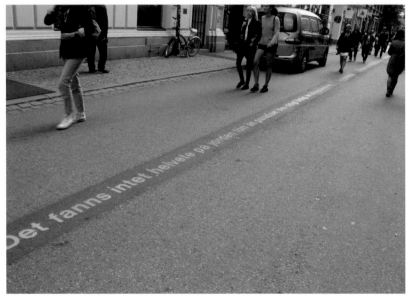

Drottninggatan, Queen Street, Stockholm, Sweden, 2010
Designers: **Ingrid Falk, Gustavo Aguerre** Photographer: **Alexandra Lindberg**
Stockholm's Queen Street is a pedestrian mall, but it was August Strindberg's home street during the last four
years of his life. Now it is site of the Strindberg Museum and well-known quotations like "My fire is the largest in
Sweden" are inlaid in the pavement.

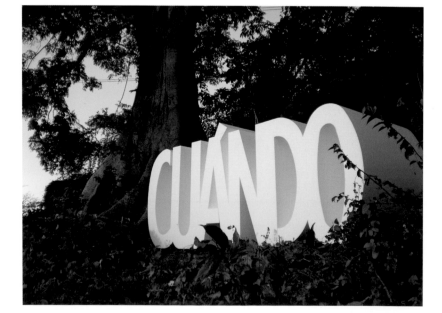

Advocacy Planning to Open Irrigation Channels as a Tourism Attraction
Isabela, Puerto Rico, 2009
Designer: **Alberto Rigau, Jorge Rigau Architects** Photographers: **Gus Pantell, Miguel Ortiz, Jorge de Cardo**
Materials: **Eco-foam** Type: **Gotham Condensed**
In early part of the twentieth century, an extensive web of irrigation channels was constructed to distribute
water to homes and farmland in Puerto Rico. They have a scenic as well as functional value, but mostly
they are unknown. Jorge Rigau Architects conceived a plan to reveal these waterways and garner support
from government, institutions, and the general public for redevelopment of the channels as an "ecotourism
attraction." The letters are surprises in nature that highlight the canals and encourage people to take note.

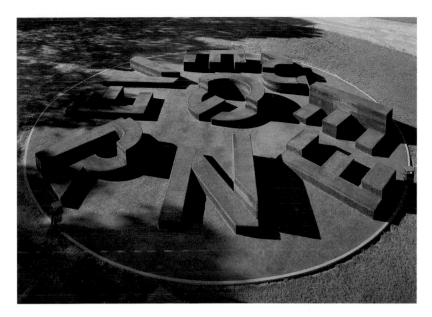

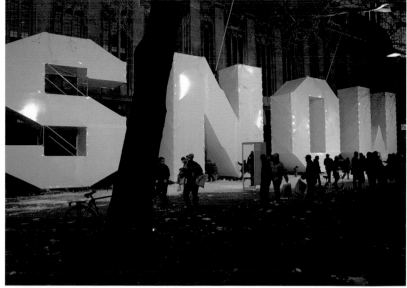

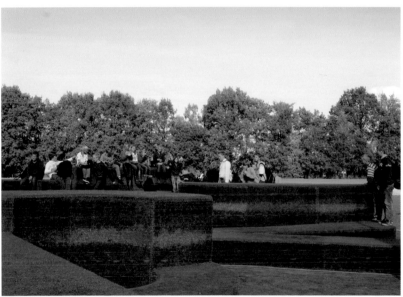

Evergreen, Oldenzaal, The Netherlands, 2008
Client: **Carmel College de Thij, NL**
Design: **Studio Vollearszwart, NL** Photographer: **Pascal Zwart, Gert Jan Van Rooij** Material: **Astroturf**
Type: **Hollywood**
For this typographic garden of oversized letters on a 20-meter circle, nine "objects" are covered in artificial grass, used as outdoor furniture for the college. The space invites secondary-school children as well as adults to socialize. The letters form a seating area and also spell out the name of the project.

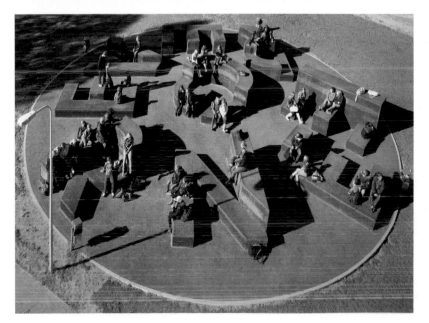

Snow, Rotterdam, The Netherlands, 2007
Client: **City of Rotterdam**
Design: **Studio Vollearszwart** Photographer: **Pascal Zwart** Scaffolding wrapped in white PVC, snow
Type: **Hollywood**
This is a winter sculpture for Winter in Rotterdam 2007. The snow is formed into letters that spell SNOW, just in case a visitor had never seen the stuff before. The project was a collaboration with artist Olaf Mooi, who provided the music, using twenty different variations of the song "Let it Snow!"

Perspectives, Southbank Center, London, England, 2012
Artists: **Trey Watkins, Cameron Brown** Photographer: **Trey Watkins**
Materials: **Wood, aluminium, paint** Type: **Times New Roman**
There are few teaching tools more iconic than classic alphabet blocks. Despite that happy association with childhood, these blocks are at once surprising and jarring.

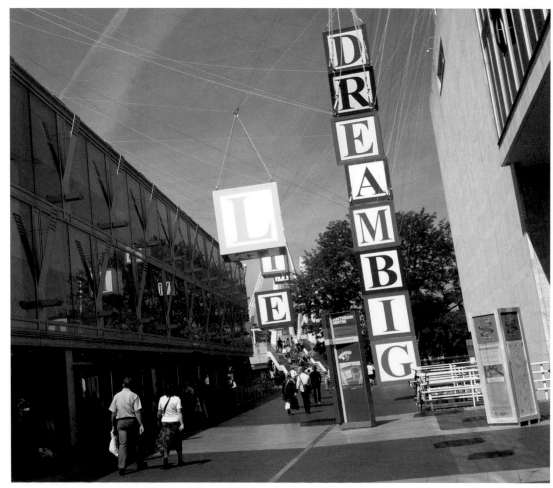

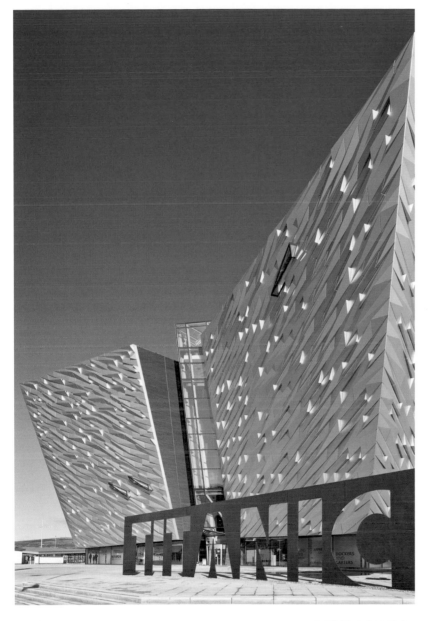

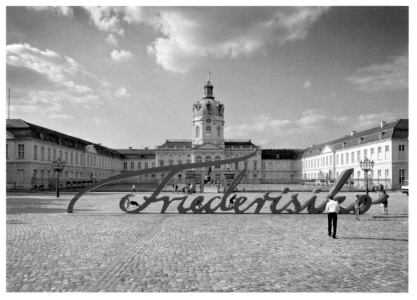

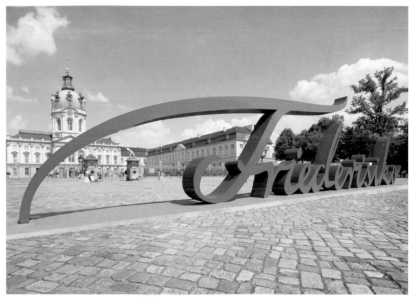

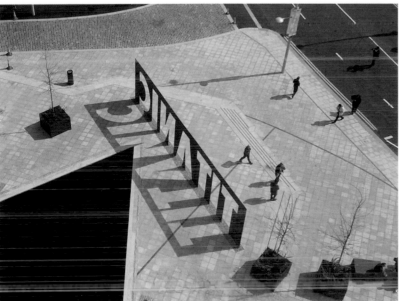

Parc de la Villette Provisional Signage, Paris, France, 2005
Designer: Intégral Ruedi Baur Paris (Ruedi Baur, Eva Kubinyi, Karim Sabano) Photographer: Intégral Ruedi Baur Paris Materials: wood, metal, concrete
The sign implies that despite all the renovation work to the Grande Halle, Parc de la Villette was nonetheless operating as usual. The signage was designed to last one summer, and the choice of materials made it clear that only a temporary use was intended. The installation included giant-sized lettering, an admission-ticket sales point, and various information kiosks, all made of Euro pallets stacked on top of each other.

TITANIC Belfast, Queen's Island, Belfast, Northern Ireland, 2012
Design: CivicArts, Eric R. Kuhne & Associates Photographers: Chris Heaney, Harcourt; Paul Cattermole and Guy Davies, CivicArts. Material: Steel plate Type: Futura Bold Condensed (customized)
The task here was to brand Titanic Belfast: the world's largest Titanic-themed visitor attraction. This striking graphic identity was cut from a three-by-twelve- meter sheet of steel. Employing a modified version of Futura Bold Condensed, the design includes a number of customized elements, such as the deletion of the horizontal stroke of the A to create a prowlike silhouette that mirrors the forms of the building behind. The letterforms are set at ground level so that they appear to be growing out of the plaza; their shadows are italicized as the sun tracks across the sky.

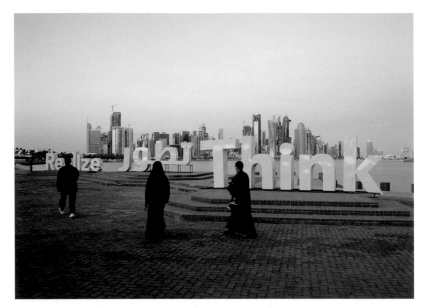

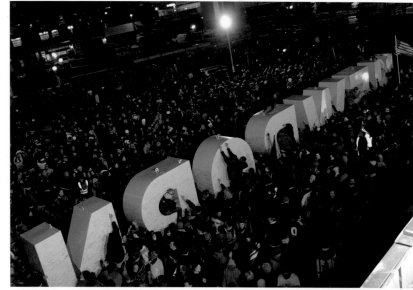

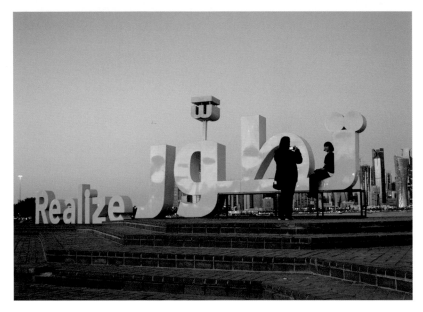

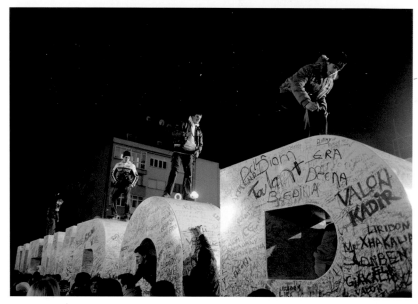

Think, Corniche, Doha, Qatar, 2009
Client: **Qatar Foundation**
Design: **TBWA/RAAD** Photographer: **Robert Čanak**
The words writ large and placed on the Corniche ta riva promenda in English and Arabic are simple notions to live by: "Realize and Think or Think and Realize." Standing before the skyline of Doha, Qatar, they seem to illustrate they idea that this city on the river is expanding quickly and that slowing down to think about the realities of life is essential for survival.

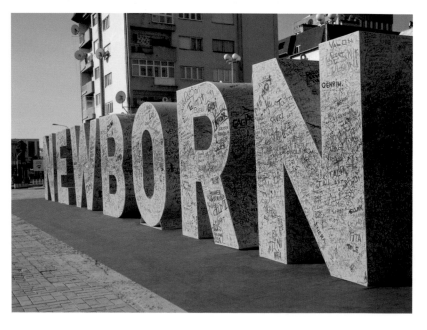

NEWBORN Monument, Prishtina, Kosova, 2008
Designer: **Fisnik Ismaili** Photographers: **Jeton Kaçaniku, Visar Kryeziu, Andrew Testa** Type: **DIN Black**
This monument celebrates the Declaration of Independence of Kosovo. The challenge was to avoid anything that would incite the crowd, but to still provide a joyful design that would mark this historic day. The giant yellow sculpture, spelling the word "NEWBORN," is made of steel frames wrapped with metal sheets, painted with durable yellow metal paint that is resistant to all elements. The entire installation is twenty-four meters long. The word "NEWBORN" was selected to encapsulate in one word everything that independence was going to bring to the country. "It was an interactive sculpture, a tool for the people to express all their emotions via black permanent markers, which we provided during the event," notes Ismali.

Emirates Stadium Brand Activation and Wayfinding, Emirates Stadium, London, England, 2006
Designer: Simon Borg Photographers: Hufton & Crowe, Dr Trishan Panch Type: Bank Gothic
The program involved producing all the environmental graphics and organizing the naming-rights
sponsorship for the new home of Arsenal Football Club, Emirates Stadium (named for Emirates Airline)
Arsenal, which was founded in 1886 by a group of workers at the Woolwich Arsenal armaments factory, has

gradually evolved into one of the perennial top contenders in the English Premier League. The history of the
club was important when preparing the proposal, due to the sensitive nature of the task of including the
corporate presence but also respecting the club's tradition by replicating certain design aspects of Highbury,
Arsenal's former home, into the new facility. The prominent entry signage, for example, is a replica of the
original Gothic Bank typeface.

Belupo Fountain, Belupo Factory, Koprivnica, Croatia, 2011
Design: **Studio Rašić** Art director: **Ante Rašić.** Photographer: **Damir Fabijanić** Type: **Belupo logo**
The existing pharmaceutical company factory was a cold, impersonal space, so Studio Rašić found a new area where an "ambient, human, and social context assumes a new humane dimension and esthetic content." That is how an otherwise mundane factory sign turned into the Belupo Fountain, "a place of inexhaustible inspiration," as the designers observe. The fountain is not only a refreshing sight, it is also an unmistakable logo.

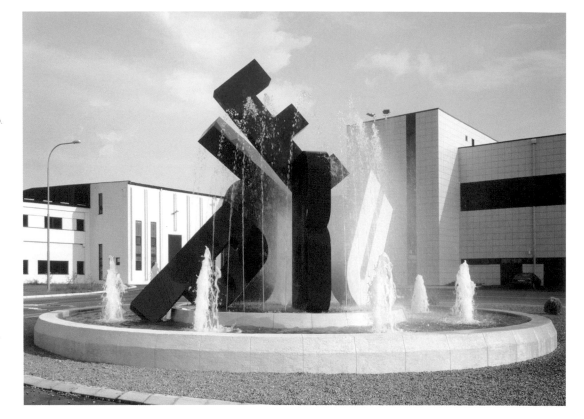

I Amsterdam, Amsterdam, The Netherlands, 2012
Designer: **Erik Kessels** Photographer: **Rogier Brans** Materials: **Steel**
Type: **Avenir**
Capturing attention in a busy metropolis is harder now than it once was. For the city of Amsterdam it was necessary to scream loudly. Making a slogan into an interactive street event—something that invites the viewer to take part—was the logical yet surprising choice of the designer, who says, "The billboard transcends its passive nature and becomes a demonstrative means of capturing attention."

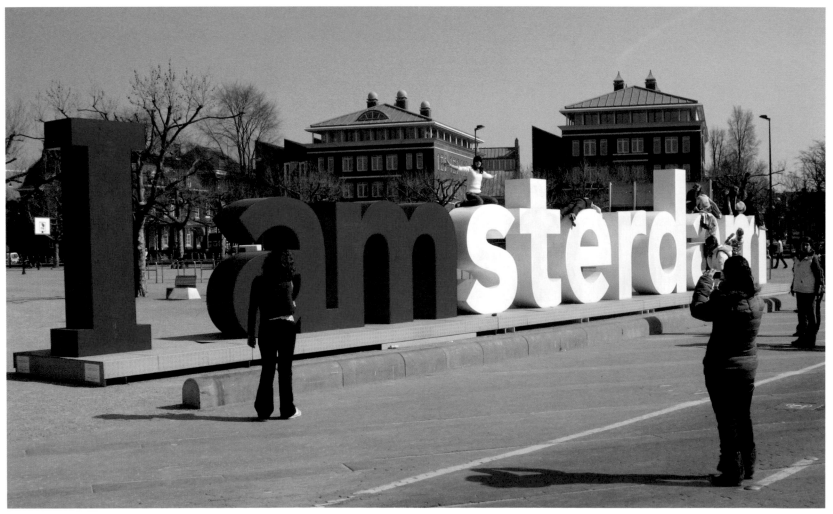

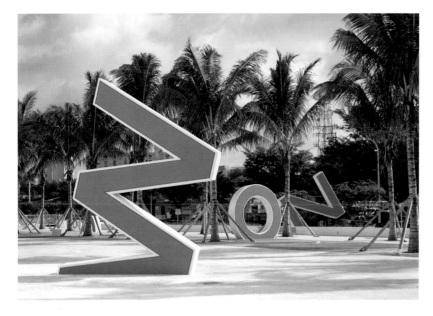

A Memorial Bowing, Miami, Florida, 2012
Designer: **Snarkitecture** Photographer: **Noah Kalina** Materials: **Concrete** Type: **Custom**
What an audacious way to design new signage from and old icon. The letters, which are sprinkled throughout the new Marlins stadium are echoes of the original MIAMI ORANGE BOWL sign that stood on this site from 1937 until its demolition in 2008. The letters are reconstructed at their original ten-foot height and scattered, as though fallen from the demolition, throughout the east plaza. "Their positions capture an ambiguous moment between ruin and rebuilding," say the designers at Snarkitecture. "The new stadium is glimpsed through fragments of the old."

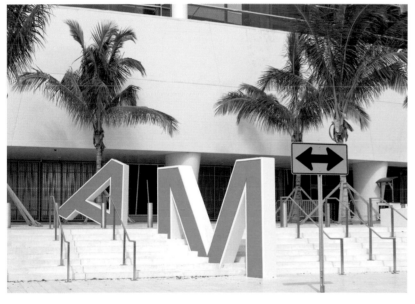

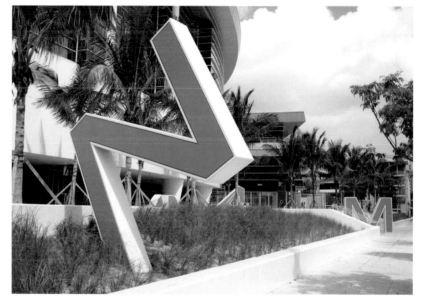

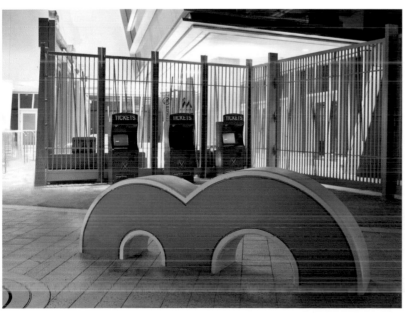

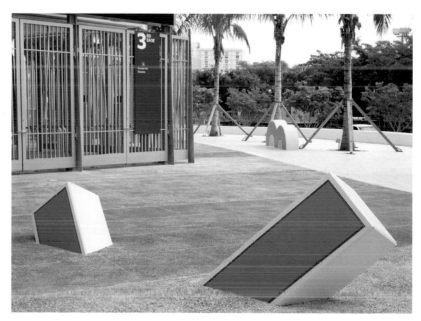

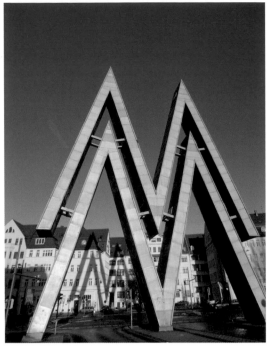

Symbol of the Leipzig Trade Fair, Leipzig, Germany, 1917
Artist: **Erich Gruner** Photographer: **Sven Türpe**
The piggyback M logo is the traditional representation for the Leipzig
Trade Fair and the portal of the old fairground. It casts a giant shadow
and provides massive visibility.

Stony Brook University, Stony Brook, New York, 2001
Designer: **Milton Glaser**
Stony Brook University project, which has lasted eight years, was an
opportunity for Glaser to work in two and three dimensions for an
institution devoted to higher education. "We have been involved in all
aspects of campus life: communication, interiors, signage, advertising,
products, and publications," he says. The large, playful and colorful A is
part of a signage system that takes routine wayfinding off the wall and
plants it on the ground.

Mollet del Vallès Town Hall, Plaça Major, Mollet del Vallés,
Spain, 2002
Designer: **Joan Brossa**
This 375-square-meter mural is one of the largest concrete poems Brossa
ever conceived, and it is one of his last designs before his death in
December 1998. An image of a mullet (a type of fish) and waves appears
in the architrave over the front of the old Gothic church in Mollet del
Vallès, as well as in the town's coat of arms. Brossa inserted this image
in a large letter A lying on its side. The poet turned to what was for him
the iconic first letter of the alphabet, "the gateway to literature," the first
letter of the word ajuntament (town hall).

Transitable Visual Poem in Three Times, Horta Velodrome,
Barcelona, 1983–84
Designer: **Joan Brossa** Photographer: **Till F. Teenck**
Brossa achieved the goal of producing poetic art without borders, having
passed from literary to visual poetry and from visual to concrete. Invited
by the architects Esteve Bonell and Francesc Rius, who designed the
Velodrome site, Brossa produced a work in which poetry is given an
urban dimension. He himself defined it as a "transitable visual poem in
three parts: birth, path—with pauses and intonations—and destruction."
This is, then, a syntactic construction in which the visitor participates
by following the itinerary the poet proposes. This itinerary begins with
a large letter A and continues with several punctuation marks (period,
comma, question marks, and so on) scattered on the grass to express the
pauses, ending with a conclusion and destruction in the form of another
letter A, this one cut up and converted into a meeting point.

NN Building Directory sign, Tokyo, Japan, 1981
Client: **Nippon Insurance Company**
Designer: **Takenobu Igarashi** Architect: **Fumihiko Maki and Associates**
Material: **Aluminum**
Igarashi is well known for his dimensional typography. In this case, he
says, "The architect requested a design that will equal the life expectancy
of a building. The two Ns are joined together at right angles. The
structure, consisting of aluminum plates fixed in a stainless steel frame
by screws from the inside, gives volume and weight to the piece. The
aluminum has a deep red natural lustre. This is a work of extreme high
precision, which is also built for durability."

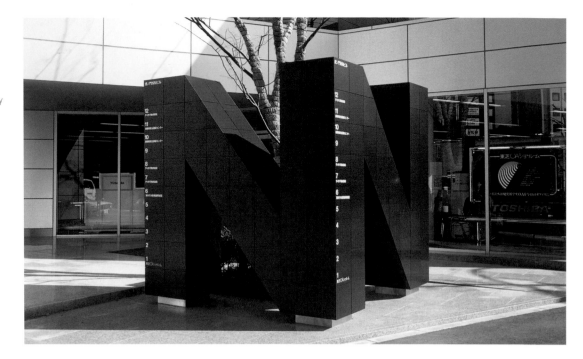

Art, Creation, Columbus, Ohio, 1999
Designer: **Doris Shlayn, Artglo Company**
Materials: **Steel, concrete base**
This sculpture was donated to the Columbus College of Art & Design
by the Artglo Company, among other donors. It continues to serve as a
touchstone for the artistic community of Columbus.

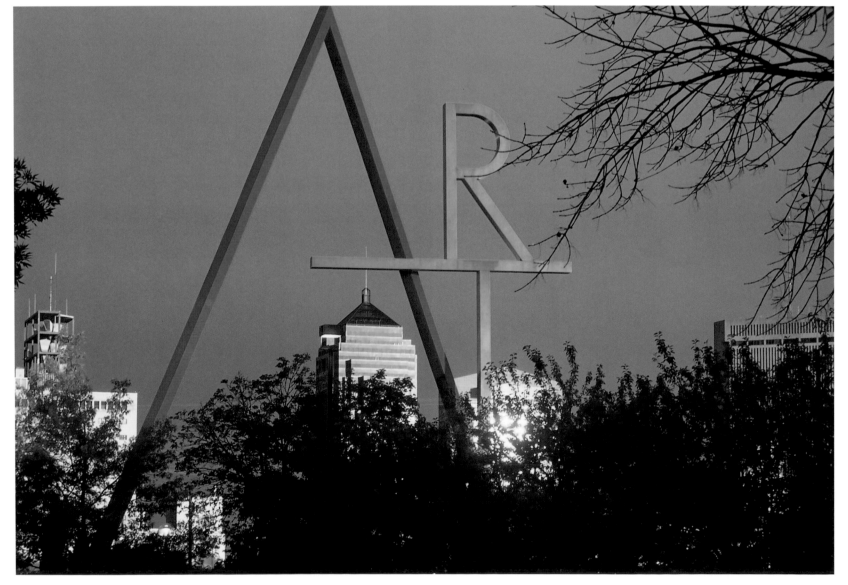

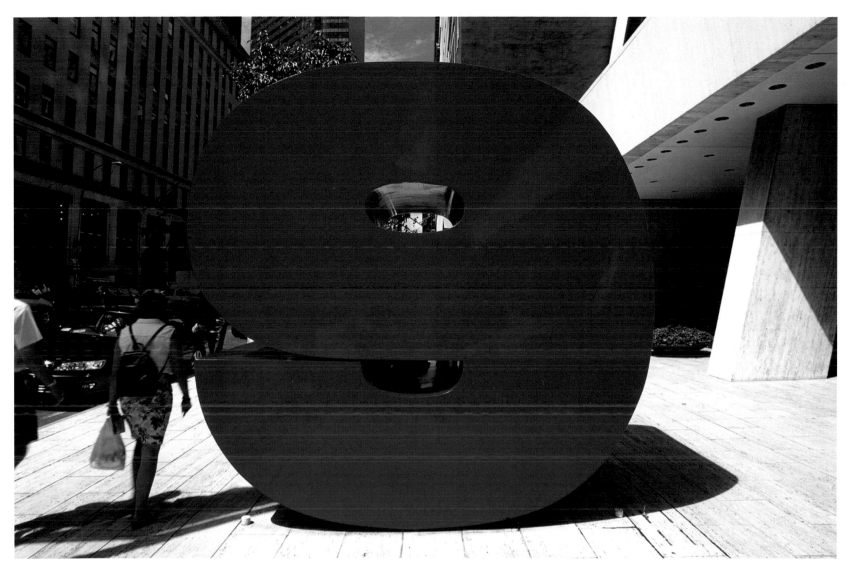

9 West 57th Street, New York, New York, 1979
Art Director: **Ivan Chermayeff** Photographer: **Elliott Kaufmann**
Material: **Steel**
At once public art and functional typographic sign, this is an iconic fixture of New York's cityscape. Ivan Chermayeff was the first modern designer in New York to take advantage of scale and form on the street level in the branding of a building or retail space.

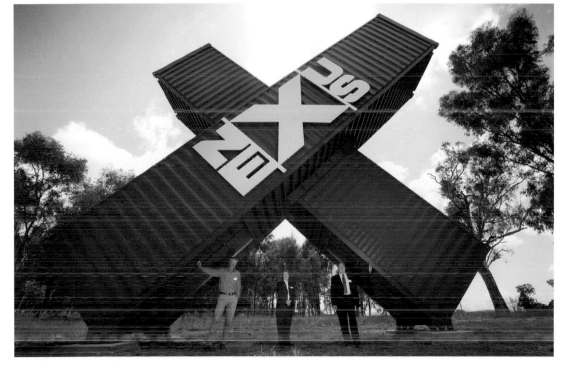

Nexus Industrial Precinct, AlburyCity, New South Wales, Australia, 2011
Art Director: **Brian Slade** Photographer: **Simon Dallinger**
Material: **Shipping containers** Type: **Custom, Forza**
This signage is designed to act as the central identifier for a new industrial precinct. It captures the brand idea for AlburyCity while evoking the essence of an industrial park. The word "nexus" means a connection, usually where multiple elements meet, like a hub. Two forty-foot containers interlock in a surprising balancing act, forming an X shape. This piece relies on prefabricated materials found in the industrial environment, helping to reduce the costs of production.

Roadshow Audi AreA1 Barcelona, Barcelona, Spain, 2010
Client: AUDI AG, Ingolstadt
Concept and architecture: **Schmidhuber + Partner, Munich** Photographer: **Andreas Keller, Altdorf**
The Barcelona waterfront was chosen to launch the "AreA1" marketing campaign for the new Audi A1. Employing imposing letters in a futuristic environment was aimed at a young, urban crowd. Visitors to AreA1 are led through a series of zones that lead to a crescendo of sight and sound. The design format of the modules in which the cars are revealed was inspired by the A1's single-frame radiator grill. The entire stage sits slightly elevated and in "brandspeak" creates its own "unique brand space" in the middle of an urban environment.

Days of Belgrade Festival, Knez Mihailova street, Belgrade, Serbia, 2008.
Design: **Slaviša Savić** Photographer: **Slaviša Savić** Material: **Tarpaulin**
Four giant capital letters that form the word "DAYS" in Serbian were placed in the main pedestrian zone in the city center. The festival lasted four days and every letter represented one day. Each letter was a hot spot, and the initial stood for the type of program for that day. Each letter was readable from both sides, and it stood on two "legs" like a gate for pedestrians to walk through.

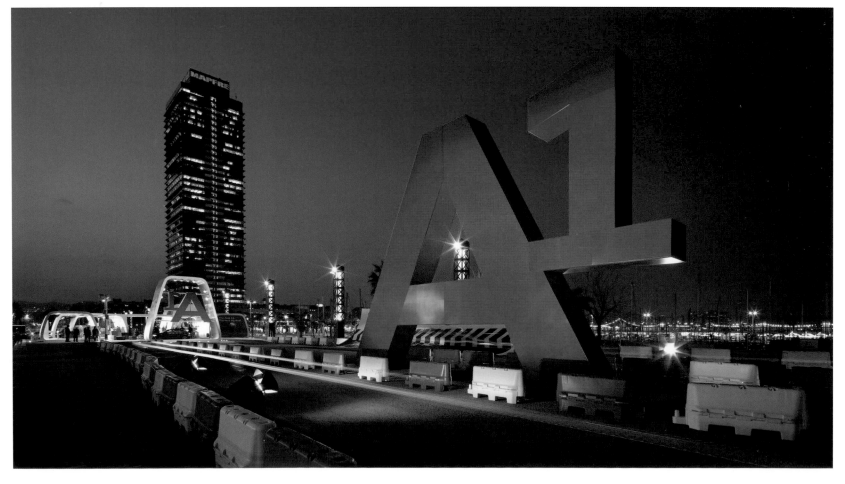

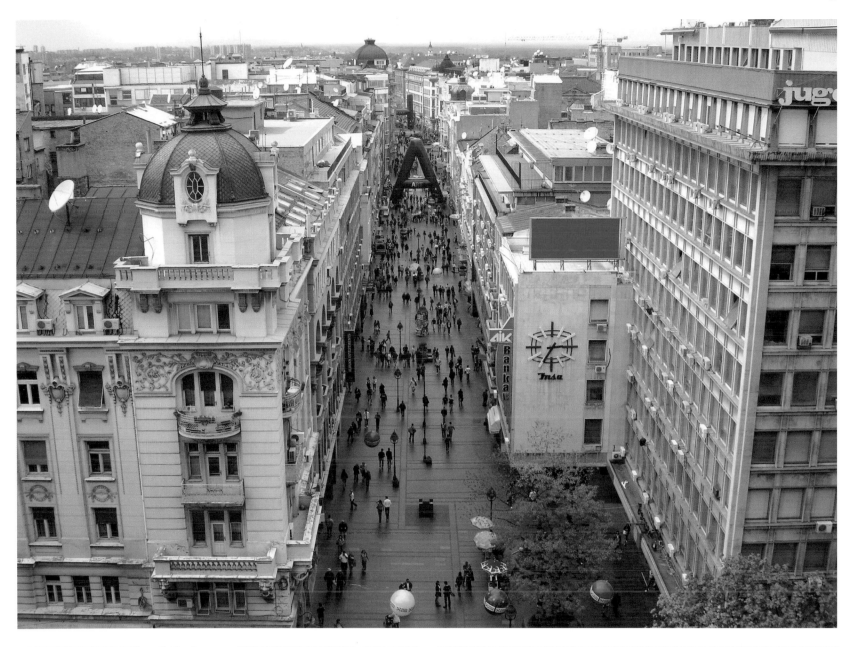

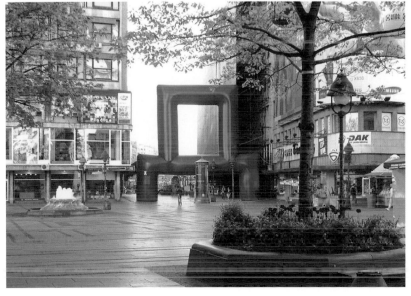

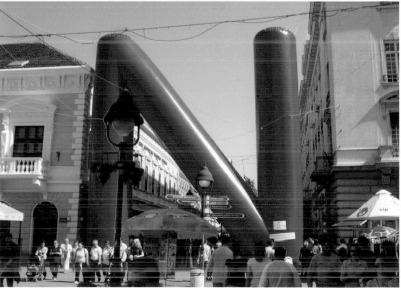

Apraksin Yard, St. Petersburg, Russia, c. 1914
Shops, storehouses, and offices built in the eighteenth and nineteenth centuries in the area belonging to the Counts Apraksin and bounded by the Fontanka River, Sadovaya Street, Lomonosova Street, and Apraksin Lane.

Type in 2D: On The Surface

The Motograph News Bulletin on the One Times Square tower was introduced in 1928. Known as "the zipper," this state-of-the-art electronic type display flashed continuously changing, up-to-the-minute headlines direct from a control booth in the New York Times building. Pedestrians were mesmerized by the moving ribbon of lights, its five-foot-high strip wrapped 380 feet around the Times building at the fourth floor, the illuminated letters visible from several blocks away. The zipper was just one of the technological marvels designed especially for Times Square and used to sell products, provide information, and glow as brightly as the technology allowed. Although some signs were three-dimensional, most were flat surfaces, like many of the earlier advertising signs and billboards perched atop buildings along the Great White Way.

Sidewalk bridges and construction netting are today's prime urban real estate for flat, two-dimensional typo-hypnotic messages—type that grabs the optically, intellectually, or emotionally. But throughout the nineteenth and early twentieth centuries, building facades, empty walls, and even doors and gates were among the preferred advertising display venues. The intense need to

promote wares and ideas, along with the relative ease of posting "the word" anywhere an advertiser pleased, resulted in buildings that were so besieged by ads that even windows were obliterated by scrims and posters. So prodigious and ubiquitous was the practice of posting bills that zoning ordinances and strict laws were passed to limit or localize flagrant postings. Times Square, Piccadilly Circus in London, and the Ginza in Tokyo are legally zoned for grand displays, with spaces on prominent buildings officially designated as sites for mammoth illuminated signs.

At various times in history, movements to ban outdoor advertising have garnered popular and legislative support. In New York, however, this ignites debate on whether or not banishment also reduces corporate revenue and by extension employment. Still, visual blight in cities and along highways is always the enemy. Ironically, two-dimensional typography on buildings has now both creatively and numerically reached an apex. Some mammoth outdoor graphics are considered treasured virtues, among other outdoor cultural assets, such as sculpture and monuments. They borrow and transcend common advertising tropes and techniques, just as Pop Art elevated quotidian products decades earlier. Typographic murals can be both art and craft. Designers and artists who directly

paint or electronically project type on buildings are more than resurrected sign painters. Of course, the results may have outcomes other than pure art when branding institutions and promoting products, but that is in the nature of public works and environmental graphics.

One trigger for the renewed interest in covering buildings with bold typography is Pentagram partner Paula Scher's 2001 environmental graphics program for the New Jersey Performing Arts Center (NJPAC) at the Lucent Technologies Center for Arts Education in Newark (page 80). Covering the building completely with type transformed what was originally a dreary 30,000-square-foot stone rectory, built in an ecclesiastic style in the 1940s, into a stunning advertisement for a performing arts school. Painting the building with spirited, stylized letterforms—drawn from billboard vernacular and car-wash marquees, as well as theatrical-poster typographic tradition—raised public expectations and enthusiasm. This was not simply a school but an event. Word patterns including "poetry," "music," "drama," "dance," and "theater" are playfully positioned in all directions across the facade, accompanied by colorful banners. The graphics recast the building as appealing, fun, and creative, and produced a lively neighborhood landmark. No single

TYPO-HYPNO

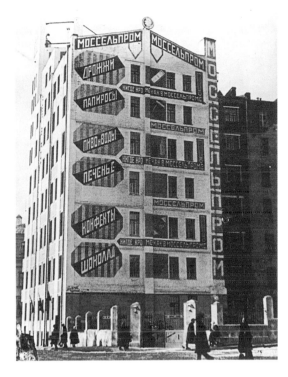

Mosselprom, Moscow, Russia, 1924
Designers: Vladimir Mayakovsky, Aleksandr Rodchenko
Decorated by Mayakovsky and Rodchenko to advertise Mosselprom's "Yeast," "Cigarettes," "Beers and Mineral Waters," "Biscuits, Sweets," and "Chocolate." The slogan "Nowhere else but in Mosselprom" is repeated on alternating floor levels.

Bonhomme, L'Aigle à L'aigle, France
Photographer: Massin
It is not clear whether the round windows preceded the inscription or whether they determined the architect's design.

sign could hope to achieve all that.

The NJPAC typographic strategy speaks eloquently to its role in the community, while Love Letter to Brooklyn (page 81) on Hoyt Street in Brooklyn, New York, designed by Stephen Power and his team of sign painters, is a unique public art extravaganza designed to celebrate a single community. Power employs the same typographic language as NJPAC, but Love Letter is less nuanced. Still, it does accomplish an aesthetic conversion of a nondescript parking garage into a selection of messages excerpted from oral histories about the Downtown Brooklyn area. It is one of a series of ongoing projects designed to highlight the history of specific communities.

Old signs have deep nostalgic appeal, which explains the work of the British Bread Collective's The Walls Have Ears, a one-hundred-meter-long mural about the neighborhood of Hackney Wick, funded by the London Legacy Development Corporation. To help regenerate what the Bread Collective's website describes as "an unloved street" leading to Olympic Park in East London, the collective produced a typographic mural that is based on replicating fragments of vintage sign relics. The mural is intentionally ambiguous and intriguing, "in the hope that passersby would question the words and be

interested to find out more about the history of the area," according to the collective's Tumblr site. The historical content includes a balance of positive and negative connotations, including subtle cautionary tales about the ravages of industrial pollution. It was important to address the unsavory aspects of the community to explain what went on before, they add. Still, the vernacular style tends to lull the viewer into a comfortable place; it is familiar yet new, safe yet intriguing.

Safe is fine, but jarring is also persuasive, which is exactly what art collective Boa Mistura achieved with their 2012 Light In The Alleyways on Vila Brasilândia, São Paulo, Brazil. This is one of the group's Participative Urban Art Interventions to uplift run-down communities, using art as a tool for change. The concept was to create new environments within the maze of narrow and winding streets that connects the alleys (vielas) through bright chromatic interventions and typographic illusions. Mistura, with the active participation of the community, painted the words BELEZA (beauty), AMOR (love), DOÇURA (trick), and ORGULHO (pride) with optical distortions that make the words appear to float in space but actually follow the contours of the irregularly shaped walls and walkways. When standing up close, the viewer sees that the letters are separated by the

alleys. The bright hues are light and joyful, serving to illuminate the language of the streets.

Optical tomfoolery is part of the allure of making environmental typography and making typography hypnotic. Toying with public perception allows the designer to test how and what people read the most. One of the most familiar optical tropes is a kind of grand-scale lenticular method usually found on campaign buttons where a face becomes lettering depending on the position of the button; in this case, depending on where the viewer is positioned, the message reads one way or another. That multiple message type-game lies behind the thinking for another piece titled The Walls Have Ears, at the Koninklijke Bibliotheek, National Library of the Netherlands, designed in 2007 by Karen Polder. The piece depends on facade panels with giant gold-leaf letters on them. Each of the panels had to be transported in exactly the right order and marked accordingly. In the end, the trick is meant to spur the visitor to ponder the nature of words and meaning.

As the saying goes, size does matter—a lot. The larger the letters, the greater the probability they will be read or at least noticed. The mind is drawn more sharply to letters large than small. The facade of the Syracuse University building Newhouse III (one of buildings at the S. I. Newhouse School

IC MESSAGES

It's A Scream, 1930s
Domino House Ice Cream Shop was a temporary structure constructed from plywood and designed as a fun house comprised of dominoes and colorful signs.

of Public Communications) features typography that may not be as breathtaking as some of the brightly lit spectaculars, but it conveys a meaningful and resonant motto. The prestigious school of communications is dedicated to the free speech embodied in the First Amendment. David Gibson and Chris Dina of Two Twelve Associates designed a monumental type display to publicly make those values part of the very fabric of the building.

Extremely large letters give an extra kick or validation to weighty words. This is the case with the "United States of America" sign atop the United States Land Port of Entry at Champlain, New York. The sign was created in 2008 by Smith-Miller + Hawkinson Architects for the U.S. General Services Administration. This Port of Entry is an iconic gateway into the United States at one of the busiest northern border crossings. The design required extremely clear wayfinding strategies for the integration of vehicle traffic with inspection and waiting areas. But the sign had a subtler role too: to signal a delicate balance between being welcoming and optimistic and being a solid barrier against illegal entry. If "United States of America" were set in the same type light-line style as Dreispitzhalle, a Swiss cultural center (page 91), the size would be similar but the impact of the words would not. The sixty-meter-wide custom typeface, designed in 2008 by Simon Hauser and David Schwarz for the Christoph Merian Foundation in Basel, fits well into this venue because the font was directly inspired by the architecture of the building. The white letters against the coal-black loading dock structure evoke the cutting-edge identity of the institution.

Self-assuredness is a given in this monumental-type field; otherwise the risks are too

costly. So an attempt to alter religious convention is indeed a huge risk that was not taken lightly when the architecture and typography for the Al-Irsyad mosque in Kota Baru Parahyangan, Bandung, Indonesia, was planned. Designed and built in 2009 by a local architect, Ridwan Kamil, the mosque facade uses pixels-like openings and light to present Islamic devotional text and suggests the calligraphic holy writing of the shahada. Here the graphic design upholds tradition and projects it into the present day.

A belief in the rightness of form should always be part of a designer's creed. For Glass Fragile Handle With Care—a 2009 project by artist Martijn Sandberg involving the glass balustrades of balconies at an apartment complex in Stadshoven Weidevenne, Purmerend, the Netherlands—the typographic rightness was clear. He devised a language that distinguished the five-story apartment complex, whose balconies are staggered vertically in relation to each other. This forms a natural concrete surface to play with language and architecture all at once.

Grand typographic statements can appear on any size structure, and given the context, the 2012 Mikser House facade in Belgrade, Serbia, designed by Aleksandar Spasojević, has already altered the look of a depressed former industrial area. Mikser House was a garage and is one of the projects within a larger Mikser initiative to restore this district into Belgrade's new design center. Its location, Karadjordjeva Street, is the most polluted street in town, so the design idea to create a typographic wall announcing the initiative also commented on the sorry environment. Spasojević's type looks like paint was belched all over the facade in shades of gray to mimic the grime of the area.

Typographic murals are often used to brand

one building or more that share a similar purpose. The Zavrtnica Business Center in Zagreb, Croatia, designed in 2011 by Bruketa&Žinić OM, a group of advertising agencies, is a stunning before-and-after case study. The commission was to refresh a group of undistinguished former factory buildings, making them more recognizable to the naked eye. The huge numbers and letters complement the architectural scheme, becoming the dominant visual force. The stark black and white respects the building's form, and by alternating those colors, like piano keys, the designers created a kinetic feeling that overtakes the entire facade.

Huge words and numerals outside of buildings and other structures resonate for those who see and interact with them. Each is designed with theatrical flair, like a leading player on a stage.

Type in 2D: Behind Closed Doors

"Supergraphics" was the name bestowed on an architectural trend that was popular for a brief time during the psychedelic sixties. More than a style, it was a frontal attack on the solemnity of most buildings and the purity of modernism—a rejection of Adolf Loos's "smooth and precious surfaces"—through the introduction of mammoth geometric decorative graphic murals. It was the kind of ornamentation that Loos called "immoral" in his Ornament und Verbrechen. Exterior and interior walls, floors and ceilings were tabula rasae for architects and graphic designers who "distorted perspective with stripes and arrows, emphasized wayfinding and movement sequences with surface designs, joined community groups to paint illustrative graphics over blighted buildings, and played with scale by using

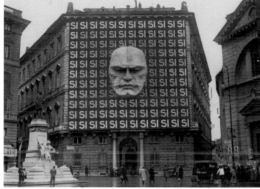

A Mid-Summer's Night's Dream, New York, New York, 1935
The sides of tenement building walls that are not obscured by neighboring buildings have long been canvases for bills of all sizes, including this full-sized posting, which is reminiscent of contemporary New York Public Theater advertisements.

Si Si Si Si, Rome, Italy, 1920s
This celebratory billboard in Rome adjacent to the Piazza Navona, which covered Benito Mussolini's headquarters in the early 1920s, showed the propaganda power of simple image and word displayed on a grand scale.

billboarding tactics," as Adrian Shaughnessy wrote in *Supergraphics—Transforming Space: Graphic Design for Walls, Buildings and Spaces* (Unit Editions, 2010).

Suddenly, buildings in Los Angeles, New York, and Chicago were turned into carnivals of colors, shapes, and forms. It was sixties hippie style writ large. Even some conservative corporations, seemingly impervious to shifts in fashion, allowed that a splash of visual exuberance might improve perceptions both in and outside their headquarters and factories. The supergraphics of the sixties and seventies, much of it following the op art aesthetic that informed clothing and textiles of the day, is now outmoded. The phenomenon gradually lost steam and sobriety returned. Yet today megagraphics are a viable option in the environmental designer's tool kit. Since the heyday of supergraphics, large lettering and mammoth typography have, more or less, replaced the bold geometries, while color palettes have become more refined. Still, designs filling unlimited space with texts have grown more expansive and expressive—and with new digital technology, more affordable. Although the term supergraphics has lost currency, the thinking that drove it is alive and well.

Even as the supergraphics trend was nearing its end, serious interior text installations flourished. One was designed to bring the tragic realities of World War II to light: the Deportee Memorial Museum in Carpi, Modena, Italy, in 1973 commissioned architecture firm BBPR and designer firm Albe e Lica Steiner to create Perspective with Fernand Léger Graffito (page 105), a section of interior walls and arches with inscriptions of hundreds of names cut into rough plaster. The names chronicle the Italians who were victims of Nazi and Fascist persecution. The installation, a "constant warning for the future,"

as Steiner notes, prefigured modern memorials like the 1982 Vietnam War Memorial.

Interior megatypography has become virtually de rigueur in public spaces. In New York's Grand Central Terminal, in 1996 Stephen Doyle created a temporary vinyl display to celebrate the seventy-fifth anniversary of women's right to vote in the United States. The display quoted the Nineteenth Amendment: "The right of citizens of the United States to vote shall not be denied or abridged by the United States or by any State on account of sex." The Vanderbilt waiting area, where the words were laid out, receives two to three million passersby daily, so even the short time it was on view, it made an impact.

The nexus of old supergraphics and contemporary megatypography can be found in the common parking garage. Few venues are more in need of large directional signs than these meandering, ramped warehouses. In 2012, Andrew Wood and Filip Bjazevic brought some life to the QV Melbourne car park in Melbourne, Australia, by implementing a series of large-scale environmental graphics. The letterforms were hand painted and overlaid. The words were fit into odd spaces while color was employed to aid in visibility. Type serves an informational role while telegraphing the space as friendly.

Paula Scher has produced many examples of environmental typography that brightens up the mood of otherwise dreary institutions, offering inspirational quotations as well as unencumbered access to necessary information, such as room designations and floor numbers. The typography and color displays designed in 2010 for Achievement First Endeavor Middle School in Brooklyn, New York, which

Scher collaborated on with Andrew Freeman and Drea Zlanabitnig, give students an extra incentive to be proud of their surroundings. The soothing colors frame a typographic language that deliberately eschews institutional clichés and suggests a high level of sophistication. The quality of the design also fends off graffiti.

Schools, colleges, and universities are perfect venues for massive interior typography with the potential to engage students consciously and subconsciously. The sign system designed by Büro Uebele in 2004 for the Osnabrück University of Applied Sciences in Osnabrück, Germany, is solely a ceiling of black letters and numbers (the walls and floor are bare), interspersed with red clouds. Words are used, say the designers, "like stars show[ing] the way," guiding the student to class. As students look forward, they also see repeated information in large text that insures a foolproof journey throughout the building.

The professional term "wayfinding" more or less describes directional and informational signs, the ancestors of trail markers, milestones, and bread crumbs. But "wayfinding" implies a consistency within all branding aspects of a building, park, or arena, so all components of the identity must be in sync to work. The graphics for Théâtre et Auditorium de Poitiers (TAP) in France, designed by Vera Sacchetti, Miguel Cochofel, Giuseppe Greco, and Ricardo Moura from 2006 to 2008, is based on a conceptual theme that also provides very visible wayfinding cues. The concept for the system, which makes use of variegated size letters, was influenced by incongruent typographies of Dada. Words and letters are freely arranged and partially expressed in an onomatopoeic way, suggesting the building is literally a container

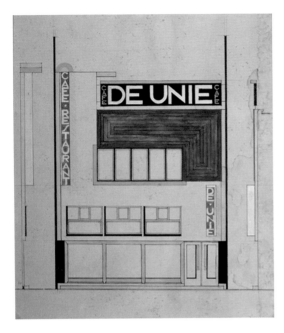

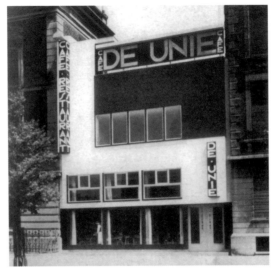

Café De Unie, Calandplein, Rotterdam, 1925
Designer/Architect: J. J. P. Oud
Café De Unie was originally built in 1925 elsewhere in Rotterdam. It was leveled by the German Luftwaffe in 1940 and rebuilt in in its original form in 1986.

for words and sounds. The system consists of oversized letters and numerals recognizable from a distance. Announcements of the seasonal events are exterior video projections on the glass "skin" of the building.

Some people might argue that having megatypography on an office wall prohibits workers from introducing their own personal objects. Seen another way, it means that workers' personal art cannot mar the beauty of a well-designed office. Designed in 2011 by Branimir Sabljić and Krešimir Stanić, the painted interior of the Croatian Lottery in Zagreb is the design analog of winning the lottery. Here is an ordinary working space transformed into a playful office where walls speak for themselves. To define the space the designers used basic and highly recognizable elements of the Croatian Lottery and other classic games of chance. In the meeting area, the main wall immediately visible upon entering was branded with the Croatian Lottery logo and enlarged graphics of lottery ticket numbers. Two offices are decorated with hyper-enlarged lottery balls that appear to be succumbing to laws of gravity and refract light, creating the illusion of volume.

Other than natural or room light, illumination for interior typographic displays is usually not critical, but nonetheless, the right light sources add considerable allure to any composition or statement. The 2010 BMW Light Wall "Reflection" at the Hamburg Airport Arrivals Hall, created by the team of Alexander Schill, Maik Kaehler, Christoph Nann, Manuel Wolff, Savina Mokreva, and Andreas Schriewer, is the visualization of two simultaneous concepts, achieved in part through lighting and reflection.

Staircases are breeding grounds for graffiti, so beating the vandals to the punch with beautiful

alternative lettering is a rather intelligent way to thwart the impulse to tag. Dana Tanamachi's 2012 massive interior chalk lettering project for the hotel Andaz 5th Avenue in New York covered over 350 square feet of space with handwritten and drawn texts. Located in the employee stairway, it was designed to give the staff a sense of pride.

Graffiti can be both pattern and text. Daniel Patrick Helmstetter's poetic scrawls were painted in house paint during three weeks in 2010 for Danny's Continental Cocktail Lounge in Newark. "It was a big, bold ceiling-to-floor literary explosion; a poem that had painted its way off the page," he wrote on his website. The painting was, in part, an ongoing exploration of the relationship between content and form. The concept being explored was that good poetry creates an image within the mind of the reader, while typography itself also functions as an image. In a room full of words, there is the possibility of innumerable images living within the content of the words. This piece pulsated with rhythm and movement—and claimed ownership of every corner.

Behind closed doors, on floors, ceilings, and walls, covering rooms or parts thereof, the ambitious typographer has countless ways to express, inform, and entertain. Whether the work is super, mega, or poetic, designs that are hidden inside spaces can be every bit as exciting as those on the outside.

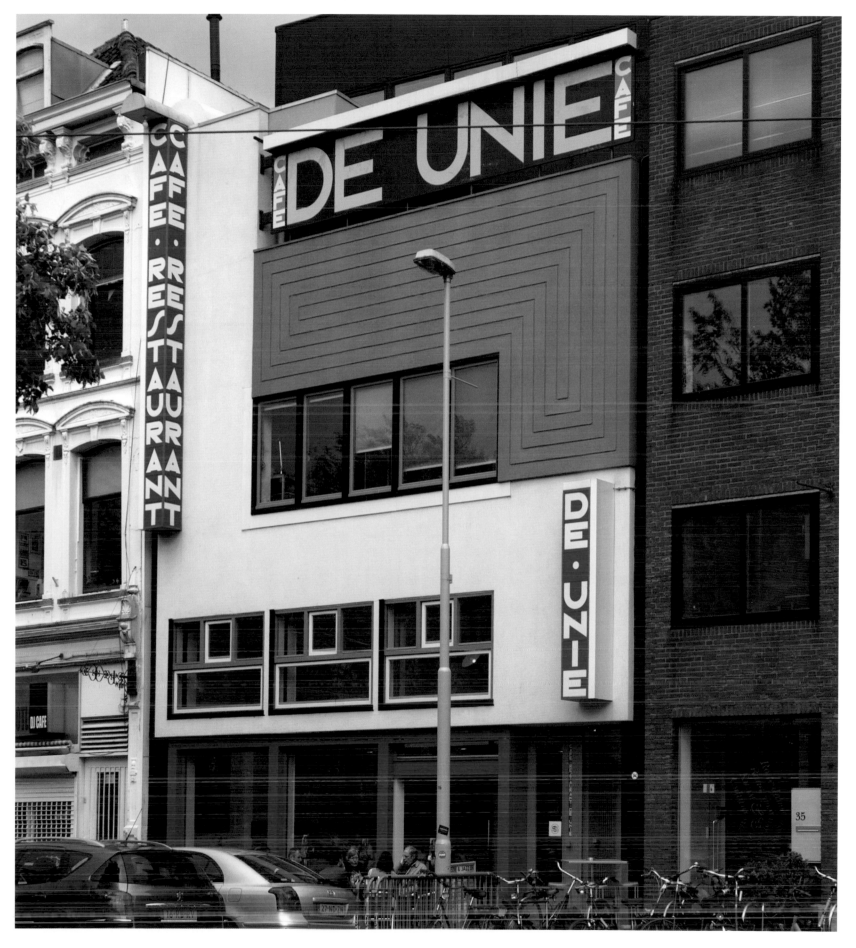

Center for Arts Education, Newark, New Jersey, 2001
Designer: **Paula Scher, Pentagram** Photographer: **Peter Mauss/Esto**
Materials: **Paint, industrial-grade linoleum tile floors**
Type: **Abemcy Gothic**

The Lucent Technologies Center for Arts Education is a school affiliated with the New Jersey Performing Arts Center (NJPAC). The school building is adjacent to the NJPAC site. Originally a rectory built in the 1940s, the 30,000-square-foot stone building is imposing and institutional, resembling an old public school. NJPAC wanted to project a warmer personality for the building, but with its limited budget, it could not afford a major architectural renovation. Paula Scher and her team at Pentagram accomplished this by covering the building in bold typography, drawing from the vernacular of billboards and car washes, as well as traditions of theatrical promotion. The building has been painted white, with a pattern of words like "poetry," "music," "drama," "dance," and "theater" playfully running in all directions across the facade, accompanied by colorful banners.

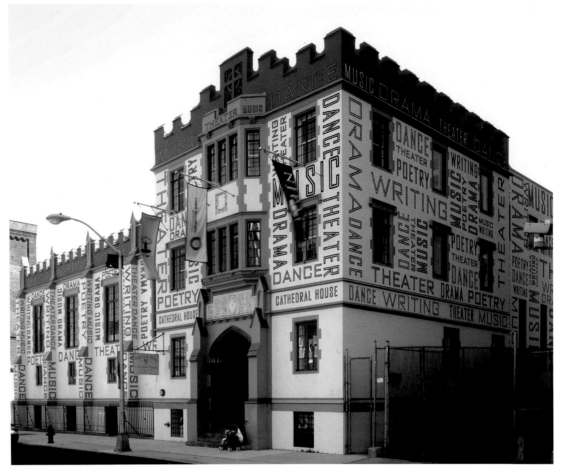

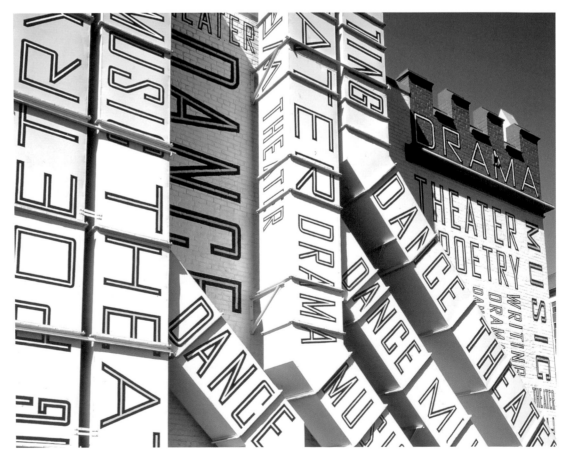

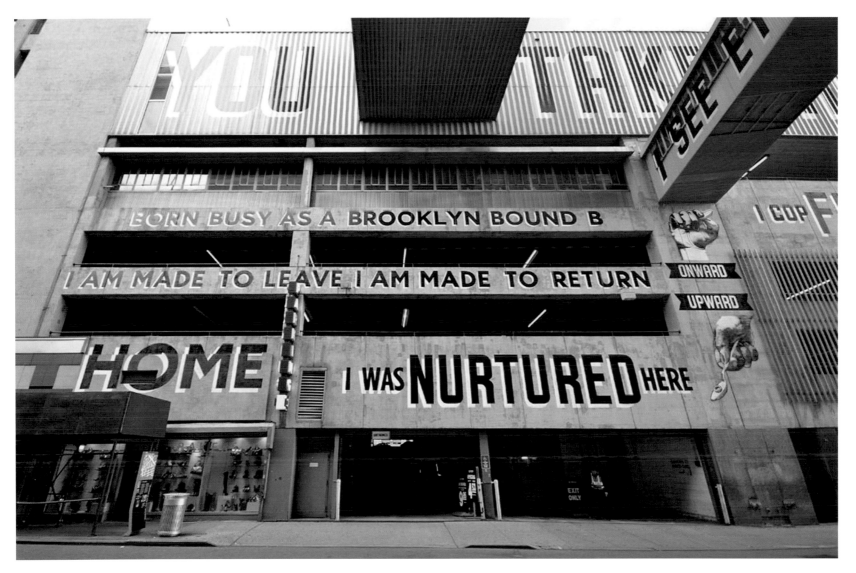

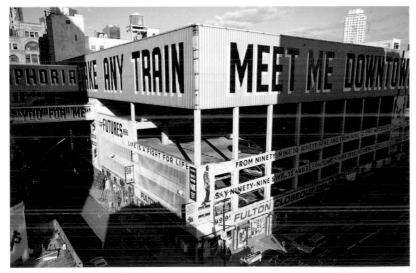

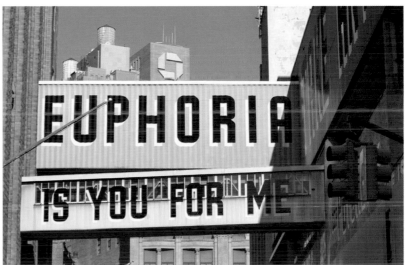

Love Letter to Brooklyn, Brooklyn, New York, 2010
Designer: **Stephens Power** Photographer: **David Villorente**
With the help of New York artist David Villorente (aka Chino) and his team of sign painters, Stephen Powers transformed a bland Macy's parking garage near Fulton Mall, Brooklyn, into a series of messages that came from

conversations he had with Chino about the Downtown Brooklyn area where he was raised. The Love Letter projects are meant to highlight important history and words that emerge during conversations Powers has with the communities where he is doing these projects. Using a vernacular sign language, the garage is transformed into another age.

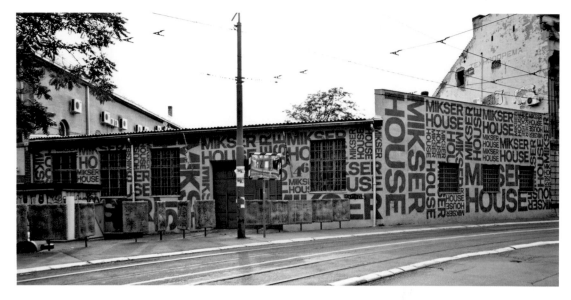

Mikser House Facade, Belgrade, Serbia, 2012
Designer: Aleksandar Spasojević, reMiks Studio
Photographer: Srdjan Mijajlović Type: Galaxy Polaris, heavy
Mikser House is an old garage found in an industrial part of Belgrade, Savamala, which used to be a city center. Mikser House is one of the projects within the Mikser initiative to bring creative people back to this part of the city, making it a new design district. Karadjordjeva Street is the most polluted street in Belgrade, making Savamala facades dirty and gray. The idea was to create a curious wall design that would look like "typography belched all over the facade," Aleksandar Spasojević said, adding "Shades of gray are used to mimic dirt."

Lee/Words Alive, Madrid, Spain, 2010
Designer: SpY
In Words Alive, the artist SpY creates visual puzzles that test perception and understanding, using word objects: single big, black words. He makes small groups of letters that convey single ideas and what SpY calls "urgent enigmas." These are "words that can become [an] intimate part of the lives of those who live, grow up, and evolve around them, that can become landmarks, catalyzing connections within and beyond the community, through a network of large-scale pieces in cities all over the world," he wrote on his website.

BEFORE

AFTER

Zavrtnica Business Centre, Zagreb, Croatia, 2011
Designer: **Brigada and Bruketa&Žinić OM** Material: **Paint** Type: **DIN black**
The Zavrtnica Business Center is a grouping of heterogeneous structures within a former factory complex. The owner wanted it modernized and renovated. The solution had to be at once graphic and economical. "We proposed using extremely large-scale typography on architectural structures to unite the entire block of four buildings," Nikolai Žinić, the designer explains. "This way 'legible' typography complements the architecture, and the text becomes the dominant feature. It respects the form while also creating added value, both in terms of graphics and signalization. The center soon became recognizable as the 'black-and-white complex with numbers and letters on it.'"

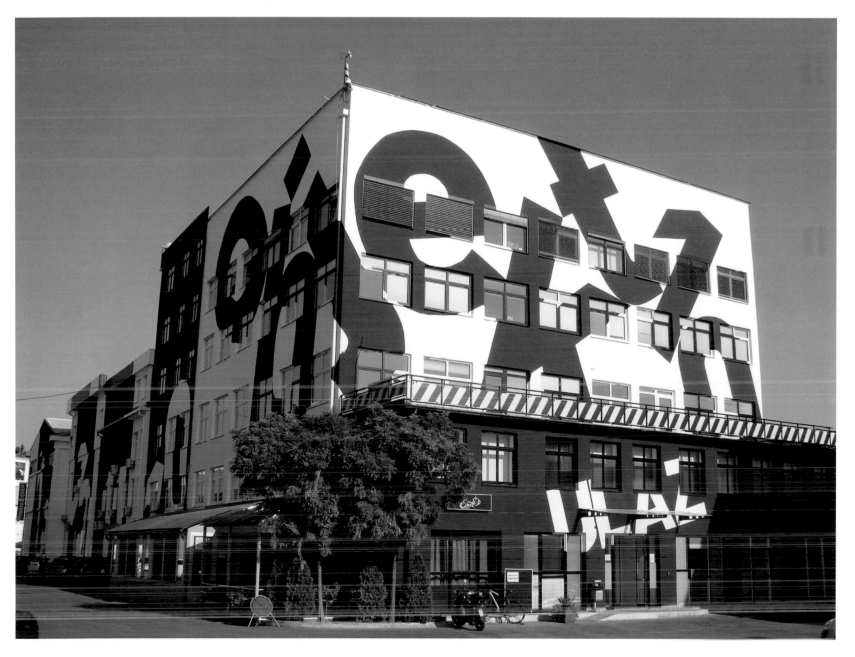

Hinting Project, Lyon, France, 2006
Designer: Superscript[2]
The aim here was to experiment with the typographic display process on different physical grids in the environment. "We were looking for different grid system[s] to compose typeface, like on a computer screen," explained Superscript2 designers Pierre Delmas Bouly and Patrick Lallemand. "So we use different structure patterns, like eggs boxes, house walls, and manhole covers, to design typefaces and introduce them in our physical world.

The Trestle Leg Series, Auckland Harbor Bridge, New Zealand, designed 2009, built 2012
Designer: **Catherin Griffiths** Materials: **Eight columns of varying heights, paint applied to steel** Type: **Verlag**
Griffiths took eight selected texts from New Zealand poets and authors, and an oratory (or korero) of a local Maori chief, and produced eight sequential columns beneath the Auckland Harbor Bridge. The spatial and built environment demanded that the texts they be engaged on an enlarged scale.

Calligraffiti on the Minaret, Jara Mosque, Gabès, Tunisia, 2012
Artist: **eL Seed** Photographer: **Kafi Films/DaFoxInDaBox** Materials: **Acrylic and spraypaint.** Type: **Calligraffiti**
The fifty-seven-meter-high mural will permanently cover all of the concrete tower faces of Jara Mosque in hopes of highlighting the convergence of art and religion and raising the public's awareness by infusing art directly into the urban landscape. Artist eL Seed quotes a verse from the Koran that addresses the importance of mutual respect and tolerance through knowledge: "Oh humankind, we have created you from a male and a female and made people and tribes so you may know each other."

Be Quiet Is To Shout Intensely, Fundación Antonio Gala, Córdoba, Spain, 2011
Designer: **Boa Mistura** Type: **Avant Garde Bold**
"Callar es gritar intensamente" (to be quiet is to shout intensely) is a sentence by Antonio Gala painted on this seventeenth-century convent, which has been turned into a creative center. The tribute to silence, which alludes to the original meditative use of the building, and is currently given new relevance on the wall.

Condominio P, Via Posada, Cagliari, Italy, 2006-9
Architects: P. Francesco Cherchi, Mario Cubeddu, C+C04 Studio Photographer: PierLuigi Dessi
Condominio P is a residence that went up in a district known for its otherwise poor-quality constructions. The design concept derives is rooted in the desire to replace the monotonous grayness of this ex-urban area with architectonic rigor. Color is deployed as what the architects call an "anti-gray" tool to display the single units. This is also emphasized through large numbers inscribed on the colored melamine panels.

Emlékpont Museum, Hódmezővásárhely, Hungary, 2006
Designer: Attila F. Kovacs Photographer: Zsitva Tibor, Attila F. Kovács Materials: Aluminum letters and engravings in granite
The "Remembrance Point (Emlékpont)" Museum chronicles the communist era in of the provincial city of Hódmezővásárhely, Southern Hungary. Kovács renovated the museum buildings, a nineteenth-century villa with a 1950s annex, and added a third wing to represent the twenty-first century. The annex is oppressively modern suggesting the imposition of communist rule. Between the grand structure and the annex is a courtyard containing the entrance to the museum, with walls adorned by weathered red frescoes from a former Russian barracks in the nearby city of Szeged. Typographically, the logo is a commentary on the Soviet constructivist aesthetic.

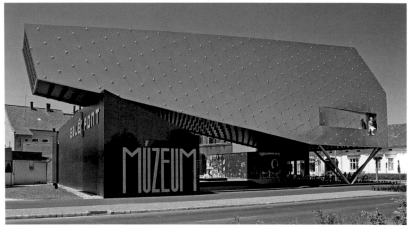

EMME, Emmenbrücke, Switzerland, 2000
Designer: Mayo Bucher / Lussi + Halter Architects
Materials: Mural with silver, white, and anthracite on concrete
Blink and it might be missed. The word "EMME," a palindrome, blends so perfectly into the building that it is almost invisible. Migros Center Switzerland Migros Zentralschweiz commissioned Bucher to typographically brand a public building constructed in 1960 that takes its name from the river Emme, which flows nearby.

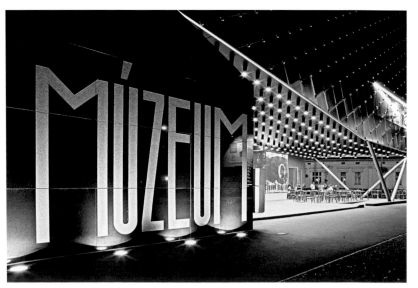

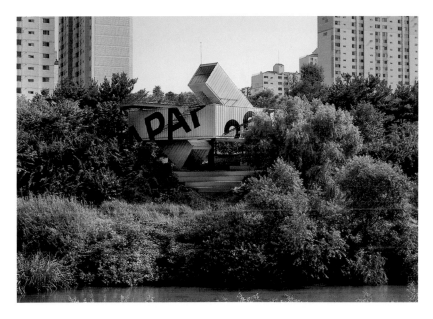

APAP OpenSchool, Anyang, Korea, 2010
Design: **LOT-EK, Ada Tolla + Giuseppe Lignano** Photographer: **Kim Myoung-sik.**
To celebrate the Anyang Public Art Program 2010, LOT-EK retrofitted multiple shipping containers into the OpenSchool. These were strategically placed over the Hakwoon Park pedestrian walkway looking over the river. Three interconnected areas provide a sequence of varied spatial experiences within the school, including community gathering and learning areas. A long decked area, resembling a diving board, stretches over the river. Yet it is the strong graphic treatment, with its bold black characters emblazoned against the bright yellow and black structure that gives it landmark status.

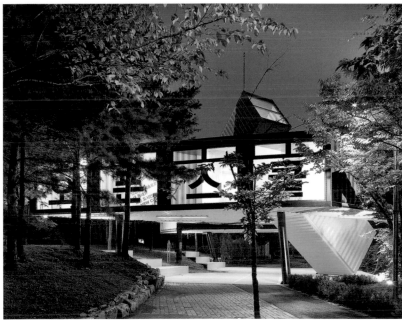

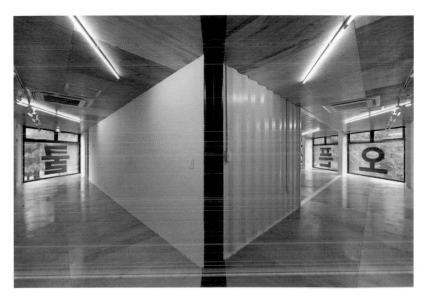

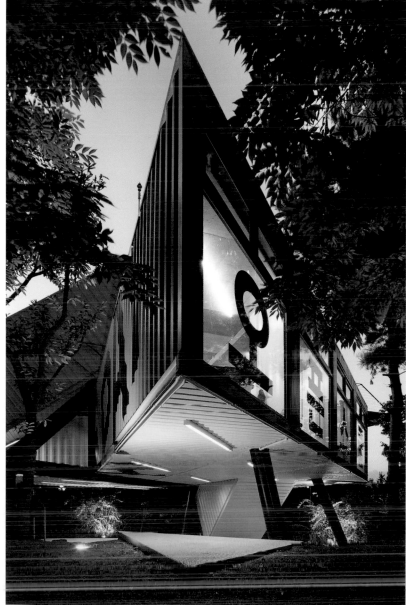

MoMA QNS, Queens, New York, 2002
Concept: **Michael Maltzan Architects** Design: **Two Twelve and Base Design** Photographer: **Christian Richters**
Michael Maltzan was commissioned to make a temporary space for the Museum of Modern art that, as Nicolai Ouroussoff wrote in the *Los Angeles Times*, "has created the museum's identity out of almost nothing—some paint, some boxes, a few fluorescent lamps." Two Twelve and Base Design developed comprehensive exterior and interior signage systems that include supergraphics on the rooftop and building facade. The large-scale logos make it easy for visitors to locate MoMA QNS, which has made the neighborhood a tourist destination.

Attractor, Fundação Iberê Camargo, Porto Alegre, Brazil, 2011
Designer: **Regina Silveira** Photographer: **Fabio Del Re** Material: **Reflective vinyl** Type: **Myriad Pro**
Attractor is an image formed by the word LUZ, which is 22.4 meters high and about 15 meters wide, made out of reflective material adhered to the various sections of the facade. The word simulates a real projected light, and responds to the empty spaces and indirect lights that are present in Álvaro Siza's architectural program for this building. Vinyl was chosen to reflect the light and color of the sky, which is also reflected on the Guaíba River in front of the foundation. "I believe the most exciting thing in doing Attractor was to work for the public outside: the ones who would read the word together with the building, like in an ideogram, as they speed by in their cars," says Regina Silveira.

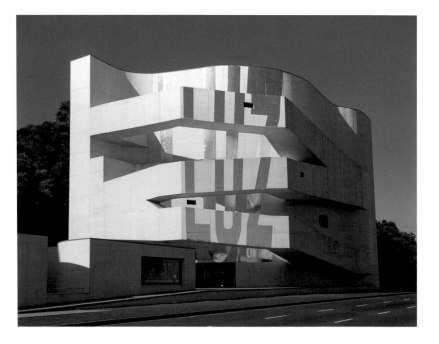

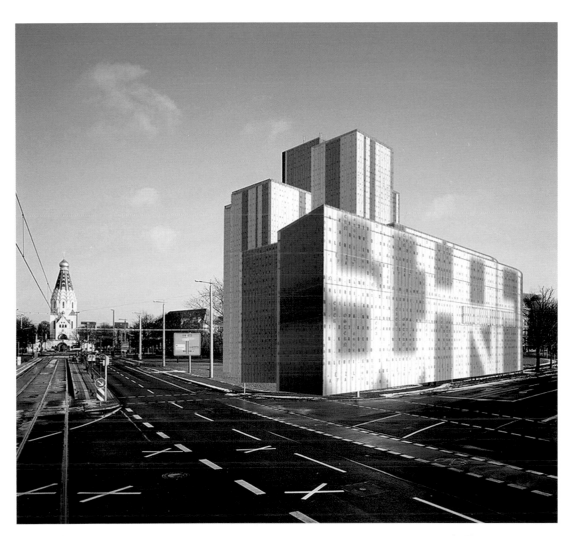

Museum for Writing and Books, Leipzig, Germany, 2002
Designer: **Mayo Bucher in collaboration with Drexler Guinand Jauslin Architects, Zürich**
In Germany's leading printing city, Mayo Bucher has proposed the monumental typographic display reading "SCHRIFT & BUCH" (Writing and Books) to be seen from the street. When built it will be a vivid testament to the venerable art and craft that made Leipzig famous.

Koninklijke Bibliotheek, National Library of the Netherlands
The Hague, The Netherlands, 2007
Designer: **Karen Polder.** Photographer: **National library of the Netherlands, Jos Uljee.** Materials:**Gold leaf on aluminum siding.**
Type: **Garamond.**
Karen Polder applied gigantic gold letters to the facade of the new building that change depending on the position of the viewer. "I was already involved in this at an early stage. The form of the facade panels is partly determined by the lettering," she says. "The design is pretty extroverted by my standards," The gold leaf has almost no mass: the total amount used is not much more than a pack of butter. The gold works well, because it glitters as no other material does. "I think it is most exciting if you stand facing the center, because then the letters run through one another and a considerable degree of abstraction is created," she adds.

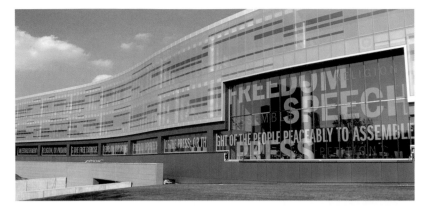

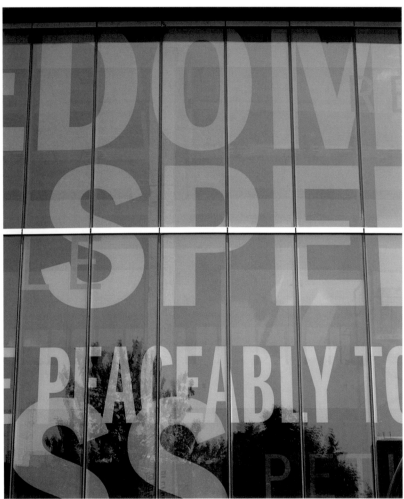

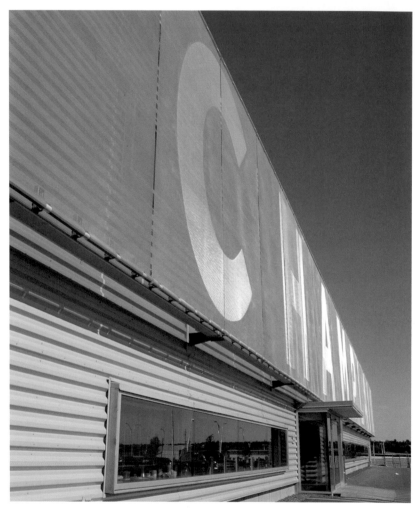

Newhouse III, S. I. Newhouse School of Public Communications, Syracuse University,
Syracuse, New York, 2007
Architect: **Ennead Architects** Designer: **Two Twelve Associate.** Photographer: **Ennead Architects**
Materials: **Silk-screened ceramic frit on glass** Type: **Franklin Gothic.**
As a home for a school of communications, Newhouse III is dedicated to free speech as it is embodied in the
U.S. First Amendment. The design team proposed this monumental rendering as a way to publicly declare that
commitment and to make the First Amendment values part of the fabric of the building.

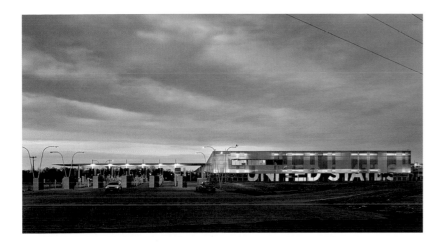

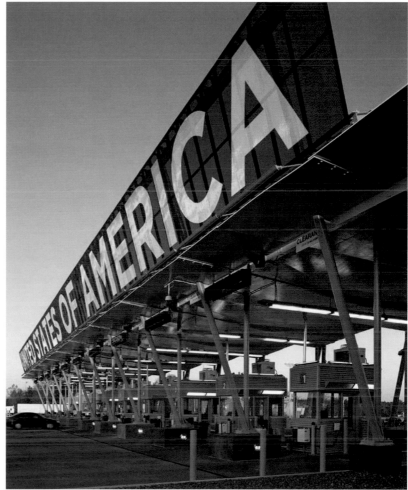

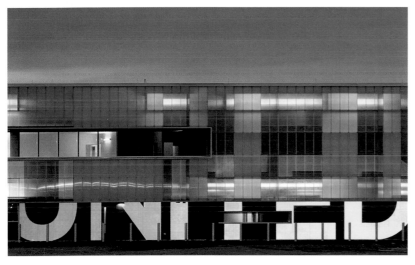

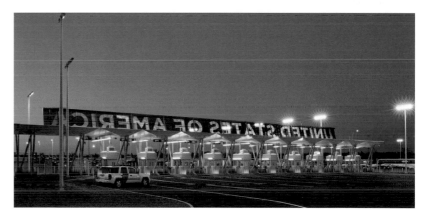

United States Land Port of Entry at Massena, Massena, New York, 2009
Architects: **Smith-Miller + Hawkinson Architects** Graphics Consultant: **Pentagram** Photographer: Michael
Moran, **Michael Moran Photograph.** Materials: **Yellow reflective coated metal** Type: **Gotham Bold**
This Land Port of Entry, located in rural New York State at the foot of the Seaway International Bridge between
the St. Lawrence and Raquette Rivers, is a new "front door" to the United States. The master plan for the port
organizes the multiple procedures involved in the inspection processes for passenger and cargo vehicles. At the
same time, the drivers of passenger operated and commercial vehicles require clarity and efficiency as they are
required to decelerate, weave, stop and accelerate while going through the border station that is traditionally
burdened with excessive conventional signs. Massena utilizes an integrated wayfinding system based on color
coding. Clarity is achieved through a cohesive language for road and building alike.

United States Land Port of Entry at Champlain, Champlain, New York, 2008
Client: **U.S. General Services Administration**
Architects: **Smith-Miller + Hawkinson Architects** Graphics Consultant: **Pentagram** Photographer: Michael
Moran, **Michael Moran Photography** Materials: **Stainless-steel mesh** Type: **Gotham Bold**
This Land Port of Entry is at one of the northern border's busiest crossings. The port links the United States and
Canada along one of the most important and rapidly growing north-south trade corridors in North America. It
required clear wayfinding. The design maintains a delicate balance, being at once welcoming within a security
zone. The new channel-glass facade is lit from behind by a concealed skylight, producing a subtle glow that
announces arrival at this important threshold.

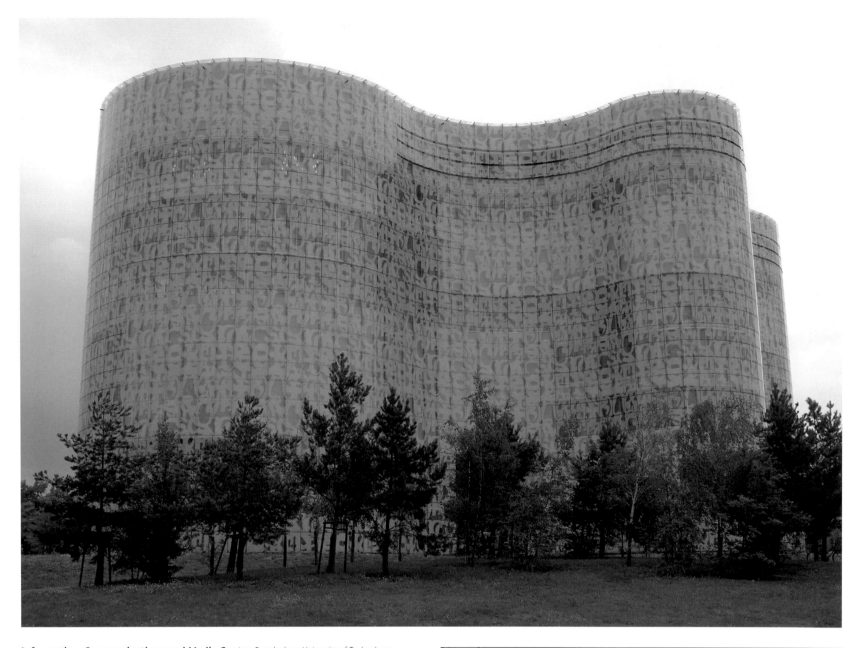

Information, Communications and Media Centre, Brandenburg University of Technology
Cottbus, Germany, 2001-4
Designers: **Herzog & de Meuron** Photographer: **Piet Bron**
A white veil is printed on both sides of the building's glazed shell. Texts in different languages and alphabets
have been superimposed in so many layers that they are no longer legible, but a pattern in unmistakably
alphabetic. It also breaks the reflection of this curved structure, eliminates the hardness of the glass, and makes
the body of the building homogeneous yet still unique from different angles.

Social Studies, Lattie F. Coor Hall, Arizona State University, Tempe, Arizona, 2004
Design firm: **Krivanek+Breaux/Art+Design, Chicago/Lafayette, Louisiana** Designers: **BJ Krivanek, Joel Breaux**
Photographer: **BJ Krivanek**
Materials: **Enamel frit on tempered-glass curtain-wall units, water-jet-cut aluminum word structure**
Type: **DIN Schrift 1451 Mittelschrift, custom letterforms and icons**
This six-story, glass-faced tower includes glass curtain wall modules inscribed with fragments of different
languages. "Language is a raw material that will be given form and disseminated as an ongoing process," says
BJ Krivanek. "Imprinted as a translucent white scrim, the modules are replicated and randomly distributed upon
selected curtain wall units, to give the facade a certain Rosetta Stone inscrutability."

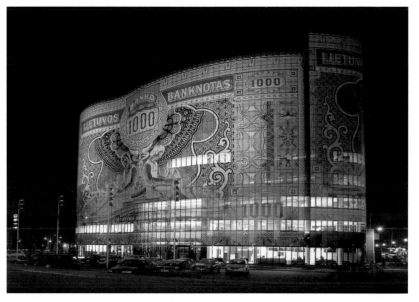

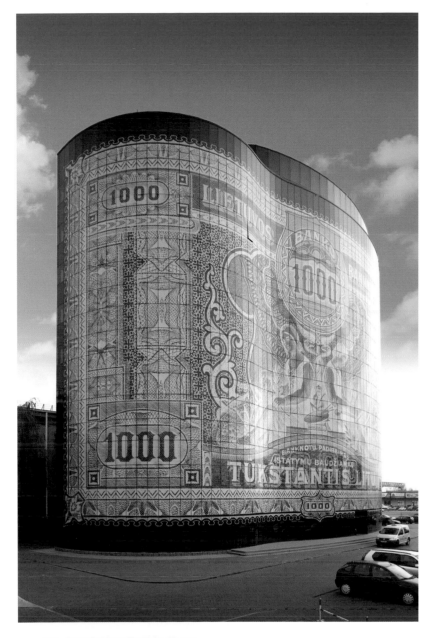

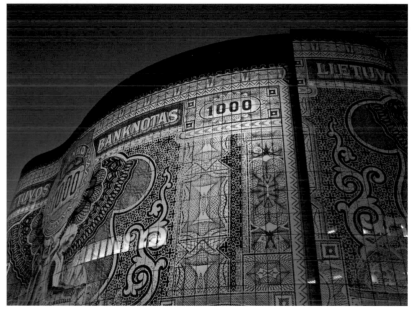

Office Center 1000, Kaunas, Lithuania, 2005-8
Architects: **Rimas Adomaitis, Raimundas Babrauskas, Marius Siaurodinas, Virgilijus Jočys**
Photographer: **Gintaras Česonis, (Jonas Plenta)**
In 2008 it was likely that the Lithuanian currency, the Litas, would be superseded by the Euro, and a monument to the Litas was proposed. The office building showing a 1,000 litu banknote (dating from 1925, during the period of Lithuania independence between the two world wars) serves as memorial for Lithuanian currency. The facade is covered from top to bottom in a striking illustration consisting of 4,500 different types of glass made in the Netherlands. Rob Borgman, a specialist in the screen-printing technique, chosen to paint the image on the glass.

J'ai fait un reve, Collège Châtelet, Douai, France, 2001
Designer: **Tania Mouraud** Material: **Vinyl on glass**
For the installation at Collège Châtelet, Tania Mouraud enlarges a phrase of Martin Luther King, which she translates into French as "Utopia of democracy."

WYSIWYG, Exhibition "La Force de l'Art," Grand Palais, Paris, France, 2006
Artist: **Tania Mouraud** Material: **Acrylic**
Tania Mouraud's concept was to "invert the common relationship with text and to elongate the time of reading, sending the reader back to his/her own perceptual experience."

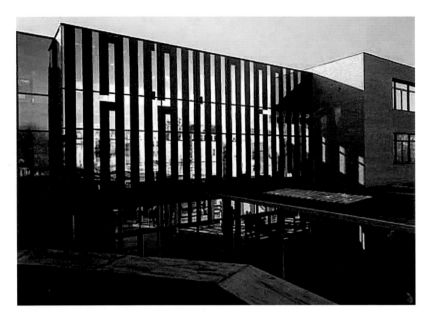

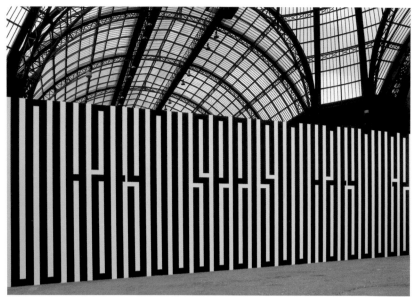

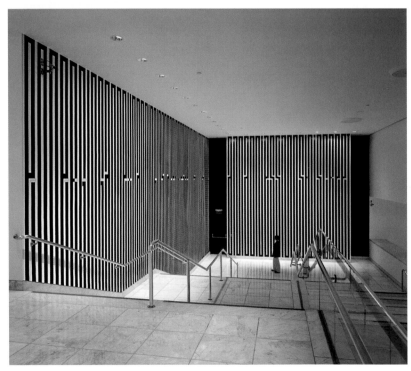

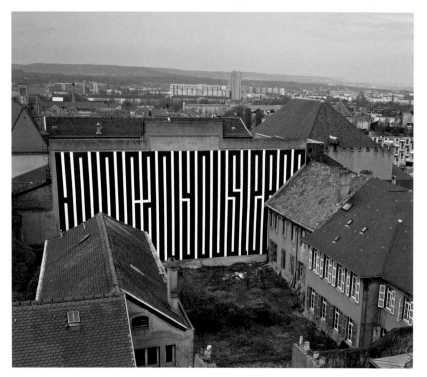

A Madness Most Discreet, Armand Hammer Museum, Los Angeles, 1999
Artist: **Tania Mouraud.** Material: **Acrylic**
In Romeo and Juliet, Shakespeare described love as "a madness most discreet." Tania Mouraud found those words equally accurate for describing the act of creation in a world of consumerism. At this museum, the whole sentence emerges and expands in space to thirty-three meters.

HCYS, Metz, France, 2005
Designer: **Tania Mouraud** Photographer: **Rémi Villaggi** Materials: **Digital print on plastic tarpaulin**
Inspired by Arnold Shoenberg's musical piece A Survivor from Warsaw, the sentence "How Can You Sleep" in the urban landscape "suggests all the problems of injustice we are faced with," says Tania Mouraud.

Glass Fragile Handle With Care, Apartment complex
Stadshoven Weidevenne, Purmerend, The Netherlands, 2009
Designer: **Martijn Sandberg** Photographer: **Peter Cuypers**
Material: **Sandblasted glass**
Martijn Sandberg's typographic pattern consisting of the common
phrases "Glass Fragile Handle With Care Glass Fragile Handle With Care."
is 75 meters long, consisting of five stories with a gallery on the west
facade. The gallery has balconies that, per floor level, are staggered in
relationship to each other. Describing his technique, Sandberg notes, "A
point raster is applied to the transparent glass by 'damaging' the surface
through sandblasting. The point raster resembles a grid of protective
plastic bubble foil, the familiar packing material. A series of letters
appears within the sandblasted point raster, making an unending and
continuous text visible to the passerby over the full length of the glass of
the gallery and balconies."

Dreispitzhalle, Basel, Switzerland, 2008
Designer: **Simon Hauser, David Schwarz** Photographers: **Simon Hauser,
David Schwarz** Material: **Black paint**
The Dreispitzhalle is a logistics hall at the Dreispitz site in Basel,
Switzerland, converted by the Christoph Merian Foundation into a new
cultural venue. "We designed a font directly inspired by the architecture
of the building and used it for the lettering, which extends over sixty
meters on the facade," says Simon Hauser. The diversity of events taking
place at the Dreispitzhalle finds its expression in the raw yet systematic
industrial-looking design of the letterforms.

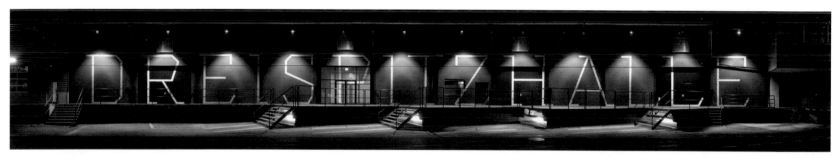

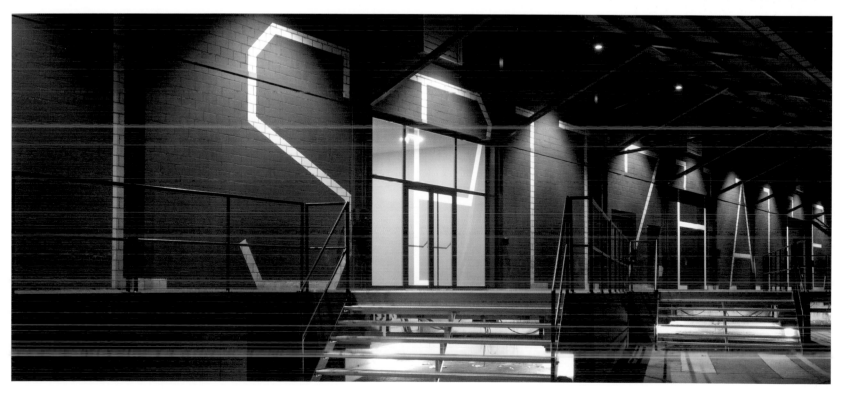

Reflections Expressions Transformations, Chicago Avenue
Station, Chicago Transit Authority Brown Line, Chicago, 2009
Designer: Krivanek+Breaux/Art+Design, Chicago/Lafayette, Louisiana
Photographer: Eric Craig Studios
Materials: Mirror-polished anodized aluminum, structural stainless
steel, die-cut reflective film
"Creative expressions take visual form—as language, symbols, or icons—
and are thrust onto the stage of public space," says B. J. Krivanek. "Here
they become tangible." To give form to these conceptual relationships
and symbols, Krivanek+Breaux mounted iconographic compositions
above the two primary station facades and platforms that face each
other across the tracks. Composed of mirror-polished, color anodized
panels, these compositions are canted slightly downward to reflect the
cityscape and the station and transit riders across the tracks. Each panel
pivots, so this is a kinetic piece that responds to wind and vibrations
from trains.

Recovering Equilibrium, 9/11 Memorial at Los Angeles
International Airport, 2003
Client: Los Angeles Department of Cultural Affairs, Public Art Program
and Los Angeles World Airports
Designers: BJ Krivanek, Joel Breaux / Krivanek+Breaux / Art+Design
Materials: Mirrored stainless steel panels on fiberglass substructure,
waterjet-cut aluminum letterforms, aluminum cladding, sand-blasted
concrete
On September 11, 2001 the three hijacked flights were headed to
LAX. This commemoration involves an existing fountain built in
1959. Colorized aluminum cladding on the perimeter of the fountain
on which phrases like "Never Forget" and "Sea to Shining Sea"
are inscribed. A stainless steel disk floats on the surface of water,
inscribed with the phrases "Probable Cause," "Privacy," "Due Process,"
etc. Another set of inscriptions, "Beloved," "Equal," "Strong," "Honest,"
etc., refer to the victims – they appear in several languages.

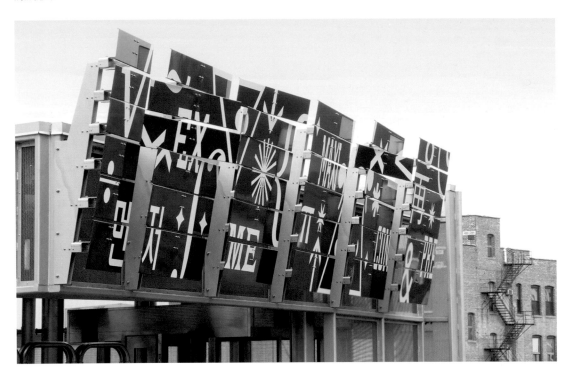

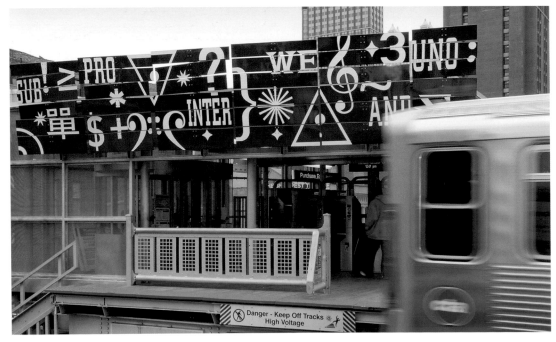

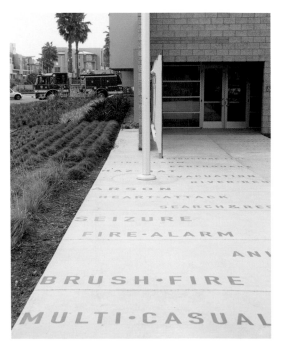

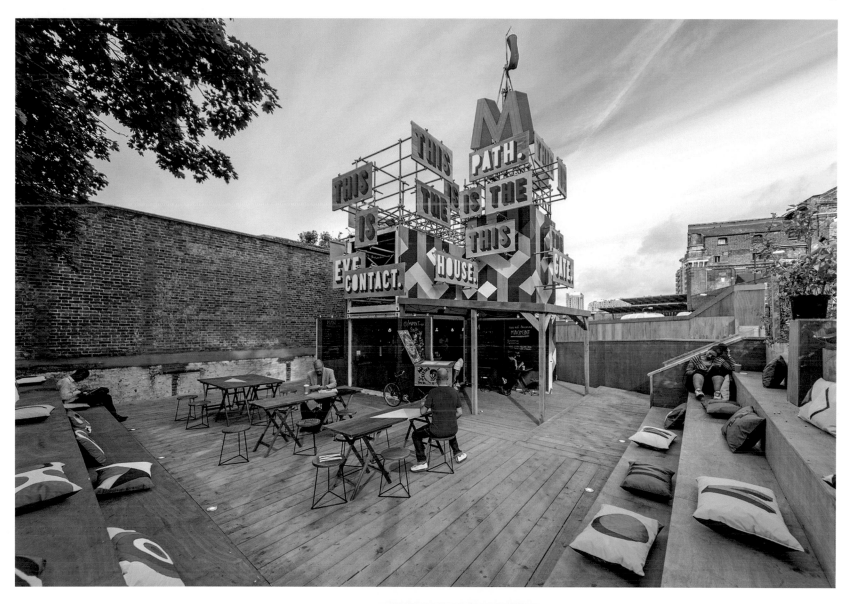

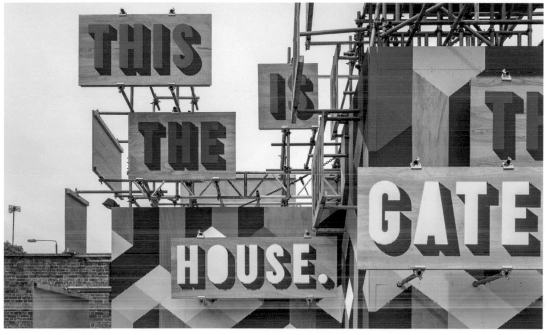

The Movement Café, London, UK, 2012
Client: Cathedral Group
Designer: **Morag Myerscough** Photographer: **Gareth Gardner.**
Material: **Handpainted plywood**
Type: **Drop Shadow**
This temporary structure to welcome the Olympic visitors was designed and fabricated in just sixteen days. The colorfully playful typography designed by Morag Myerscough reproduced a Twitter post by the poet Lemn Sissay. Myerscough turned a hole in the ground left by demolition into a welcome space that hosted a series of poetry readings, musical performances, and a film.

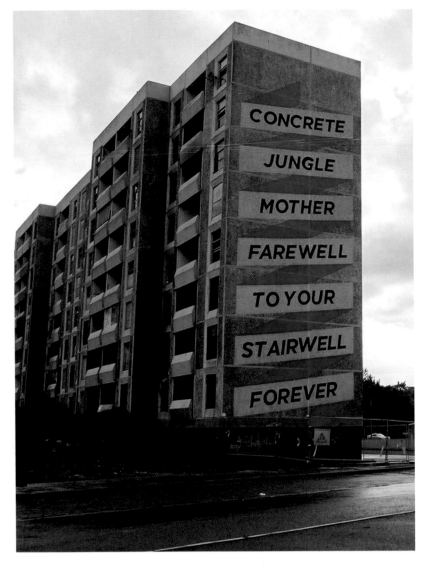

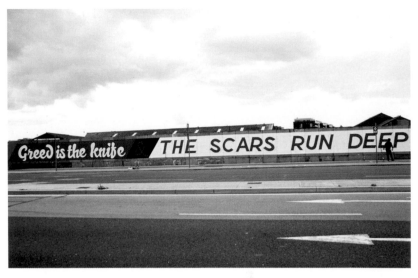

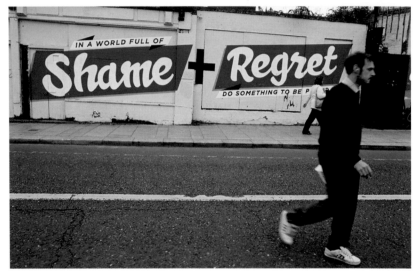

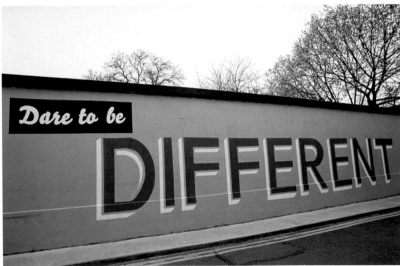

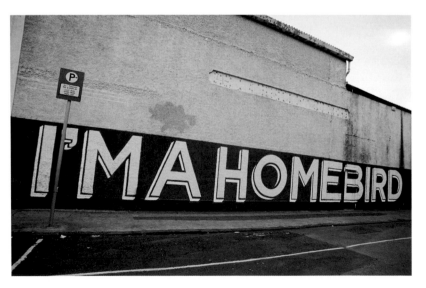

They Are Us, Dublin, Ireland, 2012
Designer: **Maser** Photographer: **Aiden Kelly** Type: **Gotham bold, Bello Pro, custom**
This project consisted of series of twenty outdoor pieces inspired by the city of Dublin, and it concluded with an exhibition of one-off canvases, screen prints, and photography. These postmodern sayings were produced in the painted-sign tradition of the early twentieth century. The sales of the work raised thirty thousand euros, and graffiti artist Maser donated all of it to the Dublin Simon Community, which aids the city's homeless. The organization used the funds to purchase a much-needed medical van.

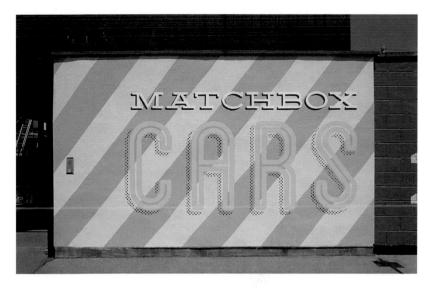

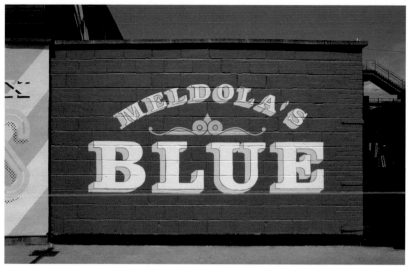

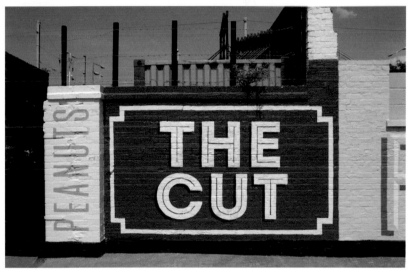

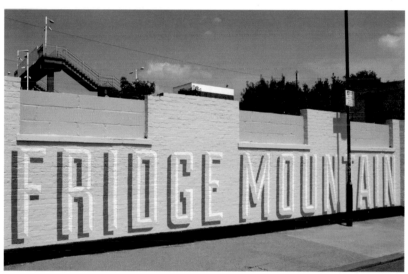

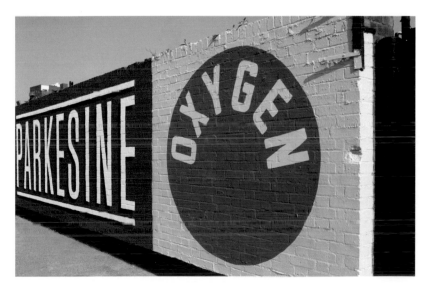

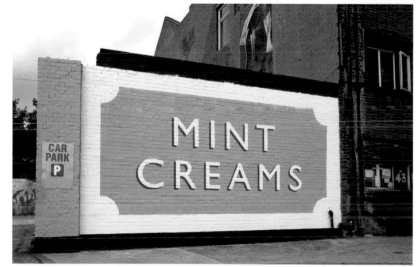

The Walls Have Ears, Hackney Wick, East London, 2012
Designer: **Bread Collective** Materials: **Masonry, paint** Type: **Various typefaces, including Clarendon and Gill Sans**
To help clean up an "unloved street" leading to the Olympic Park in East London, a 100-meter long mural

was created by Bread Collective. It was designed to celebrate the rundown area known as Hackney Wick by reproducing signs of a bygone era. These newly produced typographic artifacts drew on the storied past of the industrial area. The hand-painted typography references the vintage letters used on old factories and canal boats.

Fontenew, Fontenay-sous-Bois, France, 2007
Designer: **Fanette Mellier** Photographer: **Fanette Mellier** Materials: **Silkscreened posters** Type: **Fontenew**
(by Fanette Mellier)
As part of the 2007 Graphics in the Street festival in Fontenay-sous-bois, Fanette Mellier drew poster-sized
letters that were posted on walls around town. The giant letters' shape was determined by the technical
constraints of the dot-matrix process.. The writer and poet Laure Limongi wrote an unpublished poem echoing
the geographical context and artistic project, which is deployed in the streets of Fontenay-sous-Bois: "I head /
heart / bitter / lost / the earth rotates down / so come / tomorrow summer / quiet bye." With Josephine Charpy
Bastien Guérin, Mellier painted and glued the letters throughout the city.

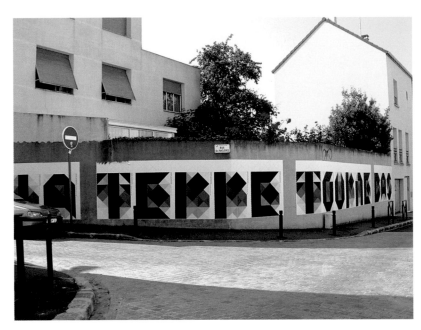

Multipli, Nantes, France, 2011
Designer: **Fanette Mellier** Photographer: **Fanette Mellier** Materials: **Silk-screened posters by Lézard
Graphique** Type: **Multipli** (by Fanette Meiller)
After Fontenew Circus, Mellier designed the typeface Multipli for the festival Midi Minuit Poetry in Nantes.
The letters of the alphabet were displayed as posters, spelling out a poem by Larue Limongi, which was dense,
concise, and deep, to resonate with typography. The Multipli letter design is based on the idea of folding posters.
"The form of letters emerges," Meillier explains, "only as folds and forms appear on the front bathed in another
color. Grid folding is overprinted varnish, creating a kind of shimmer. These changes have resulted in letters to
materialize through unique combinations."

"Imagination Makes Us Infinite", Madrid, Spain, 2011
Designer: **Boa Mistura** Type: **Avant Garde Bold**
This derives from a collaborative workshop with Argadini, a nonprofit association for the disabled. The objective was to offer new possibilities of artistic expression and to promote Argadini's growth in terms of art. Local artists were invited to take part in a meeting where sketches were made on paper. The end result was a 40-meter mural created by the art collective Boa Mistura and the locals.

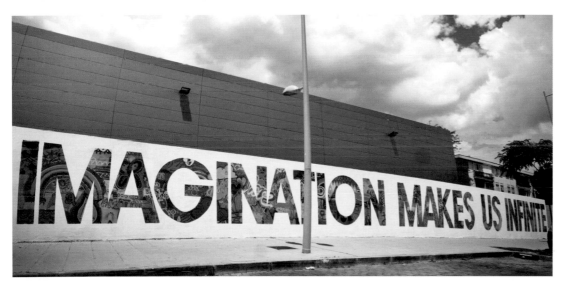

Joseph Magnin Department Store, Almaden, California, late 1960s
Art Director: **Debora Sussman** Designer: **Steve Shuck**
Materials: **Paint on plywood**
The eight-foot-high faceted letters in black, orange, and white alluded to the final design that would be used on the finished building.

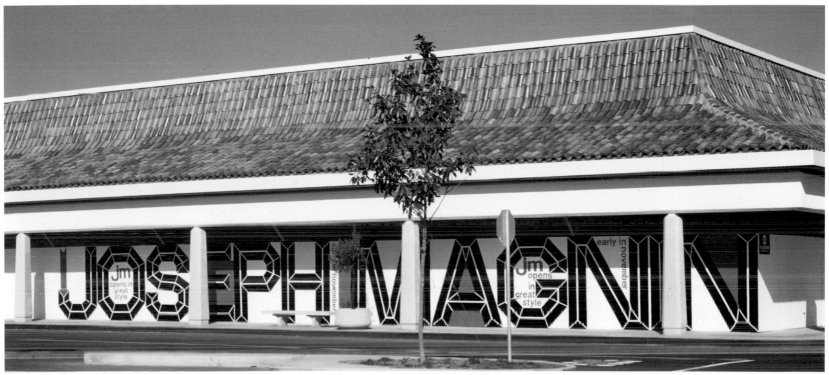

Light In The Alleyways, Vila Brasilândia, São Paulo, Brazil, 2012
Designer: **Boa Mistura Collective** Type: **Avant Garde Bold**
Boa Mistura's Participative Urban Art Interventions aims to improve rundown communities, using art as a tool for change and inspiration. The group had the chance to live in Vila Brasilândia, hosted by a local family, which gave them direct contact with the community. The project uses the narrow and winding streets that connect the vielas (alleys). Residents selected words—BELEZA, FIRMEZA, AMOR, DOÇURA, and ORGULHO—as the concepts for the intervention, an optical illusion in which the words appear to hang in air.

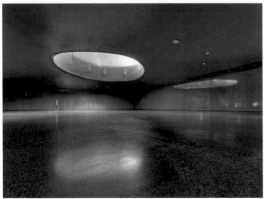

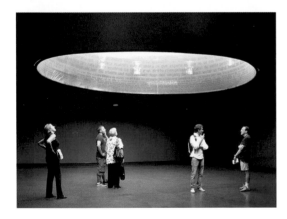

Monumento Victimas 11-M, Madrid, Spain, 2006-7
Architects: **Estudio FAM** Photographers: **Manuela Martin, Javier Gutiérrez Marcos**
The eleven-meter-high cylinder next to the entrance of the Atocha train station is a monument in homage to the victims of the bombings of March 11, 2004, created on the occasion of the third anniversary. The design of the sculpture was "the expression and the sense of Spanish society after the attacks," says Gil-Fournier, as well as an attempt to convey the "immateriality" of those feelings and "make them eternal."

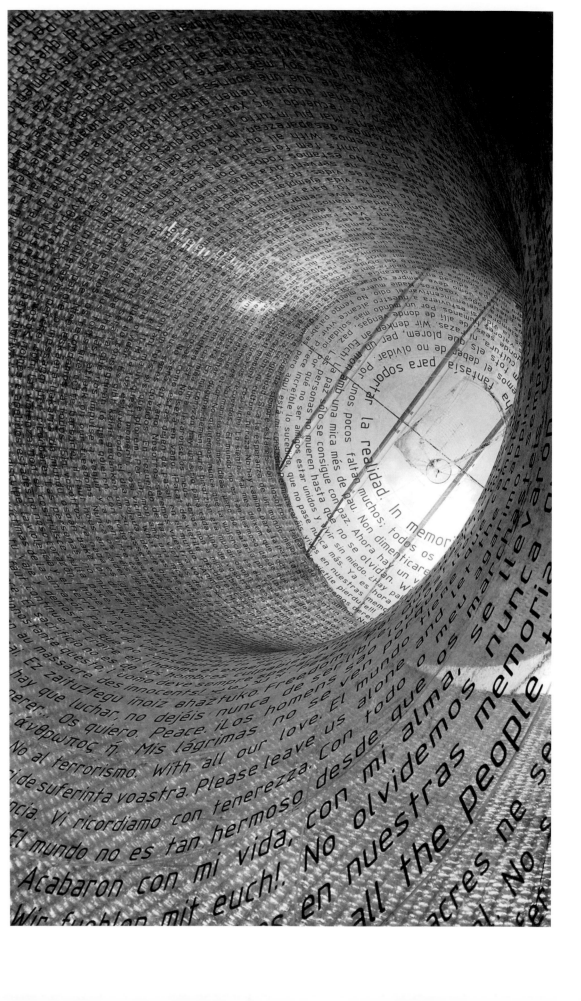

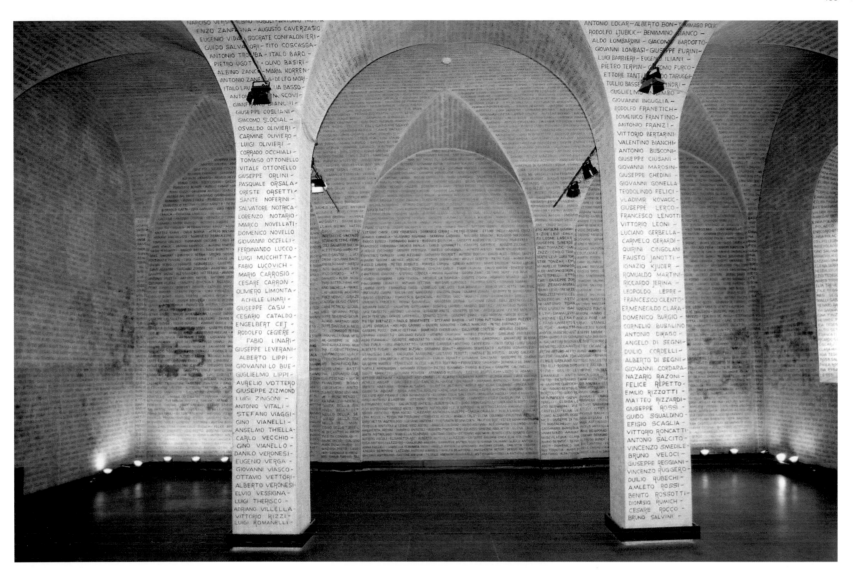

Perspective with Fernand Léger Graffito, Museo
Monumento al Deportato Politico e Razziale, Carpi, Modena, Italy, 1973
Designers: **BBPR** with Albe e Lica Steiner Photographer: Archivo
Fondazione Fossoli Material: Plaster Type: Inscriptions made on
original molds

Inaugurated in 1973, the Deportee Memorial Museum is a unique
structure that commemorates the Jewish deportation victims during
World War II. The goal of the installation is to express the memory of this
horror, still living in the surviving structures of the nearby Fossoli Camp.

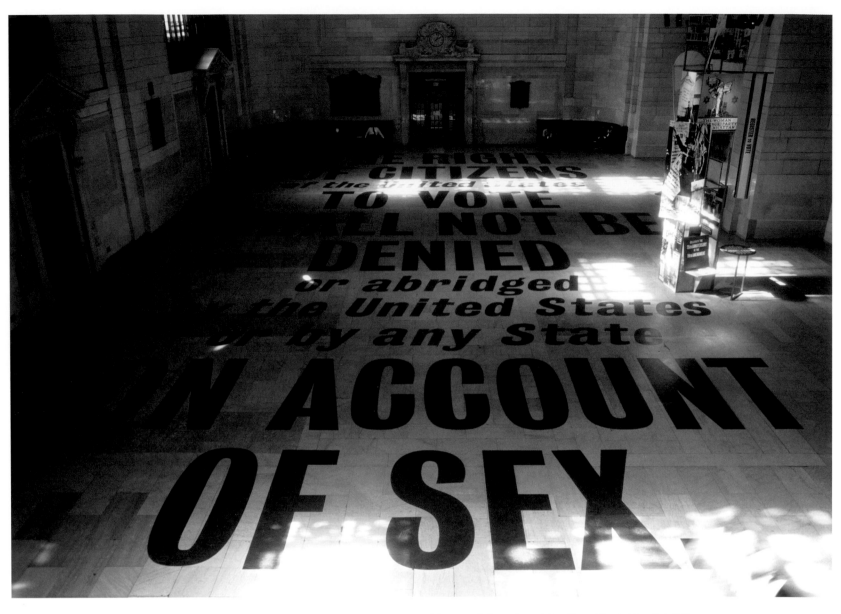

Nineteenth Amendment, Grand Central Terminal, New York, 1996
Designer: **Stephen Doyle** Photographer: **Scott Francis** Materials: **3m Vinyl**
Type: **Bureau Grostesque Three Seven**
One of the monumental additions to the Constitution of the United States, the Nineteenth Amendment, promising enfranchisement to women and suffrage regardless of sex, is reproduced on the floor of the Vanderbilt waiting room, which is traversed by millions of commuters daily, with the fanfare that these historic words deserve.

Teaching Characters, Kipp Academy, Harlem, New York, and Riverdale Country Day School
The Bronx, New York, 2011
Designer: **Stephen Doyle** Photographer: **Stephen Wilkes** Materials: **Painter's tape** Type: **Mekanik**
To produce the illusion of type floating in air, Stephen Doyle accurately determined the position of pieces of the various letterforms and then used painter's tape to construct the motivational words on floor, walls and ceiling—inside and outdoors. When photographed from the right position the letters came together as the respective words.

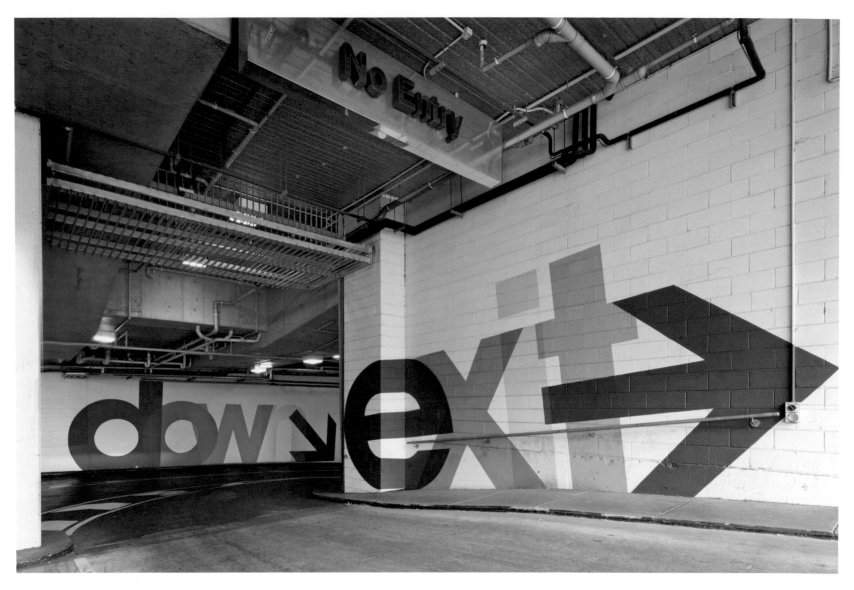

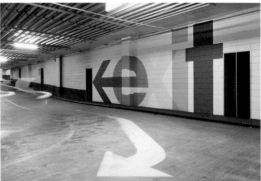

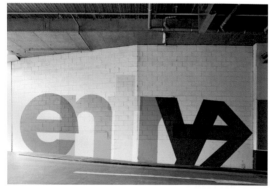

QV Melbourne Carpark, Melbourne, Australia, 2012
Designers: **Andrew Wood, Filip Bjazevic** Photographer: **Peter Clarke**
Materials: **Painted graphics**
QV Melbourne is a mixed-use area providing retail, commercial, and public space. Andrew Wood and Filip Bjazevic implemented a series of large-scale environmental graphics that act as both environmental graphics and wayfinding. Each typographic piece was individually hand painted on site overlaying the painted forms to produce a multiplied effect onto the existing brickwork. Each word is designed to fit into the exacting locations available on site.

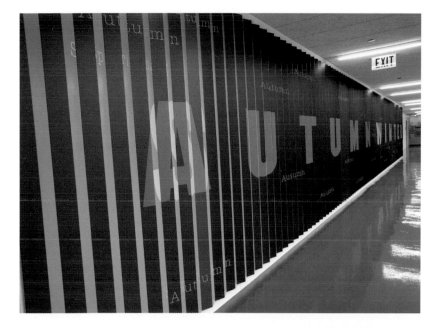

Gary Comer Your Center Signage, Chicago, Illinois, 2006
Designer: **Milton Glaser**
This corridor is made visual by introducing a seasonal theme. The corrugated wall changes depending upon which direction you are moving. The words are "winter," "summer," "spring," and "autumn." The wall creates a decorative effect without introducing illustrative elements.

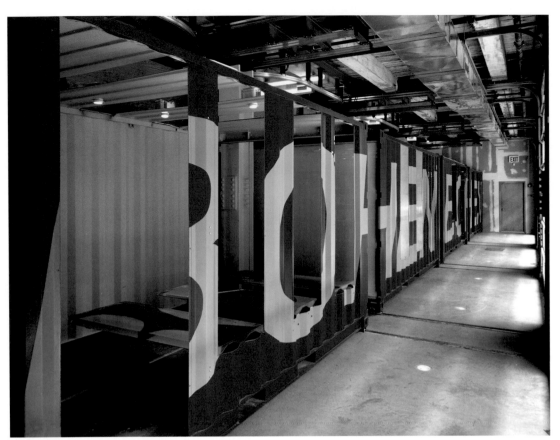

Bohen Foundation, New York, New York, 2002
Client: **Fred Henry/Bohen Foundation**.
Design: **LOT-EK, Ada Tolla + Giuseppe Lignano**
Photographer: **Paul Warchol**
The Bohen Foundation supports contemporary art and culture, commissioning and exhibiting works that require maximum spatial flexibility to allow the display of different media, from two-dimensional drawings and paintings, to projections, sculptural objects, and multi-media installations. Eight shipping-container sections form the rigid square structural grid of the ground floor of a former printing facility. The containers become exhibition spaces by sliding along tracks to preset locations. A strong visual presence is ensured between the raw warehouse space and the super white smooth interior of the exhibition areas, treating the relationship between the gallery and its surrounding space as a metaphor of a movie or TV set, where the illusion is heightened by the color and typography covering the containers.

Education Executive Agency and Tax Offices
Groningen, The Netherlands, 2006–11
Client: **Dutch Government Buildings Agency; Consortium DUO²**
Design: **Design Team: Consortium DUO² and UNStudio; Studio Linse: Arup; Lodewijk Baljon; Buro van Baar; YNNO.**
In addition to being heralded as one of the most sustainable large office buildings in Europe for governmental offices, this building is one of the most graphically friendly as well. The playful rendering of the outlined numerals against a purple and lime color scheme injects a light-hearted aura to this hotbed of bureaucracy.

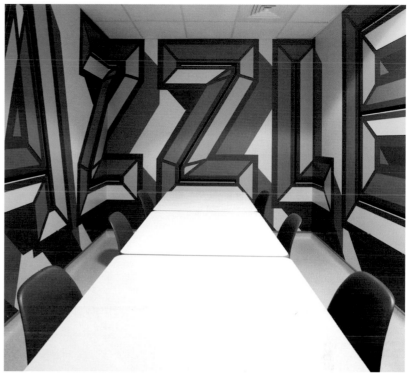

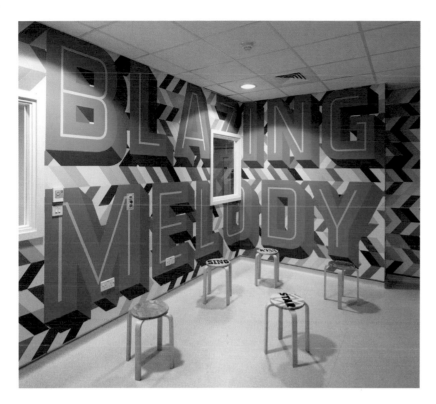

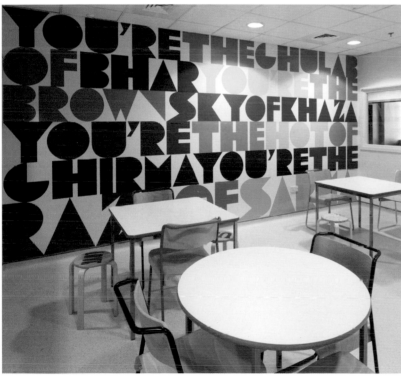

Dazzle, London, England, 2012
Client: **Barts and The London Childrens Hospital**
Design: **Morag Myerscough** Photographer: **Luke Hayes, Supergroup London**
Materials: **Digital wallpaper, paper stencils, and spray paint**
With custom lettering created by patients, words inspired by the poet Lemn Sissay, and colors ordinarily reserved for carnivals, Morag Myerscough has imbued this children's hospital with a supergraphic carnivaleque exuberance to give the young patients a respite from the usual wards.

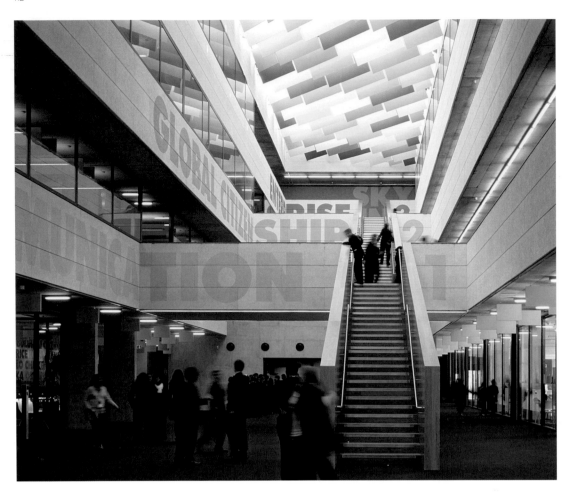

Westminster Academy Auditorium, London, England, 2007
Design: **Morag Myerscough** Photographer: **Tim Soar**
Materials: **Paint** Type: **Futura**
The bold branding for the school and the spaces within, a rich color palette, and large graphic elements relate to the vibrant reality of urban life beyond the school walls and to an international community, both on the doorstep and beyond.

GE Works, Cincinnati, Ohio, 2012
Client: **General Electric Co.**
Designer: **Bruce Mau Design** Photographer: **Andi Maier.**
Fabricator: **GES Global Experience Specialists** Material: **Paint**
Type: **Custom and GE Monogram**
GE is more than electronics these days. So the graphic design, or what Bruce Mau calls "graphic interventions," at the GE headquarters and satellite offices need not have an electrical theme or build on its past institutional accomplishments. The spritely typographic messaging involves a series of bold wraparound words and sayings that underscore the GE products, including finance and media.

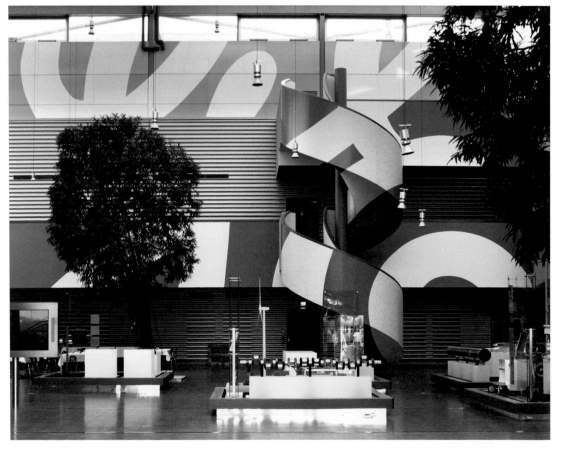

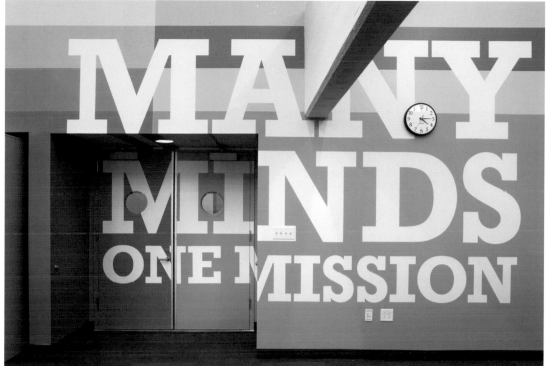

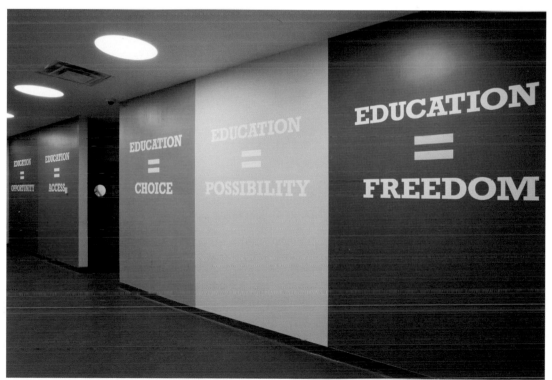

Achievement First Endeavor Middle School
Brooklyn, New York, 2010
Designer: **Paula Scher, Pentagram** Photographer: **Peter Mauss, Esto** Type: **Rockwell**
Color and type give bold and alluring dimension to a traditional New York middle school. Eschewing drab institutional colors, this pedagogical carnival evokes the pride of place that design provides.

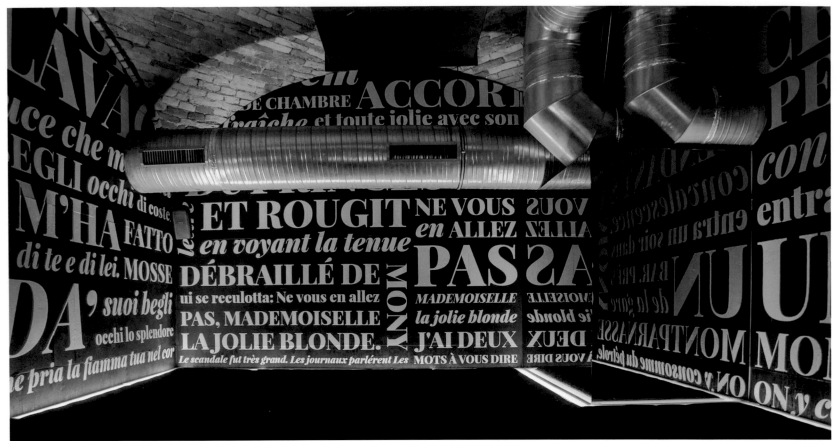

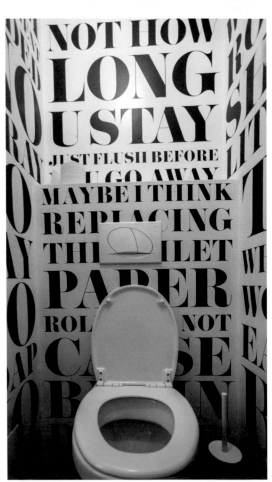

Trafiq, Budapest, Hungary, 2012
Designer: **Kissmiklos, Miklós Kiss** Photographer: **Mark Somay** Type: Playfair Display, Roboto, Open Sans,
Becker Bodoni, Bodoni Recut Condensed, Pistilli, Ogilvy Poster
This is a new, bohemian, and sultry way to decorate a tony nightclub's VIP lounge. The quotes on the walls are taken from erotic literary works in their
original languages, including Apollinaire's The Eleven Thousand Rods, Boccaccio's Decameron, and Chaucer's Canterbury Tales. In the restroom, graffiti
collected from Anglo-Saxon countries is separated according to gender. Their content was not altered, although they are presented in a classical
Antiqua. The posters are witty framed texts referring to sexuality, nighttime entertainment, and getting tipsy, all interpreted in the language of
contemporary typography.

Goli + Bosi Design Hostel, Split, Croatia, 2010
Designer: **Damir Gamulin** Photographer: **Damir Gamulin, Robert Leš**
Materials: **Stencil painting, vinyl cutting** Type: **FB Rhode**
Supergraphics and bright yellow painted floors, walls and ceiling provide
a sunny aura and necessary wayfinding in this futuristic shelter, designed
to protect its visitors from the elements..

TAP—Théâtre et Auditorium Poitiers
Poitiers, France, 2006-8
Architect: **P-06 Atelier with João Luis Carrilho da Graça Architect**
Art Directors: **Nuno Gusmão, Pedro Anjos** Photographer: **FG+SG,
P-06 Atelier** Materials: **Vinyl film, metallic plaques, totems** Type: **BS
Monofaked (by Mário Feliciano)**
This distinctive wayfinding system was influenced by Dada typography,
where words and letters are freely arranged for onomatopoeic effect.
Since the building is a container for words and sounds, the method fits
the purpose. The system consists of oversized letters and numerals
recognizable from a long distance. And to introduce seasonal events of
each season exterior video projections on the glass "skin" of the building
resemble the interior style.

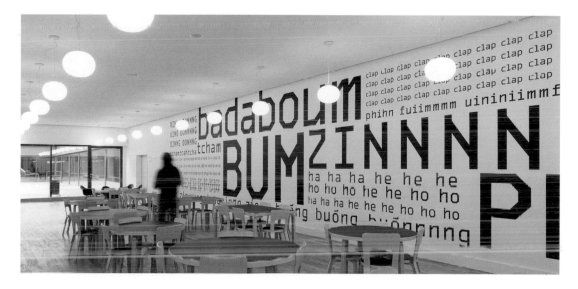

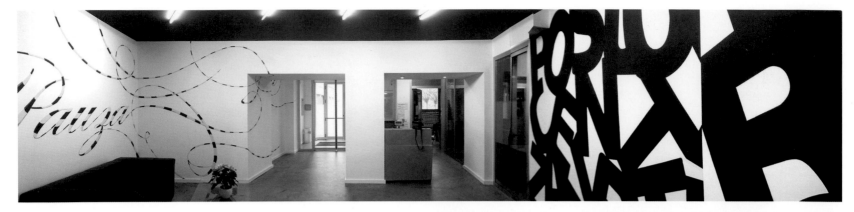

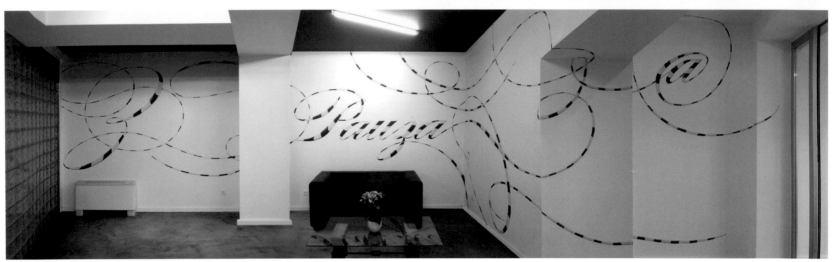

Object 10 interior, Zavrtnica 17, Zagreb, Croatia, 2011
Designer: **Branimir Sabljić , Krešimir Stanić** Photographer: **Branimir Sabljić** Type: **PF Beau Sans Bold, Burgues Script Regular**
To maintain the identity of Zavrtnica Business Centre's main building, Branimir Sabljić and Krešimir Stanić used a black-and-yellow motif with black-and-white typography. The first wall on the left is large type that reads "Poslovni centar Zavrtnica." On the right walls, they write the word pauza (pause/break) written in calligraphic font with parts of the calligraphy spreading to other surfaces and creating the @ symbol near the entrance, where visitors can access free Internet.

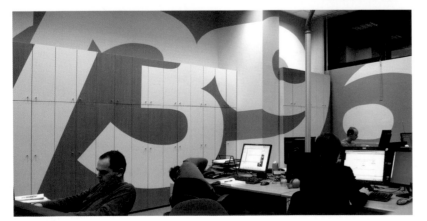

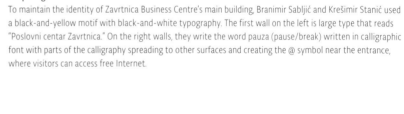

Croatian Lottery, Zagreb, Croatia, 2011
Designers: **Branimir Sabljić, Krešimir Stanić** Photographer: **Branimir Sabljić**
Materials: **Wall paint, labels** Type: **Interstate Black, Bold, Regular**
This otherwise drab space was turned into a playful office where walls express a message. The designers used basic and recognizable elements of Croatian Lottery and its classic games of chance: '7/39', '6/45' and 'Bingo'. The main wall, visible to all visitors, is emblazoned with Croatian Lottery logo and enlarged graphics of winning lottery ticket numbers.

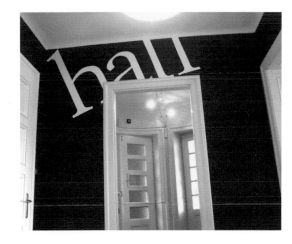

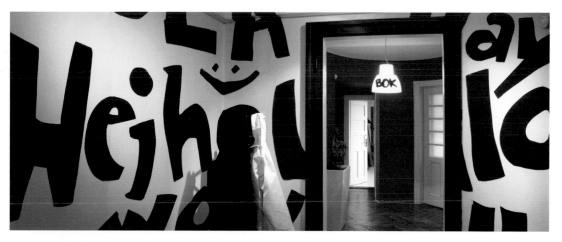

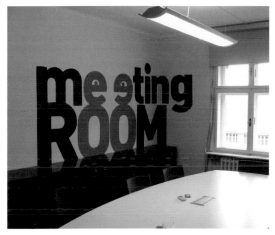

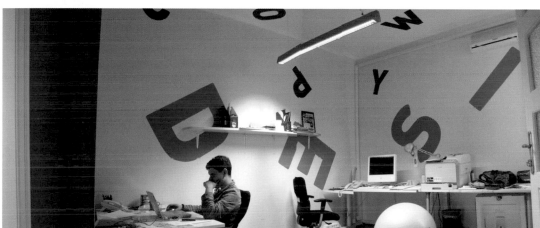

Pokobar, Zagreb, Croatia, 2011
Designer: **Branimir Sabljić** Photographer: **Branimir Sabljić**
Materials: **Wall paint** Type: **Din Bold**
A residential apartment was turned into a space for three sister companies through typography. Rooms were divided according to function, which was made explicit by a naming device using what Sabljić calls "hypertrophed typography." The effect of this "indoor grafitti" is the transformation of the apartment rooms into "public spaces where business is conducted." It does, however, retain a sense of humor—note the typographic pun in "Meeting Room."

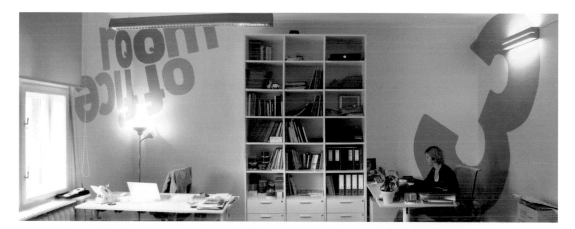

Osnabrück University of Applied Sciences, Osnabrück, Germany, 2004
Designer: Büro Uebele Architecture: Jockers Architekten bda Photographer: Andreas Körner
Materials: Black-and-white tiles, wood, steel Type: FF Din
Placing FF Din, a neutral typeface, on the ceiling tests the accepted Modernist notions of clarity and simplicity.
In this case it works to capture attention in a non-didactic manner. Or as Büro Uebele writes, the project is "a sky
of black letters and numbers, interspersed with red clouds. Words like stars show the way, guiding the traveler.
The ceiling is the firmament, scattered with words, the concrete walls are bare."

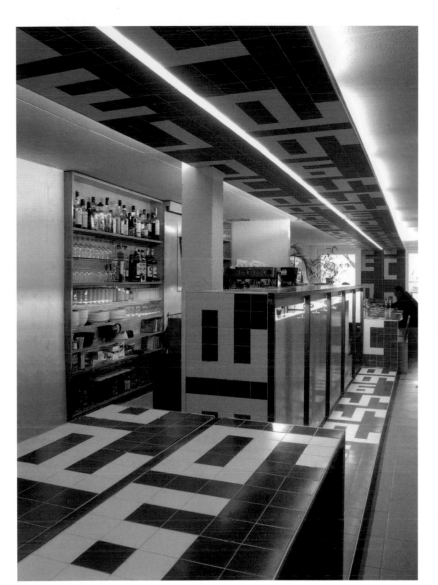

No Image No Message, Fribourg, Switzerland, 2003
Artist: **Martijn Sandberg** Photographer: **Charles Ellena** Materials: **Tile, wood, steel construction**
Using tiles as a means of typesetting a textual image within an architectural construction, the designers created what they refer to as "a hybrid form of interior design and incorporated graffiti." Floor, ceiling, counter, and two long tables are a single construction. The long strip of tiles forms a loop with the words "No Image No Message."

I Have a Dream/Li Houlm, Mouans-Sartoux, France, 2005
Artist: **Tania Mouraud** Photographer: **Tania Mouraud** Material: **Acrylic**
Martin Luther King's words "I have a dream" in Kufi Arabic, one of the thirty-six languages into which Mouraud has translated the phrase.

Linus Dean Rugs, Sydney, Australia, 2013
Designer: **Linus Dean** Materials: **Tibetan Wool**
Dean has created an exquisite range of hand-loomed "designer rugs," which are typographically inspired and traditionally made.

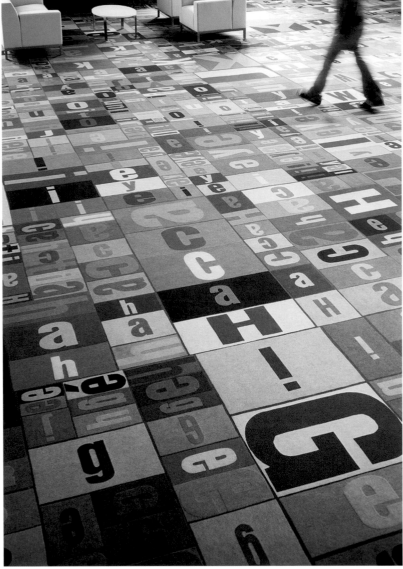

Ground, Pembroke Hall, Brown University, Providence, Rhode Island, 2010
Designer: **Ann Hamilton Studio** Photographer: **Warren Jagger**
A lettering carpet was commissioned for Pembroke Hall during the building's renovation by architect Toshiko Mori. The renovation brought together the Cogut Center for Humanities and Pembroke Center for Teaching and Research, which share a research agenda that explores the relationship between languages and the cultures they produce. The Latin alphabet, impressed upon this carpet, is the common linguistic root of the research centers.

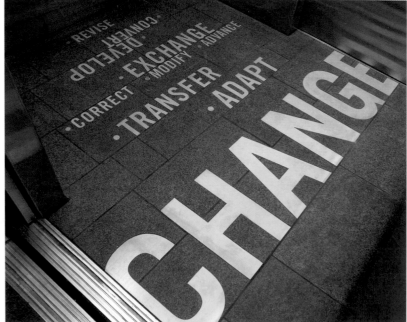

Change Elevators, PACCAR Hall, University of Washington, Seattle, Washington, 2010
Client: **University of Washington Foster School of Business** Designer: **Kristine Matthews, Karen Cheng**
Photographer: **Michael Burns, Matthew Hagen**
The "CHANGE" concept grew out of the designers' desire to incorporate actual "loose change" (coins) into the fabric of the carpet installation. The theme of "CHANGE" evolved from the physical coins into a larger human concept—the need for everyone, especially companies and corporations of all kinds, to adapt, transform, and embrace change in order to survive. This installation reflects upon the dynamic relationship between business and change. The word "CHANGE" appears on the floor of two elevators, along with eighteen synonyms.

The BMW Lightwall "Reflection," Arrivals Hall, Hamburg Airport, 2010
Agency: Serviceplan Chief Creative Officer: Alexander Schill Creative Directors: Maik Kaehler,
Christoph Nann Art Directors: Manuel Wolff, Savina Mokreva Materials: Latex print on clear adhesive vinyl
foil, with white diffusor foil behind it

The challenge was to get more impact from an advertising poster. The goal was to design one readable headline
out of half letters. Finding words that could be completed in reflection was no easy task. Serviceplan took over a
long and narrow area, where the reflection doubled their media space and doubled the attention for free.

Permanent Drift, Belle île en mer, France, 2012
Designer: **Sean Hart** Photographer: **Sean Hart** Type: **Mydriasis**
Sean Hart calls his installation Permanent Drift a "photo-roman" (photo novel). The author's note says, in part,
"War is Peace. Peace is Security. Security is Order. Order is Comfort. Comfort is Money. Money is Happiness.
Happiness is Slavery. Slavery is Freedom. Ignorance is Strength. Pray to our God. Trust our Masters. Pay our taxes.
Follow our leaders. Play our games. Respect our rules." The sayings appear on walls in a darkened cave, leaving
the impression that these words are fading artifacts in an alien world.

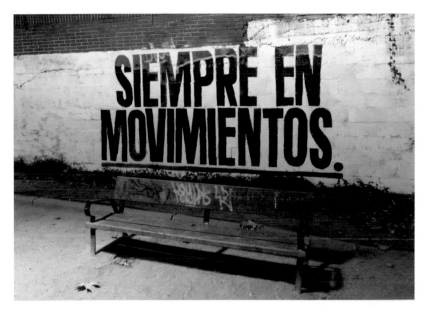

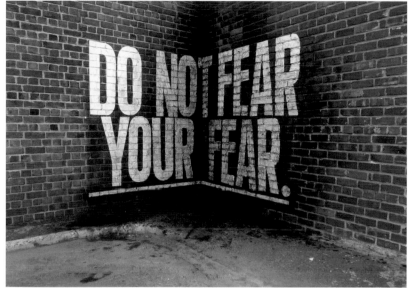

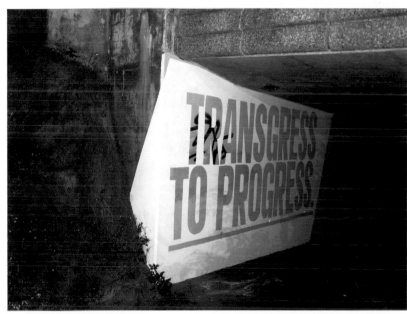

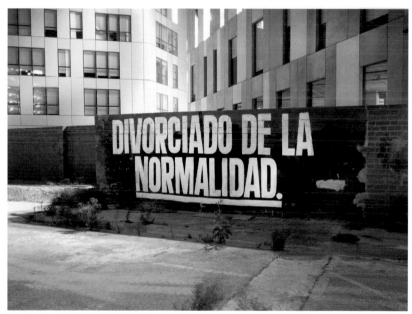

Yes Future, 2011

Rio de Janeiro, Brazil; Barcelona, Spain; Madrid, Spain; Strasbourg, Austria; Cape Town, South Africa
Designer: **Sean Hart** Photographer: **Sean Hart** Materials: "Reverse Stencil," paint Type: **Mydriasis**

Sean Hart writes with the paint and then with the light. This is a set of poetic correspondences that sit under various texts, which he photographs in stages. The themes add up into crystallizing stories. "The photography allows me to immortalize the short-lived in a long-lasting work," he says. "It is the means which allows me to fix, to archive my interventions before they disappear. They constitute, in a way, the pages of a personal diary."

Danny's Continental Cocktail Lounge, Solo(s) Project House, Newark, New Jersey, 2010
Designer: **Daniel Patrick Helmstetter** Photographer: **Matt Kabel, Lynn Belles** Material: **House paint**
Over the course of three weeks in September 2010, the installation called Danny's Continental Cocktail Lounge
was a ceiling-to-floor literary explosion; a painted poem in space. Good poetry creates an image within the mind
of the reader, while typography itself can function as an image. "You have the visual of the letters, and you have
the visuals the poet creates by joining the letters together in a particular way," says Patrick Helmstetter. "You
have the rhythm of the words, and you have the visual movement inherent in the form of the letters. You have
one image of a room full of words, and simultaneously, you have the possibility of innumerable images living
within the content of the words." In this case you have a room that reads like a manuscript.

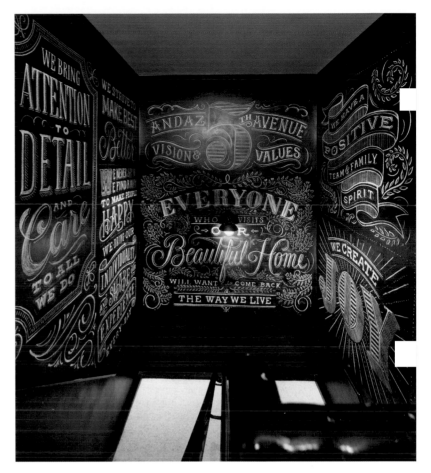

Andaz 5th Avenue Installation, New York, New York, 2012
Art Director: **Nasly Kasim BBDONy** Design: **Dana Tanamachi** Photographer: **Billy Siegrist BBDOONY**
Materials: **Chalkboard paint, chalk**
In September 2012, Hyatt Corporation embarked on an ambitious typocentric mural for the Andaz Hotel in New
York. Totaling over 350 square feet and approximately 100 typographic words written in chalk. This typographic
feat, commissioned by BBDONY took three full days to complete, and more than a few boxes of chalk. Oddly,
this elaborate piece is located in the hotel's rear stairway, which is only used as an employee entrance.

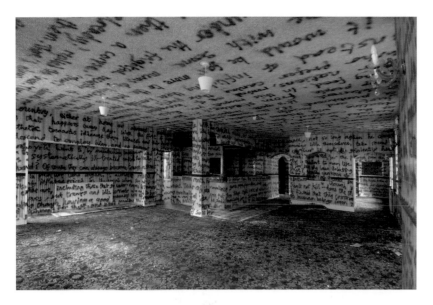

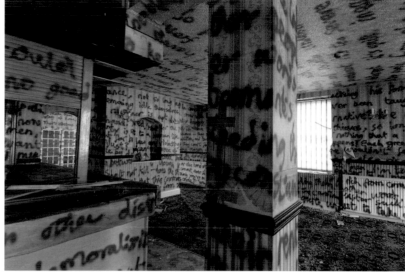

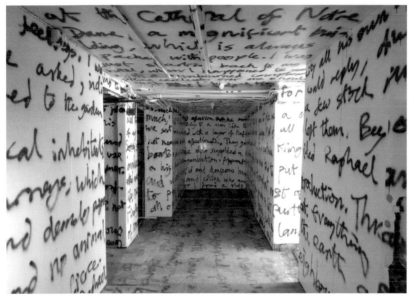

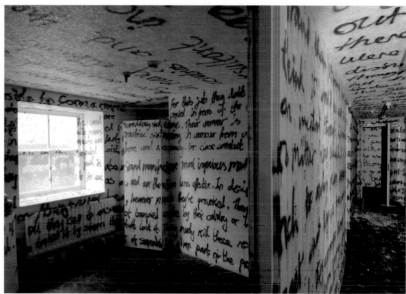

Utopia, Project House, Newark, New Jersey, 2006
Artist: **Rory Macbeth**
Macbeth does not make literal representations of utopia. His Utopia installation, a handwritten version of Sir Thomas More's classic volume, is what he calls "a gap between the purity and clarity of ideas and intentions, and the messy contingencies, contradictions, and conflicts of the social realm."

"My Favorite CD-Shop," Cultural and Information Center—Forum Gallery, Zagreb, Croatia, 2012
Exhibition Design: **Studio Rašić** Art Directors/Designers: **Marko Rašić, Vedrana Vrabec**
Photographer: **Studio Rašić**
This unique way to design an exhibition paying homage to music relies on the painted word, massively composed and filling the space from floor to ceiling.

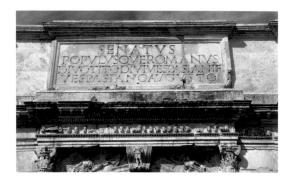

Arch of Titus, Rome, Italy, 81–85 AD
Inscriptions are characteristic of ancient buildings, particularly Roman triumphal arches. This one was dedicated by Emperor Domitian to his brother Titus. The inscription reads: "The Roman Senate and People (dedicate this) to the divine Titus Vespasianus Augustus, son of the divine Vespasian."

Cuneiform script emerged in Mesopotamia as the first pictorial writing system during the late fourth millennium. Meanwhile the ancient Egyptians made paper from the papyrus plant and developed three of their own writing scripts, notably hieroglyphics, used mostly by priests. But dimensional lettering on buildings dates back to an age when paper was still new and rare, stone was the primary medium for statements writ large, and walls and gravestones were default message boards. Rome, the birthplace of the Roman alphabet, gave rise to various monumental writing methods.

While Trajan capitals were laboriously carved into travertine, which captured light and produced dimension-enhancing shadows, bronze letters were also affixed in relief to wood or stone, providing greater dimensional intensity. Centuries later, imitating the storied grandeur of the Roman Empire, Benito Mussolini decreed that Italian architects design generous spaces on facades of new fascist buildings on which the dictator's orations would be immortalized in sculptural friezes. Born of his hubris, a voluminous three-dimensional block lettering style emerged that referenced ancient Roman epigraphy while celebrating the past, present, and future of Il Duce's oppressive reign. Today's neon (and recently, LED) advertising signs perched atop or bolted onto the facades of many Roman buildings may come and go, but Mussolini's so-called action words were literally set in stone less than a century ago and were given the same

credence, epigraphically speaking, as the venerated inscriptions by and about many emperors and popes from millennia past.

Three-dimensional typography made from stone, concrete, metal, or other indigenous materials, owing to volume and mass, is well suited for architectural display. And there is no better place to post statements for all to see than on permanent structures in well-trafficked outdoor environments. When three-dimensional typography is rendered large, its architectonic impact is even more impressive—and physically much more enduring—than temporary scrims, banners, or posters affixed to similar platforms.

The practice of placing lettering in relief on or around buildings has experienced a revival of sorts. Increasingly, dimensional lettering is used not just for advertising, but also for integral components of architectural schemes, including artworks and institutional branding. Artists and designers, not bound by a single medium, style, or purpose, have been imprinting letters, words, and statements on the physical and visual landscape in a form that might best be called twenty-first-century epigraphy, and doing so, have added to the charm of otherwise stolid structures. Consider Jonathan Adams's 2004 Wales Millennium Centre (page 145) as a Roman inscription on steroids: the mammoth typographic statement literally cuts deeply through the facade of the center. The letters are made into veritable alphabetic caves that open onto the building's public space.

Letters and words are used to a more calming effect in Jaume Plensa's 2010 Ogijima's Soul, a visitors center in Ogijima, Japan (page 148). The canopy over an information center consists of a "membrane" of letters that, in bright sunlight, cast dancing shadows of various alphabets, including Japanese, Hebrew, Chinese, Arabic, Russian, Greek, Latin, Korean, and Hindi. This sidewalk of babble is designed to unify rather than discriminate. Likewise, Martijn Sandberg's 2012 stairway project titled De Sleutel Ligt Onder De Deurmat (The Key Is Under the Doormat), for De Zilverling apartment building at the Colijnstraat in Amsterdam (page 150), positions words and sayings in unexpected spaces. It is an optical illusion designed to surprise and delight. Sandberg has hidden what he calls "a secret message" among the layers of the concrete stair treads that when deciphered is a found treasure (hence, the reference to the key under the doormat).

For a different kind of surprise, Sussman/Prezja's 2008 painted aluminum "space frame" for Duke Energy Convention Center in Cincinnati, Ohio (page 154), is at once a billboard atop a building (which from a distance clearly says "Cincinnati") and a total enigma that becomes more abstract the nearer the visitor gets.

The broad range of typographic challenges facing designers is more impressive than ever, due to the rise of once-improbable installation techniques and practices, such as grafting dimensional type onto an existing structure. Attila F. Kovács's 2002 House of Terror Museum in Budapest, Hungary (page 152),

BIG AND BIGGER

Lepcis Magna, First century B.C.
Once a prominent city of the Roman Empire, Lepcis Magna, founded by Emperor Trajan (whose triumphal column in Rome contains the models for the Roman alphabet) is now a ruin in the Mediterranean that preserves about ninety inscriptions.

Pavilion for the Monza Biennale Internazionale delle Arti Decorative, Monza, Italy, 1927
Designer: **Fortunato Depero**
As a boisterous Futurist, Depero was known for making monumental statements through typography. His pavilion for books, made from block letters, is one of his boldest feats.

achieves monumental status and makes a powerful typographic statement aimed at making passersby aware of the former headquarters for the murderous, nationalist Arrow Cross Party, which briefly ruled Hungary and was allied to the Nazis during World War II. After the war the building was transformed into the headquarters of the brutal ÁVO, Hungary's Soviet-era secret police. The nineteenth-century building was not as sinister looking on the outside as the activities were inside, and so its dark history needed to be brought out. Kovács made the entire building into a monument of criminality by constructing a shroud or canopy that hangs over the entire structure, symbolizing both the megalomania of totalitarian regimes and the massive moldings of neo-Renaissance buildings from the nineteenth century. The word "TERROR" is cut out of the black steel canopy, and when the sun is at its height, the building is covered in a large, ominous pall with the museum's logo and the word "TERROR" casting shadows on the sunlit surface that serve to brand the facade. What a strong, rhetorically acerbic use of signage.

Any building surface can be a tabula rasa for ideological rhetoric, but contemporary dimensional-lettering projects are not as politically motivated. Designers are now more engaged in making public art for art sake. Typography is more integrated into noncommercial art projects than ever before. But even apolitical typography, when displayed at this scale, demands a passerby's attention, if only to contemplate the message that the public is encountering. With artists becoming increasingly active in public spectacle, the result is ever grander and more complex sculptural/architectural typographic extravaganzas as outlets for intimate expression.

Carrying on a personal exchange in public space is certainly the aim of English-born artist Liam Gillick (page 151). For the Public Art program of Vancouver, he created a piece that wraps two sides of the Fairmont Pacific Rim hotel's facade with a running line of repeated text "Lying on top of a building the clouds looked no nearer than when I was lying on the street." His poetic phrase (typeset in Helvetica Bold) spans from the fifth to the twenty-second floor of the building. Which begs the question, why would a real estate developer even consider having an artistic statement on a high-stakes investment? The answer: civic pride.

Letters and words are something that both visually challenged and visually savvy clients can understand. And this is at least one reason for architectural typography's growing popularity in some surprising venues. For instance, the design firm R2 was commissioned by a gallery owner to create the 2008 Go with God (page 160), which covers the whole exterior of the Hermitage of Nossa Senhora da Conceição chapel in Lisbon (now a gallery) with statements that smartly combine divinity and popular culture. The design features idiomatic expressions in Portuguese, such as "God is good and the Devil isn't so bad" and "God save us from the bad neighbors on our doorstep." Using the Knockout typeface by Hoefler & Frere-Jones and painted in the same color and texture as the background, the letters and words both blend into and, in the right light, surprisingly jump off the chapel walls.

Type is a vessel of meaning, so it follows that anything produced using type, especially large, comes with an overt meaning or covert significance—poetic or otherwise. But as Sigmund Freud reportedly said, "Sometimes a cigar is just a cigar," and sometimes a monumental typographic extravaganza, like Mitsutomo Matsunami's 2007 Number House in Hozumidai in Osaka, Japan (page 151), is just a house number that happens to be as large as the entire house. Matsunami's job was not to make art per se (that is a consequence, not a goal) but to take a mass-produced, previously constructed four-unit home and add value to it by creating an ingenious typographic mnemonic. Using cost-effective production techniques, he transformed the facade into a functional spectacle by turning the balconies into the street number. In a similar spirit, perhaps, Neutelings Riedijk Architecten's giant letters for the 1997 Minnaert building on the De Uithof campus of Utrecht University have a very clear function. The signature feature of this building is the full-story-high letters that spell "Minnaert" on the ground floor. Behind the mammoth word is an area for bike parking, and with such a visible address there is no excuse for missing a class.

TYPE AS OBJECT

Metz & Co Window Display, Amsterdam
The Netherlands, 1920s
The department store Metz & Co. was known for its avant-garde graphic design—shopping bags, labels—and for its dramatic typographic window displays, some designed by Gerrit Rietveld and Bart van der Leck.

Academy Theater, Inglewood, California, 1939.
Architect: S. Charles Lee
Designed in a classic Art Moderne style, this theater was intended to house the Academy Awards. The Oscars were never awarded here, but, with its towering, type-encrusted gem of a spire, the Academy was often the location of gala film premieres and served as a major suburban theater for the Fox West Coast Theatres chain. The theater continued to show movies until 1976, when it became a church.

The green cross throughout Europe signals the presence of a pharmacy in no uncertain terms. But just in case any ambiguity exists, in 2010 Manuel Clavel Rojo of Clavel Arquitectos created a two-story-high metal FARMACIA sign for Casanueva Pharmacy in Murcia, Spain. The impetus was the new marketing needs of pharmacists, who are realizing the importance of identity and publicity. But the height of the word is not the only awesome attraction. The entire building seems to lean on the text, FARMACIA, making up a double-height shop window. This element not only announces the identity of this pharmacist but also provides necessary solar protection. Incidentally, the sign is only understandable when viewed at a certain distance and becomes more abstract as the passerby gets closer. This is spectacle as mnemonic.

The great type masters would never admit it, but type can also be purely decorative. The installation that Markus Bernatzky produced in 2009 titled Liebe Lili (Dear Lili) (page 157), for the CEO of Ikarus Design Handel, was a partly decorative installation housed in the caretaker's towers in a garden park. The idea was to typographically chronicle the tale of when famed writer Johann Wolfgang von Goethe met a young woman in this park, fell in love, got engaged, and split up after a few months. The text, which fits into the arches of the towers, include Goethe's poetic memories of this romance. The typography was designed to resemble, at first glance, a patterned decorative gate, whose words become clearer as the viewer moves close enough to read them.

Whether the purpose is rhetorical, functional, or decorative, monumental dimensional typography is a way to make the public engage with the text in a fundamental manner—by reading, looking, contemplating, or even climbing. Whether permanent or temporary, dimensional typography reaches out to people.

Castle Ashby, Northamptonshire, England, fifteenth century
Photographer: **Amy Elizabeth Robinson**
The restored Latin words that comprise essential parts of the banisters, parapets, and turrets of this fifteenth-century castle can be attributed to Henry Lord Compton and his son William, the first Earl. The latter was responsible for some of the upper rooms and the lettered parapet. This typographic feature is found on very few houses, according to Alan Bartram, in *Lettering in Architecture*, but there are examples at Temple Newsam

in Yorkshire and Felbrigge Hall in Norfolk, and this typographic style can be attributed to fashion for the Italian manner in England. The legend on the east wing at Castle Ashby reads: nisi dominus aedificaverit domum in vanum laboraverunt qui aedificant eam. (Unless the Lord builds the house, they labor in vain that build it.) On the west wing a similar homily reads: nisi dominus custos custodiverit domum frus, and it is continued on the north side of the courtyard: // fra vigilat qui custodit eam /l.

The Minaret of Jam, Shahrak District, Ghor Province
Afghanistan, 1194
Photographer: **Mark van Raai**
Arabic script fills the Minaret of Jam, which is believed to mark the site of
the ancient city of Firuzkuh, the capital of the Ghurid dynasty that ruled
Afghanistan and parts of northern India, from Kashgar to the Persian
Gulf, in the twelfth and thirteenth centuries. The date of construction
is inscribed as 1194. It is likely that the Minaret was constructed to
commemorate his victory at Delhi in 1192 over the Ghaznavid Empire,
and it is often called the Victory Tower.

Minaret of the Idriss Medersa, Moulay Idriss Zerhoun
Morocco, c. 790
Photographer: **Linda de Volder**
Moulay Idriss Zerhoun is in northern Morocco at the base of Mount
Zerhoun. The mosque honors Moulay Isdriss I, who founded the city
and brought Islam to the region. It is said that six pilgrimages to Moulay
Idriss during the annual festival are equivalent to one hajj to Mecca.

Bibi-Khanym Mosque, Samarkand, Uzbekistan, fourteenth century
Photographer: **Adam Jones, Global Photo Archiv**
After a victorious Indian campaign in 1399, the Turco-Mongolian ruler, Timur, a devout Muslim, built a gigantic mosque in his capital, Samarkand. The mosque was comprised of precious stones, the spoils of war of India. Construction was completed between 1399 and 1404. However, the mosque crumbled to ruins until 1974 when the government of Uzbek SSR began reconstruction. The current mosque is still not completed.

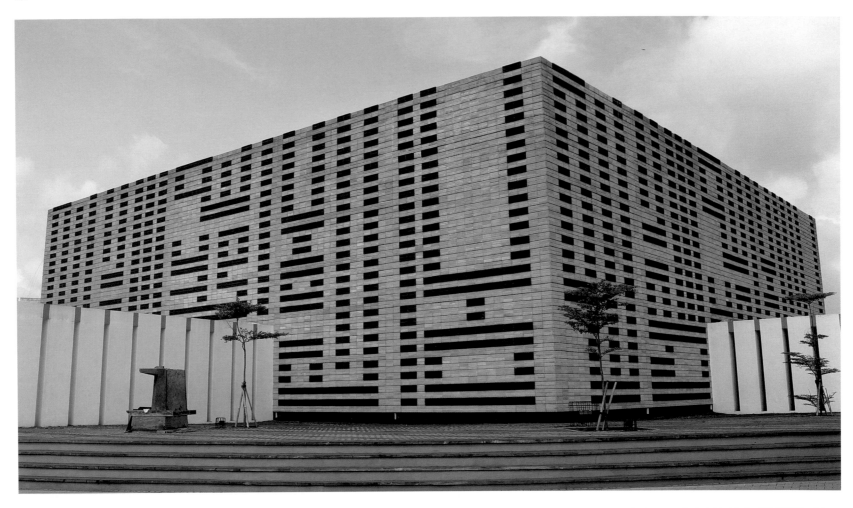

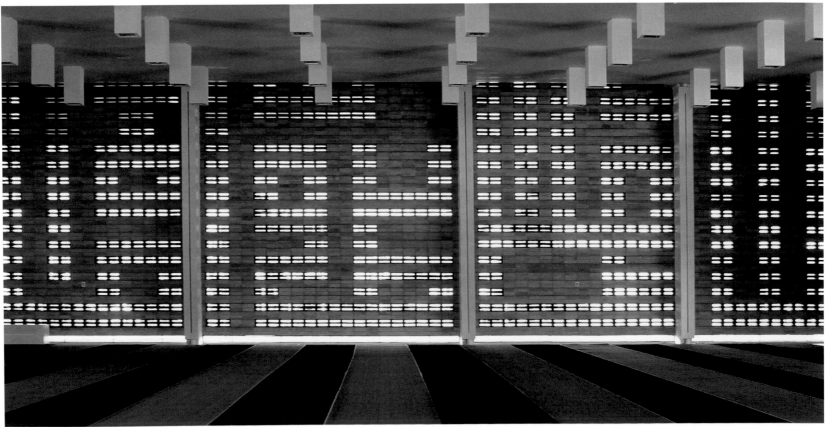

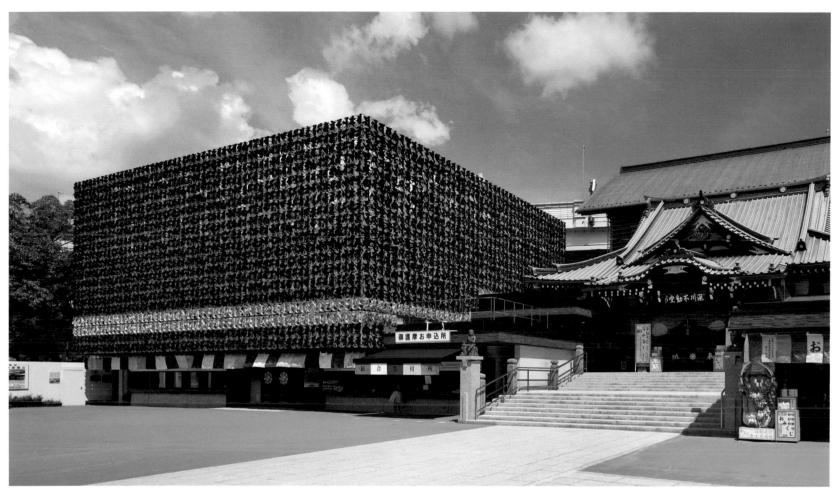

Al-Irsyad Mosque, Kota Baru Parahyangan
Bandung, Indonesia, 2009-10
Architect/Designer: **Ridwan Kamil** Photographer: **Nur Atika Zainal**
Holy words are a defining element of the architecture of this mosque
designed by local architect Ridwan Kamil. He took inspiration from
the Kaaba in Mecca, Saudi Arabia, which is also the most sacred site in
Islam. The facade of the mosque features the calligraphic text of the
holy shahada.

Fukagawa Fudoudo, Tokyo, Japan, 2010-12
Designer: **Jun Tamaki** Photographer: **Kei Sugino** Materials: **Black letter,
die-cast aluminum silver plate, aluminum plate.** Type: **Sunskrit (Bonji)**
The new main hall of Fukagawa Fudoudo temple in downtown Tokyo
was planned to accommodate an annual increase in pilgrims. The old
main building was preserved for its cultural heritage, with the new and
old attached together by other existing buildings. The new main hall
extends the existing floor height, and the space for prayer was shaped
like a bowl, with the high ceiling and wall painted black from top to
bottom to emphasize the existence of a barrier. Twenty-four Sanskrit
characters from the Açala mantra sung by worshipers inside the hall
were cast at the periphery of the building. The new main hall becomes
"a prayer space wrapped in prayer," says Tamaki. "The weight from the
volume of the main hall can be felt through this combination between
the outer Sanskrit wall and the inner black wall, a design language that
speaks of the same quality as the hollow attics that can
be found in ancient Japanese temples.

IBM Pavilion, New York World's Fair, New York, 1964-65
Designers: **Charles Eames** and **Eero Saarinen Associates**
Photographer: **John H. Martin**
Visitors to the New York World's Fair could not help but admire the enormous egg or "ovoid" that sat atop the IBM Pavilion covered in relief by the iconic IBM logo, designed by Paul Rand. Rising to 90 feet, it housed the main attraction, the Information Machine. Visitors were lifted into the ovoid by means of the People Wall, a moving tier of twelve rows of seats (around five hundred seats), which at a 45-degree angle transported the viewers into the multimedia experience.

Midrash, Rio De Janeiro, Brazil, 2009
Architect: **Isay Weinfeld** Photographer: **Leonardo Finotti**
The Midrash building was designed to house a study center for the Congregação Judaica do Brasil (Jewish Congregation of Brazil). The center is devoted to the debate, discussion, and teaching of various themes around Jewish traditions in literature, arts, history, psychology, and politics in the search for meaning, connections and references in life. On the facade, a fiberglass mesh made up of Hebrew letters in different layers, sizes, and tones of white overlaps the brickwork, extending from the first floor to the top, and to the limit of the neighboring lots. Letters always form the word "Midrash," which means "to draw sense."

Social Energy: Contemporary Communication Design from the Netherlands, OCT Art and Design Gallery, Shenzhen, China, 2009
Art direction: **Hei Yiyang** Designers: **Hei Yiyang, Wang Xiaomeng, Lin Zhan** Photographer: **Liang Ron** Materials: **PVC.**
"Social Energy—Contemporary Communication Design from the Netherlands" is a touring exhibition held in the Chinese cities Beijing, Chengdu, Shenzhen, and Shanghai. A panoramic view of Dutch communication design, it involves works from eleven influential design groups. Responding to the unique appearance of the OCT Gallery, the exhibition designers created an inflatable hexagonal device with a round light tube. The hexagon represents a single molecule, which, though tiny, brings immense energy (the theme of the show) to the human body. As a basic element, an "Energy Typeface" in Chinese and English was used in every aspect of this exhibition: the main image system, the external space design, the interior signage system, and the promotional materials. The exhibition title in this Energy Typeface covers the whole exhibition hall, and this architecture, according to the designers "becomes an information container."

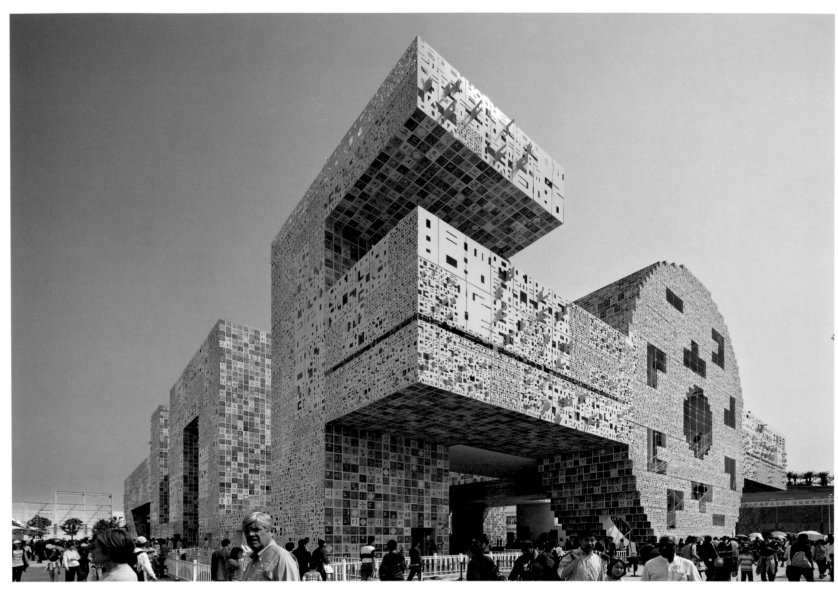

Shanghai Expo 2010: Korea Pavilion, Shanghai, China, 2010
Client: Korea Trade-Investment Promotion Agency
Architects: Mass Studies: Minsuk Cho, Kisu Park, Joungwon Lee, Taehoon Hwang, Hyunseok Jung, Joonhee Lee, Hyunjung Kim, Bumhyun Chun, Jisoo Kim, Moonhee Han, Sungpil Won, Kyungmin Kwon, Dongwon Yoon, Betty Bora Kim, Kyehnyong Kwak, Jungwook Lee, Doohyun An.

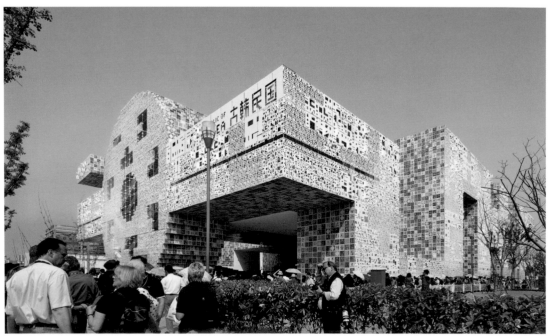

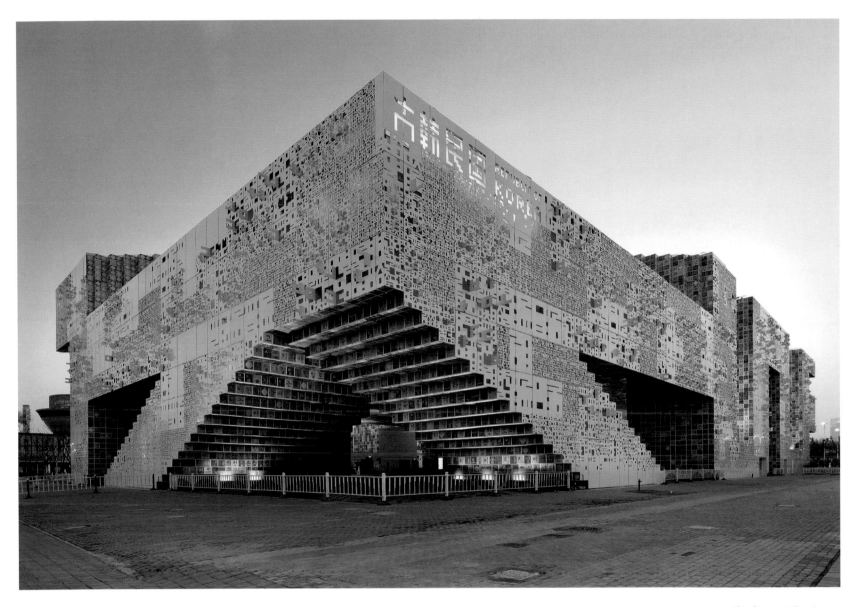

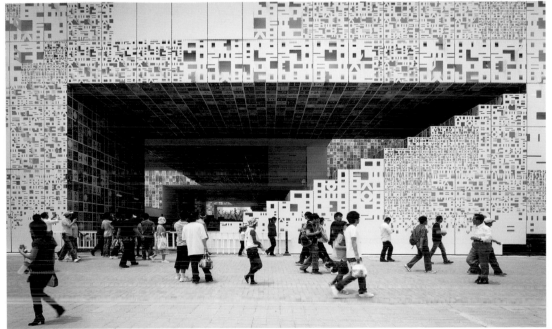

The Korea Pavilion was an amalgamation of "sign" (or symbol) and "space." Han-geul, the Korean alphabet, is the prime element of the signs within the pavilion. The exterior surfaces of the pavilion are covered in two kinds of typographic pixels: "Han-geul Pixels" and "Art Pixels." Han-geul Pixels are white panels with a relief of letters in four different sizes whose combination forms the majority of the exterior. Most of the nonperipheral surfaces are composed of Art Pixels, which are aluminum panels created by the Korean artist Ik-Joong Kang. About forty thousand of these bright colored panels are on the facade, and they symbolize hope and unity.

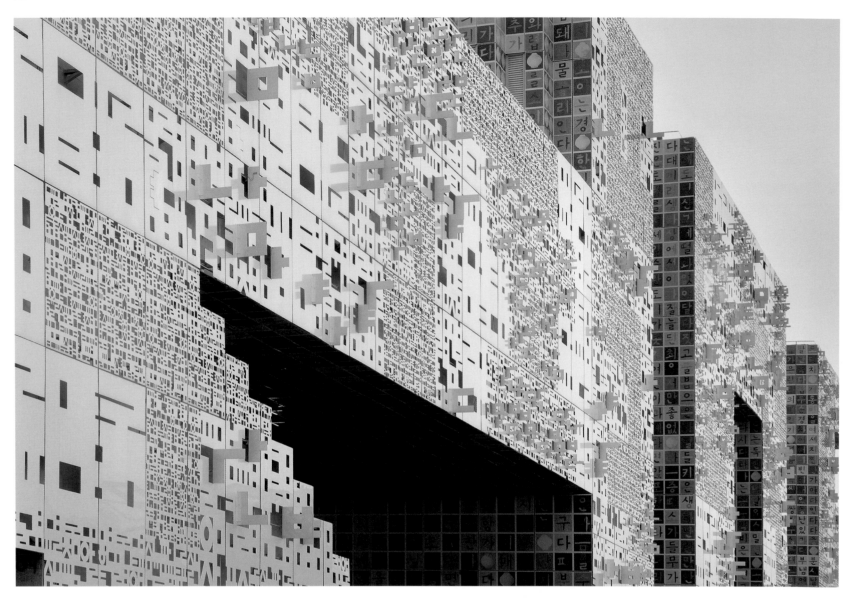

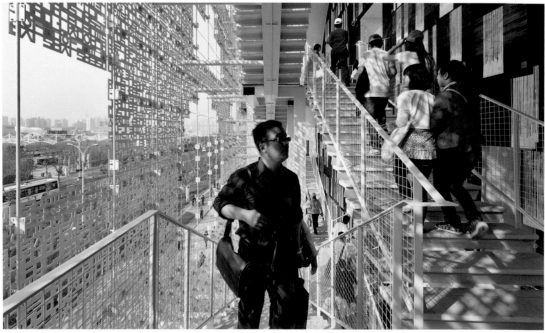

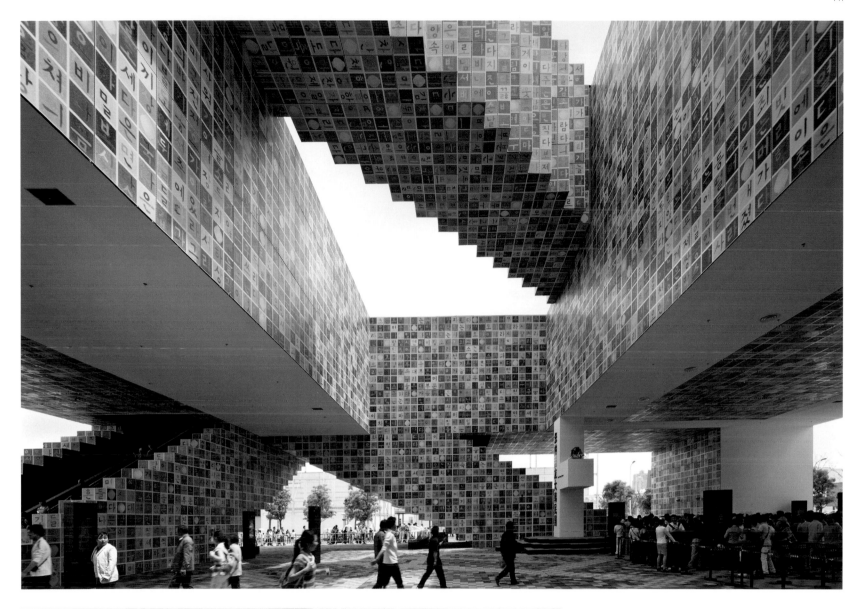

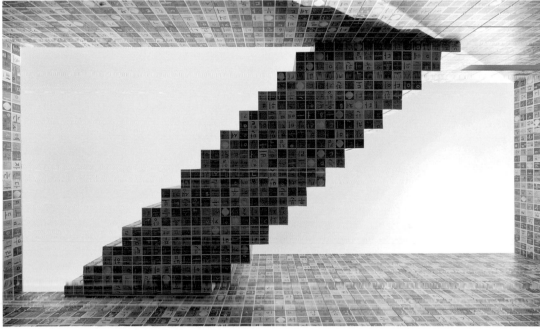

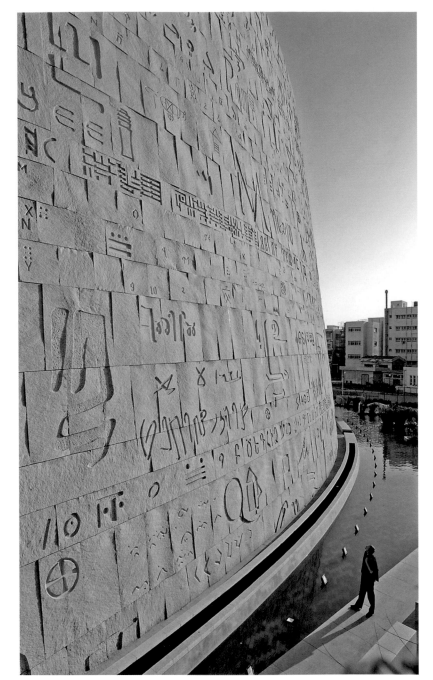

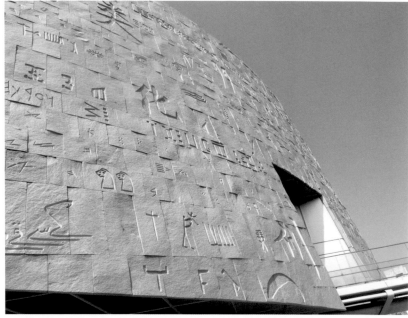

Bibliotheca Alexandrina, Eastern harbor in Alexandria, Egypt, 2002
Designer: **Snøhetta Hamza Consortium** Photographers: **Nils Petter Dale, Andrea Calabretta**
The objective of reviving the Bibliotheca Alexandrina is to establish a comprehensive new research library
to contain some 5 million volumes. The outer granite wall is inscribed—as though gouged out of clay—on
all sides with modern-day Cuneiform letters. This is appropriate since the library contains the Calligraphy
Center, which includes Cuneiform, Arabic, Persian, Turkish and Greek lettering from the pre-dynastic period
to the digital age.

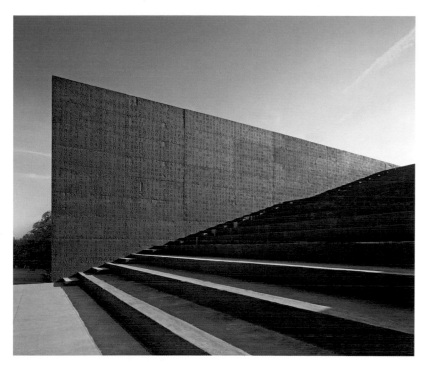

Curno Library and Auditorium, Curno, Italy, 1996–200.
Designer: Studio Archea:Giovanni Polazzi, Marco Casamonti, Laura Andreini, Silvia Fabi, Ezio Birondi, Giuseppe Pezzano Photographer: Pietro Savorelli Materials: Concrete, concrete pigments
An open book is the metaphor for the entire design of this new public library. Some of the spaces look like bookshelves. There is a sloping roof, terraced to form a seating grand stand for public events. The materials, "which have been reduced to the essentiality of an untreated concrete mixed with color," say the designers, enable the vertical surfaces appear as the pages of a book, engraved throughout with letters

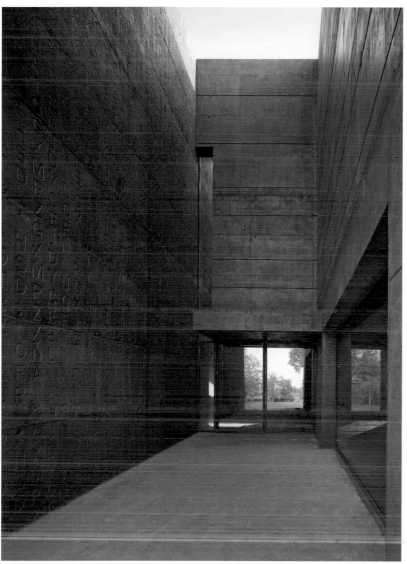

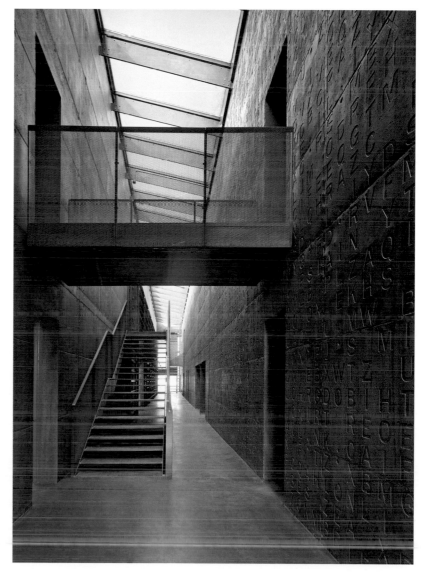

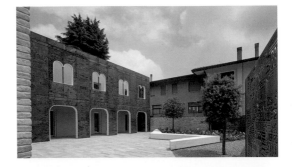

Palazzo di Vigonovo "Campiello," Venice, Italy, 2011
Client: **Cosmo Immobiliare snc**
Architects: **3ndy Studio/Marco Mazzetto, Alessandro Lazzari, Massimiliano Martignon** Sculptor: **Giorgio Milani**
Photographer: **Fernando Guerra** Materials: **Bricks, painted steel, Corten steel, wood**
In 2011 the Venetian designers at 3ndy Studio renovated this nineteenth-century structure, which had been damaged by fire. The concept was to reintegrate the building into the community by returning to its history and claiming its present. During the ideation phase, many sheets were scrawled upon, and this pile was made into a 300-square-meter sculpture using 190 sheets of Corten steel. It was akin to reading pages of a book with lettering selected from twenty-two different alphabets in upper and lower case. The fonts represent various eras, which blend into a startling graphic image that is illuminated through the patterned openings on the sheets.

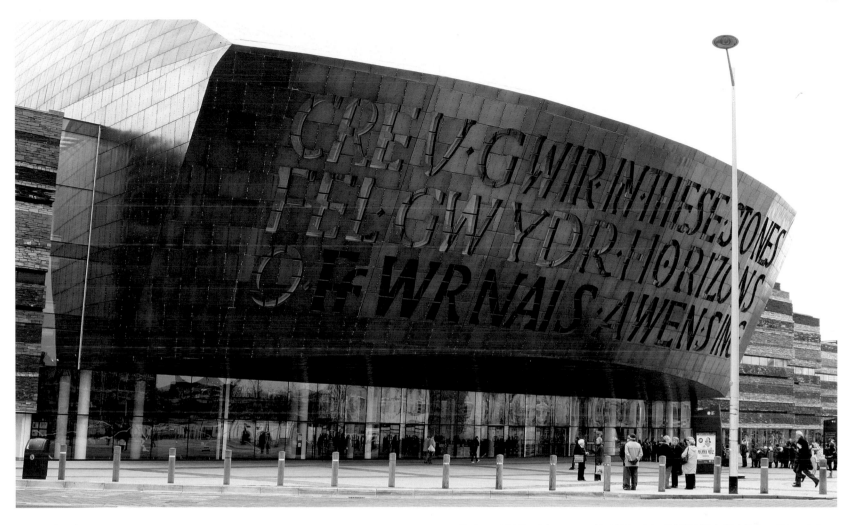

Wales Millenium Center, Cardiff, Wales, 2004
Designer: **Jonathan Adam** Photographers: **Jonathan Adams, Craig Aukland, Sarah Duncan, Fabio Quinci** Materials: **Steel, GRP.**

This is the first national cultural institution built since Wales was given a measure of political self-determination. "I knew that I had to look beyond the familiar language of contemporary architecture," Adams says. One of the defining aspects of Welsh culture is the Welsh language. The inscription window of the center was conceived to give scale and a point of focus to the principal west elevation. It was further developed as a device for framing views into and out of the theater foyer area. The characters of the inscription were made just a little larger than the height of an average person. "The analogy between the individual letters and human physical proportions is deliberate," says Adams. The letters of the inscription are based on Roman forms because these forms are timeless. "I was always moved by the living, organic quality of the characters that seemed to have lost none of their vigor over the 1,500 years since they were cut into the stone," he adds.

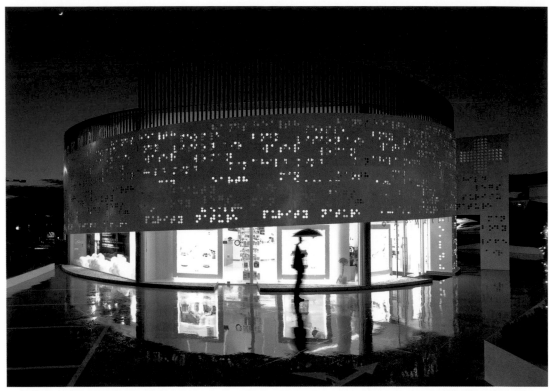

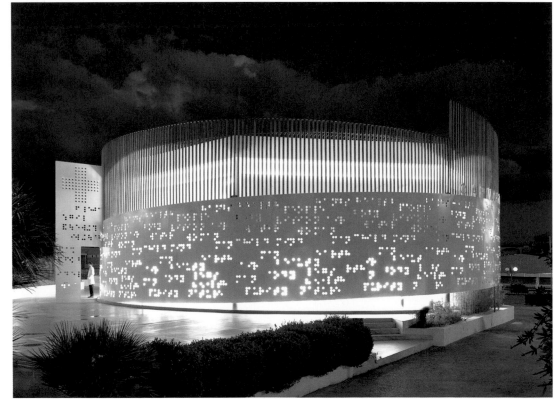

Placebo Pharmacy, Glyfada, Athens, Greece, 2010
Client: **Sofoklis Morfopoulos**
Designers: **Xara Marantidou, KLab Architecture** Photographer: **Panos Kokinias** Material: **Laser-cut metal** Type: **Braille**
The octagonal shape of the existing structure was re-formed into a cylinder in order to create a spiral that seeks, says Marantidou, "to converse with the rapid motion on Vouliagmenis Avenue," the street where building stands. The panels of the facade are perforated using Braille, which implies how the system is used on pharmaceutical packaging. It further "boosts visibility by allowing the light to find its way into the interior." All the written words are inspired by a healthy way of living and positive thinking. The continuous game of guessing the words forces passersby to engage with the world of Braille language. The new facade protects the interior while acting as a draw for customers. The changes of the natural light coming through the Braille holes into the store are inevitably playful, varying according to the route of the sun.

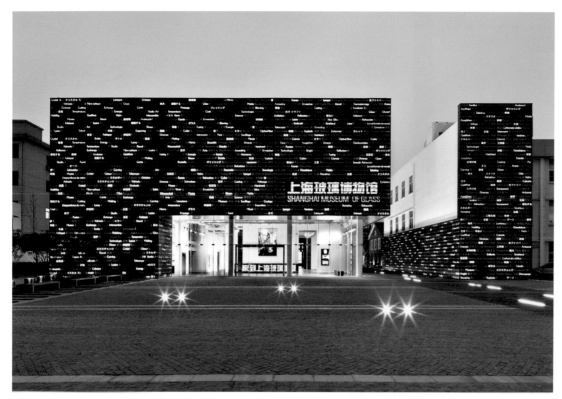

Shanghai Museum of Glass, Shanghai, China, 2011
Client: **Shanghai Glass Co**
Architecture: **logon** Creative Director: **Frank Krueger** Interior Design: **Coordination Asia**

The designers had to invent a new type of glass facade for this glass museum, which is owned by a glass-production company. The design uses standard industry glass, U shaped glass panels treated in a unique way. The elements were sandblasted from the back to reduce transparency. Then glass-related keywords were chosen in ten languages and applied as plastic foil on this surface. The letters are revealed by removing the foil where an enamel coating was heat fixed. The selected keywords were illuminated with LED backlight to produce a dramatic light presentation.

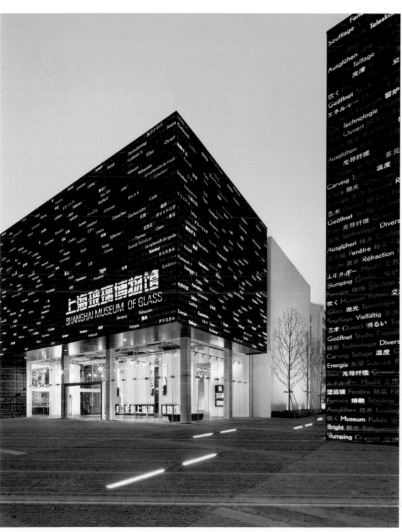

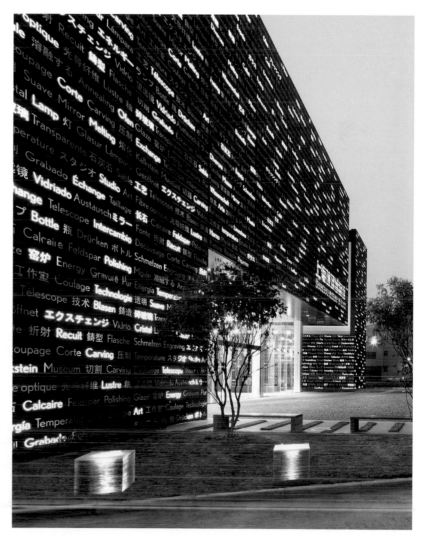

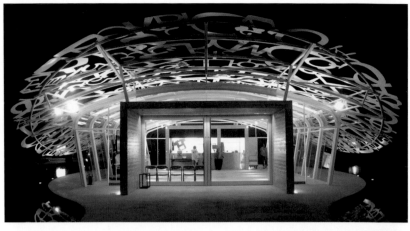

Ogijima's Soul (Ogijima Community Hall), Ogijima, Seto Inland Sea, Kagawa Prefecture, Japan, 2010
Artist: Jaume Plensa Associate architect: Tadashi Saito (VAKA)
Photographer: **Laura Medina, Plensa Studio, Barcelona**
Ogijima's Soul is a welcoming place where visitors rest and get information. It is also an icon in Ogijima that represents the spirit of the community and brings people to the island. Letters from various alphabets compose the roof of the structure, which in the evening is illuminated from inside, visible from far away. During the day, the roof's letters project shadows all around. Chosen to evoke the world's diversity, the alphabets include Japanese, Hebrew, Chinese, Arabic, Russian, Greek, Latin, Korean, and Hindi, among others.

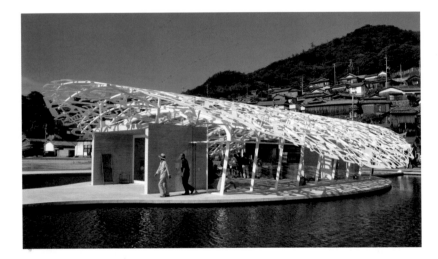

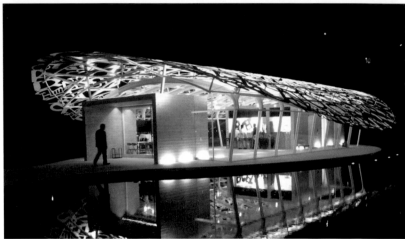

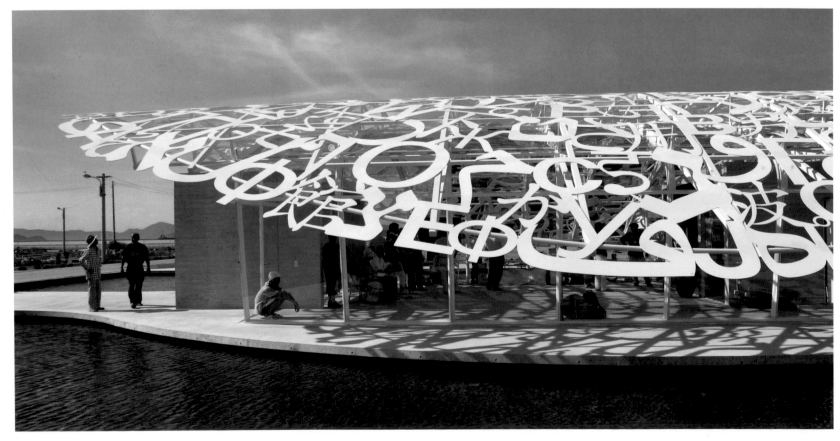

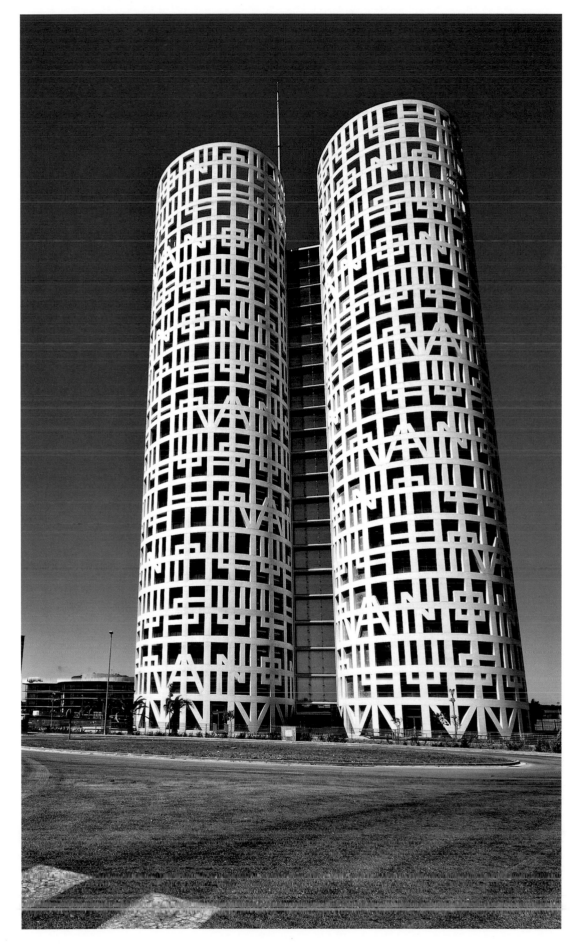

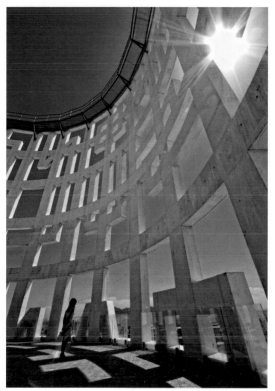

The Hercules Towers, Los Barrios., Cádiz, Spain, 2009
Architects: **Rafael de la Hoz Architects** Photographer: **Eduardo Mascagni Valero**

Rafael de la Hoz designed the two cylindrical white towers rising from a flat pool of water. On the facade is a giant lattice with the motto from the Hercules legend "Nothing Further Beyond," warning sailors in the Mediterranean of the edge of the known world. At 126 meters, the tower rises up from the Bay of Algeciras, changing the landscape of the Campo de Gibraltar and the transition of the Strait. The building is composed of two identical towers joined by a crystalline prism. The lattice containing the giant letters is designed to protect the interior from excess solar radiation while providing panoramic views of the Bay of Algeciras, the Rock of Gibraltar, and the Serrania.

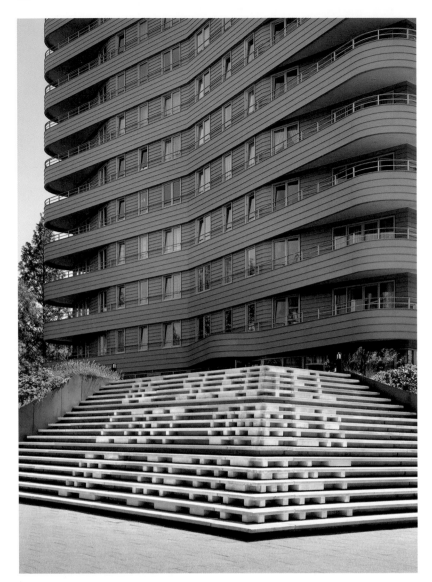

De Sleutel Ligt Onder De Deurmat (The Key is Under the Doormat), Amsterdam, The Netherlands, 2012.
Designer: **Martijn Sandberg** Photographer: **Peter Cuypers**
Material: **Cast concrete** Type: **White, 3-D**

Martijn Sandberg's site-specific, poetic artwork is integrated with the communal corner stair belonging to De Zilverling apartment building in Amsterdam. A secret message hides among the layers of concrete stair treads. He writes on his website that it is "for your eyes only: 'the key is under the doormat'. Public and private. Open and shut. Locked and unlocked. Encrypted and decrypted. A secret does not easily divulge itself." There are other messages, too. A message with tips for preventing burglaries states: "don't make it easy for the burglar" and "don't make your absence visible." This project is composed of open secrets. "The secret message emerges from the 'pixels' of the figuration," he continues, "distributed over both sides of the stair. Now you see it, now you don't . . . It all depends on the point of view you take, the angle you see it from. Perhaps today, otherwise tomorrow, at a certain moment—in a flash—everything converges. Suddenly you see it before you, from far away or close up. And then you know where the key is."

Rocklea Road Warehouse, Port Melbourne, Victoria Australia, 2008
Client: **Fairmant Pacific Rim**
Architects: **Jackson Clements Burrows** Material: **Wood**

This numerical edifice is an office/warehouse comprised of six interconnected structures. They are branded through the use of super graphic numbers integrated into a slatted timber.

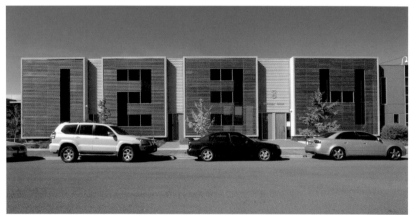

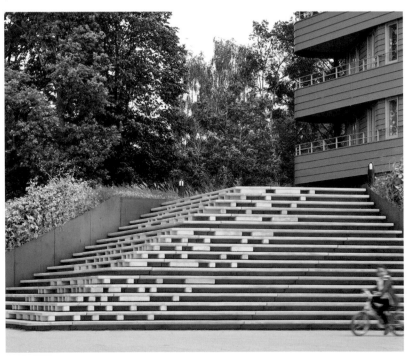

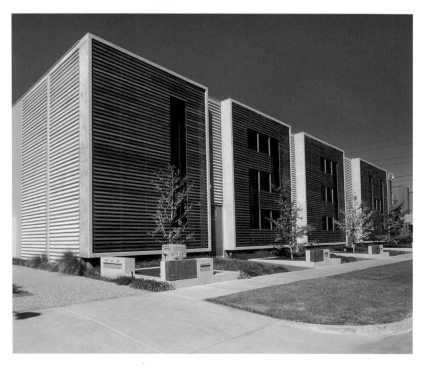

Lying on top of a building the clouds looked no nearer than when I was lying on the street..., Vancouver, Canada, 2009
Designer: **Liam Gillick** Materials: **Stainless steel** Type: **Helvetica Bold**
Liam Gillick's public-art piece wraps around two sides of the Fairmont Pacific Rim Hotel facade. The commission by Westbank and Peterson Investment Group is a valued addition to the city of Vancouver's public art collection. The artwork consists of a running line of tightly packed text: "Lying on top of a building the clouds looked no nearer than when I was lying on the street . . . " repeated on the facade from the fifth floor through the twenty-second. From street level, the letters reflect the surrounding structures and shifting colors of the changing Vancouver sky. Inside, the reversed stainless-steel letters spell words not immediately recognizable. Gillick is known for creating art that investigates the role of power in politics and commerce.

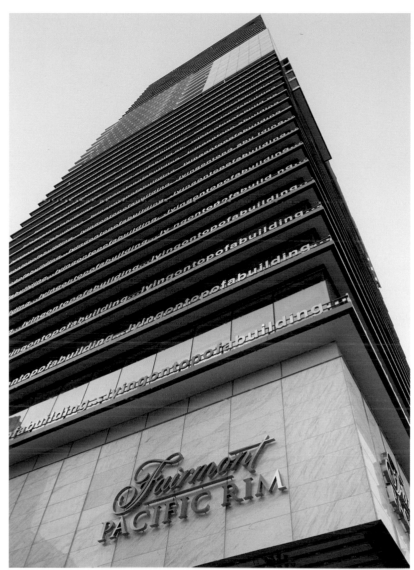

Number House Residence in Hozumidai, Hozumidai Ibaraki-Shi, Osaka, Japan, 2007
Designer: **Mitsutomo Matasunami** Photographer: **Mitsutomo Matasunami** Type: **White, 3-D, and extruded**
This is a mass-produced, prefabricated house commonly developed in rows of three or more. In many cases, explains Matsunami, the facades are changed at the owner's pleasure, resulting in rows of houses that do not match aesthetically. In order to overcome this chaotic mixing, he unified four units to appear as one building by transforming the balconies into the street number. It was a strong message to the town, he says. What's more, price competitiveness was maintained by cost-effective production. And no one will ever mistake this address for any other.

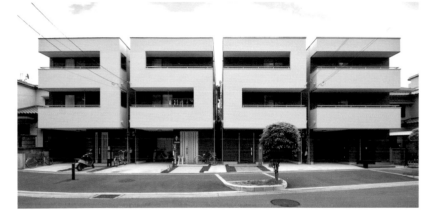

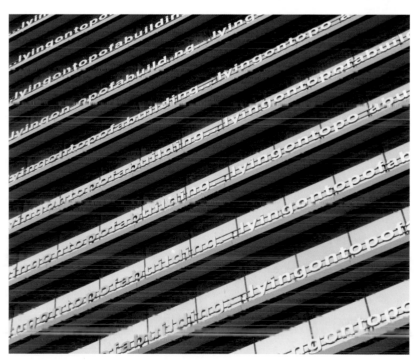

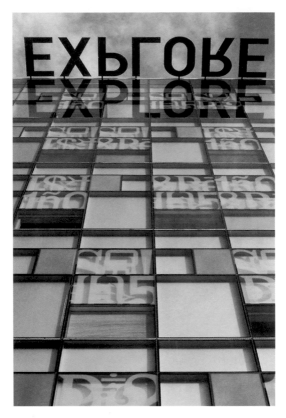

Lattie F. Coor Hall, Arizona State University, Tempe, Arizona, 2004
Designers: BJ Krivanek, Joel Breaux, Krivanek+Breaux/Art+Design,
Chicago/Lafayette, LA Photographer: BJ Krivanek Materials: Enamel
frit on tempered-glass curtain-wall units, waterjet-cut aluminum word
structure Type: DIN Shrift 1451 Mittelschrift and custom letterforms
and icon
This Arizona State University science building has two-dimensional and
three-dimensional typographic assets. The word "Explore" cantilevers
over the glass curtainwall, as though floating off the side. Krivanek
says its purpose is to reference "the social dynamics" between the
university and the community. As the sun skims the letters, they cast
either a shadow or reflection upon the facade, which varies in intensity
depending on the time of year and time of day. "Directed west to the
Tempe community, Explore is both an explanation of the university's
purpose and an invitation to the community, underscoring the societal
role of the university," Krivanek adds.

House of Terror Muesum, Budapest, Hungary, 2002
Designer: Attila F Kovacs Photographers: Janos Szentivani, Attila F
Kovacs
Material: Metal frame resopal covering
The House of Terror Museum building, one in a row of ordinary
nineteenth-century apartment buildings, was the headquarters of the
national socialist Arrow Cross Party (which murdered hundreds of Jews
during World War II), and afterward it was the headquarters of the feared
ÁVO (State Security Department). During the time it belonged to the
Arrow Cross, there hung a huge banner with pictures of Hitler and Il
Duce. When ÁVO took over the building, the windowpanes were covered
which thick white paint or tinplates. Now the museum is a monument
to the victims of terror—the facade was painted monochrome gray,
and the windowpanes were changed for nontransparent matte glass.
The original architectural structure was kept with a black passe-partout
added, composed by the new massive molding, which emphasizes its
historical relevance. These massive black blade walls are huge black flags
of mourning. When the sun is at its highest, the building is covered in a
big shadow, referring, says Kovács, to Arthur Koesler's key novel Darkness
at Noon. The logo of the museum and the letters of "TERROR" cast
different shadows throughout the day.

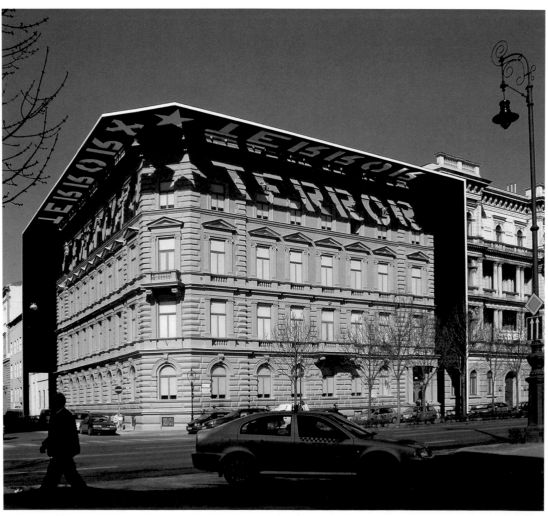

AEIOU, Wellington, New Zealand, 2009
Designer: **Catherin Griffiths** Material: **Steel** Type: **Based loosely on Verlag Extra Light**
Griffiths was commissioned to make a site-specific artwork for a new block of apartments with the practical objective of providing a screen of privacy for the residents and connecting to the street. Her idea was a series of metal rods she calls AEIOU, a typo/sound installation where passersby are able produce vibrating sound. The structure is a nod to the myriad accents and languages spoken on Cuba Street below. "The typography frees itself and wanders across disciplines," she says about the ethereal quality of the work. AEIOU is part of an ongoing series of installations (including Sound Tracks, 2011, and Fifth Movement, 2012) in which Griffith

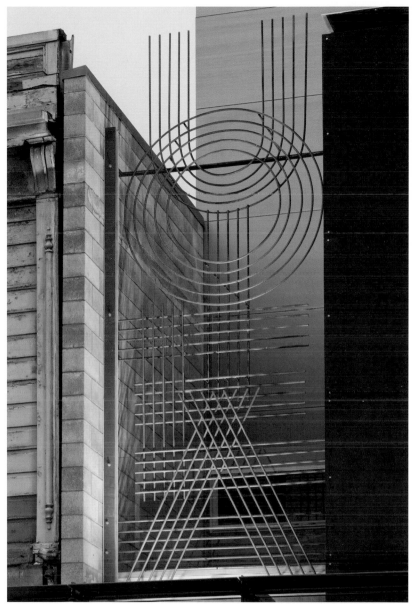

Fukutake House, Echigo-Tsumari, Niigata and Megijima, Kagawa, Japan, 2006–10
Art Director: **Masayoshi Kodaira** Designers: **Masayoshi Kodaira, Yukiharu Takematsu & E.P.A**
Photographers: **Kozo Takayama, Mikiya Takimoto, Keizo Kioku** Materials:**Wood, iron scaffolding**
Type: **Trade Gothic**
When Masayoshi Kodaira and Yukiharu Takematsu were commissioned to design an exhibition sign on a former elementary school, they did not take the easy route. Or did they? This idea was a continuation of the idea for a sign for an earlier exhibition, which was held in 2006. "We kept the letters, so that we could reuse them," says Kodaira. In 2009, the number 6 turned upside down to make 9. Two new galleries joined, "so I made new letters only for them," he adds.

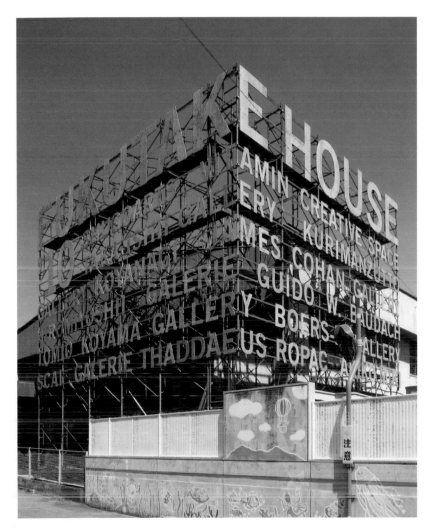

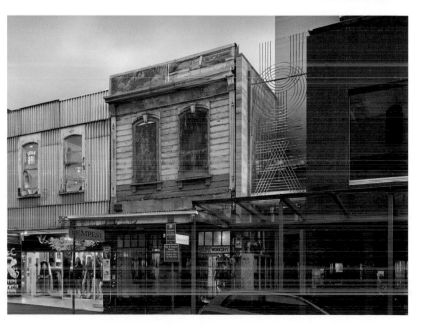

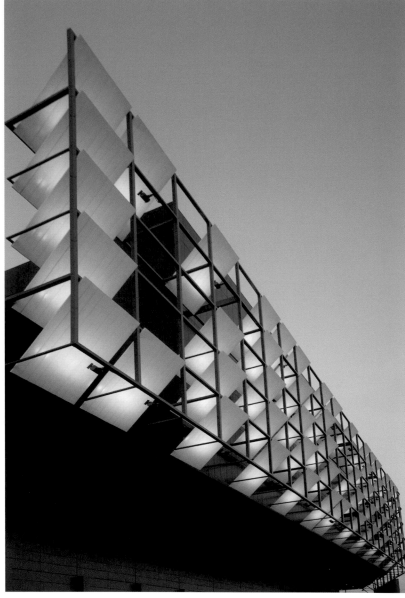

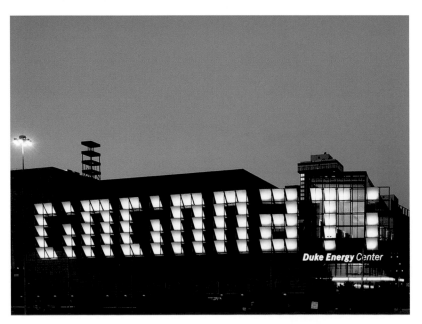

Duke Energy Convention Center, Cincinnati, Ohio, 2008
Designers: **Debora Sussnab, Hillary Jaye** Photographer: **J. Miles Wolfe** Materials: **Painted aluminum**
Duke Energy Convention Center has become a familiar landmark in the Cincinnati skyline with a sign that welcomes meeting delegates and visitors with an iconic series of glistening metal panels set at angles along the western facade of the new structure that gleam alongside Interstate 75, proclaiming C-I-N-C-I-N-N-A-T-I in fifty-foot-tall letters. Not exactly the grandeur of the HOLLYWOOD sign, but it's close enough and makes the point without ambiguity—at least, when viewed from far away. The metal space frame exterior treatment is visible across the Ohio River yet becomes more abstract the closer one gets.

Water Street Digital Clock, New York, New York, 1971.
Client: **City of New York**
Designer: **Rudolph de Harak** Photographer: **Eli Mergel, Alex Scott** Type: **Helvetica**
This display clock was an innovative addition to building facades when Rudolph de Harak designed it in the early 1970s. It belongs to the adjacent 200 Water Street, a 32-story building that was completed in 1971. De Harak's concept was to make financial district structures more human-scale. The clock consists of 72 square sections, each containing a number from 00 to 59. It displays the time by hour, minute, and second.

Hackney Empire, Hackney, London, England, 2005
Architects: **Tim Ronalds Architects** Photographer: **Hélène Binet**
Materials: **Terracotta, concrete, steel**

This building is part of the Hackney Empire, a variety theater designed by Frank Matcham in 1901. On the inside the building provides new public facilities. On the outside the theater has a newly renovated "showbiz" facade that reorients the building to face the adjoining town square. The giant letters (the largest of which is 3.6 meters high and weighs 3.5 tons and in typographic terms is over 10,000 point) appear to hang in space. The facade and its typography have become the graphic identity for the theater. The typographer and design historian Richard Hollis helped refine the lettering, and ensured that the letters were made of exactly the same materials as the decorative elements of the historic building and were truly massive. Made of precast concrete clad with terracotta, the letters were hoisted into place and supported on the slenderest of steel brackets.

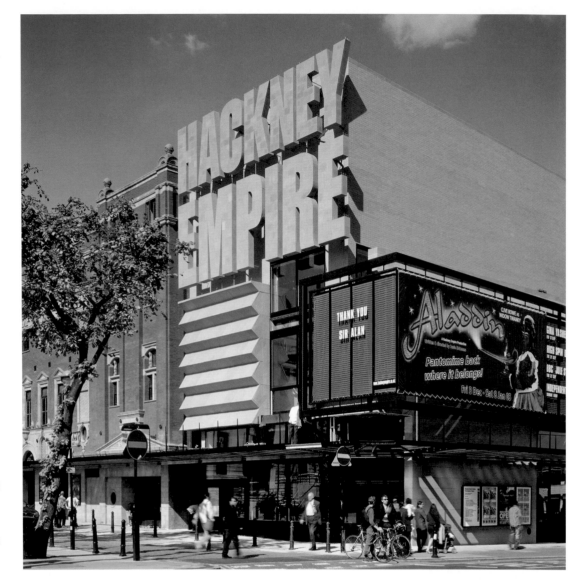

Commemorate, London, England, 2001-4
Designer: **Leanne Bentely** Photographer: **Leanne Bentely**
Type: **Trade Gothic, Bold**

Leanne Bentley became very disheartened at the increasing numbers of shops and venues closing around the U.K. due to the recession and the rise of online shopping and entertainment. "Each shop would be covered in chipboard and left for months on end, attracting vandalism and contributing to a rundown area," she says. It occurred to her that these chipboard hoardings had potential to convey a message: to act as a forum for the local community to discuss their memories of the building as it once was. Each empty window and door became a typographic message board designed to draw interest—not graffiti.

Liebe Lili (Dear Lili), Offebach am Main, Germany, 2010
Design: **Markus Bernatzky,atelier himmelbraun; Fabian Thiele, Light:Tools** Photographer: **Irina Zikuschka**
Materials: **Styrofoam, wood, light** Type: **Plamo.**

For the Luminale 2010, atelier himmelbraun was invited by the CEO of Ikarus Design Handel to design an installation in his garden park, which is 200 centimeters wide by 360 centimeters high. Surrounded with a fence, the park has two little towers with three windows each. In 1775 Johann Wolfgang von Goethe met the seventeen–year-old Anna Elisabeth "Lili" Schönemann in this park. They fell in love and soon got engaged. But Goethe, who was twenty-six years old, was restless and left for Italy, leaving Lili after only a few months. Texts for the panels created to fit in these towers were excerpted from Goethe's poems about this romance, while other phrases are memories written and preserved in letters to his friends.

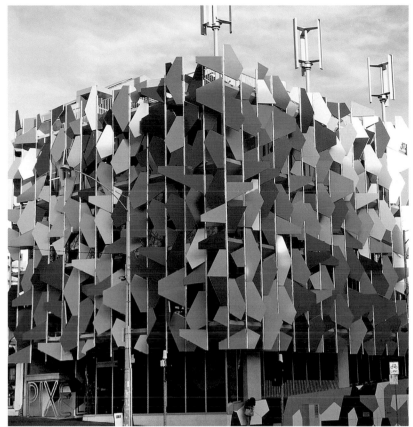

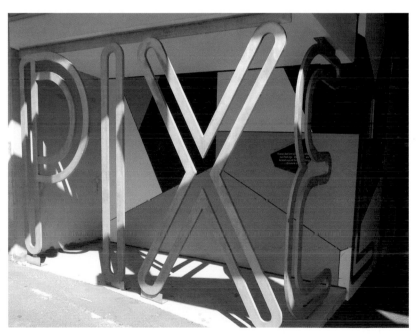

Pixel Building, Melbourne, Australia, 2010
Designer: **Grocon** Photographers: **Katherine Lim, Martin Rowland, Dominique Falla**
Grocon's carbon-neutral Pixel building is not just a colorful folly. Its typographic and decorative facade reveals announces an innovative building technique. Pixel is designed, says Grocon's CEO Daniel Grollo, on the firm's website, to offset all of the carbon used in its construction by generating energy back to the grid. The photovoltaic panels on the roof and wind turbines are meant to capture power for the building and uses rainwater too.

Lowther Primary School, Phases 1 and 2
North Barnes, London, England, 2009–12
Art Director: Patel Taylor, Sam Selencky Photographer: Charlotte Wood,
Phase 1; Timothy Soar, Phase 2. Materials: Laminated plywood, with
oak veneer
The "Lowther" lettering works on various levels. It creates new teaching
space as well as serving as a new entrance to the school. "The lettering
was a key part of the overall project in terms of announcing the
confidence and intent of the school to the community, and engendering
a sense of identity," says Taylor. Architecturally, the lettering forms the
first of a series of touchstones that guide visitors through the building.
It also supports the canopy, which stitches the new and old buildings
together and creates a screen for a store behind. The lettering has been
designed with the scale of the child in mind, and the chunky laminated
plywood brings a very tactile quality. It has therefore become part of the
children's playscape.

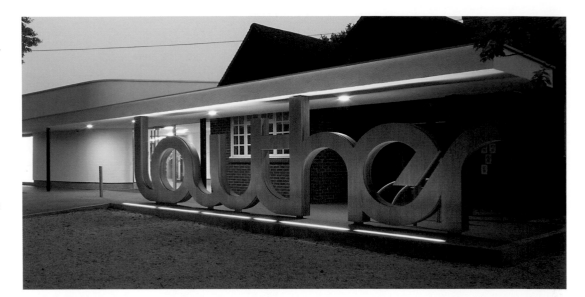

Museo Bellas Artes Castellón, Castellón, Spain, 1998-2000
Architects: Emilio Tuñón, Luis M. Mansilla Photographer: Javier
Gutiérrez Marcos
The roof of the Museu Bellas Artes is not held up by the letters spelling
"museu" but the super-sized word certainly holds the concept of
the building together as it signals an an unambiguous message. The
architects wanted the building to be a kind of Roman sphinx in which the
"treasures of the city."

Even, Rotterdam, The Netherlands, 2007
Designer: Marc Ruygrok Photographer: Marc Ruygrok
Material: Mirror-polished stainless steel
This typography is a public art piece that literally supports an apartment
building by Arons and Gelauff architects of Amsterdam. "EVEN" means
"a very short moment" in Dutch. There is more than a hint of irony in
designing the word "EVEN" to support the building permanently.

MInneart Building, Utrecht, The Netherlands, 1997
Architects: Neutelings Riedijk Architecten
Photographer: Sieneke Toring, Mark Van Raai
The Minnaert Building's bold, red-painted concrete, wormlike wave
pattern exterior, complimented by the giant letters spelling "Minnaert"
on the ground floor is hard to miss. The letters occupy one entire story,
and while not structural, give the impression a weight-bearing structure.
The Minnaert building, designed by OMA, is within the De Uithof campus
of the Utrecht University.

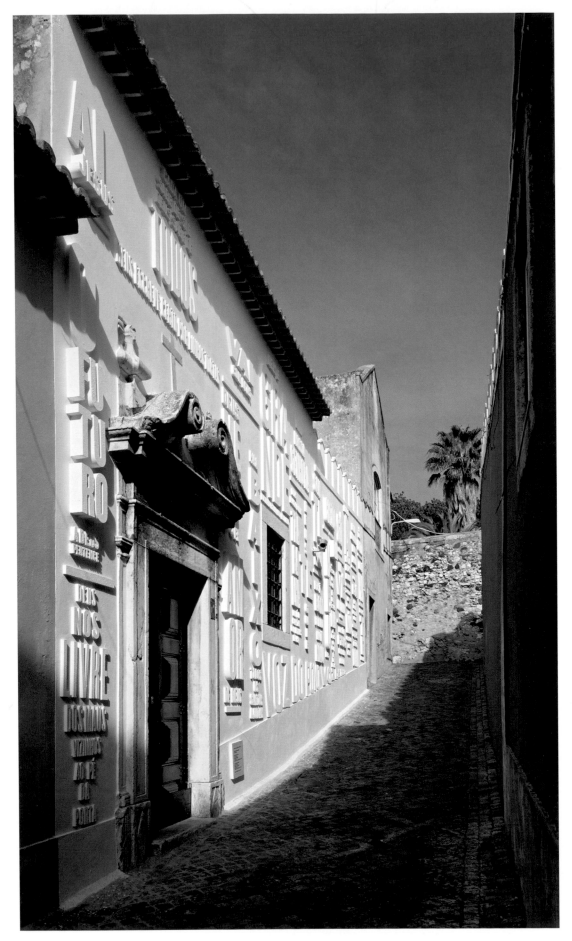

Vai com Deus (Go with God), Lisbon, Portugal, 2008
Designers: **Artur Rebelo, Lizá Ramalho** Photographer: **Fernando Guerra**
Materials: **Hydrofuge MDF** Type: **Knockout.**
The church of Nossa Senhora da Conceição was built in Lisbon in 1707.
When it reopened in 2008 as a gallery, owner asked Artur Rebelo and
Lizá Ramalho to develop a way to promote its new purpose. "One of the
things that fascinated us was the chapel's original function as a place
of worship," Rebeko writes. "The dual presence of divinity and popular
culture led us to play with idiomatic expressions in the Portuguese
language that refer to God." The popular expressions they selected
highlighted the diversity of words and proverbs that are repeated
as though by rote—expressions like "God is good and the Devil isn't
so bad" or "God save us from the bad neighbors on our doorstep."
Composed with the Knockout typeface in the same color and texture as
the background, the tactile letters and words are coming out from the
chapel's wall.

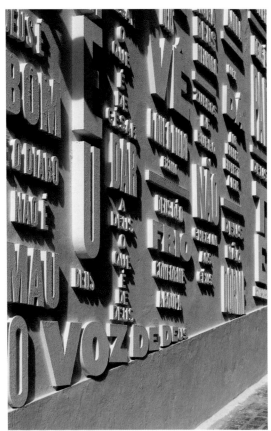

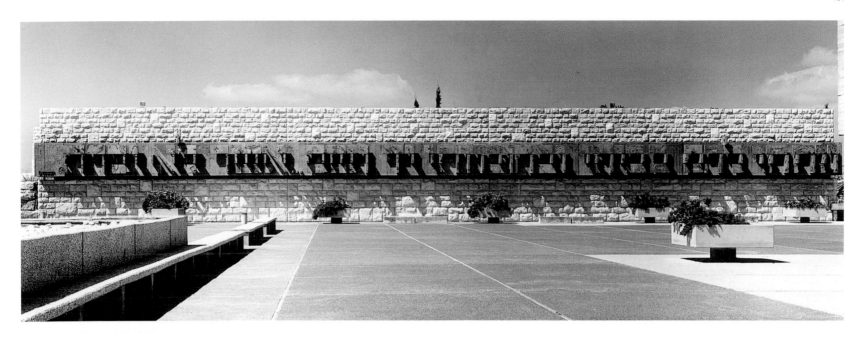

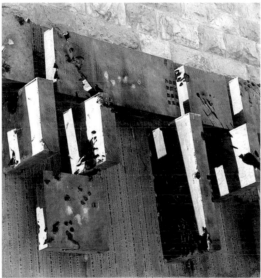

Yad Vashem, Yad Vashem Holocaust History Museum
Jerusalem, Israel, 1979
Designer: Dan Reisinger Material: **Sand-cast aluminum**
The Yad Vashem Holocaust History Museum allocated a building to
house the names of those who perished in the Holocaust. The quotation
from Isaiah, chapter fifty-six, verse five, was chosen for the stone facade
of the building: "And to them will I give in my house and within my
walls a memorial and a name [Yad Vashem] . . . that shall not be cut off."

Reisinger designed this verse out of two modular units measuring
100 by 50 by 10 centimeters and 50 by 50 by 10 centimeters, sand cast
in aluminum covering the full length of the facade, which measures 50
by 20 meters. The modules create letters/words that are legible from a
distance. However, as the visitor approaches the building, they lose their
legibility and break up into abstract shapes signifying the disintegration
of European Jewry during the Holocaust.

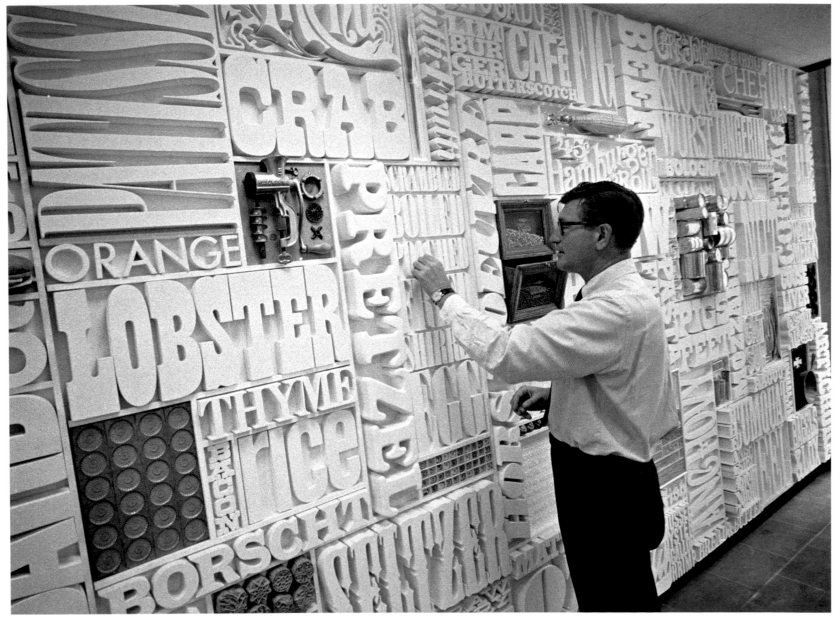

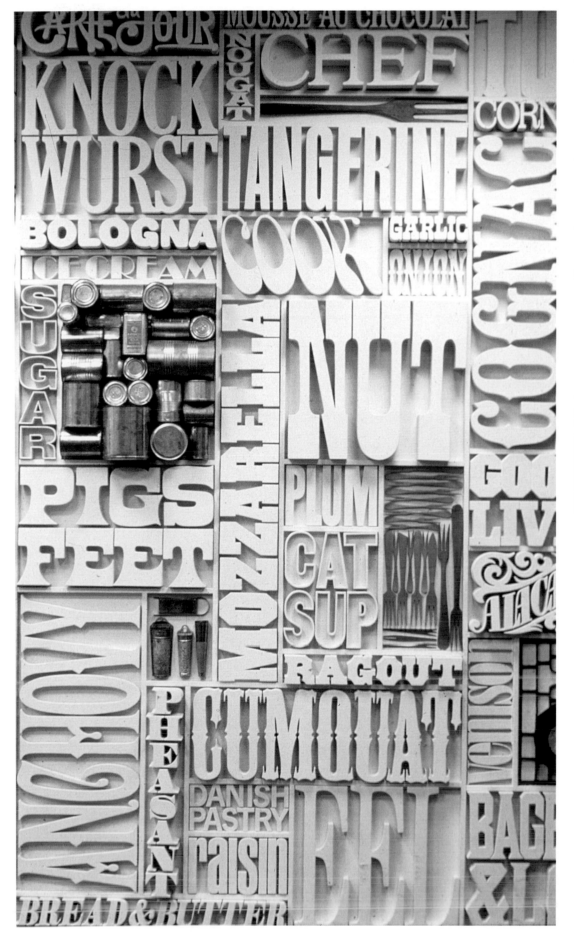

Gastrotypographicalassemblage, CBS Cafeteria,
New York, 1966
Concept/Design Director: **Lou Dorfsman** Designers/Typographers: **Herb Lubalin, Tom Carnase** Photographer: Eugene Cook
Known as "the wall," Gastrotypographicalassemblage is 33 feet long and 8 feet high, featuring a melange of food-related words and objects—a perfectly orchestrated collage of appetite. The type was custom designed by Herb Lubalin and Tom Carnase, and the wall contains almost 1,500 individual characters. The wall was a fixture in the CBS Black Rock building designed by Eero Saarinen. "There are few pieces that represent the typographic and design spirit that illuminated that moment of history, and certainly none on a scale as ambitious," wrote Milton Glaser. Dorfsman was the director of design for CBS at the time. Upon hearing the interior design plans for the new cafeteria, he offered an alternate solution that envisioned a wall of solid type, similar to a typesetter's typecase.

Centro de Ciência Viva, Lisbon, Portugal, 2008-10
Art Director: **Nuno Gusmão** Designers: **Giuseppe Greco, Vera Sacchetti, Miguel Matos** Photographers: Foyer: **ACF** (construction, installation and lighting), **Demetro a Metro** (Signage); Entrance: **Eurostand** (colored acrylics), **Demetro a Metro** (Signage). Materials :Foyer: **Cnc cutted and lacquered panels, acoustic panels (climavert), led lighting, vinyl film for the signage**; Entrance: **coloured acrylics, coloured translucent vinyl for the windows, and opaque vinyl for the signage** Type: **OCR-A (by American Type Founders)**

Centro de Ciência Viva (Science Alive), a science museum in Lisbon, started with design of the foyer to create a perforated wall with acoustic and lighting. The theme of the project is ASCII (American Standard Code for Information Interchange), representing a means of sharing information. The design involves different pattern densities "with bigger or smaller cuts, acoustic percentages and the openings in the window areas of the rear rooms were managed," note the designers in their brief. LED white lighting between the wall and the SKIN was balanced with natural light and the enormous signage is repeated on the floor and on the walls. The type used, OCR-A, is the natural choice because it is a typeface used by computers..

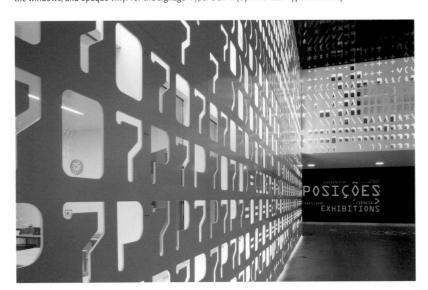

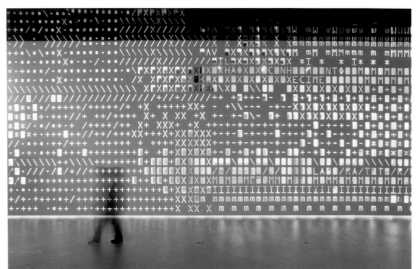

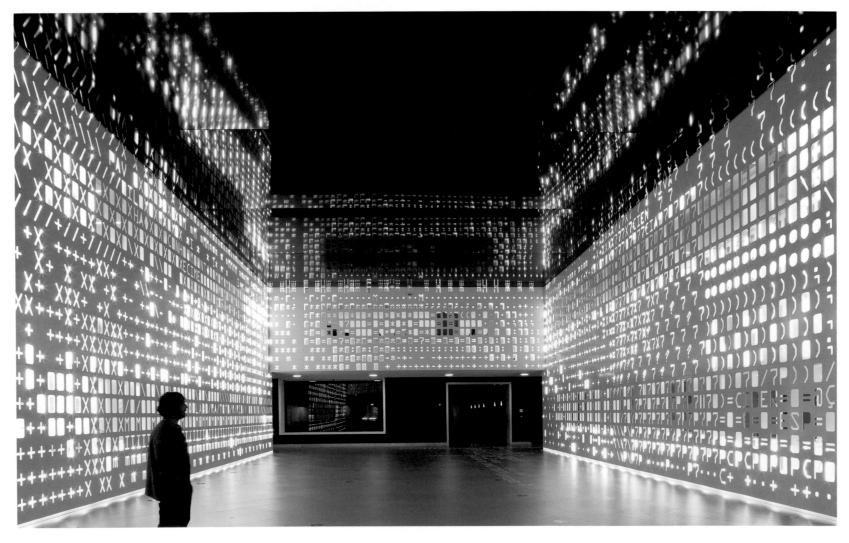

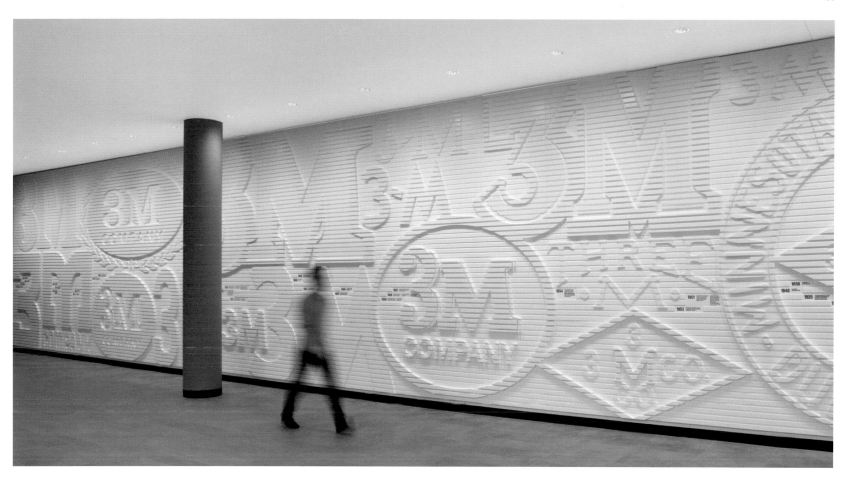

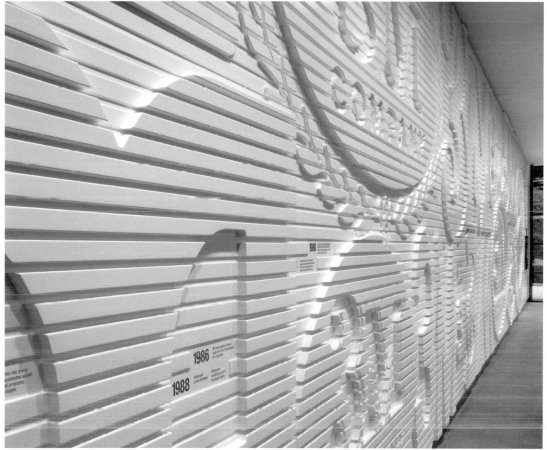

Project Vitality—3M Heritage Wall, Sydney, Australia, 2013
Client: **3M Australia**
Designer: **Jon Zhu** Creative Director: **Paul Tabouré**
Photographer: **Simon Hancock** Materials: **50mm routed MDF with 2pac
finish** Type: **Helvetica and others.**

John Zhu developed a branded environment that celebrated 3M's "storied
heritage of landmark innovations as well as tell the interesting tales of
the engineers and inventors behind each and every one of them." While
exploring the 3M archives Zhu's team unearthed a long history of graphic
symbols and logos and produced a graphic evolution of the corporate
logo spanning the entire wall. The logos were routered into horizontal
slats, at various depths, to take advantage of the natural light in the
foyer space.

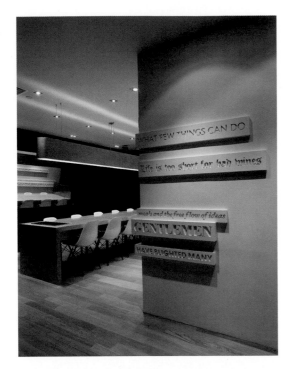
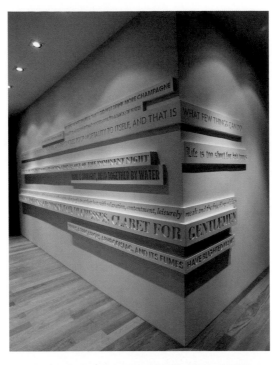

Artisan Cellars, Singapore, 2008
Client: **Artisan Cellars**
Creative Director: **Chris Lee** Design Director: **Cara Ang**
Graphic Designer: **Yong**
Quotes about wine and wine drinking were engraved into wooden blocks
and painted white to add subtle textures to the clean interior.

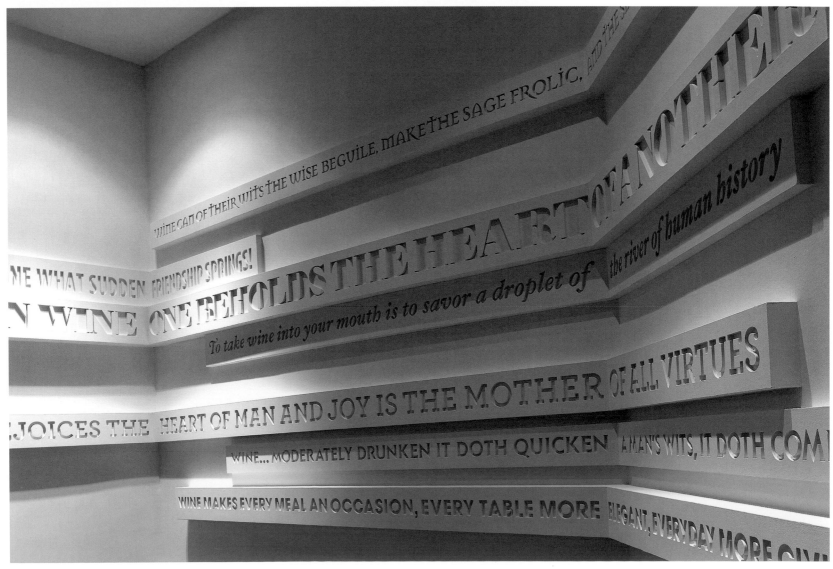

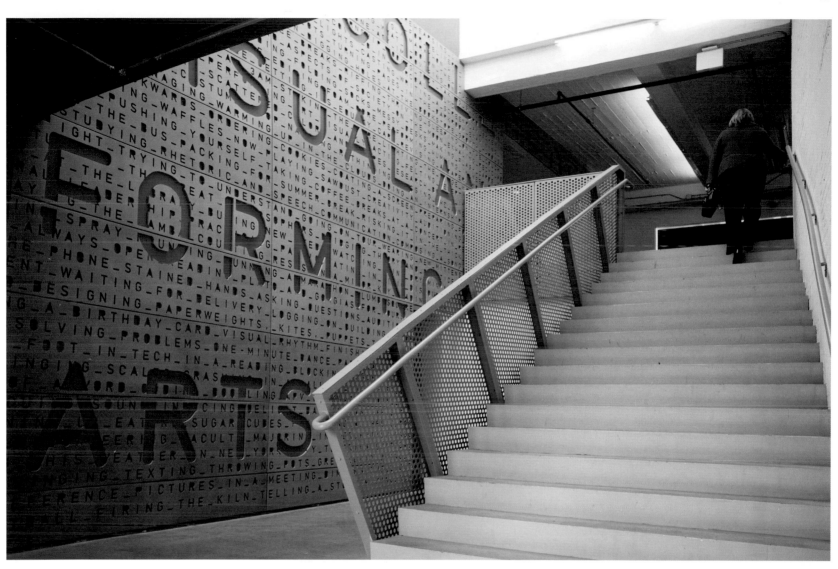

Syracuse University Ribbon Wall, New York, 2009
Client: **Syracuse University, College of Visual and Performing Arts**
Art Director: **Cheryl Towler Weese** Designer. **Brian Watterson**
Photographer: **Studio Mercury** Type: **DIN 16**
Syracuse University's design programs are located in a warehouse in downtown Syracuse, New York Weese and Watterson collaborated with the architects Fieldler Marciano to design a wall that runs from the exterior to the interior of the building. The lettering is comprised of Twitter-like texts collected from students, faculty, staff, and the community describing the school and individual activities.

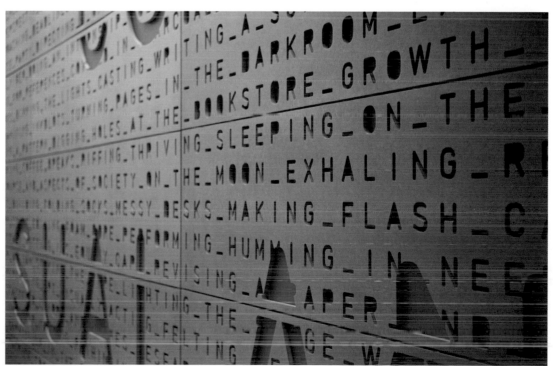

U Heeft Tien Bewaarde Berichten (You Have Ten Saved Messages), Amsterdam, The Netherlands, 201.
Designer: **Martijn Sandberg** Photographer: **Martijn Sandberg** Materials: **Polished stainless steel.**
On a concrete wall in the entrance hall of the Synagogue LJG in Amsterdam, this polished metal typographic sculpture reflects sunlight into the entry hall through a roof window. The tints and reflections of the surroundings change in the mirroring surface. The contours of letters become visible, a message from above materializes, "Over and over again, a vision for now and forever more," says Martijn Sandberg, "'You have ten saved messages'."

Forever Young, OSG Singelland, Drachten, The Netherlands, 2005
Designer: **Martijn Sandberg** Photographer: **Gert Jan van Rooij** Materials: **Point relief cast, plaster**
A kidney-shaped school building was constructed on the roofed-over central square of the OSG Singelland College in Drachten. Sandberg created a piece of typographic artwork that conforms to the architecture. A line of text covers the entire circumference of the building so that the beginning and end touch each other. Each new text line is displaced relative to the one above, and dynamic images are created of new word combinations. Sandberg notes "The rhythmic repetition of a lyric, sampled ad infinitum" and a refrain spreads over the pavilion's skin that reads: "Sleep All Day, Party All Night, Forever Young, Never Grow Old."

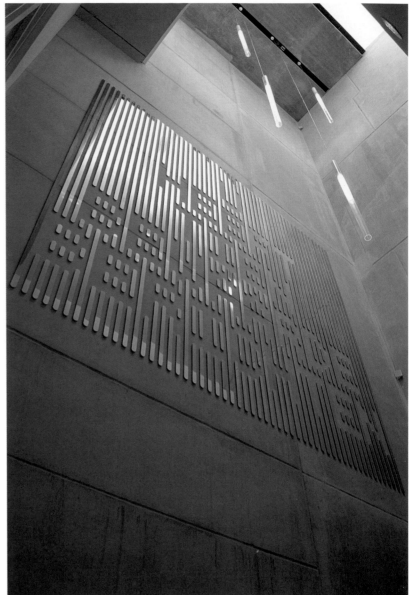

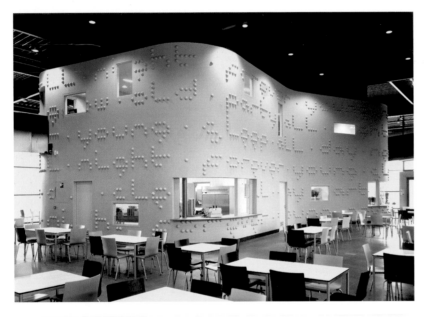

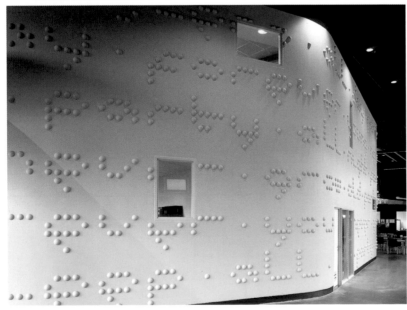

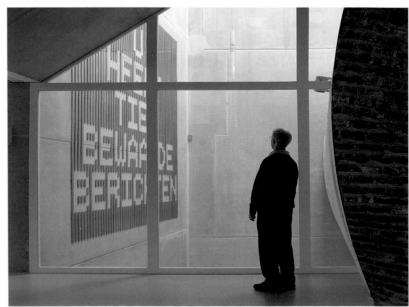

Big Type Says More, Museum Boijmans van Beuningen, Rotterdam, The Netherlands, 200.
Designers: **Ryan Pescatore Frisk, Catelijne van Middelkoop**
Photographer: **Strange Attractors Design.** Materials: **Handcut honeycomb cardboard, plack paint, micro controllers, LEDs**
The designers manually produced a typographic installation as part of the ongoing exhibition Cut for Purpose. The typography beckons the viewer from the windows and glass entrance. Upon seeing the work, passersby are presented with what the Museum Boijmans van Beuningen calls a "complex, yet graceful forms, merging contemporary technology with traditional craftsmanship while representing the diverse, multicultural, and architectural city of Rotterdam."

Letter Furniture SET 26, Sulgen, Switzerland, 2004
Designer/Cabinetmaker: **Erich Keller** Photographer: **Reinhard Fasching**
A full set of twenty-six letters, as well as a + and period, is designed as
functional and aesthetic furniture. These letters are storage devices or
partitions. The five drawers in each letter offer space for storage. There
is also an opportunity to move the letters and create personal messages.
The Set 26 was designed for home, office, and stores.

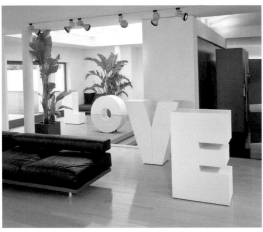

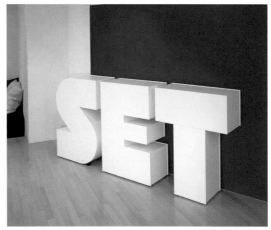

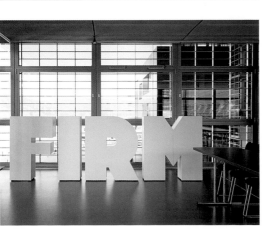

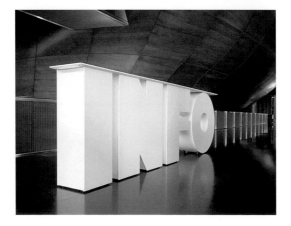

"Eames Words," Architecture and Design Museum, Los Angeles, California, 2011
Designers/Curators: **Deborah Sussman, Andrew Byrom** Architects: **Todd Erlandson, Lara Hoad**
Photographer: **Clark Dugger, William Larsen** Materials: **E shelving and M stucture constucted in MDF, other lettering in flat vinyl** Type: **Din**
The "Eames Words" exhibition was part of the Getty's Pacific Standard Time initiative. The Architecture and Design Museum is directly opposite the Los Angeles County Museum of Art, whose contribution to the initiative was the epic "California Design 1930–1965" exhibition. The exterior glass elevation of the A+D Museum was utilized to "shout" across Wilshire Boulevard to LACMA visitors and to introduce them to this more focused exhibit. The glass facade features the word "EAMES," designed by Andrew Byrom in eight-foot-high black letterforms. Visitors enter and exit through doors featuring the letters A and S; the letter M extends onto the pavement outside, while both the letter Es extrude into the museum space—creating three eighteen-foot-long display units.

Lessness, Paris, France, 2003.
Artist: **Ugo Rondinone.** Photographer: **Marc Domage.** Materials: **Plexiglass, speakers, audio system.**
The big X marks the spot for Ugo Rondinone, a Swiss born New York artist, who is known for working with typographical messages. At such a large scale the monolithic X is an evocation of the power of letters to communicate one-at-a-timte.

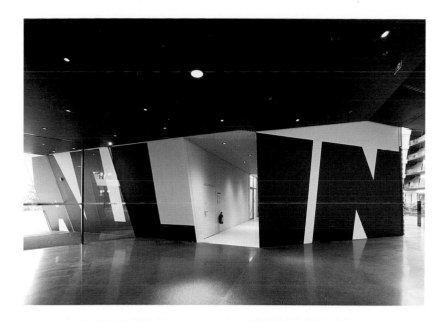

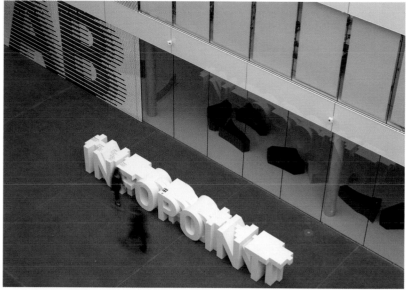

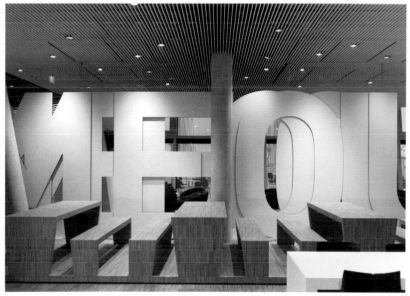

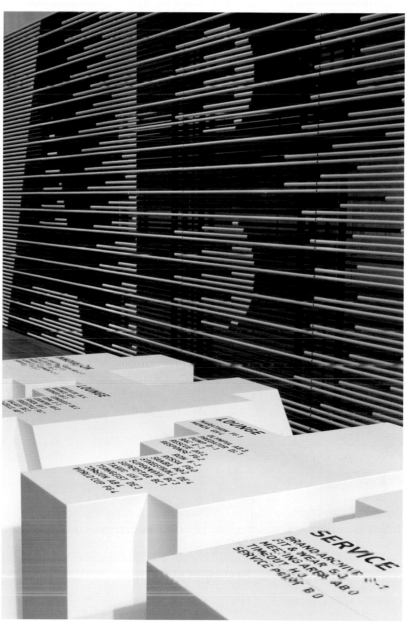

Adidas Laces, Herzogenaurach, Germany, 2011
Interior design: **Zieglerbürg, Büro für Gestaltun.** Architecture: **Kadawittfeldarchitektur**
Photographer: **Nob Ruijgrok** Type: **Adihaus, custom**

Kinetic typography is a key feature throughout the new Adidas Design Centre. The typeface of the signage system is described by Adidas as "fast and light, it leaps and bounds across walls and balustrades." Laces is dedicated to development and design; In the meeting areas a mural of white lettering suggests words frozen in mid-movement. On the glass balustrades of the walkways in the interior of the building, the letters appear to have been stamped into transparent gauze. In certain locations the letter forms became even more abstract Walls meant for wayfinding are painted blue, red, yellow, green and black. Suspended walkways cross the atrium space, "lacing" the building's structure together like the laces of a sports shoe. The corporate typeface, a variation on ff Din, is dynamically varied and creates a dynamic effect of shimmering characters. Throughout, an alphabetical code is displayed at the entrances of the departments.

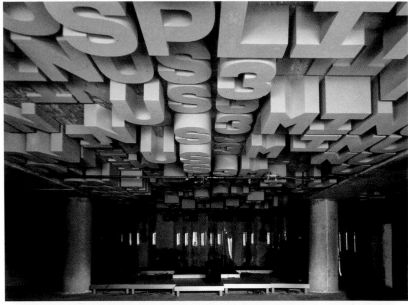

Minus3, Split, Croatia, 2012.
Designer: **AD/D/T Damir Gamulin** Photographer: **Damir Gamulin, Viktor Popović** Materials: **Styrofoam, paint, concrete milk cover** Type: **ZHdK (by Claudio Barandun)**
Dimensional letters hung from the ceiling provide both meaning and texture. The block letterforms capture light that produces surreal shadows and textures.

16AOUT Complex, Minamiaoyama Minato-ku, Tokyo, 2012
Client: **Twenty-One Planning Inc.**
Interior Designer: **Masaru Ito** Photographer: **Kozo Takayama** Material: **Mortar, glass mosaic tile**
16AOUT COMPLEX is a multi-brand boutique with a theme: melange. The shop boasts a wide selection of products from around the world, including fashions and furniture. Their motto is "Everything in the shop is an article for sale except sales clerks." The space is as edgy as the concept. The walls shine and fixtures are quirky. Inside the store, the name "16AOUT" is spelled in large aluminum letters finished with rivets, a sign that serves to both identify and distinguish the sales area.

Cursing Stone and Reiver Pavement, Tullie House Museum and Art Gallery, Carlisle, England, 2000
Designer: **Why Not Associates, Gordon Young** Material: **Granite**
Type: **Bembo**

In 1525 the Archbishop of Glasgow, Gavin Dunbar, put a curse upon the Border Reivers, in an attempt by the Church to stop violence by the robbers and sheep rustlers who terrorized the borderlands between England and Scotland. "The Monition of Cursing" is a wonderfully passionate piece of medieval language. "Finding the curse inspired me as my part of the city's millennium project," says Gordon Young, who was born in Carlisle. The granite boulder, which originally weighed fourteen tons, was found in Scotland. Even before installation the stone was called a "shrine for devil worship" and blamed for local disasters.

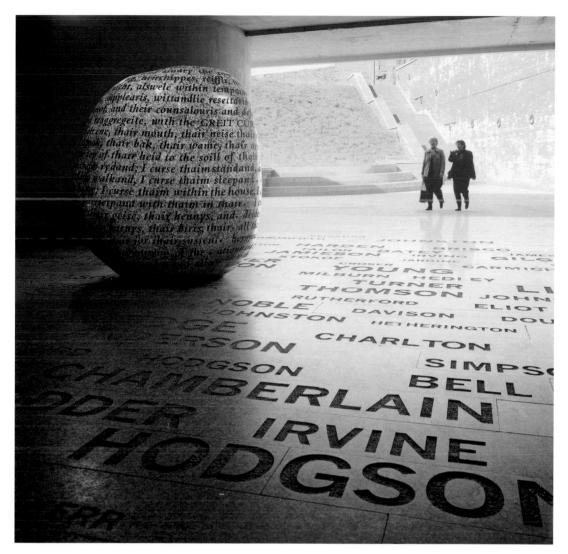

Verse, The William Oxley Thompson Library, Ohio State University, Columbus, Ohio, 2011
Designer: **Hans Cogne** Architect: **George Acock (Acock Associates)**
Photographer: **Fredrik Marsh.** Materials: **Two Colors Cork.**
Type: **Gotham HTF.**

This is a two-color cork floor laid as a field of words set in relief and located in a library reading room. The text is created by an alphabetic intersection and line-by-line weaving of three different accountings of world history that are arranged in a literary concordance. The spine along the north-south axis is composed of 299 words in alphabetic order and adapted from "The End of the World"—a White River Sioux tale. The east-west lines of text intersect this story with prose fragments from *A Little History of the World* by E. H. Gombrich (1936) and *Mirrors: Stories of Almost Everyone* by Eduardo Galeano (2009).

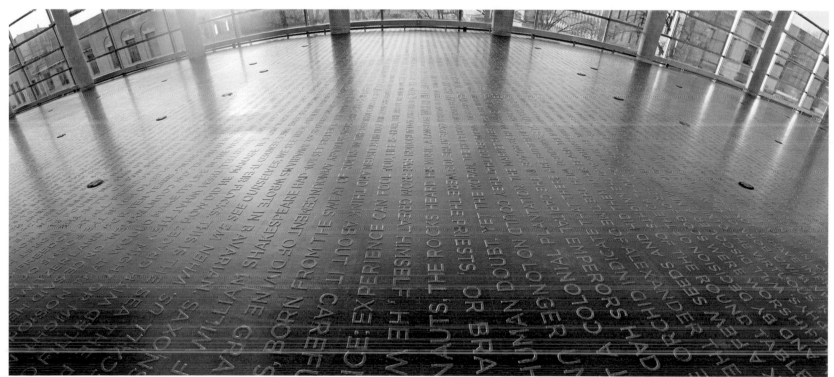

Pablo Picasso, **Table with Bottle, Wineglass, and
Newspaper**, 1912
Pasted paper, charcoal, and gouache on paper
Musée National d'Art Moderne, Centre Pompidou, Paris. Gift of
Henri Laugier

A typeface is the outcome of aesthetic decisions
and meticulous calculations. A typeface's
acknowledged function is a vessel of meaning
and a conveyer of thought, not the actual meaning
or thought. A typeface must be, above all else,
readable and unobtrusive—unless its function
demands bold display.

Art is the essence of creative alchemy. It can
be almost anything or a single insightful, inspired
manifestation that magically materializes when least
expected. It can be opaque or transparent, dark or
light. It can say something personal or universal.
Using these definitions, a typeface is not art, but
typefaces are used to make art. Artists are treating
typography as a medium for expression, like oil paint
and watercolor, pencil and pastel, marble and clay.

Typographic installations, paintings, sculptures,
and all manner of hybrid forms aggressively push
the accepted notions of what art is. Since type and
lettering are quotidian and linked to commerce, it is
often difficult to understand the artistic merits of
artworks that are either driven by or composed of
type and typography as forms of personal expression.
Of course, text is nothing new to art—Pablo Picasso,
Juan Gris, Kurt Schwitters, Hannah Höch, Marcel
Duchamp, and many other early-twentieth-century
artists included disjointed fragments of printed
pages in their works. Sixties Pop Art appropriated
commercial brands and logotypes, while Fluxus

and other conceptual art movements blurred the
boundaries between art and text. It was Barbara
Kruger (as well as Jenny Holzer, Ed Ruscha, Lawrence
Weiner, Sol LeWitt, Joseph Kosuth, and others) who
cast typography in a leading role rather than as a bit
player in art.

Composed of satiric epigraphs and ironic
slogans and images, Kruger's typographical gallery
installations, outdoor billboards, and environmental
supergraphics (pages 200, 201, 202 and 203) were
typeset in Futura Bold and other stark Gothic
typefaces. They covered walls, floors, and ceilings,
buildings, bridges, fences, stairways, and buses and
trucks, paving the way for typographic artworks to
flourish in virtually every environment. Influenced by
advertising and magazine design (she was once an art
director at Condé Nast), her work is stark in display
and intimidating in its disregard for the conventions
of art as a framed canvas on a wall.

Filling a gallery's walls, floor, and ceiling with a
common, everyday typeface letters was not entirely
novel when Kruger began. Artist Stanisław Dróżdż
created Między (Between) (page 204) in 1977 at
the Foksal Gallery in Warsaw, Poland, based on his
observation of a common fly darting around a train
compartment and landing on different surfaces.
This was a perfect early example of how letters
could be introduced as a metaphor for something
else. By 2010, when artist Pascal Dombis created

Text(e)~Fil(e)s in the Galerie de Valois at the Palais-
Royal in Paris, the covering of huge interior spaces
with type was well practiced but still awesome at
such a large scale. "Dombis's piece is a 252-meter-
long floor ribbon, on which thousands of text lines
(from literature, poetry, philosophy, and more)
related to the history of the Palais Royal appear
at different scales," notes the artist's website. The
temporary installation invited visitors to stroll across
text in about twenty different fonts that he believed
related to the original typefaces in which they could
have been published (e.g., Garamond for Voltaire,
Futura for Walter Benjamin).

Not all type treatments are as massive or
overpowering as the majority of pieces shown here.
For example, Ryo Shimizu's 2011 CNJPUS TEXT (page
193) involves thousands of tiny characters—and
for a good reason. Shimizu's installation, which is
created using an alphabet of "converted characters"
that borrow from Chinese characters with some
strokes deliberately missing, is a set of phonograms
and ideograms. Shimizu uses Chinese characters
that are identified with a venerable aspect of the
Japanese character, insofar as something from the
outside world is emulated, experienced, adapted,
and improved for the Japanese people and locale.
The text is full of allegories that are derived from the
Shimizu's memories, dreams, and experiences.

Now that graphic design is no longer persona

A - R - T I N

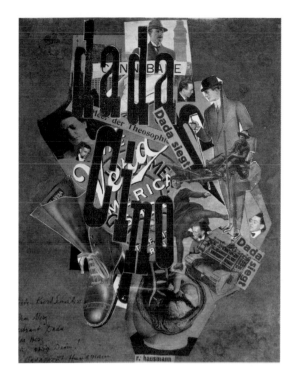

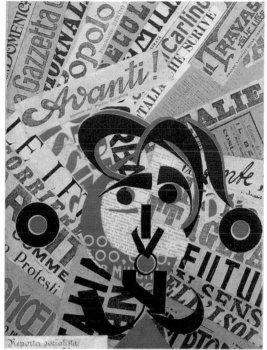

Raoul Hausmann, **Dada-Cino**, 1920
Photomontage
Private collection, Switzerland

Angelo Rognoni, **Reporter Socialista**, 1921
Collage
Private collection

non grata in galleries and typographic art is an accepted genre, creating big letters is not enough to satisfy the creative gods. Exploring unique materials is key, as is finding inventive ways of composing work within unpredictable environments. Graphic designer Stefan Sagmeister has found a variety of counterintuitive materials for assembling his personal pronouncements—they include masking tape, garbage bags, plumbing pipes, and ripening bananas, the centerpiece for his 2008 exhibition at Deitch Projects in New York (page 210). Sagmeister created a wall of ten thousand bananas. Green bananas created a pattern against a background of yellow bananas spelling out the saying "Self-confidence produces fine results." After several days the green bananas ripened. Now in yellow, the words disappeared. When the yellow background bananas ultimately turned brown, the words reappeared briefly, only to disappear forever when all the bananas turned brown.

Quirky materiality also played a role in Thonik's project for the 2008 exhibition "Out There: Architecture Beyond Building" (page 211). The group responsible for overall identity, interior plan, and graphic design; the result was a design for the 380-meter-long corderia at the 11th Architecture Biennale in Venice. Thonik chose to link presentations by architects through three-dimensional sculptures. Walls of black and white elements and a globe visualized key words printed in the exhibition catalog.

When looked at from different angles the work paid homage to Venice itself. Thonik's results, like so much typographic artwork, are more hybrid sculpture than graphic design.

Traditional sculpture and type are more closely related than one might suppose. A typeface is a miniature sculpture. Cutting metal punches or carving wood type is sculpting. Yet a typeface is the embodiment of language, the conveyor of messages; a sculpture is the message. Often a piece of sculpture will have grafted on it a lettered inscription or label, which serves as dedication or explanation. When the two components are seamlessly wed—when typography is the sculpture—then the fusion of form and content occurs.

A true typographic sculpture should be entirely on its own, making its own integral statement unfettered by any other relationship. This does not mean typographic sculpture is art for its own sake. During the early twentieth century, tenacious designers played with volumetric letters either as the basis of a total structure or as its sculptural veneer. The Italian Futurist and advertising artist Fortunato Depero proposed in 1933 that his client, Campari, build a pavilion formed by molding in concrete the repeated words "Campari" and "Cordial"; the exaggerated dimensions of the letters resulted in dynamic lines and patterns that gave Depero's concept a sculptural quality. The Campari structure

was somewhat based on his 1927 Bestetti Tumminelli Treves book pavilion, a main portion of which was composed of words and two stand-alone type totems that read vertically: "Treves" and "Libro." If the book pavilion seems like a folly, it was, but a marvelous one (he failed to convince Campari to build his pavilion).

But the reigning paragon of typographic sculptural monumentality is and always will be Robert Indiana's 1964 LOVE. Although not the first usage of mammoth lettering, or even the first time Indiana used short, pithy words as the basis of artwork, it became the standard by which to judge subsequent typographic monuments. By simply balancing the word "LOVE" on two lines and skewing the position of the "O" just a little, Indiana created a puzzle that all could solve, which became a logo of affection, every bit as memorable as Milton Glaser's "I [heart] NY."

The trail was blazed for type sculptors like Nils Wad, who in 1993 created Helvetica I (page 214), a stainless-steel tower of letters that spells Skulptur, produced for an art competition in Oslo, Norway. Set in the typeface Helvetica, each of the letters is tipped and skewed, forming a somewhat jumbled word in order to "give the sculpture a certain touch of alienation," Wad says. Instead of alienation, engagement is the aim of a typographic sculpture by Emily Campbell. Her mission with her brushed and

T - Y - P - E

Soggetti, **Avenue**, 1921
Watercolor, 27 by 37 cm

Ed Rusha, **OOF**, 1962
Oil on canvas
The Museum of Modern Art, New York. Gift of Agnes Gund, the Louis and Bessie Adler Foundation, Robert and Meryl Meltzer, Jerry I. Speyer, Robert F. and Anna Marie Shapiro, Emily and Jerry Spiegel, an anonymous donor, and purchase.

polished stainless-steel 2005 Love Ties for Hanley Park, Stoke on Trent, England, was, she wrote, to "entangle the viewer in an experience that can be either celebratory or tragic." Quotations from real love letters cascade down stairs, hug islands in a boating lake, and culminate in huge dimensional Times New Roman letters large enough to sit in and write a love letter.

Typographic sculptures impact the environments they inhabit in many different ways. Made of steel painted with polyurethane enamel, Claes Oldenburg and Coosje van Bruggen's 1993 Bottle of Notes in Middlesbrough, England, sticks out of the earth, giving the impression that a passing motorist casually threw this gigantic bottle from the car window to the side of the road. Still, the structure is as permanent as the concept is sound.

A more eccentric obsessiveness is apparent in Jim Sanborn's multilayered 2004 A Comma, A (element #1), an awesome typographic light projection at the plaza in front of the M.D. Anderson Library at the University of Houston in Texas. When viewed from the plaza and the library's reading rooms on the second and third floors, a spiral copper screen forms a three-dimensional representation of a comma on a long line of text. On the screen are hundreds of phrases, clauses, and other fragments of text, each separated by a comma. Each fragment, by authors as diverse as Emily Dickinson, J. D. Salinger, Albert Camus, Goethe, Oscar Wilde, Boris Pasternak, Emile Zola, and William Shakespeare, is intended to draw the viewer onto a "stream of consciousness" narrative. The spiral form of the screen requires that viewers walk around the piece to read the texts. In

addition, viewers are encouraged to collaborate with their friends and colleagues from other cultures in order to translate the texts. The light-emitted words are thrown every which way, attaching themselves to the ground and buildings like an infestation of abecedary insects.

A sculptural piece can also stand in for a logo, and that may be the most common use for environmental typography. Insight's 2011 design for the Nexus industrial precinct in AlburyCity in New South Wales, Australia, made from two forty-foot steel shipping containers, was to act as the central identifier for a new industrial area. Nexus, meaning a connection or hub, demanded a gutsy sign. Forming the shape of an X by interlocking the two containers in an almost impossible balancing act" did the trick and marked the spot. Using prefabricated materials found in the industrial environment helped to reduce the costs of production.

Many typographic sculptures are clever, but others are decidedly reverent, designed to honor a person, place, or thing. Ruben Nalbandyan is a serious stonecutter. His 2005 The Stone-Cross Letters to the World, at St. Mesrop Mashtots Church in the village of Oshakan, Armenia, was commissioned by Karekin II, the Catholicos of All Armenians, to pay tribute to the 1,600th anniversary of the Armenian alphabet. The thirty-six stone-cross letters are beautiful in their faithful historical intricacy, yet they are profoundly sad, standing as gravestones behind the church in space usually reserved as a resting place.

Certain memorials are emotionally charged sculptures. Studio Kuadra's 2006 Memorial of Jewish Deportation in the Borgo San Dalmazzo Train Station,

Italy, is as poignant as the typography is haunting. Creating a tribute that is both subtle and overt is the challenge of any artist designing such a monument. In this case the base is a concrete slab to represent the typical platform for loading the freight wagons. On this surface the names of twenty survivors are spelled out in three-dimensional letters made from Corten steel; 350 additional plaques commemorate deportees that were killed in Nazi concentration camps. The words are cast in metal, which through oxidation will ultimately turn the same color as the rolling stock that sealed the fates of the victims.

Nuance differentiates typographic art from pure typography. The ability of letterforms to be both abstract and realistic, symbolic and literal allows the artist to deliver messages that are at once coded and decipherable.

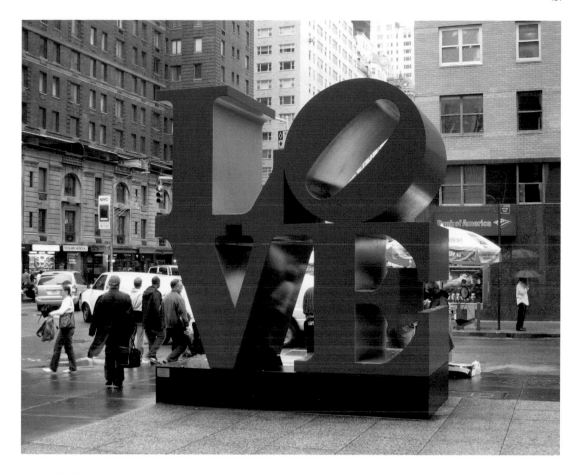

Robert Indiana, **LOVE**, 1970.
An early example of typographic public art, Indiana's iconic sculpture, the original of which is made of Corten steel, began as a Christmas card for the Museum of Modern Art in 1964. This example is installed on Sixth Avenue in New York City.

Robert Indiana, **Ahava (הבהא "love")**, Jerusalem, Israel, 1977
Corten steel
Israel Museum
Many iterations were done in numerous languages, including Hebrew, Chinese, Spanish, Italian.

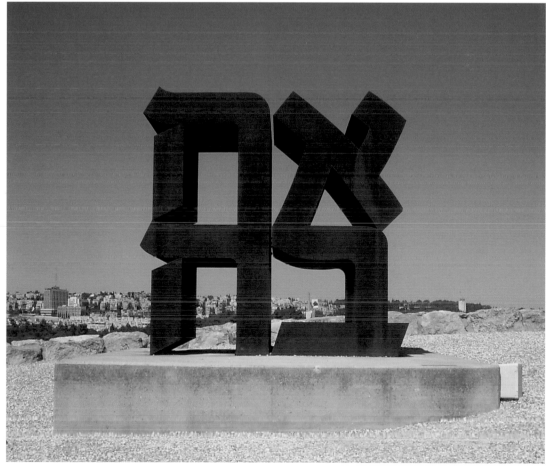

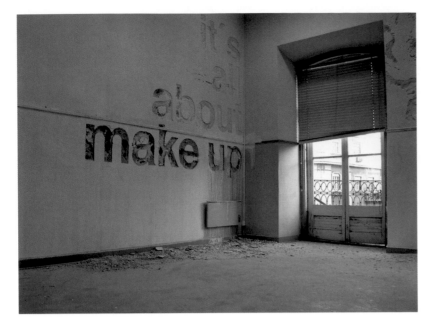

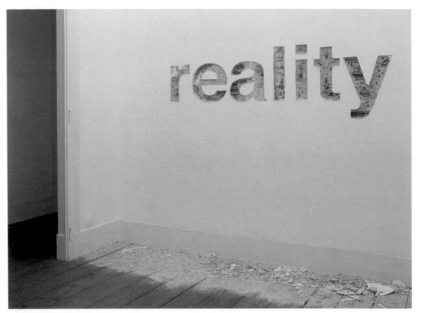

Scratching the Surface, Lisbon, Portugal, 2009
Artist: **Alexandre Fartom, aka Vhils** Type: **Helvetica**
One of a series, this interior piece features typographic statements cut into the drywall of an abandoned loft.
The Helvetica typeface is cut to perfection.

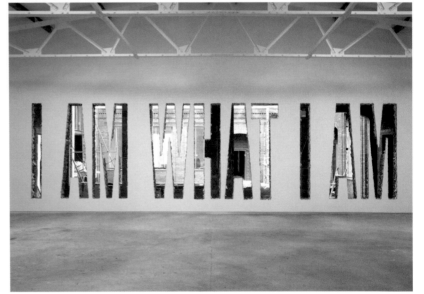

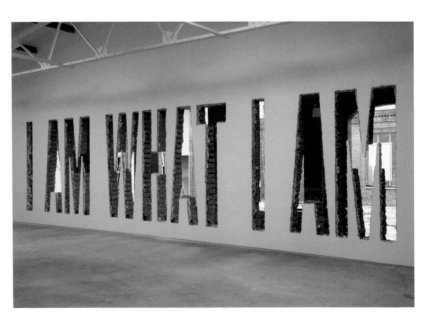

I Am What I Am, Ikon Eastside, Birmingham, England, 2008
Artists: **Tercerunquinto (Julio César Castro Carreón, Gabriel Cázares Salas and Rolando Flores Tovar)**
Photographer: **Stuart Whipps**
This was the first installation in the UK for the Mexican art collective Tercerunquinto (which means a third
of a fifth). Their project took them to Ikon Eastside in a Birmingham district that was being revitalized.
Smashing through the gallery walls, they opened up a view onto the street that spelled out "I am what I
am." The art suggests the fragility of the infrastructure in this otherwise tough area. The artists' aim was
to show a rupture between art and society, while asserting the possibility of fluid exchanges between
local institutions and the environment.

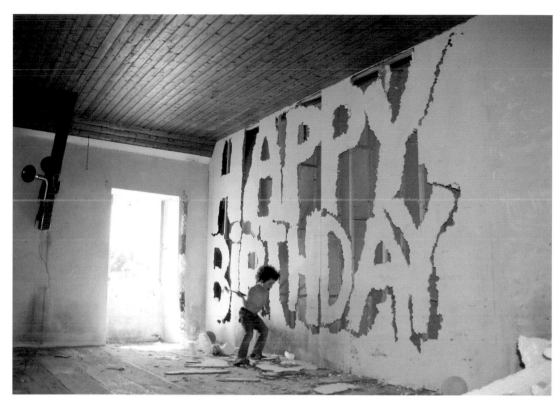

Happy Birthday, Paris, France, 2010
Artist: Julien Berthier
Photograph courtesy of **Galerie G-P&N Vallois, Paris**
A sign of love is mordantly and ironically expressed through the act of cutting away portions of wall space as a birthday greeting.

Welcome Home, Paris, France, 2003
Artist: Julien Berthier
Photograph courtesy of **Galerie G-P&N Vallois, Paris**
Both beautiful in sentiment and shocking in execution, this expression of reunion is also an act of desecration of the sanctity of the home.

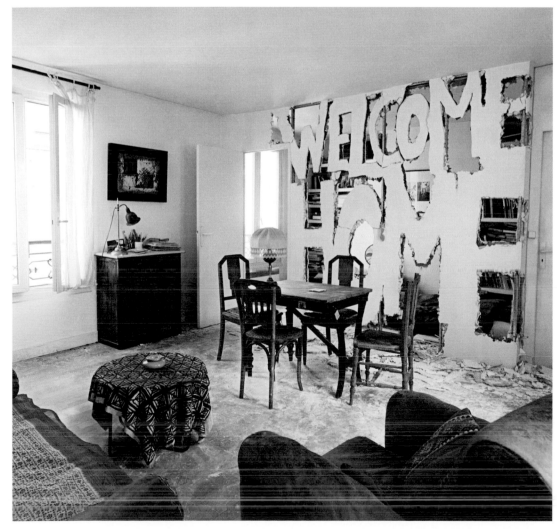

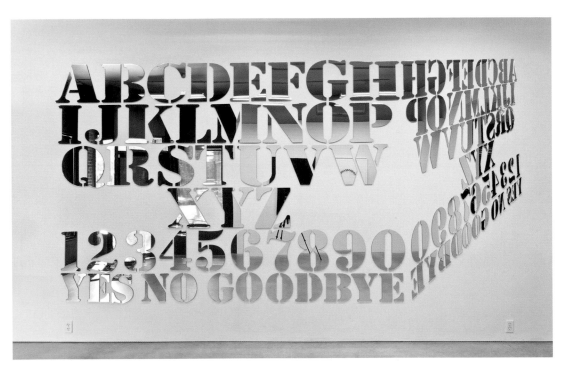

Mirror Mirror, MKG127, Toronto, Canada, 2011
Artist: **Adam David Brown** Photographer: **Adam David Brown**
Material: **Acrylic Mirror** Type: **Stencil**
If Ouija boards are the original touch-screen technology, says Adam
David Brown, "then one might ponder the implications of this installation
in which Ouija boards, mirrors, and illusion converge to create a work
that bridges multiple dimensions and the paranormal."

Silence, MKG127, Toronto, Canada, 2009
Designer: **Adam David Brown** Photographer: **Jennifer Sciarrino**
Materials: **Pink Pearl eraser** Type: **Helvetica**
Guided by the principle of less is more, this work attempts to find a
balance between emptiness and form, mark making and erasure. Using
Pink Pearl erasers as a marking tool is an ironic gesture that playfully
inverts the role of the erasers, allowing them to lend form to ideas of
ephemerality and impermanence.

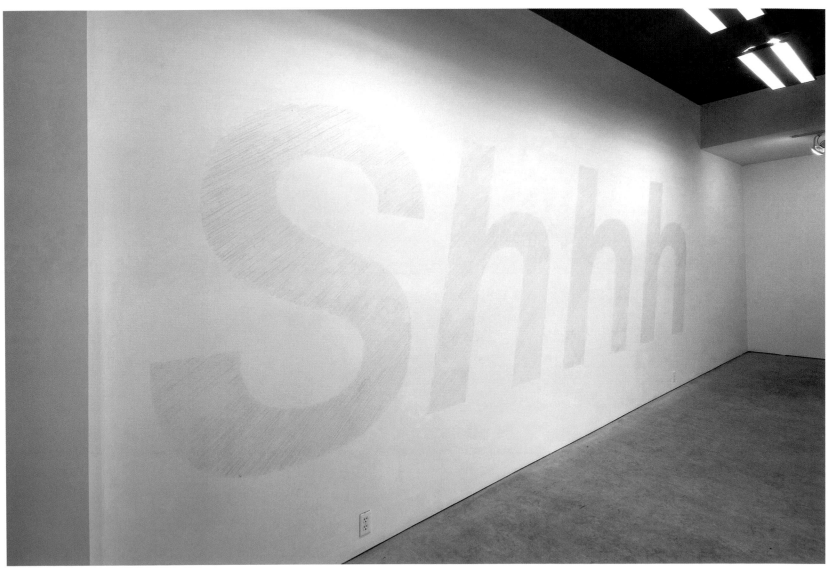

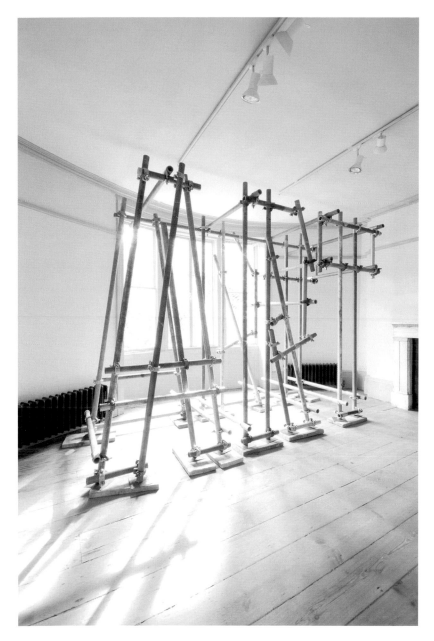

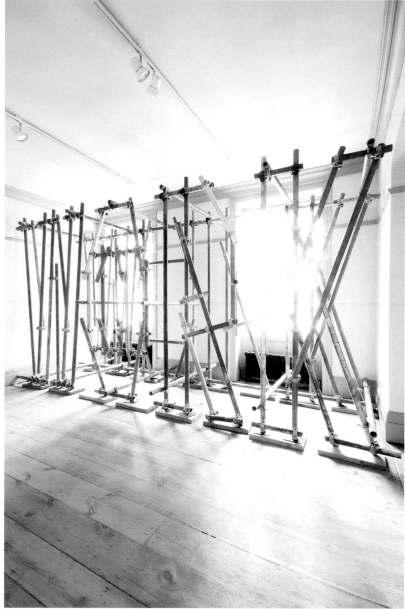

ART WORK, Man&Eve, London, England, 2008
Artist: **Ben Long** Photographer: **Ben Long**
Materials: Scaffolding components
For this exhibition, Ben Long constructed the words "ART" and "WORK" from scaffolding materials.
The piece forces the viewer to consider what goes into making works of art—from inspiration to
development of the concept through the production process.

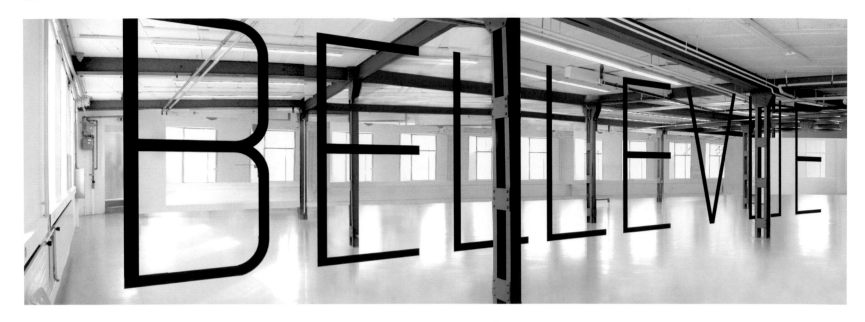

BELLEVUE (BEAUTIFUL SIGHT), Kunsthalle IG alte Fabrik, Rapperswil, Switzerland, 2004
Artist: Mayo Bucher
This word piece is constructed with black drainpipes stacked and welded together. The inherent irony (it is not a beautiful view) is that the letterforms are beautiful.

Counter Void, Tokyo, Japan, 2003
Artist: Tatsuo Miyajima Photographer: Kunihiko Katsumata
Materials: **Neon, glass, integrated circuits, aluminum, electric wire**
Tokyo is a city crammed with media spewing out information twenty-four hours a day. In her artwork, Tatsuo Miyajima shows the contrast of "Life" and "Death," as well as the different face of day and night. She wants to challenge the information glut by making a void that competes with feelings and thoughts of passersby. The mammoth computer type on the screen presumes to have significance, but is an enigma.

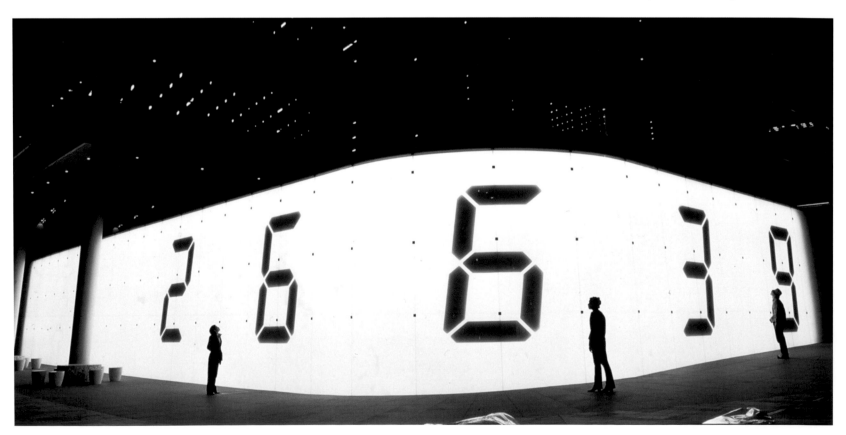

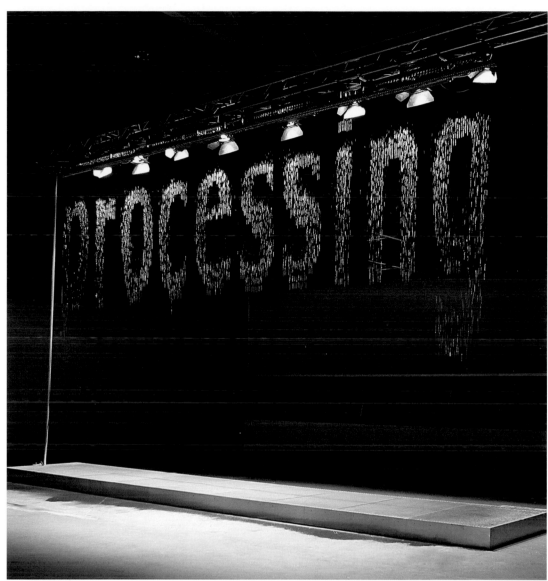

Bit.fall, Leipzig, Germany, 2007
Artist: Julius Popp
Materials: 320 nozzles controlled by computer software and electromagnetic valves
Julius Popp has invented a device that controls falling streams and drips of water to make temporary words and images. The machine, which was featured at the London Olympic Park in 2012, is programmed to scan the Internet and randomly pulls the most popular words and then turns them into water. In an online video, Popp calls his work a "metaphor for the incessant flood of information we are exposed to."

Bit.code, Leipzig, Germany, 2007
Artist: Julius Popp
An assembly of plastic chains with, black and white pieces that act as pixels, is driven by software to create words and letters. Like the transformation in Bit.fall, these generated pixels combine to display frequently used Internet key words taken from various web feeds.

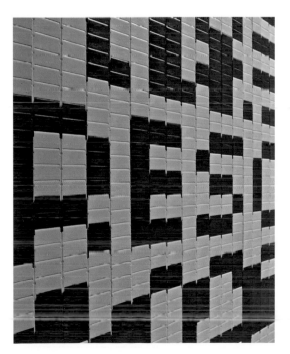

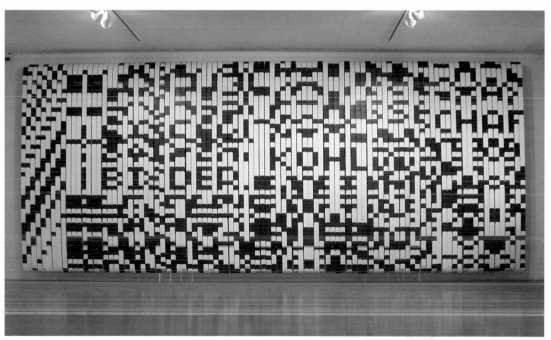

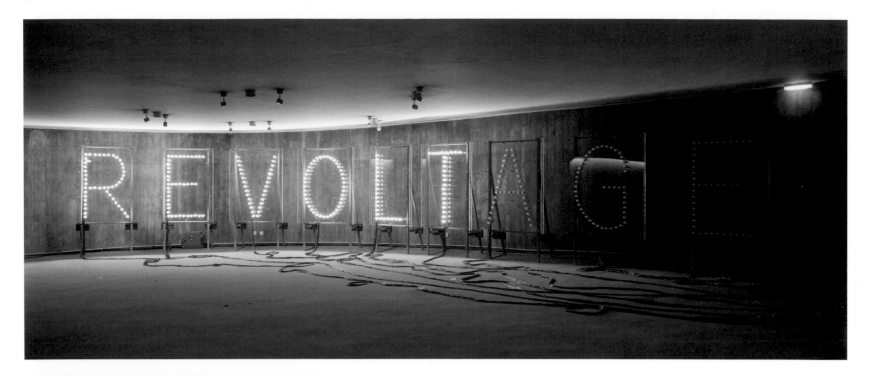

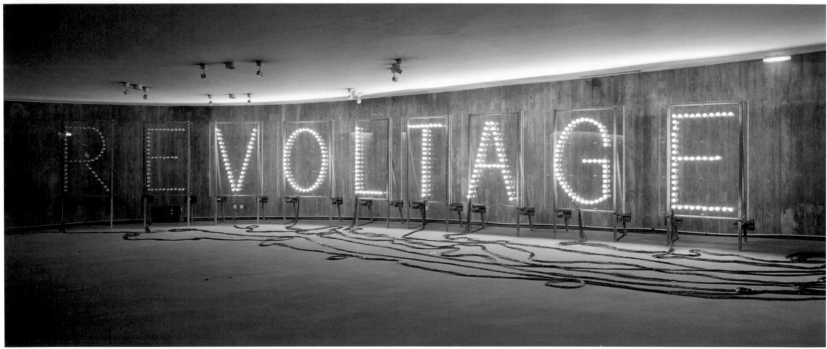

Revoltage, Headquarters of the Parti Communiste Français, Paris, France, 2012
Designer: **Raqs Media Collective** Photographer: **Martin Arygolo** Materials: **Acrylic, lightbulbs, wire, sequencer**
This piece fills the space it occupies with warmth, light, "and the charge of an idea that embraces both celebration and rage," say its designers. An array of lightbulbs spells a series of nine larger-than-human-size letters—R, E, V, O, L, T, A, G, and E—like the elements of a festive marquee. The letters join to suggest an incandescent hybrid between electricity and uprising—alternately illuminating the words "REVOLT" and "VOLTAGE" through a fluctuating electrical current in order to coin a new thought: "REVOLTAGE."

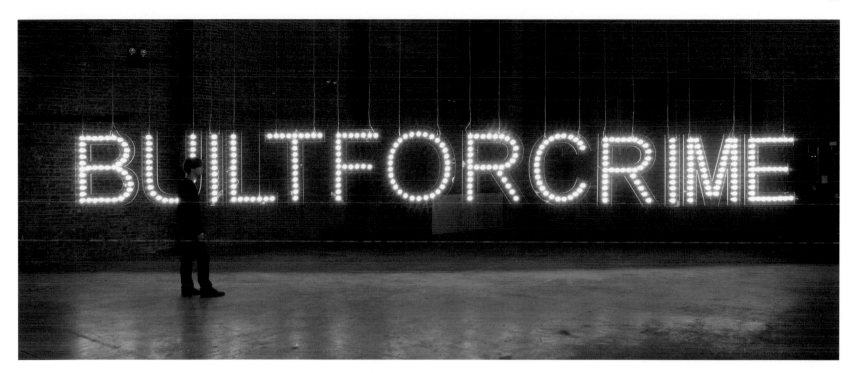

Built for Crime, Sculpture Center, New York, New York, 2006
Artist: Monica Bonvicini Photographer: Jason Mandella
Materials: Broken safety glass, lightbulbs, five dimmer packs, LanBox, airplane cables
Enigmatic statements are a staple of contemporary luminescent typographic art. Built for Crime is a forty-foot-long light sculpture constructed of shattered safety glass. Words serve as an advertisement, but according to the artist it makes a declaration that is really a question: What crime is going to be committed?

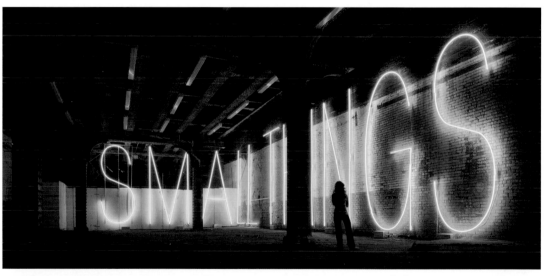

Work No. 755: Small Things, New York, 2007
Artist: Martin Creed Photographer: Ellen Page Wilson
Material: Yellow neon Type: Helvetica, adjusted to fit

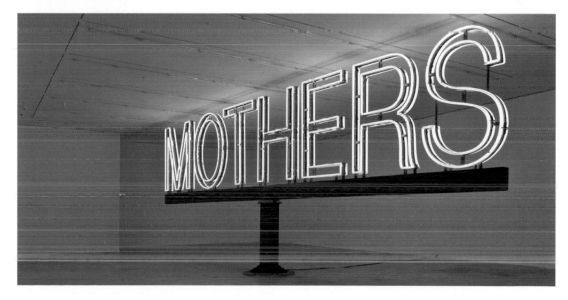

Work No. 1090: Mothers, London, England, 2011
Artist: Martin Creed Photographer: Hugo Glendinning
Materials: White neon, steel. Type: Helvetica, adjusted to fit
The Guardian says Creed "rearranges the rules of art." His sense of minimalism (the same newspaper calls him "the deadpan Scottish minimalist"). Is vividly striking with his "Mothers" sculpture, which sits majestic in a spare room.

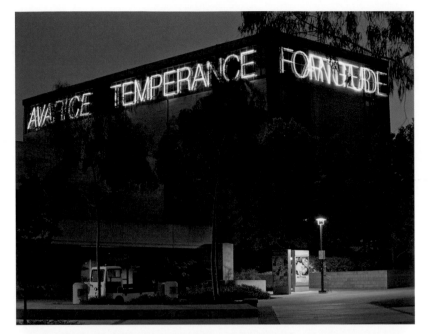

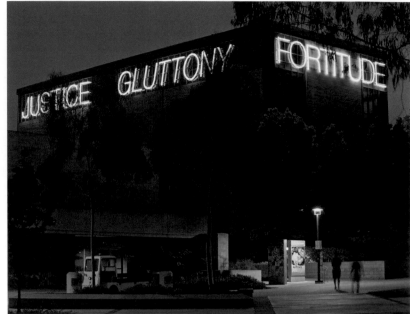

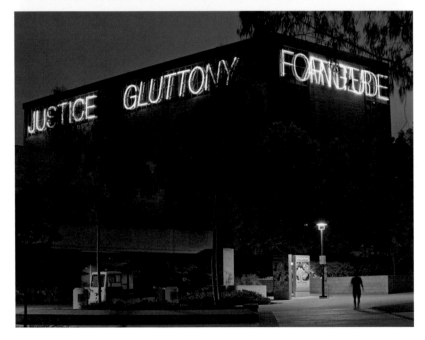

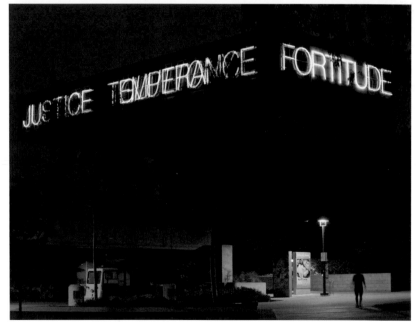

Vice and Virtues, University of Califorina, San Diego, 1988
Client: **Stuart Collection**
Artist: **Bruce Nauman** Designer: **Mary L. Beebe** Photographer: **Philipp Scholz Rittermann**
Materials: **Neon tubing and clear glass tubing mounted on an aluminum support grid**
Vices and Virtues consists of seven pairs of words superimposed in blinking neon atop of the Charles Lee Powell
Structural Systems Laboratory. The virtues flash sequentially clockwise around the building at one rate; and the
vices circulate counterclockwise at a slightly faster rate: FAITH/LUST, HOPE/ENVY, CHARITY/SLOTH, PRUDENCE/
PRIDE, JUSTICE/ AVARICE, TEMPERANCE/GLUTTONY, FORTITUDE/ANGER.

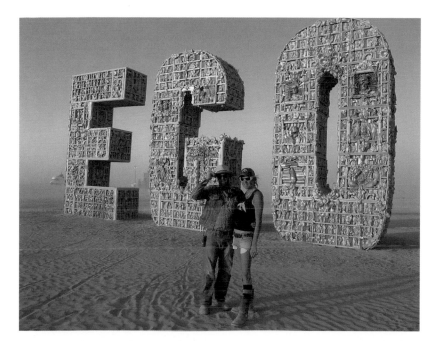
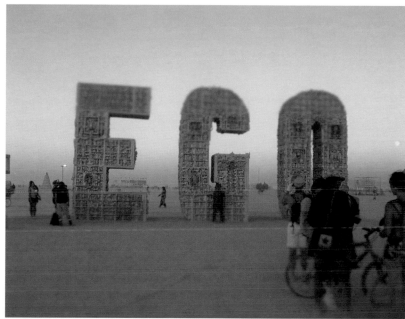
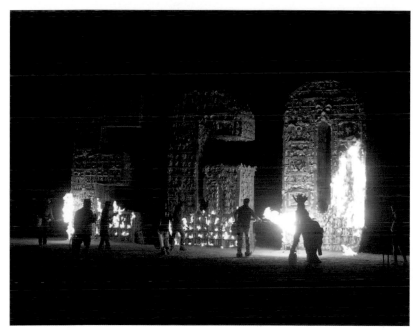
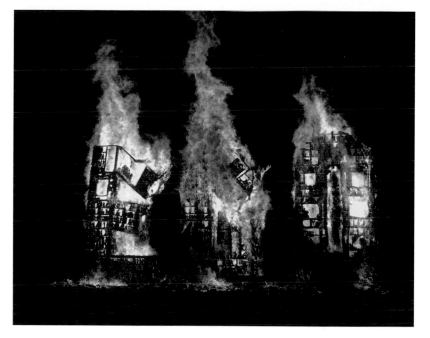

EGO, Burning Man, Black Rock Desert, Nevada, 2012

Artist: **Laura Kimpton** Photographer: **Courtney Biggs** Materials: **Wood, plaster of pans, paint, screws**

EGO took hubris; it was made of wood and framed with plaster casts of pans, trophies, and religious relics as depictions of ego. The sculpture was set aglow at Burning Man 2012. The idea, Krimpton noted on her blog, was to burn down the EGO and see what remains: "The thinking was that not all of the artifacts would burn, and there would be tokens to take home from the playa when the embers cooled."

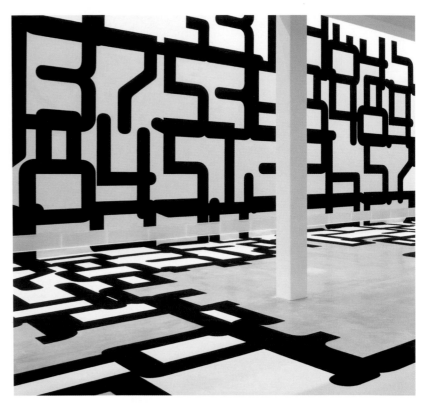

RAPPORT: Experimental Spatial Structures, Berlinischen Galerie, Berlin, 2011–12
Designer: J Mayer H
This is a walk-in (and on) installation for the Berlinischen Galerie's ten-meter-high entrance area. The walls and floor are clad in carpeting, on which data security patterns are printed in black and grey. The enlarged, repeating patterns simulate a flickering sensation that transforms the hall into a playful swath of interconnected forms and structures.

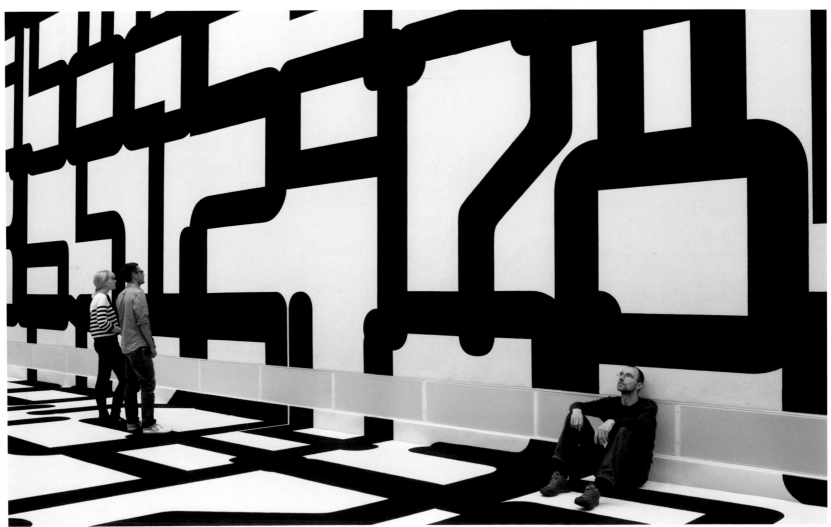

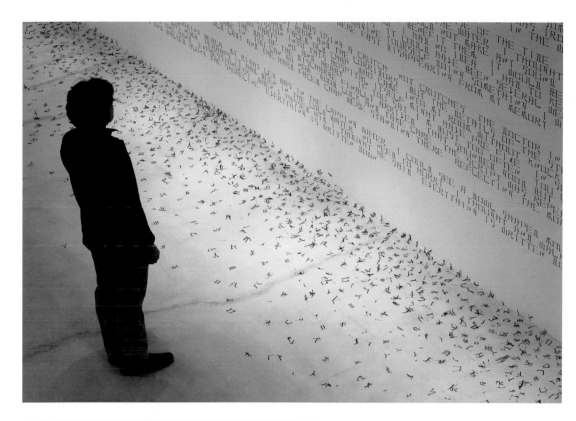

CNJPUS Text, Towada Art Center, Towada, Japan, 2011
Client: **CNJPUS Text**
Artist: Ryo Shimizu Materials: **Colored PVC sheet on wall**
Type: **CNJPUS**
CNJPUS TEXT is a set of fonts that have characteristics of both
phonograms and ideograms. It is an alphabet of "converted characters,"
made by using existing Chinese characters without certain strokes. The
characters, set high on the gallery wall, appear to have fallen off onto
the floor.

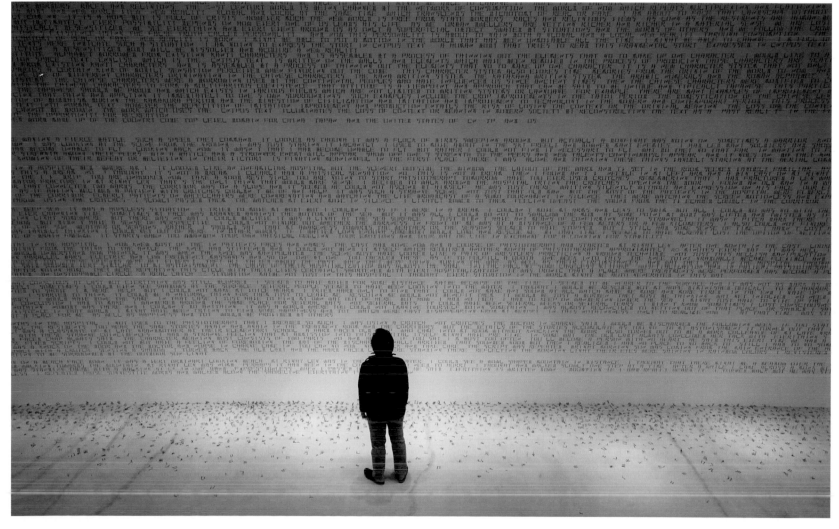

Shape My Language, Walking-Chair Gallery, Vienna, Austria, 2010
Client: **Dalton Maag**
Designer: **Bruno Maag** Photographer: **Fidel Peugeot** Curator: **Sanne Flyvbjerg** Materials: **Inkjet printing on perspex.** Type: **Multiple custom and library fonts**
As viewers saunter through the translucent curtains filled with a range of letterforms, glyphs, and characters, the expanse of the typographic and linguist world increases within the confined space. There is no way to navigate linearly so language simply bombards the senses.

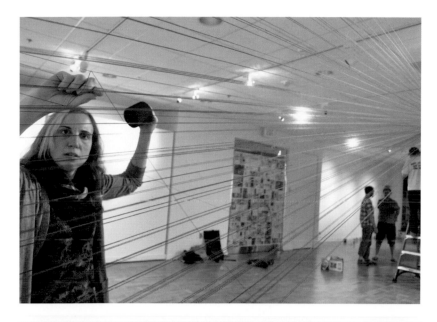

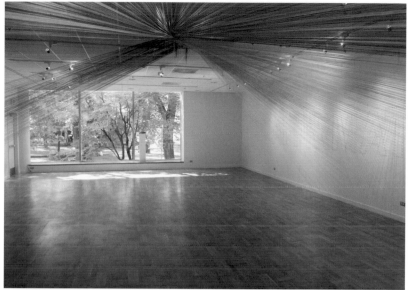

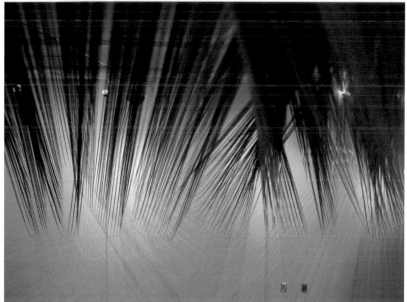

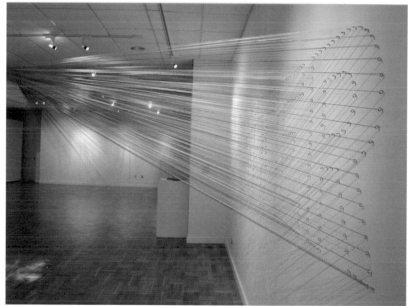

Over It, Littman Gallery, Portland, Oregon, 2010
Artist: **Aaron C. Rayburn, Jelly Helm, Aaron Rayburn, Jeremy Pelley, Matthew Foster, Fritz Mesenbrink, Chris Hutchinson, Damion Triplett, Jennie Hayes, Kate Bingaman-Burt, Marco Kaye, Mike Giepert, Justin Scrappers, Morrison, Driscoll Reid, Jason Sturgill, David Neevel, Taylor Twist, Jimm Lasser, Julia Oh**
Photographer: **Aaron C. Rayburn** Materials: **2500 eyelet screws, 14.2 miles of string**
Type: **Trade Gothic Outline**
This project is based on the idea of being "over" something, such as insults, affirmation, and banter. First the artists filled the gallery with those three words by projecting them on the walls and tracing them with pencil. Then they inserted 2,500 eyelet screws and began hand stringing more than fourteen miles of string. In this piece, "The uncaged letter is practically a force of nature," says Rayburn.

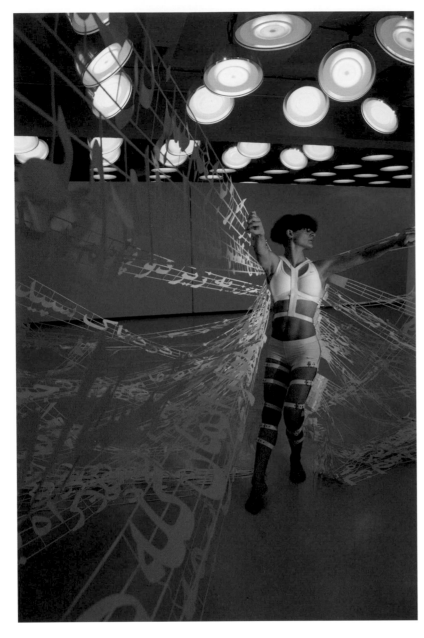

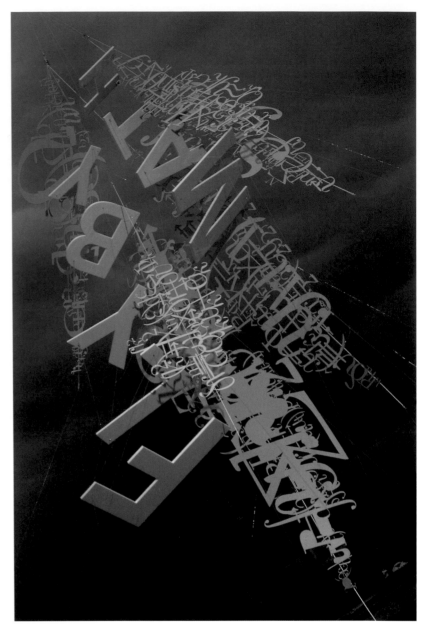

Fly by Math, Berlin, Germany, 2012
Client: **Intel**
Artist: **Ebon Heath** Photographer: **Max Merz** Materials: **Die-cut vinyl, acrylic rods, elastic string, leather, custom-cut polystyrene findings, Auto-poles** Type: **XB Zar (Farsi)**
This is from Ebon Heath's performance work that fuses the human body and typographic language together. The type floats freely in air and intersects with the dancers. Part of a four-act performance, this piece was based on poetry in Farsi dedicated to the women fighting to be heard in Iran.

Green Delusion, Berlin, Germany, 2010
Commissioned by: **MADE (Berlin)**
Artist: **Ebon Heath** Photographer: **Max Merz** Materials: **Laser cut paper and acrylic, nylon thread.**
Type: **Trade Gothic, found mathematical equations**
In this project, words fly in the air across the Berlin skyline. The floating type and mathematical equations are used, says Heath, for navigation. He created the headline and language fragments used in these navigational equations as two different typographic structures. Then he suspended the structures on a rooftop overlooking Berlin, where he fought the wind and waited for the ideal light to get the perfect photograph.

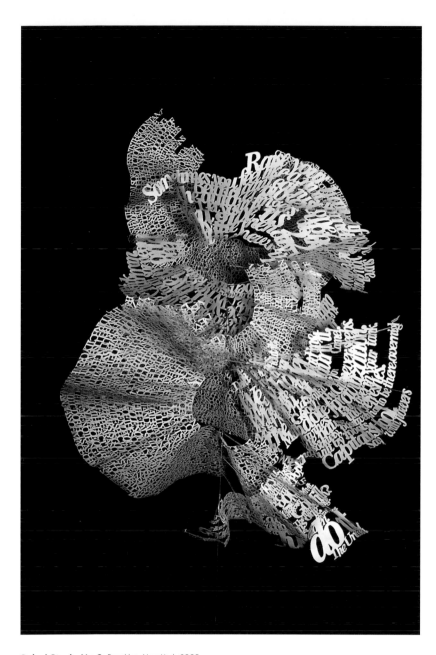

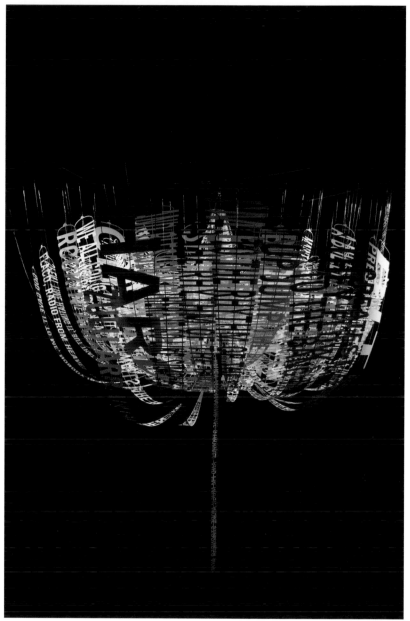

Spiral Study No.2, Brooklyn, New York, 2008
Artist: **Ebon Heath** Photographer: **Ebon Heath** Materials: **Laser cut Tyvek, acrylic rods, nylon thread**
Type: **Times New Roman Bold, Times New Roman Bold Italic**
With text by Guy Debord (excerpts from "Society of the Spectacle"), this piece is part of the early series of experiments Heath fabricated with hand-cut Tyvek. The cutting process took a lot of patience and time before he changed to lasers. This was the beginning step to many other so-called spiral sculptures he has created.

Quiet Dog Bite Hard, Contemporary Art Museum, Raleigh, North Carolina, 2011
Artist: **Ebon Heath** Photographer: **Max Merz.**
Text: **Mos Def** Materials: **Laser-cut paper, steel rods, metal findings, nylon string.** Type: **Trade Gothic Bold, Trade Gothic Bold Condensed**
This piece was inspired by the circular rhythm found in the poetry of "Quiet Dog Bite Hard," a song by Mos Def. This piece was intended to be assembled without the artist present. The structure has an intricate numbering system and uses metal hooks and rods for simple assembly. It was originally produced for the exhibition "Deep Surface: Contemporary Ornament, and Pattern" at the Contemporary Art Museum in Raleigh in 2011.

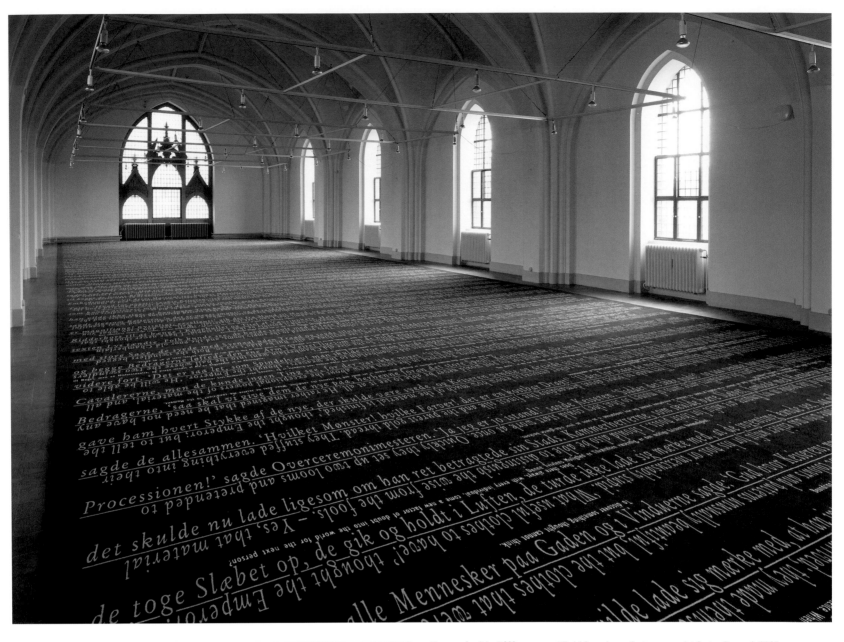

Recognizable Differences, Nikolaj Copenhagen Contemporary Art Center, Denmark, 2005
Artist: **Joseph Kosuth** Photographer: **Florian Kleinefenn/Photograph courtesy of Joseph Kosuth and Sean Kelly Gallery**

Recognizable Differences offers visitors the opportunity to wander about Hans Christian Andersen's literary world. It was a giant carpet that covered an entire gallery with the text of The Emperor's New Clothes woven into the fabric. It also includes a selection of quotes from Kierkegaard that provide a subtext. Kierkegaard was a vocal critic of Andersen's work, and Kosuth cleverly refutes Kierkegaard's critique by interspersing his own words.

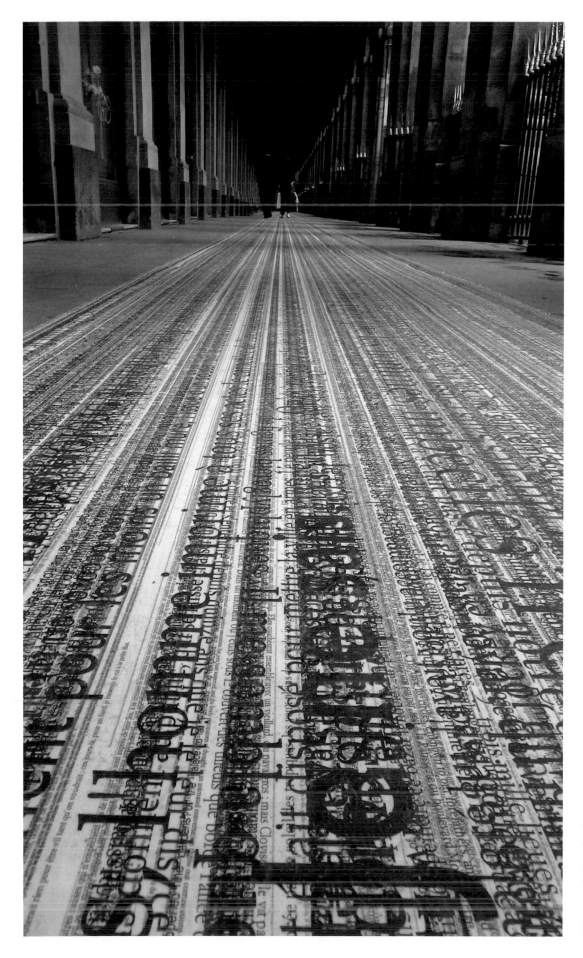

Text(e)~Fil(e)s, Galerie de Valois, Palais-Royal, Paris, France, 2010
Artist: **Pascal Dombis** Photographers. **Pascal Bombis, Andreas Von Lintel** Type: **Twenty fonts that match the timeframe of each text**
On this long floor is a ribbon made up of thousands of variously sized, overprinted thoughts (literature, poetry, philosophy) about the Palais Royal in Paris. These texts are phrases from Voltaire, Rousseau, Beckford, Diderot, Dickens, Balzac, Flaubert, Baudelaire, Nerval, Céline, Aragon, Lautréamont, Cocteau, Colette andr Breton, but also from unknown Parisians and occasional travelers who were inspired by the place.

Kunst-Station St. Peter, Cologne, Germany, 2003
Artist: **Barbara Kruger** Material: **Digital print**
Type: **Futura Bold Condensed**
Kunst-Station at Cologne's Jesuit Church of St. Peter is a favorite venue for installations by contemporary artists. Kruger's mammoth photo of praying hands fits appropriately into the chapel setting as does her message: Who salutes longest? Who prays loudest? Who dies first? Who laughs last?

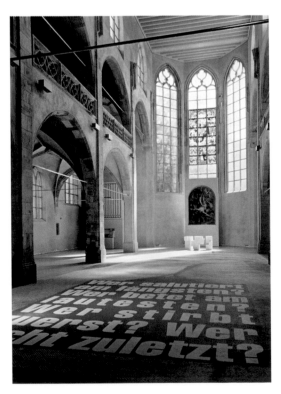

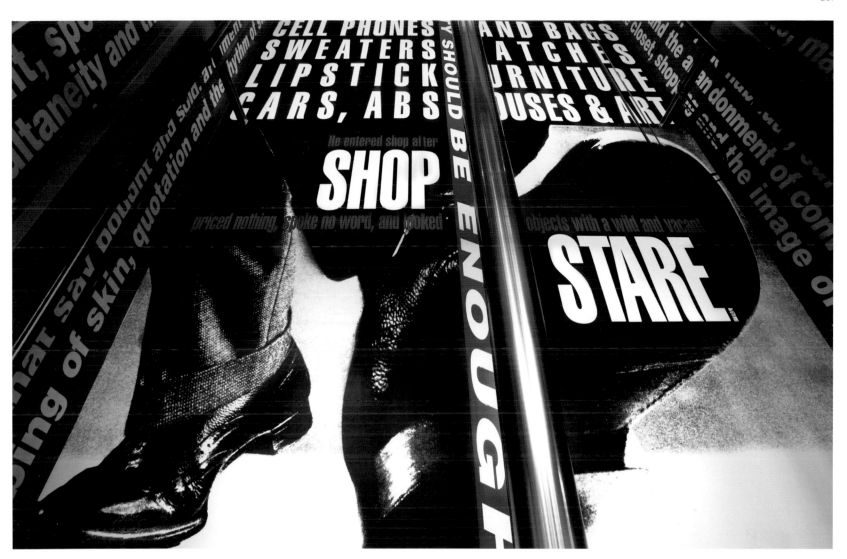

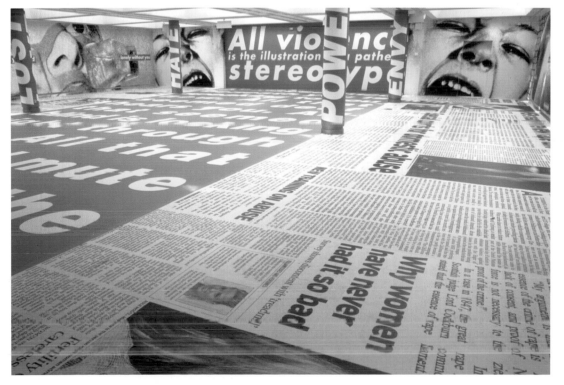

Untitled (Shafted), Broad Contemporary Art Museum at the Los Angeles County Museum of Art, 2008
Artist: **Barbara Kruger** Photographers: **Frederik Nilsen**
Materials. **Digital print** Type. **Futura Bold and Futura Bold Condensed**
A three-story elevator shaft, some 94 feet high, showcases a piece that LACMA commissioned from Kruger. The goal is to bombard viewers waiting to take the elevator with a the generic names of common products— computers, sneakers, sunglasses, handbags—which critiqued by the phrase "PLENTY SHOULD BE ENOUGH—RIGHT?" Kruger appropriates the language of advertising to critique (and satirize) consumerism, misogyny, power, and desire.

All Violence is the Illustration of a Pathetic Stereotype, Gallery of Modern Art Glasgow, Scotland, 2005
Artist: **Barbara Kruger** Photographers: **Ruth Clark** Type: **Futura Bold**
Material: **Digital prints**
GoMA's 2005 "Rules of Thumb: Contemporary Art and Human Rights" series featured a gallery filled with green and white typographic murals that covered the floors, walls and columns with blunt messages against violence, such as "You stone my face and harden my heart" and "Who will write the history of tears?" Another part of the gallery was covered with enlarged newspaper articles on cases of violence against women.

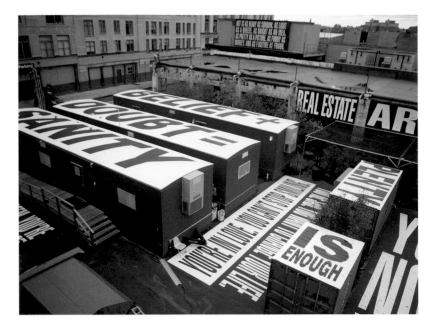

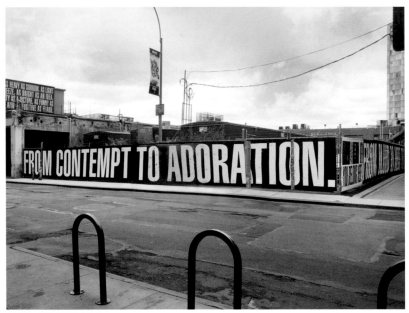

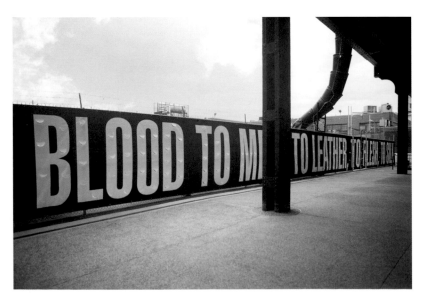

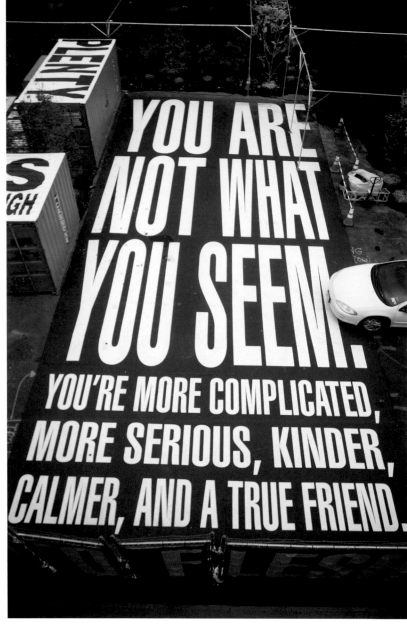

Whitney on Site, New York, New York, 2010
Artist: **Barbara Kruger** Photographs courtesy of Anna Schwartz Gallery
Materials: **Paint and wood, vinyl digital prints**

For this installation commissioned by the Whitney Museum of American Art for its new building, Kruger chose to make confrontational statements using enigmatic textual statements referencing the history of the site. For Kruger "the streets are rife with remembrance. So I've tried to mark the site with a gathering of words about history, value, and the pleasures and pains of social life," she told the Whitney. Phrases include "YOU BELONG HERE" and "BELIEF + DOUBT = SANITY." She also focuses in on changes in real estate concerns and gentrification from meatpacking to fashion to art, issues related to the neighborhood of the new building.

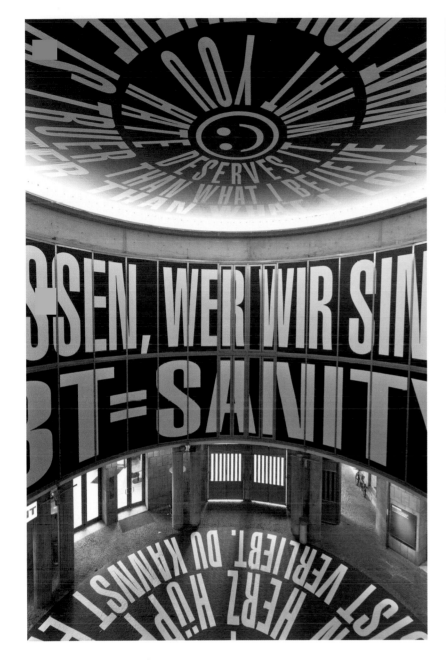

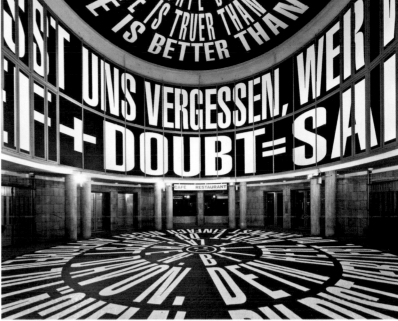

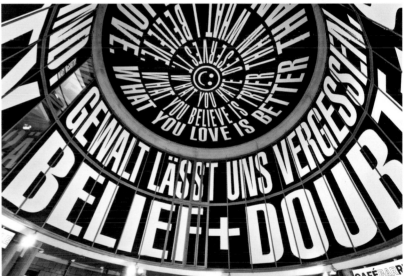

Circus, Schirn Kunsthalle, Frankfurt, Germany, 2010
Artist: Barbara Kruger Photographer: Norbert Miguletz
Kruger's ability to transform spaces, large and small, into powerful statements is uncanny. For the Schirn Kunsthalle, she is the ringmaster of Circus, a word-intensive installation that covers the rotunda with circular type treatments. The spiraling black and white words and phrases include "What you love is better than what I love," "What you believe is truer than what I believe," "What you hate deserves it."

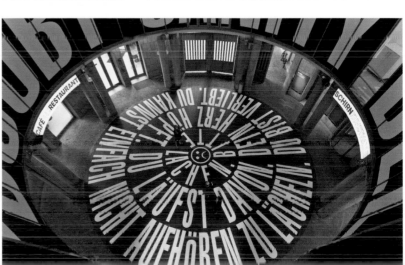

Between, Folesal Gallery, Warsaw, 1977
Artist: **Stanisław Dróżdż** Photographer: **Mariusz Michalski**
Type: **Helvetica**
Dróżdż, a concrete poet who died in 2009, came up with this idea when
he was on a train to Warsaw, as he watched a fly flitting around the
compartment and landing in different places. He immediately saw letters
dislocated in space yet uniform in composition.

Archiscriptura, Leipzig, Germany, 1991
Diploma project, Hochschule für Grafik und Buchkunst
Designer/Typographer: **Andreas Stötzner**
Photographer: **Matthias Hoch** Material: **Kapa plast foamboard**.
ARCHISCRIPTVRA was inspired by the classical architecture of the
Hochschule für Grafik und Buchkunst atrium, where this large-scale
physical installation of letterforms was first displayed. "There is no
hidden meaning or symbolism in it," says Stötzner. "ARCHISCRIPTVRA just
is what one sees." All the elements had been designed to the millimeter
in advance and then hand cut by the designer out of two-centimeter
Kapa plast on the site.

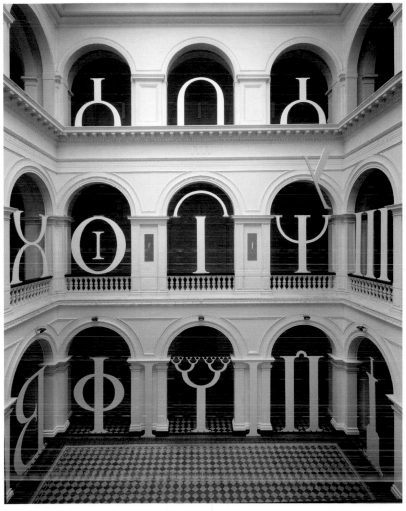

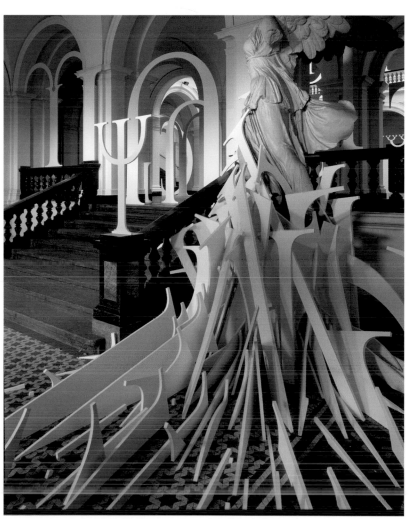

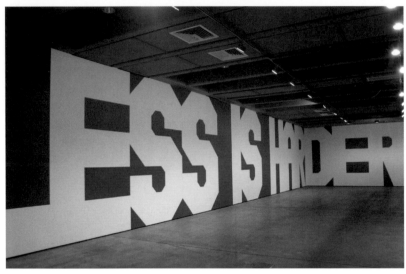

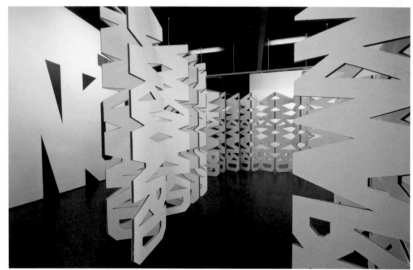

Why Do We Do The Things We Do Over and Over Again, Installation 1, Artspace, Sydney, Australia, 2008
Why Do We Do The Things We Do Over and Over Again, Installation 3, Artspace, Sydney, Australia, 2008
Less is Harder, IMA, Brisbane, Australia, 2008
An Awkward Screen, Victorian College of the Arts, Melbourne, 2011
Hard But Fair / Point Less, Anna Schwartz Gallery, Melbourne, 2009
Artist: **Rose Nolan** Photographs courtesy of the Anna Schwartz Gallery Materials: **Paint, fabric, cardboard**
Nolan paints words onto walls, pennants, banners, and cardboard using bold typefaces in black and white, often on red. This selection of typographic epigrams fills her gallery spaces with words to both navigate and ponder.

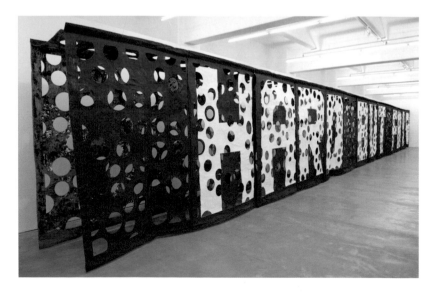

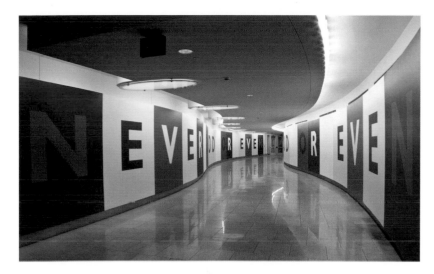

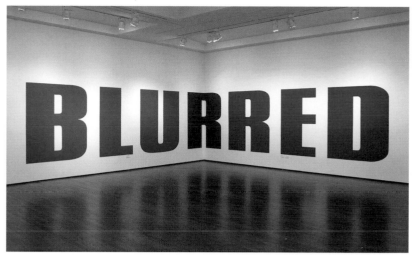

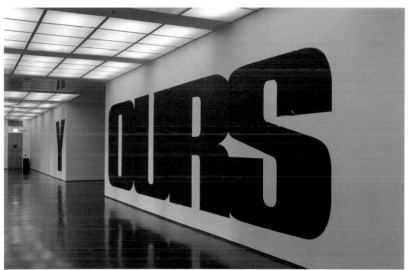

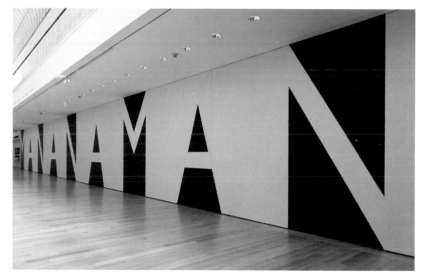

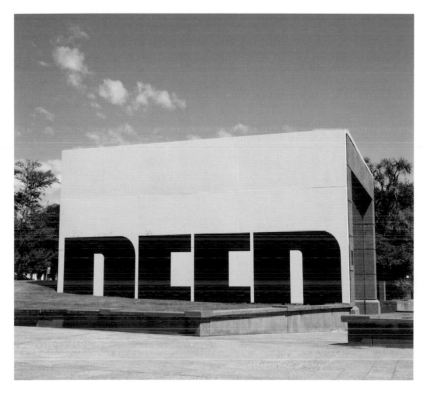

NEVER ODD OR EVEN, Indianapolis Museum of Art, Indiana, 2005
Artist: **Kay Rosen** Photograph courtesy of the Museum of Fine Arts Boston
Materials: **Muralo Ultra Ceramic flat paint** Type: **Gil Sans**

BLURRED, University Art Museum, University of California, Santa Barbara, 2004
Artist: **Kay Rosen** Photographer: **Tony Mastres** Materials: **1 Shot sign paint on wall** Type: **Commador**

YOURS/OURS, Museum of Contemporary Art, Chicago, Illinois, 2010
Artist: **Kay Rosen** Photographer: **Nathan Keay** Type: **Commado**

MAÑANA MAN, Museum of Fine Arts, Boston, Massachusetts, 2011
Artist: **Kay Rosen** Photograph courtesy of the Museum of Fine Arts, Boston
Materials: **Benjamin Moore Aura matte paint on wall** Type: **Gil Sans**

DEEP BEEP, Concrete structure above an underground parking garage at Christchurch Art Gallery
Christchurch Art Gallery Te Puna o Waiwhetu, Christchurch, New Zealand, 2011
Artist: **Kay Rosen** Photographer: **John Collie** Type: **Commador**
Rosen's murals are linguistic essays that recall the work of the Dada artists and concrete poets. They are seeped in irony. "Though her linguistic repertoire is often fairly basic, homonyms and synonyms" wrote Judith Russi Kirshner in *Artforum*. "Rosen's weaving and over lapping of elements are intricate and rich." The statements take over the gallery walls forcing the viewer to experience the typographic force of the words.

Concrete Carpet, Arab Museum of Modern Art, Qatar, 2011
Designer: **Nada Debs** Typographer: **Pascal Zoghbi** Photographer: **Marino Solokhov**
Materials: **Concrete, mother-of-pearl, stainless steel** Type: **East & East Typeface, based on the Arabic Kufi calligraphic style**

This installation is a manifestation of the role of Arabic typography in contemporary design and visual culture in the Arab world. The Khatt Foundation's exhibit focused on the ubiquitous nature of text and letters. The space acts as an open book, taking letters off the page and assigning them a tangible presence. Debs's concept was to create a carpet that would reflect the twenty-first century. The carpet is composed of twenty-eight modular panels in concrete, using Arabic script to create Haiku-like "concrete" poetry. Each of the panels represents a single letter of the Arabic alphabet where the words with the same letter are designed to evoke a visual and musical rhythm.

Null, eins, zwei, drei, vier, fünf, acht, neun, zehn, Hochschule für Grafik und Buchkunst Leipzig, Leipzig, Germany, 2002
Designers: **Mayo Bucher Architects, Zürich**
From 1992 to 2002 Bucher produced word art. This piece was included in a ten-year exhibition included in his retrospective "Open Sign," which also included his interest in structures, colors, forms and signs that address the productive association of painting to design, architecture and music.

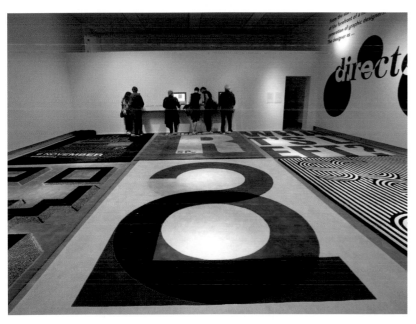

Made in China, Made by You, Museum of the Image, Breda, The Netherlands, 2009
Designer: **Thonik** Materials: **Wool tapestries**
Thonik was invited to exhibit their graphic work at the Museum of the Image in Breda. The firm chose to substitute their usual paper and screens with wool. Sixteen hand-woven tapestries were based on their own existing designs and made in China. Museum director Mieke Gerritzen says, "After establishing such a prominent international profile, it is high time Thonik was given the space to show its magnificent work in a Dutch museum."

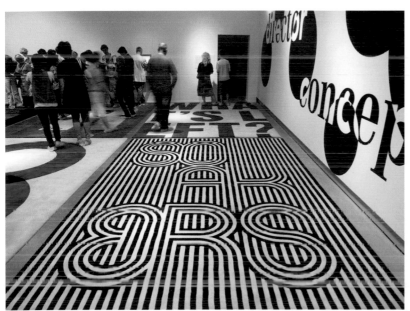

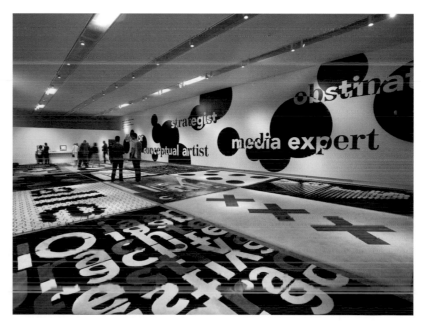

Self-Confidence Produces Fine Results, Deitch Projects
New York, New York, 2008
Art Director: **Stefan Sagmeister** Design: **Richard The, Joe Shouldice**
Sagmeister's solo exhibition included a wall of ten thousand bananas,
designed to spell out one of the mottos that have appeared in his
work. Green bananas created a pattern against a background of yellow
bananas spelling: "Self-confidence produces fine results." Nature was one
of the collaborators in this installation. When the green bananas turned
yellow the words disappeared. When the yellow background bananas
turned brown, the words returned.

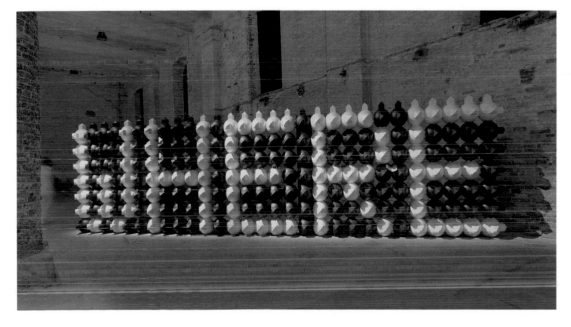

"Out There: Architecture Beyond Building"
Venice, Italy, 2008
Client: Venice Biennale
Designer: **Thonik.** Photographer: **Maurice Boyer, Rob 't hart**
Type: **Akkurat**
Thonik created all identity and graphic components for "Out There: Architecture Beyond Building" at the 11th Venice Architecture Biennale as well as two spatial installations. "Graphic Wall" was installed in the Corderia and linked eighteen projects by international architects. "Graphic Tapestries" (see page x), a series of sixteen tapestries based on Thonik designs, was installed in the Arsenale. Walls of black and white globes formed the key words from the program. Five thousand plastic balls, which were later recycled, were made for the production of the words.

Passing Time, Wilson Reserve, Christchurch, New Zealand, 2011
Artist: **Anton Parsons** Photographer: **Duncan Shaw-Brown** Materials: **Copper, Stainless steel 316**
Type: **Helvetica**
This Möbius strip–shaped strand of numerals was placed on the campus of a technology institute in
Christchurch, a city now devastated by earthquake where little but the sculpture still stands. Passing Time
was commissioned in 2011 to commemorate 104 years in the institute's history: the numbers portray the years
of its existence.

WHERE, Batumi, Georgia, 2010
Artist: **Jean Dupuy** Photographer: **Slaven Lunar Kosanović** Materials: **Steel**
The declarative "WHERE" of this sign of type, punctuated with arrows, suggests "here" and "there."

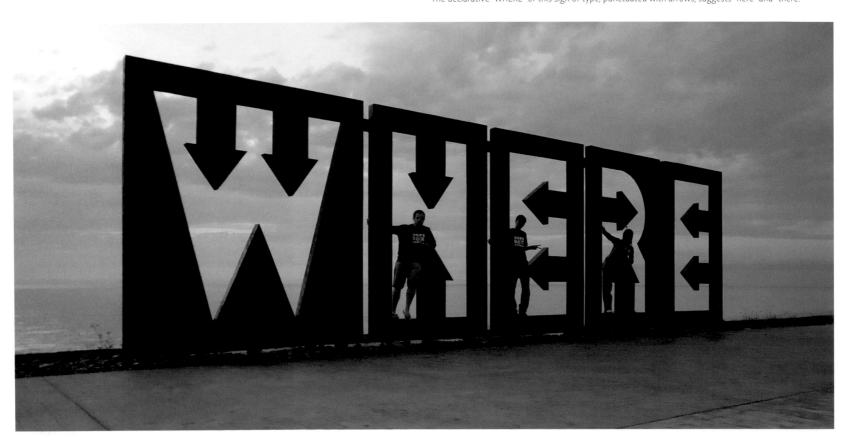

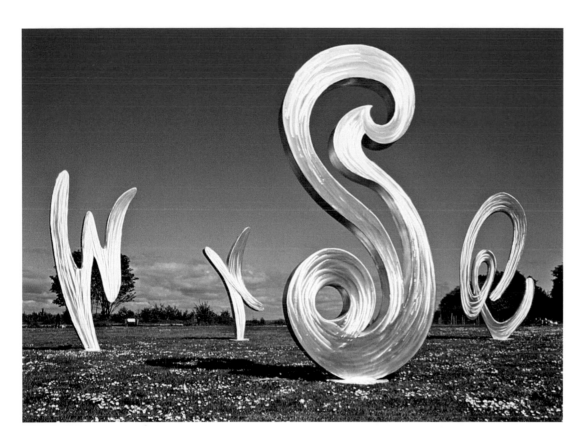

Compass, Bend, Oregon, 2004
Artist: **Steve Jensen** Photographer: **Steve Jensen** Material: **Aluminium**
This vibrant north, south, east, and west directional sign virtually
dances on a roadside roundabout.

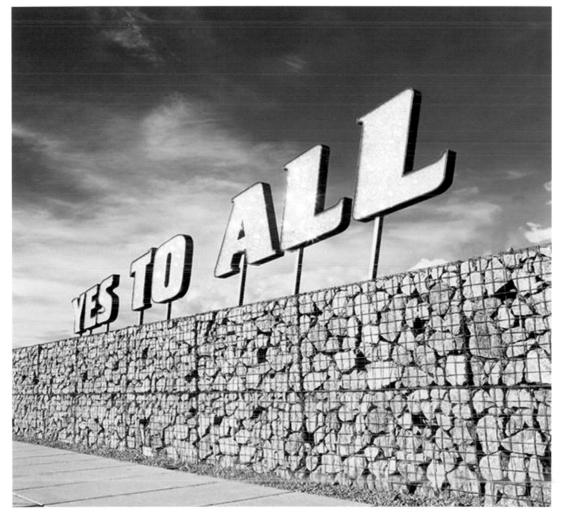

Yes to All, Swarovski Kristallwelten, Wattens, Austria, 2005
Artist: **Sylvie Fleur.** Photograph courtesy of Kunstraum Innsbruck/
Thaddaeus Ropac Gallery and the artist. Materials: **Swarovski crystals
on mirror**
Fleury covered "Yes To All" in thousands of STRASS® Swarovski®
Crystal. The inclusive sentiment is a sly commentary on contemporary
consumerist strategies focused on converting everyone into consumers
who ritualistically gather at large shopping malls around the world.

Helvetica, Oslo, Norway, 1995
Design Director/Art Director: **Nils Wad** Photographer: **Bjorn Wad** Material: **Stainless steel** Type: **Helvetica**
Wad says that the rationale for this sculpture partly comes from a graphic art piece "that I came across, which
combined the number 3 with the letters THREE. I shaped the eight letters of Skulptur to one unit. The letters
were carved in wood in a small scale, in my preferred font, Helvetica." He combined those wooden letters in
different ways, until he arrived at a pleasing configuration.

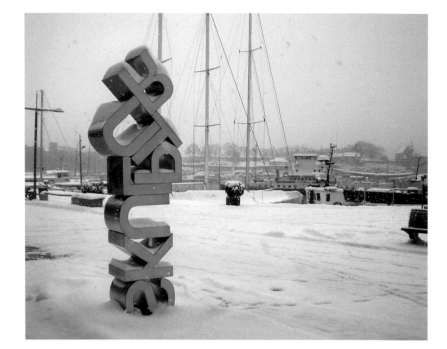

The Monument, Navy Pier, Chicago, Illinois, 1995
Artist/Sculptor: **Theodore T. Gall** Photographer: **Theodore T. Gall** Materials: **Welded aluminum, epoxy painted**
Type: **Based on Bodini Bold or Craw Clardon**
This pulsating melange of hybrid types was designed to identify and honor the Chicago public radio
station WBEZ.

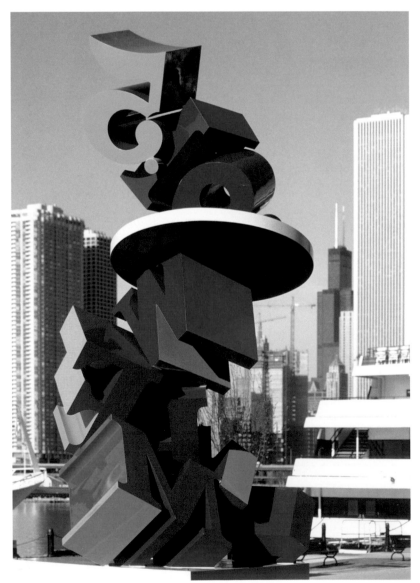

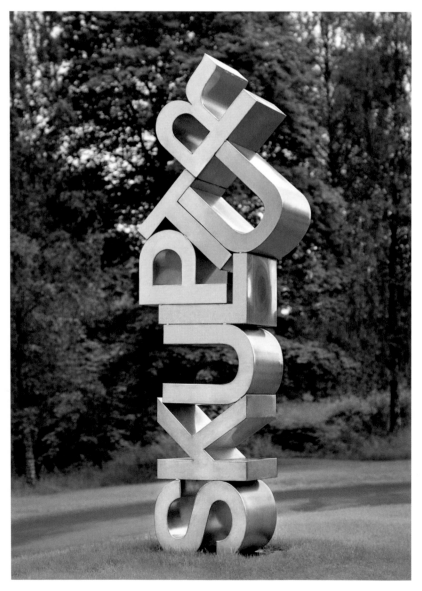

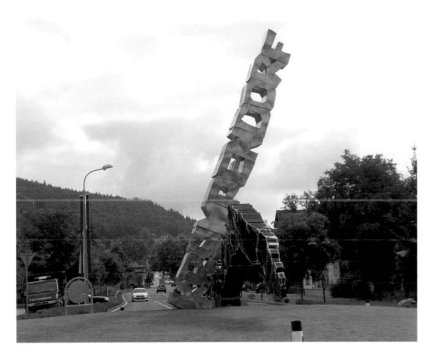

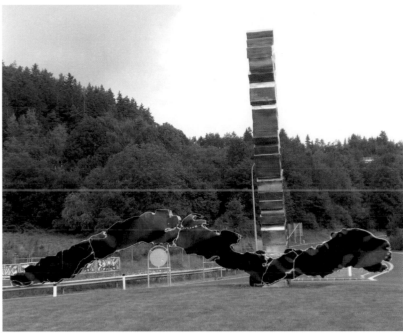

KRUMPENDORF, Krumpendorf am See, Austria, 2009
Art Director: **Herbert Gahr** Photographer: **Herbert Gahr** Material: **Ground stainless steel, blue stainless steel**
The city Krumpendorf am See needed a sign to welcome visitors. The creation of this traffic roundabout sculpture was the first official act of the new mayor.

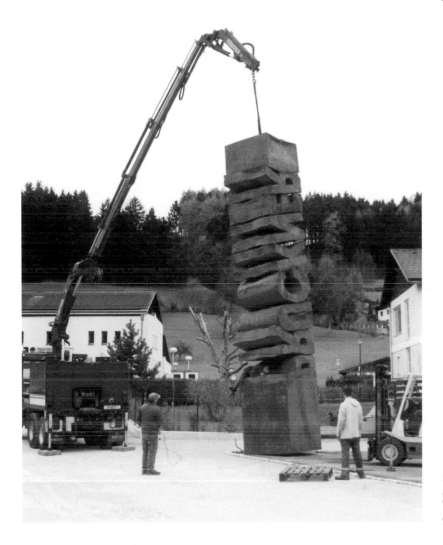

Pruckner, Ybbsitz, Austria, 2001
Artist: **Herbert Gahr** Photographer: **Herbert Gahr** Material: **Rusted steel**
This sculpture is on the so-called Lower Austrian Iron Route, a center for iron works earlier in the twentieth century. The piece recalls the time when wrought-iron crafts were displayed and sold along this road.

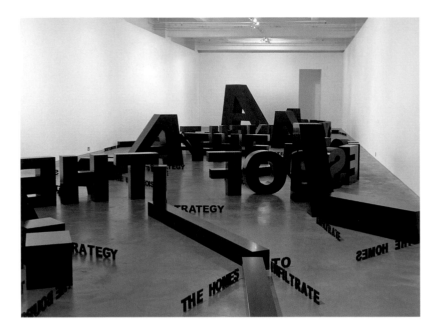

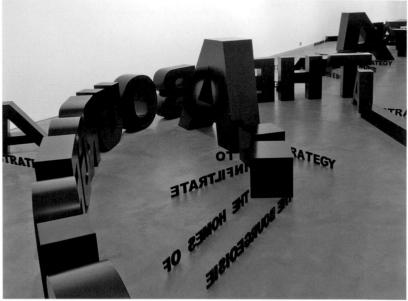

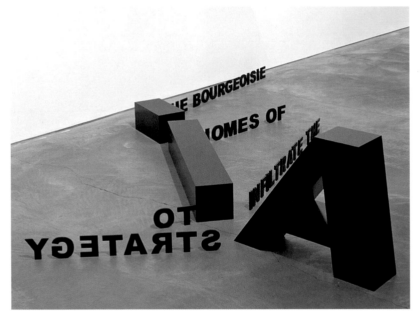

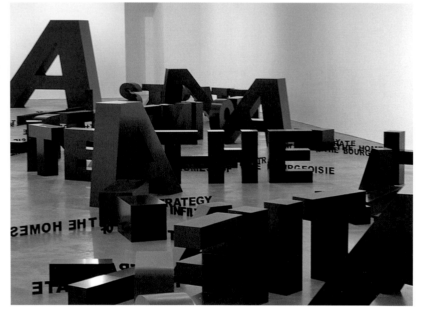

A Strategy to Infiltrate the Homes of the Bourgeoisie, Melbourne, Australia, 2005
Artist: **Emily Floyd** Photographs courtesy of Anna Schwartz Gallery Materials: **Paint and wood**
Floyd, a typographer, thinks it is important to find new ways of working with language. The piece
is about how people look at signs. Her melange of words and letters reflects the clutter of signs in
the environment.

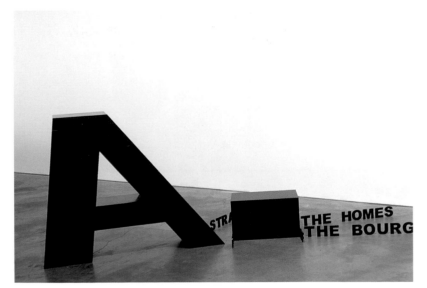

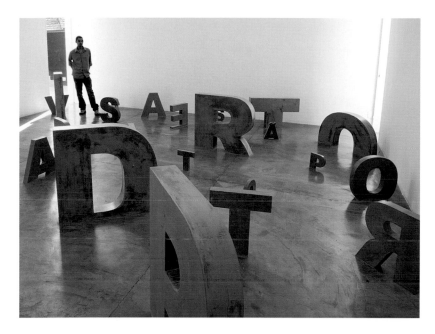

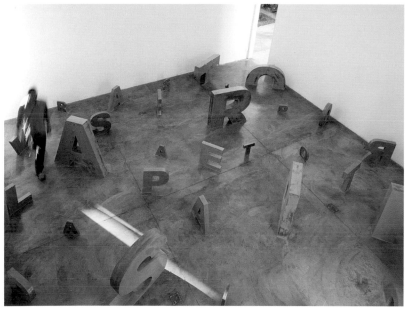

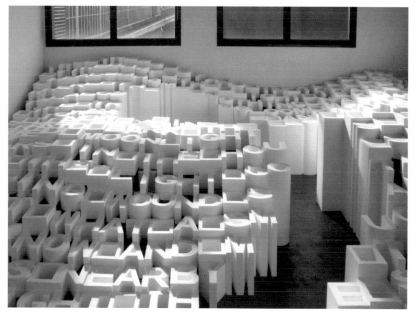

Porque as palavras estão por toda parte (Because the words are everywhere)
Galería Vermelho, Saõ Paolo, Brasil, 2008
Artist. **Marilá Dardot** Photographer: **Ding Musa** Material: **Wood, cement** Type: **Arial Black**
Dardot is obsessed with literature and "Because words are everywhere," first included the exhibition "Proyectos Para Desconstrución" in Mexico City, is an evocation of that passion. The installation consists of thirty-three letters cast in concrete and laid randomly on the floor forming a labyrinthine path.

Towards a Poetic Morphology, La Fabrique, Chaumont, France, 2011
Designer: **Floriane Pic, Joris Lipsch—The Cloud Collective** Photographer: **The Cloud Collective, Guillaume Coutret** Material: **polystyrene, cardboard**
A landscape of letters spells out the poem "Oppressive Light" by Robert Walser. A path invites visitors to explore, read the poem in full, and discover new connotations that arise between text and form. This arrangement in space—strongly affected by sunlight, time and weather—detaches the text from its intrinsic meaning and lets form, typography, and composition take over.

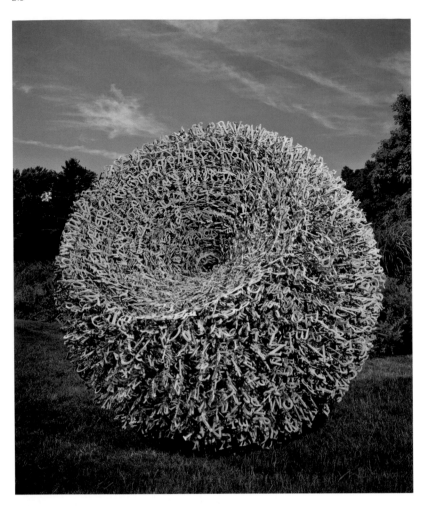

Syntax, Naples, Florida, 2011
Art Director/Designer/Typographer: **Steve Tobin** Photographer: **Kenny Ek**
Syntax is constructed out of hundreds of cast-bronze letters, joined together in such a way that the overall piece is unified while each letter is set in chaos. Steve Tobin's ball of letters represents all possible ideas humans can express through words.

Genius, Leon M. Goldstein High School for the Sciences, Brooklyn, New York, 2002
Artist: **Ralph Helmick, Stuart Schechter** Photographer: **Clements-Howcroft Photography**
Materials: **Cast bronze, stainless steel cable**
This sculpture was inspired by the activities taking place at a high school for the sciences. Wisdom and education were the general themes for the work, and by using text the artists were able to represent the vast array of human knowledge, from mathematical equations to poetry.

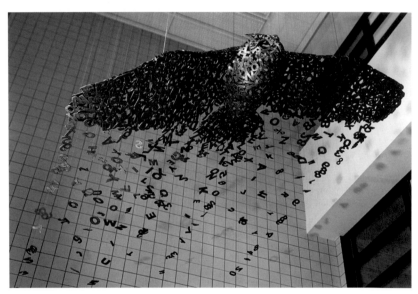

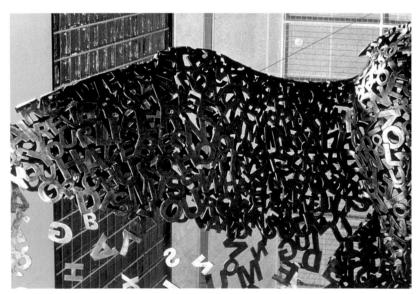

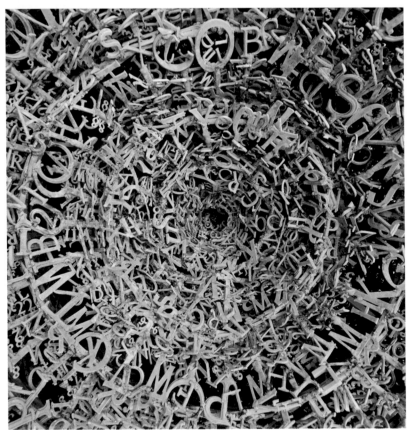

Bottle of Notes, Central Gardens, Middlesbrough, England, 1993
Artist: **Claes Oldenburg and Coosje van Bruggen** Materials: **Steel painted with polyurethane enamel**
This extravaganza is designed to shock the senses, as all Oldenburg's work tends to do. Rather than the typical urban waste (bottles thrown about), this enormous container is an urban treasure standing tall in stark contrast to the old style beauty of this classic English city.

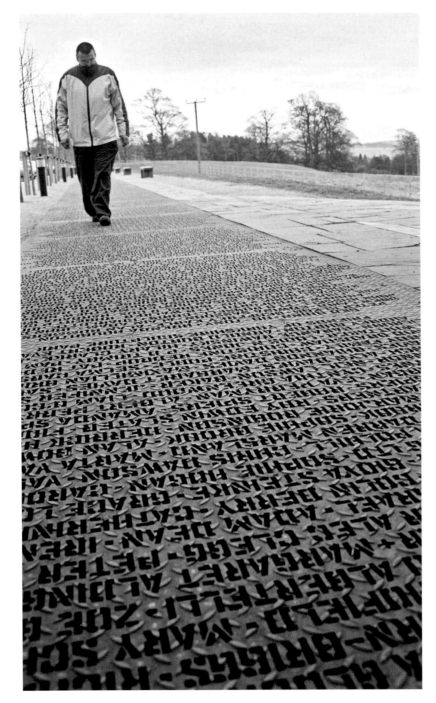

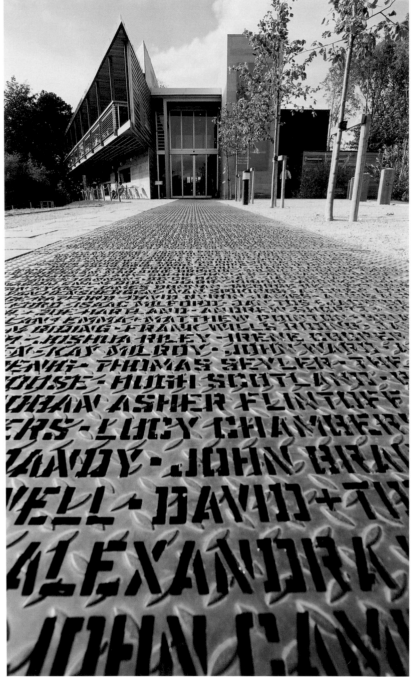

Walk of Art, Yorkshire Sculpture Park, West Bretton, England, 2002
Art Directors/Designers/Typographers: **Gordon Young** and **Why Not Associates** Photographer: **Rocco Redondo**
Material: **Chequer plate steel** Type: **Watertower**
As part of a major fundraising initiative for the Yorkshire Sculpture Park, one of Europe's leading outdoor art organizations, the Walk of Art was designed as pathway of words leading to a new visitor center. It includes the names of all the donors to the park.

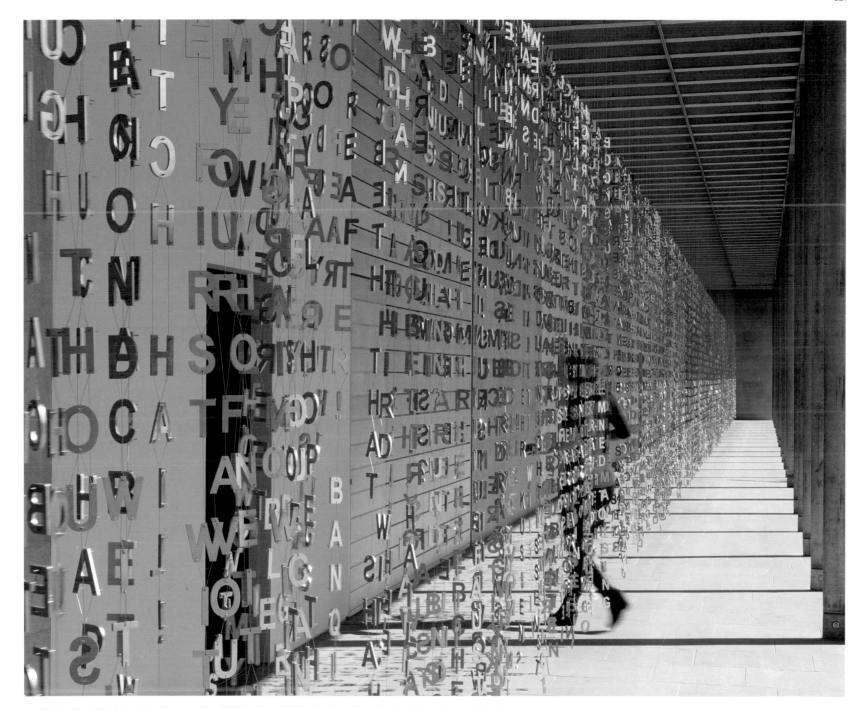

29 Palms, Yorkshire Sculpture Park, England, 2007
Artist: Jaume Plensa Material: Stainless steel
29 Palms is comprised of hundreds of strands of text from various poems. Each strand hangs on its own thread
and the letters are stacked creating a chain of type. These form into a curtain of words that invites the viewer
to enter and either pass through or become entangled

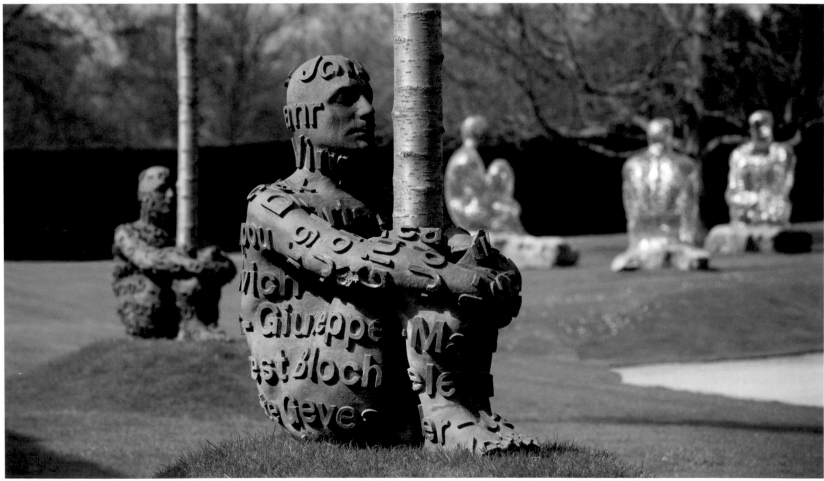

Ha-Ha Bridge, Yorkshire Sculpture Park, 2006
Artist: **Brian Fell** Material: **Corten Steel**
The Ha-Ha Bridge for Yorkshire Sculpture Park is a surprise in a park full of surprises. Brian Fell has cut "Ha-Ha" out of the sides of the bridge to make an amusing reminder that this vernacular term that refers a device to keep grazing livestock out of gardens while allowing for an uninterrupted view. It was coined by the French and is said to be the expression of surprise by a passerby an obstruction in a field.

The Heart of Trees, Yorkshire Sculpture Park, England, 2007
Artist: **Jaume Pelnsa** Materials: **Bronze and tree**
This installation involves bronze self-portraits of the artist, seated with his arms and legs wrapped around living trees. Plensa's vision is for the trunks of these trees to literally grow into the figures so each truly exists as one. The figures are inscribed with names of composers, such as Ludwig van Beethoven, Béla Bartók, and George Gershwin. Plensa hopes that viewers will recall the composers' works and that will bring an interactive dimension to the sculptures.

Nomad, Yorkshire Sculpture Park, England, 2007
Artist: **Jaume Pelnsa** Materials: **White steel**
Nomade is a man of letters, a 27-foot-tall hollow human form sitting Buddha-like and made of a latticework of white steel letters, which looms over passersby and cast a shadow of letters and words. The piece was originally placed on the newly renovated Bastion Saint-Jaume in Antibes overlooking the Mediterranean, and has since found resting places in many other sculpture parks.

Mirror, Yorkshire Sculpture Park, England, 2012
Artist: **Jaume Pelnsa** Materials: **Marine-grade stainless steel, paint**
This piece is designed to celebrate dialogue. Two figures face each other in eternal silent communion. They mirror each other representing reflections of the other's aspirations. The space between the two figures allows the viewer to virtually "enter" the conversation. Eight alphabets—Arabic, Chinese, Greek, Hindi, Hebrew, Japanese, Latin, and Russian—comprise the figures, which indicates the cultural diversity underpinning the project.

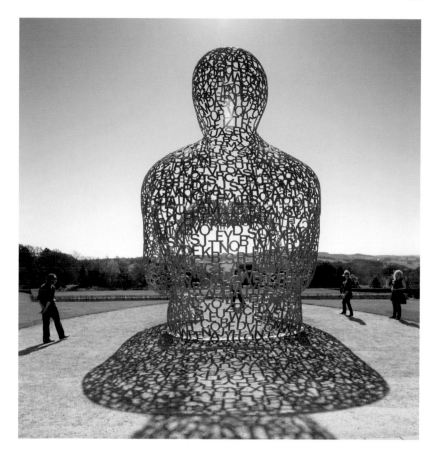

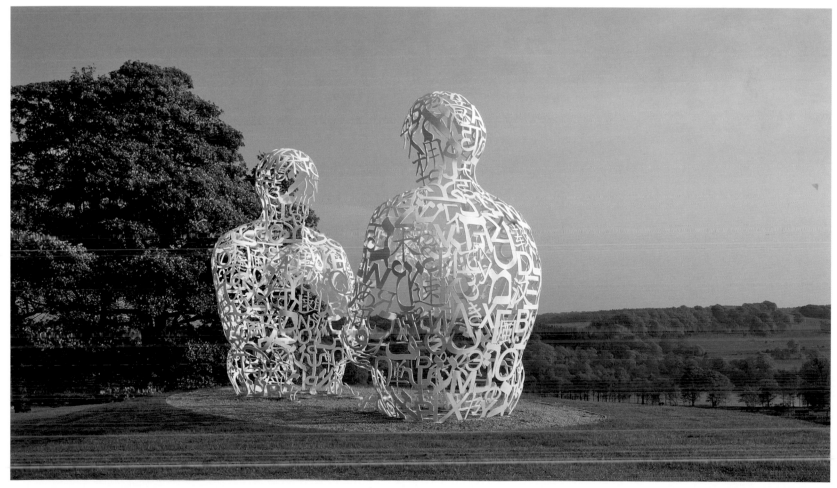

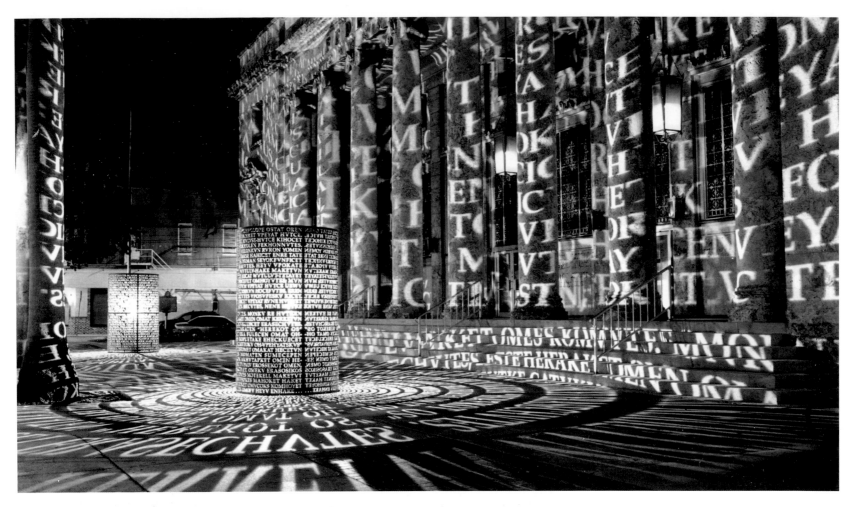

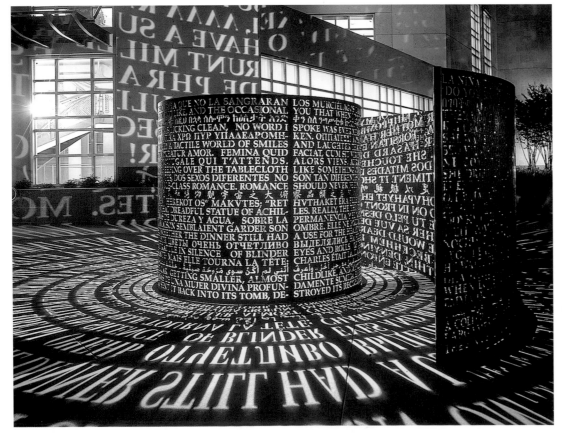

Lux, Old Post Office Building; Fort Myers, Florida, 2001
Artist: Jim Sanborn Materials: Bronze, waterjet cut text,
pin point light source Type: Palatino Bold (Palatino "Onondoga"),
Clarendon by Linotype, Times New Roman Bold (for Greek and symbol
glyphs), Vremya, Addis98

Scientists at Thomas A. Edison's Fort Myers laboratory studied thousands
of species of plants for the manufacture of rubber for automobile tires
and lightbulb filaments. Facing the old post office building, the left-hand
cylinder lists alphabetically in Latin the names of these plants. Before
Edison and before the post office building, there was a large Native
American settlement on the site. The right-hand cylinder projects in the
Creek language a portion of the Seminole/Creek migration chronicle.

A Comma, A, M. D. Anderson Library, University of Houston, Houston,
Texas, 2004
Artist: Jim Sanborn Materials: Copper, text, light, black granite
paving inlay Type: Palatino Bold (Palatino "Onondoga"), Clarendon
by Linotype, Times New Roman Bold (for Greek and symbol glyphs),
Vremya, Addis98

When viewed from the plaza and from the reading rooms on the second
and third floors of the new library the spiral copper screen forms a
three dimensional representation of a comma on a long line of text. The
Harbrace College Handbook demonstrates through the use of phrases,
clauses, fragments, sentences, and punctuation the power of flawless
writing. For the new M. D. Anderson Library, Jim Sanborn filled the lines
of text on the copper screen with hundreds of phrases, clauses, and
fragments of text, each separated by a comma. The source material was
drawn from provocative and consequential works of fiction presented in
their original languages. Each fragment is intended to draw the viewer
onto a flowing line of vibrant, "stream of consciousness" narrative.

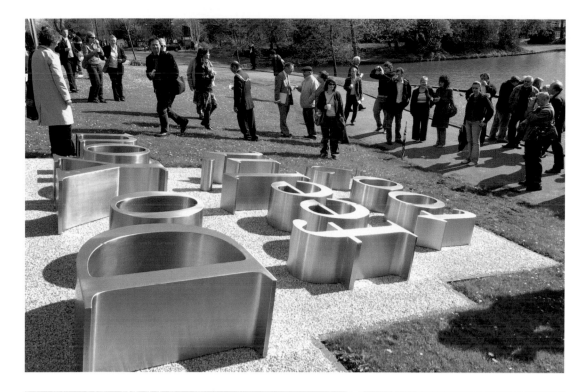

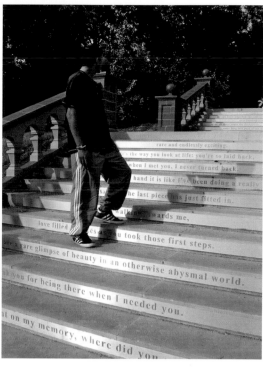

Love Ties, Hanley Park, Stoke on Trent, England, 2005
Art Director/Designer/Typographer: **Emily Campbell**
Photographers: **Albert Bowyer, Emily Campbell** Materials: **Brushed and polished stainless steel** Type: **Times New Roman**
Quotes from love letters cascade down the stairs, hug the islands in the boating lake, and lastly, in enormous size throughout the environment, ask you if you feel it too. Around the lake, when the sun is obscured, the letters sit unobtrusively waiting to be discovered. Once the sun shines the texts burst into the daylight; the reflections of type shimmers giving the texts a kinetic quality. Shiny texts with scribbled emotions are made from stainless-steel letters. And reading the entire text requires walking around the grounds.

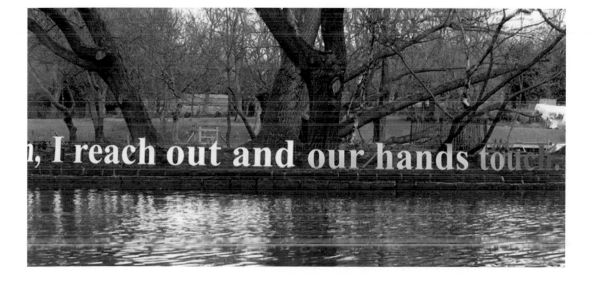

Everything's Gonna be Alright, France, 2004
Artist: Julien Berthier
How simple, how hopeful. This message is dug deep into a garden and can only be viewed from above.

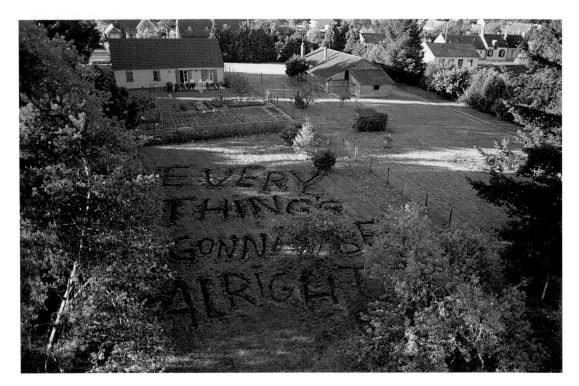

Plan Ahead, Kent Avenue, between 5th and 6th Streets, underneath the Williamsburg Bridge, Brooklyn, New York, 2011
Artist: **Magda Sayeg** Photographer: **Jonathan Hokklo** Materials: **Acrylic yarn; plastic zip ties**
The project, which covers 312 fence posts, spells out "PLAN AHEAD," and it goes beyond simply covering an object in knitting. It is a nod to the homespun wisdom that is often expressed through traditional needlecraft, while also playing a visual game with the passerby. The text of the installation cannot be read straight on, but only from an angle, and as it comes into view, it's clear that the final two letters of "AHEAD" occupy the same space, implying advice not taken. This folksy humor is both a reference to our grandmothers' needlepoint and the public's responsibility to urban landscapes.

Utopia, Norwich, England, 2006
Artist. **Rory Macbeth.**
The entire text of Sir Thomas More's *Utopia* was painted on the wall of the Eastern Electricity building on Westwick Street in Norwich for the EASTinternational 2006 contemporary art exhibition. Macbeth worked out precisely where each line must be positioned for all 44,000 words to fit perfectly on the wall.

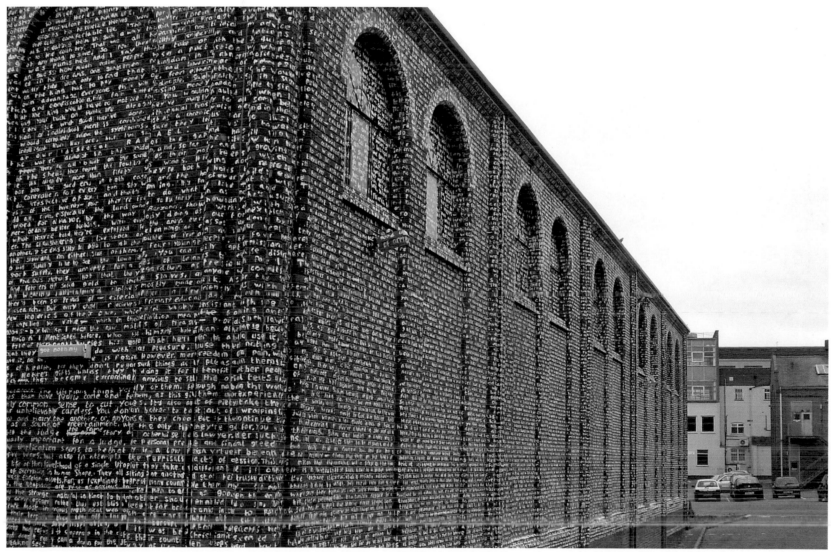

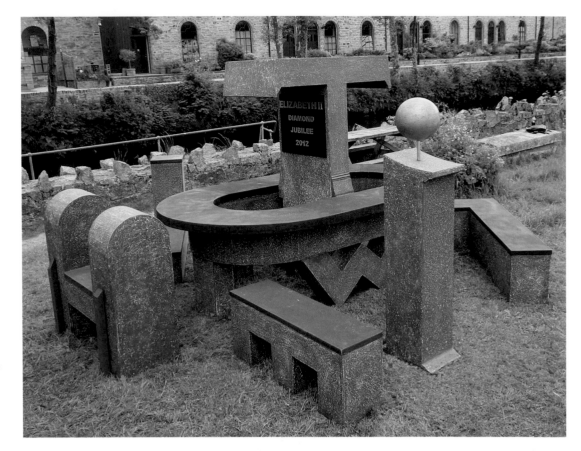

Lostwithiel Diamond Jubilee Sculpture, Quay Street,
Lostwithiel, Cornwall, England, 2012
Client: **Lostwithiel Town Council** Artist: **Robin Guest**
Photographer: **Mat Connolly**
Designed to celebrate the Queen's Diamond Jubilee, the piece takes the
form of standing stones of the eleven letters that spell "Lostwithiel." The
design has a functional purpose as a picnic table and chairs. As Guest
explains, "At first I couldn't think what to do, so one night, I got up in the
middle of the night and wrote the letters 'Lostwithiel' down and looked
at them and thought 'Hang on a minute, they're all shapes' and that's
where the idea came from."

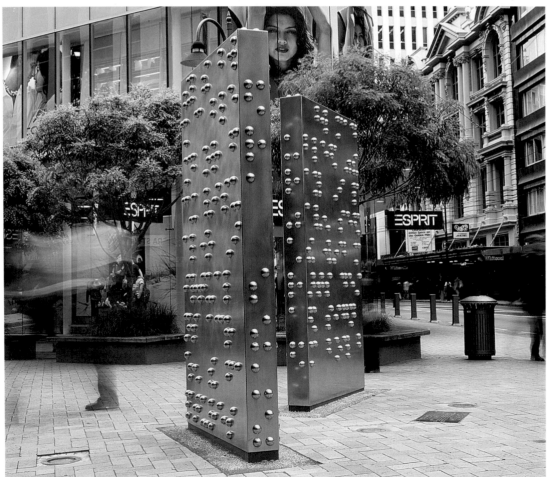

Invisible City, Lambton Quay, Wellington, New Zealand, 2003
Artist: **Anton Parsons** Photographer: **Sarah Lawn** Material: **Stainless
steel 316** Type: **Braille**
"Invisible City" is the name of a poem written by a blind poet, which
was fabricated in stainless steel in giant Braille letters by sculptor
Anton Parsons. Once the poem is transcribed in the oversized Braille it
can no longer be read. The process of removing the meaning
moves another step further away, first from those who have sight,
and then from those who don't. Typographic art often champions the
power of words. Parsons prefers to strip words of power, to make them
not only words without meaning, but also no longer even words.

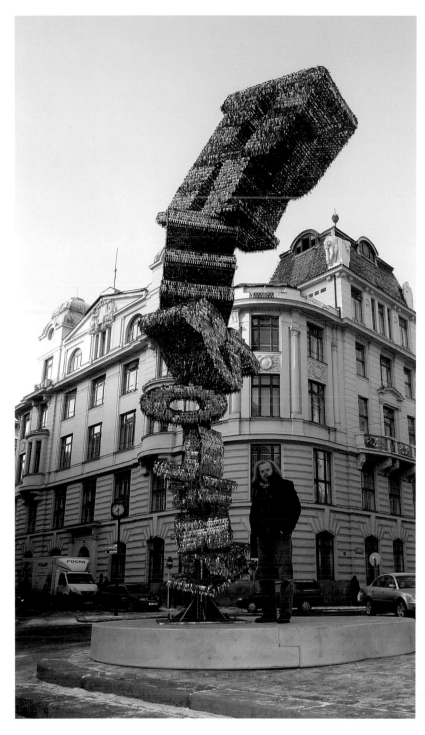

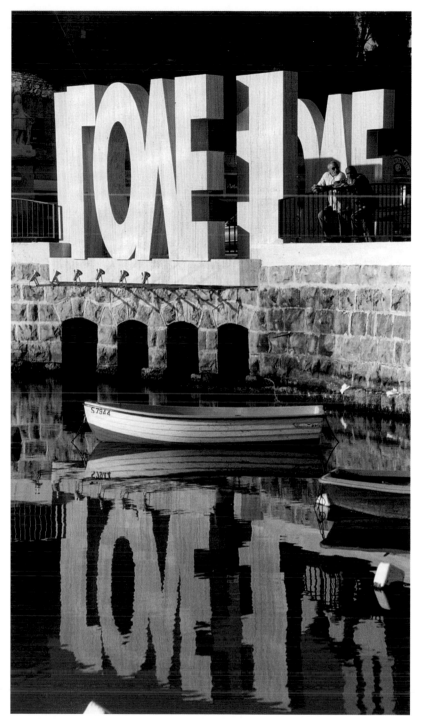

Revoluce, Prague, Czech Republic, 2010
Art Director/Designer/Typographer: **Jiří David** Photographer: **Jiří David**
David (pictured) says his scupture, a precarious assemblage, is a metaphor for the political and social situation in the Czech Republic twenty years after Velvet Revolution. At least it can be shown in public, unlike during the pre-revolutionary regime.

LOVE, Spinola, Malta, 2002
Artist: **Richard England** Photographers: **Peter Bartolo Parnis, Richard England**
Additional: **Halmann (Maga)** Material: **Travertine** Type: **Variation on Gothic Heavy**
Creating this piece required two parallel screens with the inverted word "LOVE." It is designed to cast shadows and reflections in the waters of the Spinola Bay, evoking the legend of Narcissus gazing at his own reflection.

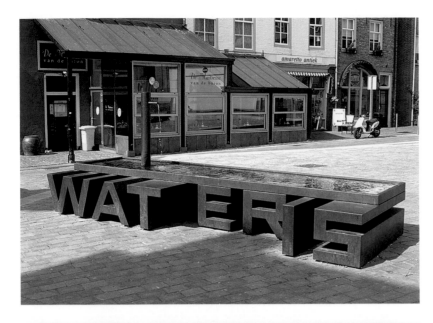

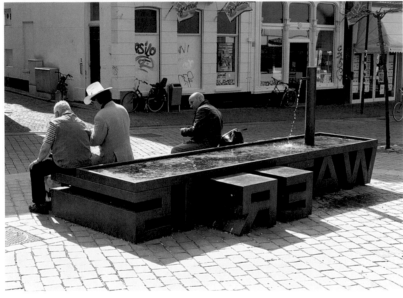

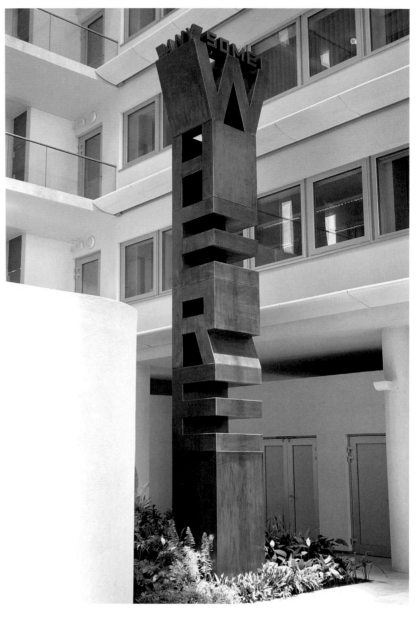

Wat er is (What is there—Water is), Ganzenheuvel, Nijmegen, The Netherlands, 2002
Artist: **Marc Ruygrok** Photographer: **Marc Ruygrok** Materials: **Bronzed brass, stainless steel**
This piece serves as a fountain in the medieval city center. The combination of letters forms several words
and even phrases including 'water', 'what is', 'what is', 'what is'. The water table and the wells are fabricated in
bronzed brass. Ruygrok likes how the weather alters the character of the piece.

SOMEWHERE-ELSEWHERE-ANYWHERE-EVERYWHERE-NOWHERE, Embassy building for the
Netherlands, Germany, and the UK, Dar es Salaam, Tanzania, 2003
Artist: **Marc Ruygrok** Photography: **Marc Ruygrok** Material: **Bronzed brass**
This typographic tower announces "WHERE" the visitor is when coming to this tripartite embassy. The same
bronzed brass is used because it reacts well with the elements.

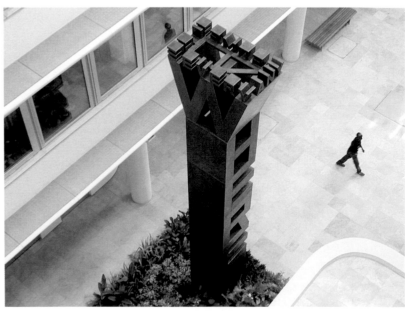

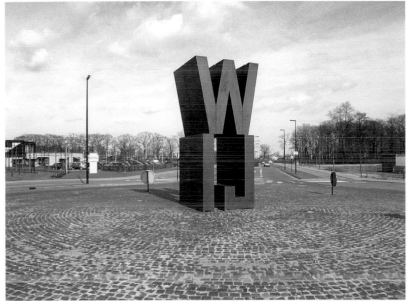

Series HIJ GIJ MIJ ZIJ WIJ JIJ, De vijfhoek / Deventer, The Netherlands, 2002
Artist: Marc Ruygrok Materials: Bronzed brass
These signs represent six turnpikes connecting neighboring locales. The letters are the initials of the respective communities.

HUIS BOOT VIS (House Boat Fish), Zuiderzeemuseum, Enkhuizen, The Netherlands, 1998
Artist: **Marc Ruygrok** Photographer: **Jan Derwig** Materials: **Brass**
The museum shows how Dutch fishermen lived and worked around the Zuider Zee in the nineteenth century. The letterforms serve as resting spots for the weary visitor.

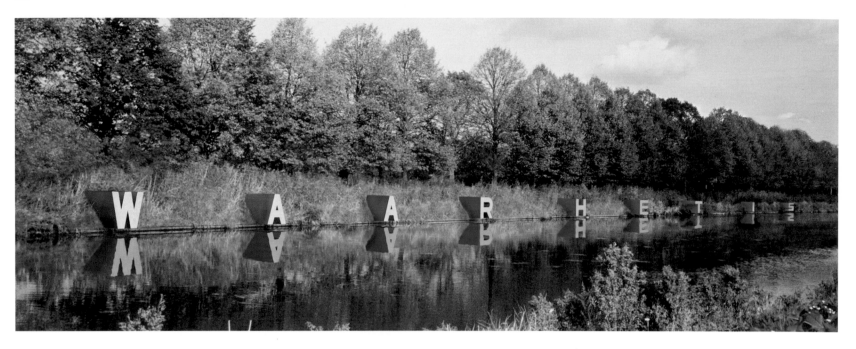

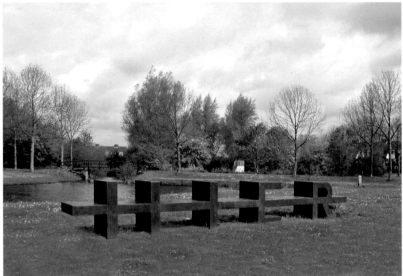

WAAR HET IS / WAAR IS HET (Where it is / Where is it), Valleicanal, Amersfoort,
The Netherlands, 1999
Artist: **Marc Ruygrok** Material: **Brass**
Ruygrok's assignment was to enliven a rather dull canal along the Amersfoort Schothorst between South and
Torque. He created an environmental sculpture consisting of letters that make up the phrases "WHERE IS" and
"WHERE IS". Fabricated in bronzed brass, the letters are set deep into the bank and are used as seats.

HIER (here), Houten Park, The Netherlands, 2002
Artist: **Marc Ruygrok** Material: **Bronzed brass**
This irrefutable statement doubles as a bench in Houten Park, underscoring the fact that the visitor is right here.

ZAANSONG (Song of the River Zaan), Koog aan de Zaan, The Netherlands, 2006
Artist: **Marc Ruygrok** in collaboration with the poet **Arie van den Berg** and **NL-architects**
Photographer: **Luuk Kramer** Materials: **Mirror-polished stainless steel, plexiglass, LEDs**
The idea here was to revitalize the space underneath a highway crossing the river Zaan in the north of Holland.
Poetic lines by Arie van den Berg "support" the weight of the highway. Eight hundred meters of LEDs let four
columns function as lanterns at night.

OK-Bob, 2001
Artist: **Marc Ruygrok** Photographer: **G.J. van Rooij**
Ruygrok's urban gas pump takes retail branding to a new functional level. The dog Bob is waiting at the pumps.

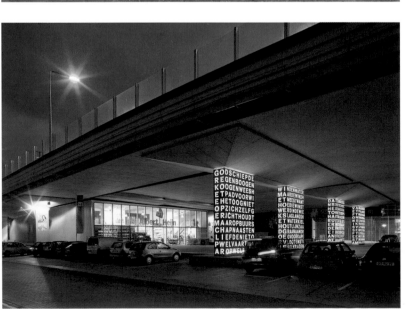

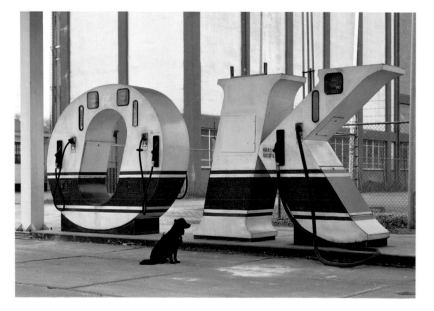

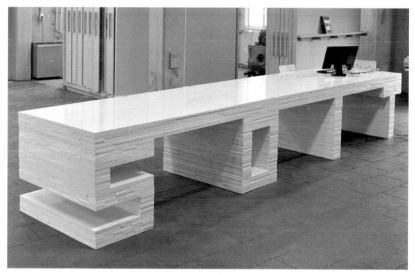

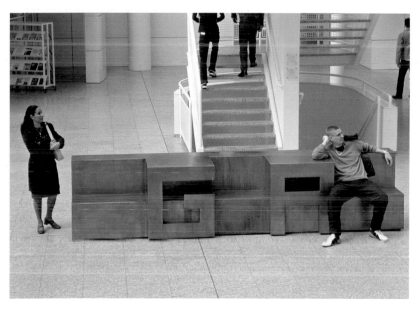

KOM GA ZIT STA (Come Go Sit Stand), City Hall of The Hague, The Netherlands, 2005
Artist: **Marc Ruygrok** Photographer: **Gerrit Schreurs** Materials: **Bronzed brass**
Part of an international sculpture exhibition, this piece provides a nice contrast to Richard Meier's architecture.

TO BE TO DO, Amsterdam, The Netherlands, 2012
Artist: **Marc Ruygrok** Photographers: **Duco de Vries, Nob Ruijgrok**
Ruygrok makes furniture out of letters. And the artist envisions this set of desks to ultimately be used in an office setting.

SOIT (So Be It), Amsterdam, The Netherlands, 2012
Artist: **Marc Ruygrok, Piet Hein Eek** Photographer: **Nob Ruijgrok**
Another of Marc Ruygrok's desks comprising a four-letter word of resignation that means "anyway" or "so be it."

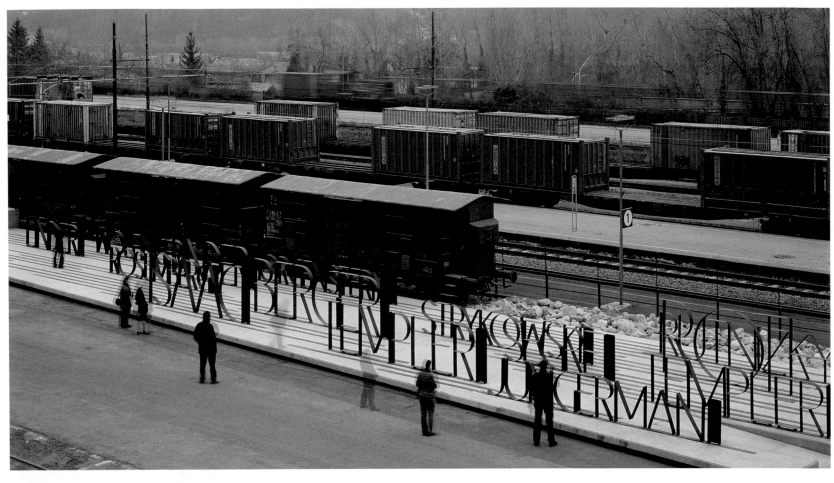

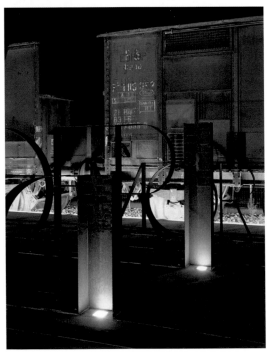

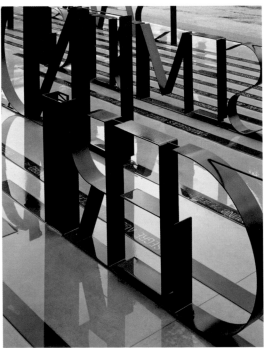

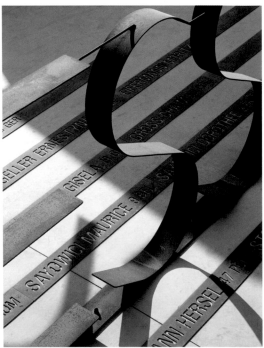

Memorial of Jewish Deportation, Borgo San Dalmazzo,
Italy, 2006
Artist: **Studio Kuadra** Photographer: **Alberto Piovano**
Material: **Corten Steel** Type: **Swiss 721 BD Cnoul BT** for the horizontal
letters; hammered thin for the vertical letters. Both of the typefaces
have been modified to simplify the construction

In this train station where decades earlier human beings were packed
like beasts into cattle cars, the victims of the holocaust are remembered.
Each prisoner is identified by name, age, and nationality as recorded in
the camp register. Each family group is separated from the next by an
un-cut strip of metal. All the words are written in metal, which over a
short time will become oxidized relics.

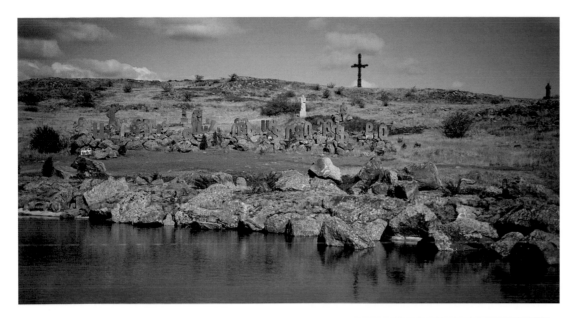

The Monument of Armenian Alphabet
Artashavan, Armenia, 2005
Architect: Jim Torosyan Photographer: Photolure News Agency
The Armenian alphabet celebrated its 1600th birthday In 2005, and in commemoration, the country was given thirty-nine giant, carved tracery Armenian letters that were created in 405-406. They were positioned around the grave of Mesrop Mashtots who created the alphabet. Armenian architect J. Torosyan created the stone carvings of every letter, which, juxtaposed with a statue of Mashtots, pay tribute to the Armenian language.

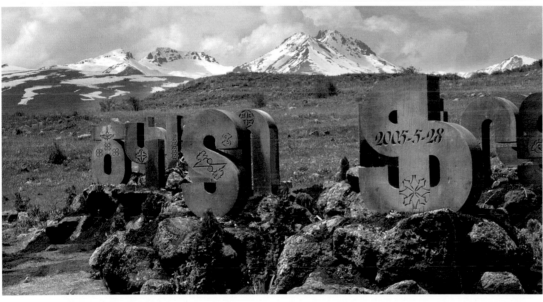

The Stone-Cross Letters to the World, St. Mesrop Mashtots Church, Oshakan, Armenia, 2005
Designer: **Ruben Nalbandyan** Photographer: **Ruben Nalbandyan**.
Material: **Stone**.
Karekin II, the Catholicos of All Armenians, blessed the thirty-six stone-cross letters, representing the Armenian alphabet that erected in the yard outside of the St. Mesrop Mashtots Church on the occasion of the 1,600th anniversary of the invention of the Armenian alphabet.

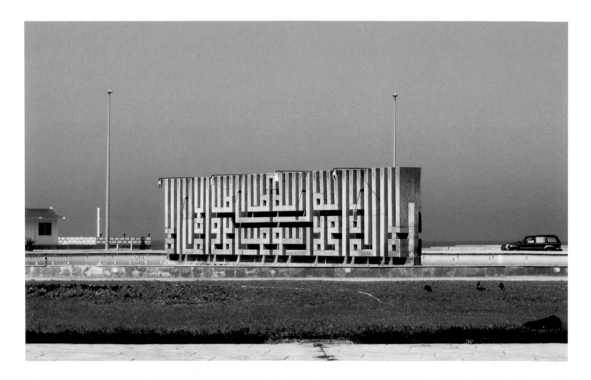

Shahādah Sculpture, Jeddah, Saudi Arabia, c. 1970
Artist: **Julio LaFuente** Photographer: **Susie Khalil**
This is a Square Kufi or geometric Kufi composition representing a verse from the Koran. The "shahādah" is considered the basic pillar of Islam: "There is no god but God, Muhammad is the messenger of God."

The Verse Boat, Jeddah, Saudi Arabia, c. 1970s
Artist: **Julio LaFuente** Photographer: **Susie Khalil**
Verse from the Koran in the shape of a ship using the Diwani script. In Arabic calligraphy, this verse from the Qur'an reads: "And say: 'My Lord, lead me in with a just ingoing, and lead me out with a just outgoing: Grant me authority from thee to help me.'"

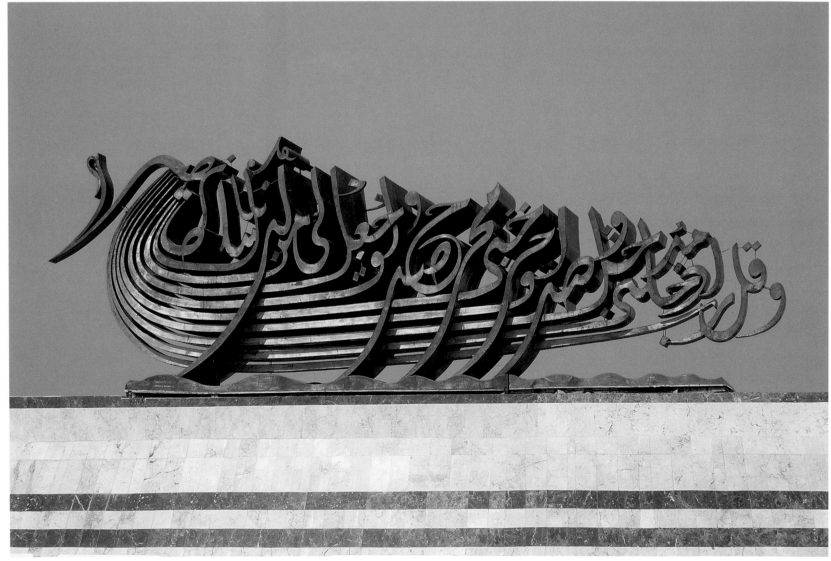

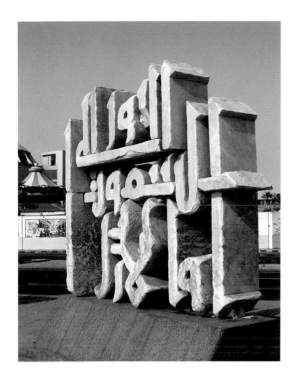

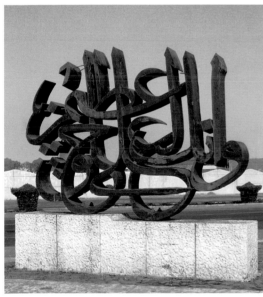

Jeddah Sculpture, Jeddah, Saudi Arabia
Artist: **Julio LaFuente** Photographer: **Susie Khalil**
This sculpture represents a verse from the Quran, Surat al-Nur made in
the early Kufic style that translates to "Allah is the light of the heavens
and the earth."

Koranic Verse, Jeddah, Saudi Arabia, c. 1970s
Artist: **Julio LaFuente** Photographer: **Susie Khalil**
In calligraphic script, the Islamic verse written in Arabic translates to
"Surely thou art upon a mighty morality."

Swords of God, Jeddah, Saudi Arabia,
Artist: **Aref I Rayess** Photographer: **Susie Khalil**
When seen from a certain angle, Swords of God spells out "Allah" in
Arabic calligraphy. The sculpture is situated in Jeddah at the corner of
a busy intersection with an overpass from which passersby have a very
good view.

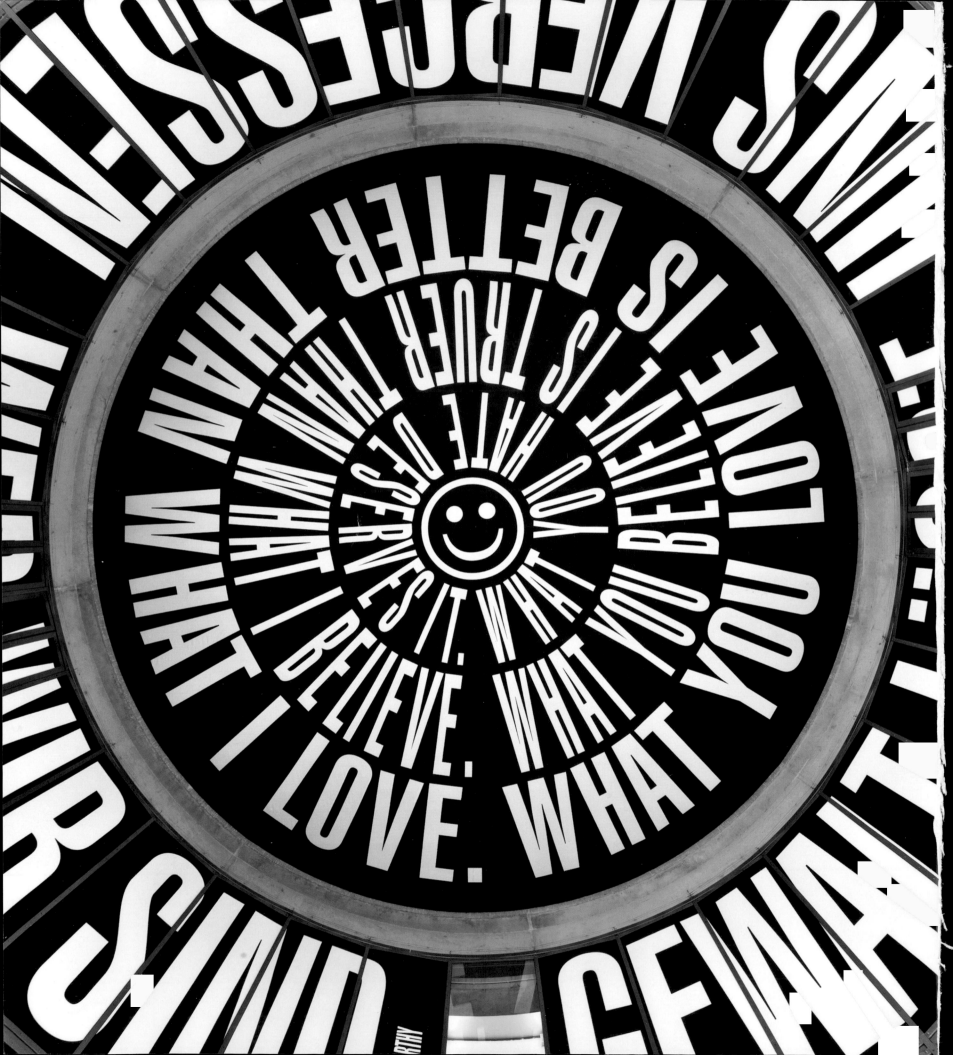